EQUUS

TIM FLACH

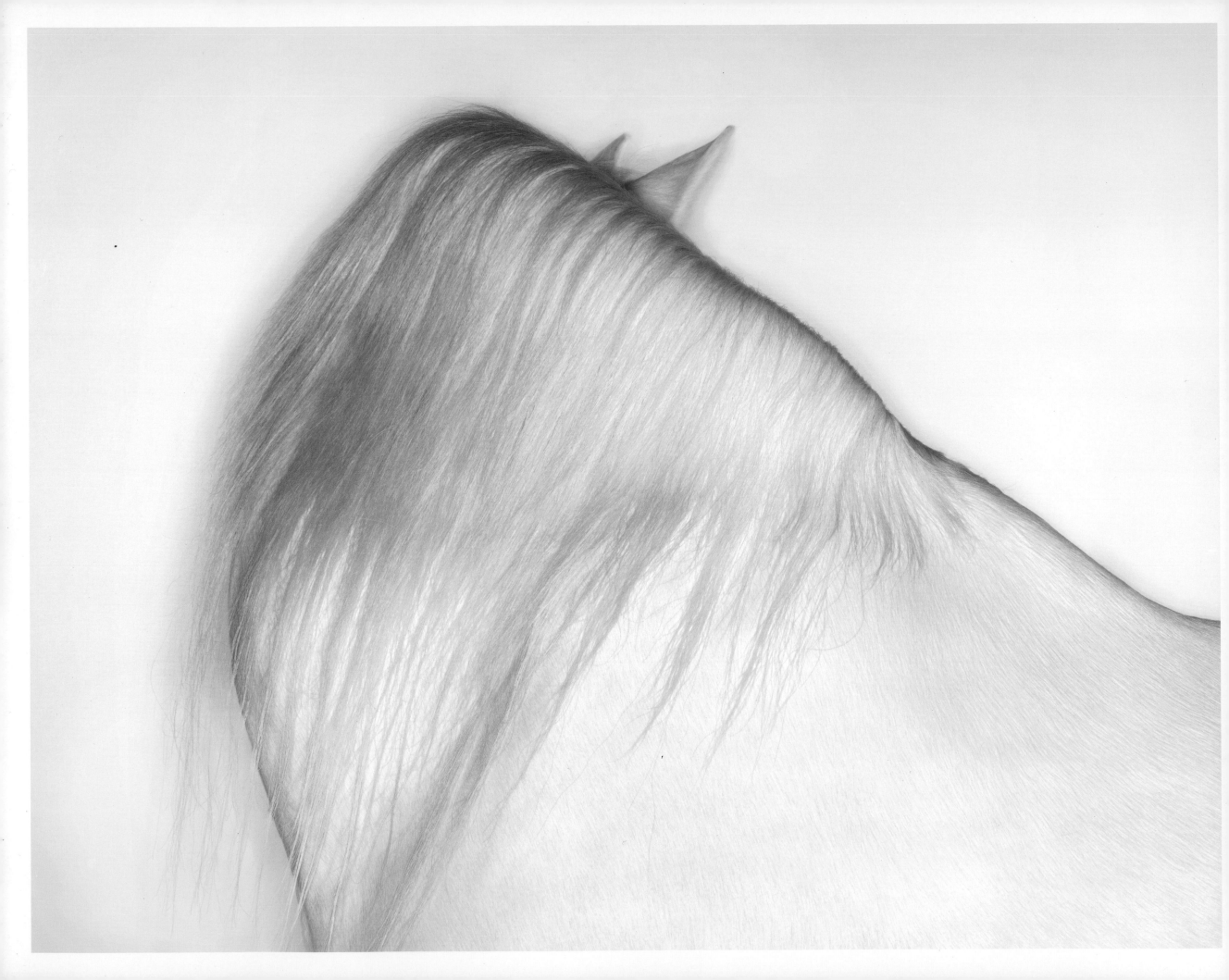

EQUUS

TIM FLACH

Abrams, New York
in association with PQ Blackwell

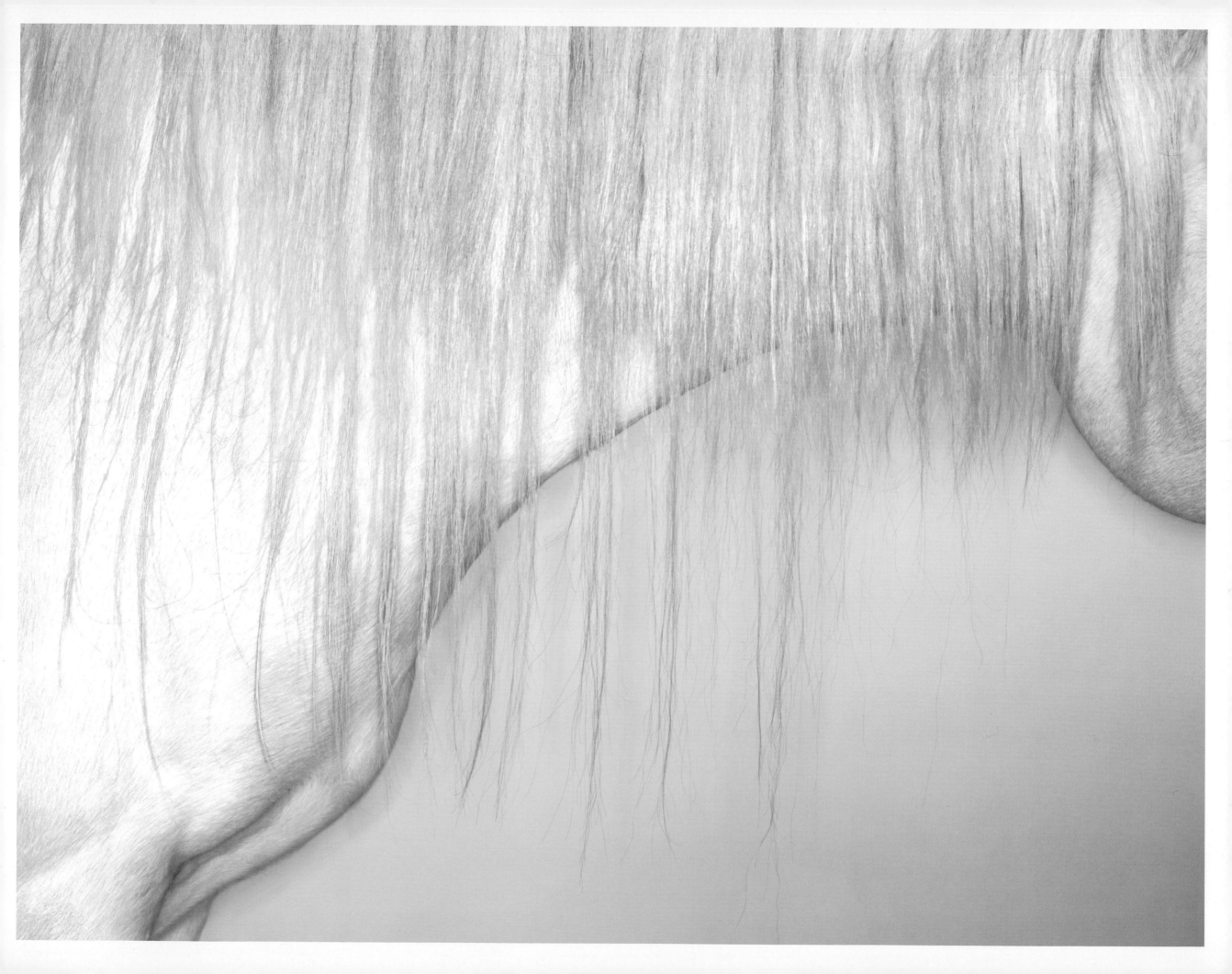

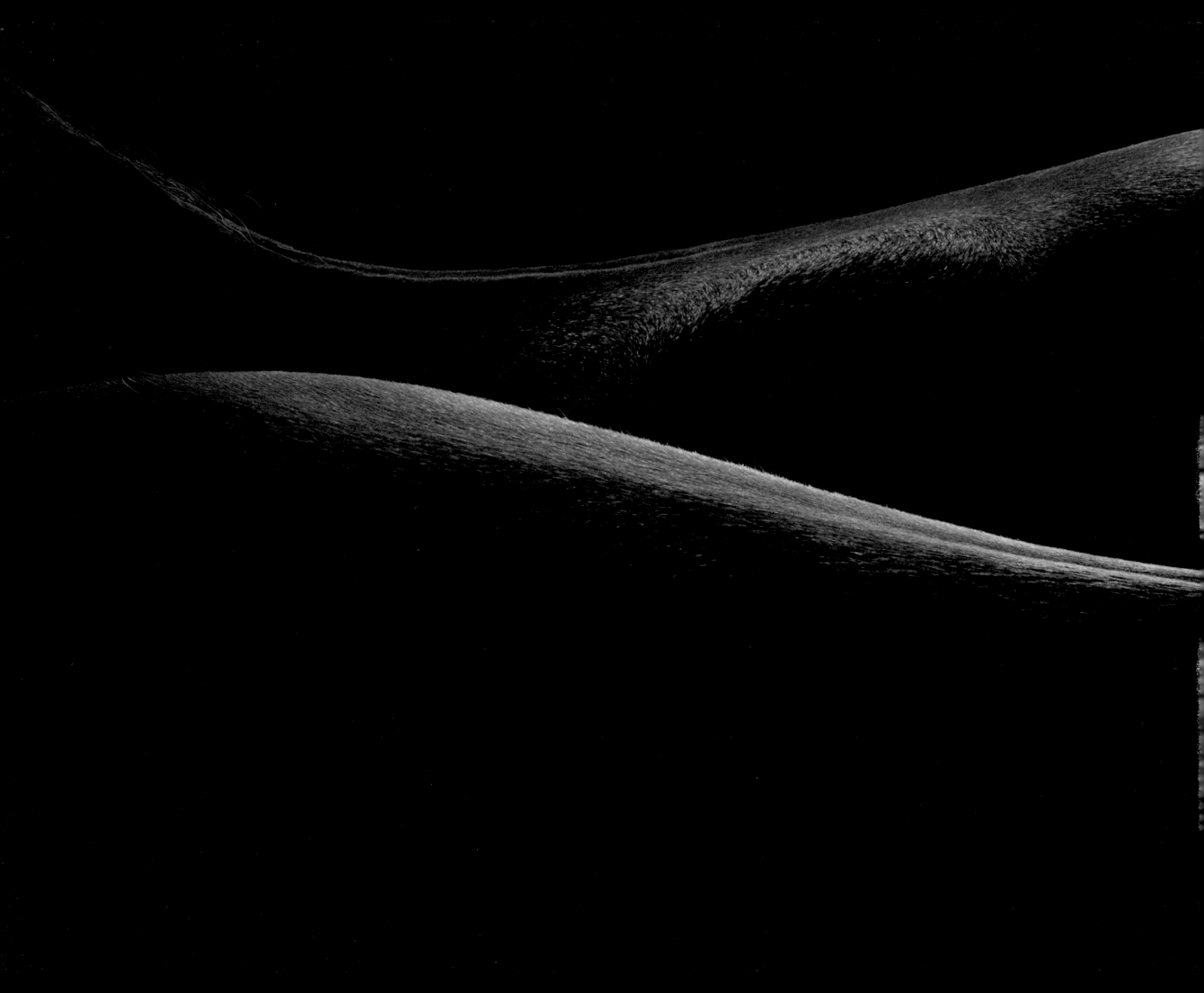

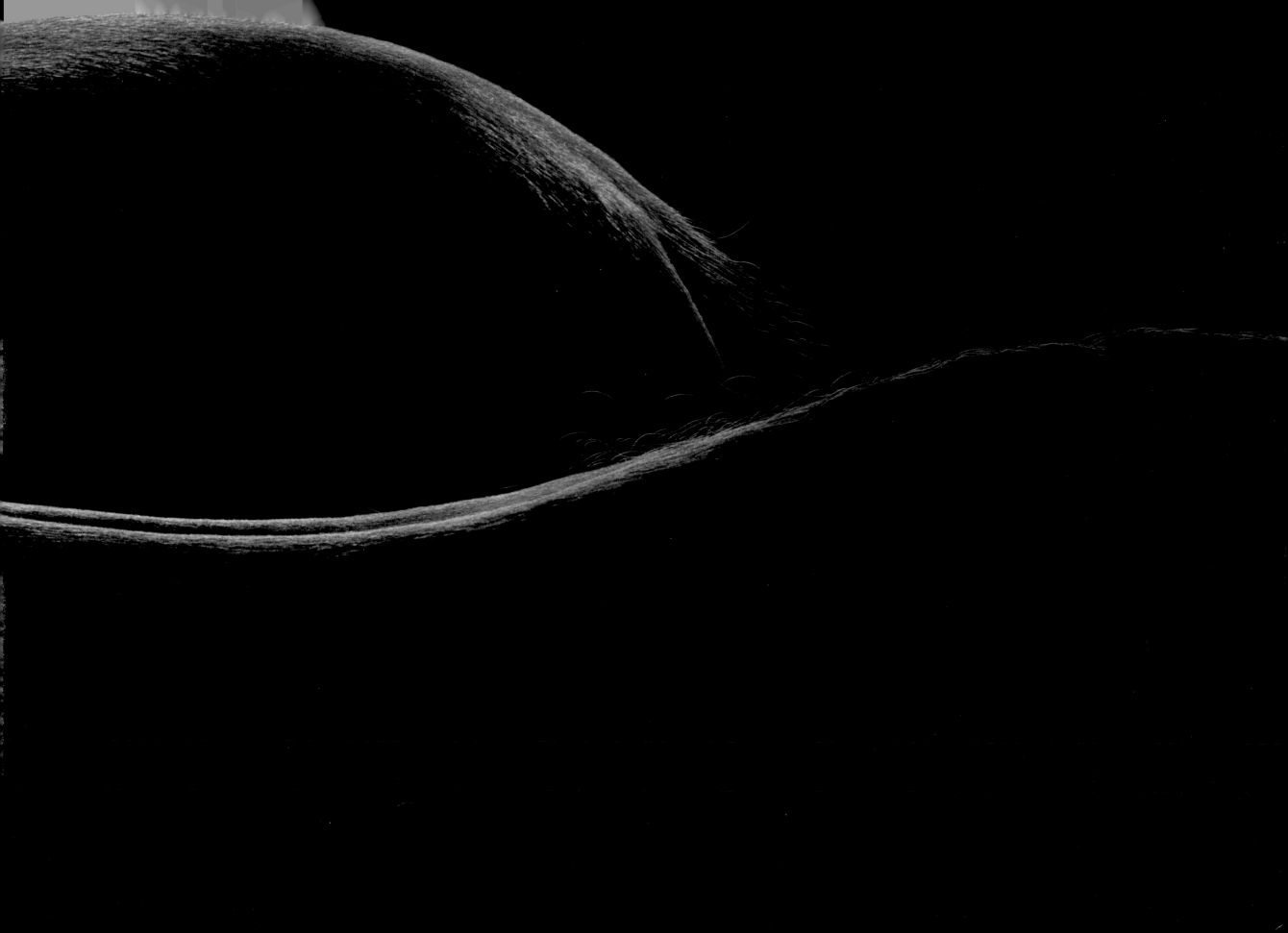

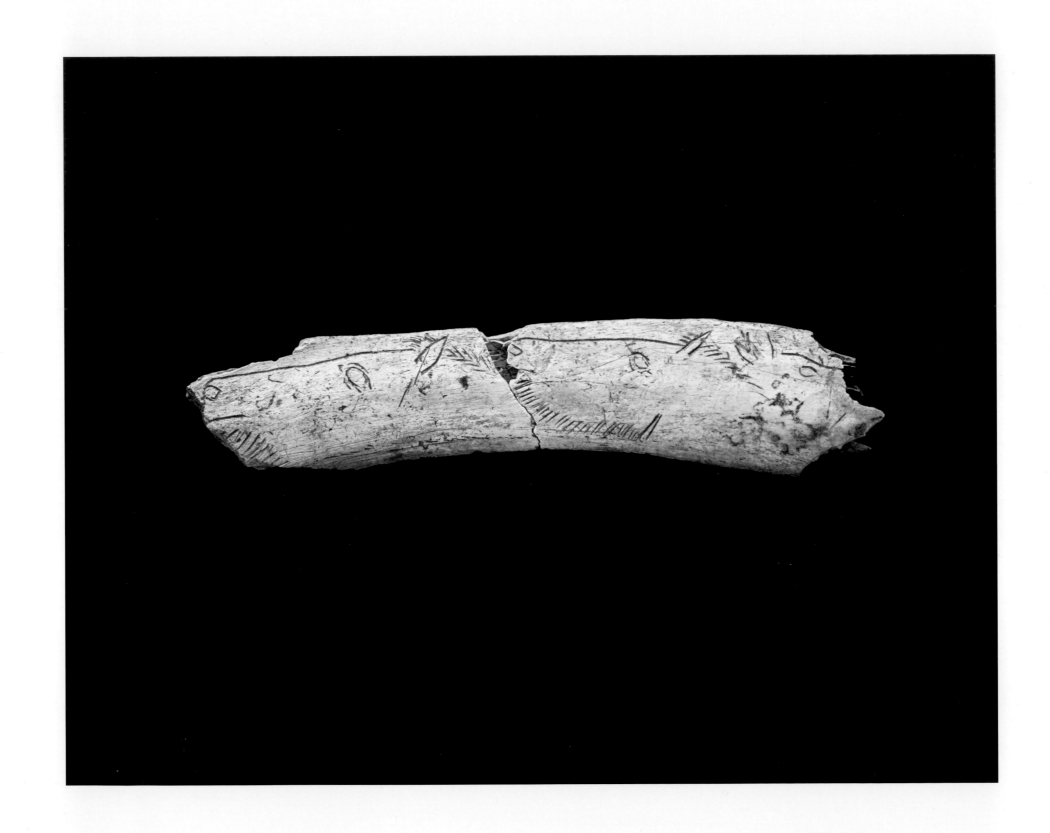

Animals and photography are inextricably linked for me. At the center of that relationship is a part of a horse.

The first time I picked up a camera in earnest was as a student, when I went to the London Zoo to explore composition as part of an art foundation course. I duly delivered a series of abstracts, but something greater had been stirred in me. Working with photography and studying the appearance of animals were simultaneous revelations then and have continued to be great passions. I became, and remain, fascinated by observing all kinds of creatures. I ceaselessly inquire into how we see them and how they, in turn, see or relate to us. Our relationship with animals constantly stimulates new questions about how we view and construct the world around us.

It took years for me to realize I could focus on the subject I have explored in this book, which is to take an extended look and inquire into the wonder of *equus*, the family of animals that encompasses horses, donkeys, zebras, and other horselike animals both recent and extinct. While I grew up with horses, it was a long time before I managed to photograph a horse in a way that I was happy with. But in 2001 I shot a series, and when I saw how strongly all kinds of people responded to the images of two Arabians (pages 21 and 25) I was able to photograph, I realized I had found something fresh.

In particular, there was one image of a horse named Hassan. Or rather, it was just a part of Hassan in a photograph that I have come to call *Horse Mountain* (page 25). A white shoulder and mane on a black background, the image manages to say more by having so little in it. This semi-abstract picture has a level of ambiguity that resonates—a detail of a beautiful horse that at the same time suggests a pristine snow-covered mountain. The attention this image received made me realize that the horse was not only a subject that fascinated me, it also had a special connection for many other people. Somehow the image had punctured their consciousness and prompted them to respond.

I felt that part of the impact of the shoot was due to the fact that we relate to horses in a unique way; it is a relationship that may go back tens of thousands of years, near to the origins of both of our species. Artifacts such as a bone engraving (opposite) suggest that what I am engaged in here, image-making around equus, is a project that directly descends from the earliest attempts by humankind to record and express our mutual existence with these animals.

When I set off to document and gather evidence on this relationship, I knew the direction I wanted to explore but not what I would find. Now, as I separate myself from the project and present the images to you, I am the more richly informed and yet have an even greater sense of our ambiguous friendship with this species. We have exploited equus to extremes, and yet also nurtured them perhaps more than any other.

The connection between man and horse goes back before any documentation, but is extensively depicted in the earliest records we have, with many drawings in the finest rock and cave art. From hunting horses, which are depicted as animals bearing a striking similarity to the only wild horse in the world today, the Przewalski (pages 85–89), our ancestors took the species through a long period of domestication and breeding, leading to an incredible diversity of forms today. This range reflects both the functional and symbolic needs we have of the horse. The split between

purpose and pleasure, between the everyday and the mythical, seems essential to the development of the horse both now and in the future. There is a lot more to our relationship than the fact that the horse was a vital tool; and honing that tool through a combination of utility and location has done much to shape how horses are today. Yet now we shape it according to functions that are largely built around its heritage and symbolic significance.

The function of the horse today is highly sophisticated: The various breeds are often standard-bearers for communities, representative not only of their own history but also of the diversity of humanity and our heritage. If you are a farmer in the Austrian Tyrol and can afford a horse, it really should be a Haflinger; in Norway it will be a Fjord; while in Iceland, strict breeding regulations mean that you will only have an Icelandic, and it has been that way for many hundreds of years. The horse represents how we are what we are. However, it now rarely functions as a core working tool; even where the horse is put to practical use, mechanical alternatives typically exist. Today the horse resonates for most of us as a symbolic or sporting presence.

My exploration of horses in this book is loosely divided into three parts. The first section focuses on an aesthetic appreciation of the remarkable forms and variety of the species; the second part examines how location has played a part in shaping the appearances of different horses, and how location also shapes our response to the species today; the third section of the book is more conceptual, scientific, and futuristic. It was some time into this project that I realized this was how the book should be structured, and hindsight now helps me understand why. I began, as any photographer might, with a highly visual appreciation, but came to see that the issue I was examining was the very nature of what a horse has been and can be. As a result, in the final section the images range from looking at how we alter the horse in state-of-the-art embryonic transfers, to the outcome of exotic crossbreeds, and even to masking practices that almost make a fetish of the horse's head. Of course, the multibillion dollar horse-racing and gambling industry is never far from being the "function" behind the modern Thoroughbred in our final pages. I suspect some may find this last section a little disquieting; at times it was for me, but there were issues that I found myself drawn to record.

Throughout the book you will see that, despite the horse's close relationship with *Homo sapiens*, I have allowed few people to make it into the frame. While the modern horse is the result of man's shaping and intervention, I did not want to direct the focus toward what clothing or behaviors people display while around horses. That would have been inevitable if I had let the eye become preoccupied with any significant human presence. You will have to settle for the boots of Olympic horseman John Whitaker atop Cruisings Mickey Finn (page 40) and a distant string or two of stable lads riding out on the hallowed turf of England's Newmarket racecourse (page 274). Give or take a few excited wildebeest, feeding flies, and two enormous dog paws, the rest of these pages are a pure celebration of equus.

The images range from the highly conceptual and near-abstract to the more narrative and literal. I realized quite early on that it would be quite unworkable to make a book in which every image stands alone—that would have been akin to offering a bag of sweets, rather than a satisfying and balanced meal. So sometimes images were deliberately shot and edited to work as sequences, and sometimes a quiet image was preferred for its content over another with more

obvious aesthetic impact. If this makes it all sound very pre planned, it wasn't quite that organized. While there is a great deal of preparation required to be in the right place at the right time, the photographer who wants to observe something fresh has to be open to what happens rather than simply seek an image that is already in mind. Sometimes you simply don't get close to what you set out for, but end up with something else that needs to be valued for what it is. I am still of two minds about the pictures I took when I went to the Mongolian steppes to photograph the Przewalski. This horse is a crucial link between today and the past, as it is the only wild horse remaining in the world, even though it was reintroduced from captive animals in order to be bred back into a sustainable wild community. Riding around the vast terrain on the back of a motorbike, hoping to get close to these wary creatures, I never quite delivered the images I imagined. But I did make the visual link with a horse whose features are remarkably similar to the sketches on bone seen on the preceding spread and whose form disappears back into the Paleolithic mist.

I had similar challenges in shaping events when I went to document the Great Migration in Kenya as part of my inclusion of the zebra. I had a familiar picture in my mind of how the animals have to risk their lives to cross the river. So that's where wildlife photographers go to capture the image that we know perhaps only too well. Sure enough, when I was there so were other photographers. But as we watched the herd lining up to cross, something spooked the zebras and they took off, back against the flow of animal traffic. Suddenly I was able to get a much more unexpected image (page 123), one that for me sets off a stronger sense of the life struggle involved than if I had the river shot I had originally imagined. And yet it is also clearly a photographic experience of some sophistication; it is not entirely raw. There is something of the jungle scenes in *King Kong* in the way the light catches the earth and the vegetation mixes in with the animals and dust.

At the other extreme, there are highly constructed, referential photographs that are more deliberately meant to ask questions and to tease the eye as unnatural. There is one I took of an Arabian show horse, indeed a supermodel of the horse world, which often seems to throw the viewer (page 199). For one thing, there is the suspicion that the picture was made from at least two images put together—it wasn't. The horse is in the immaculate stables of the Ajman Stud, lit from within the stable by flash, and the view through the window is there to be seen when the shutters are open. Of course, the human eye doesn't tend to see the two things, the dark interior and bright exterior, in the way that the camera can capture them, bringing the light levels into a viewable balance in one frame. The image is also carefully shaped in the sense that I was looking to allude subtly to the famous painting by George Stubbs called *Whistlejacket*, and my subject, JJ Ballarina, seemed happy to oblige with a suitable pose. The result is an image that happened entirely in-camera, but is in a sense highly constructed and has an unreal—or is it superreal?—appearance. How we read the image is perhaps more a comment on our culture and the heritage of the horse image than anything I devised in the making.

As a photographer seeking evidence I sometimes have to hold back on being too presumptive as to what I might find or shoot. I have to be open to possibilities in order to see what is there rather than impose preconceptions. Occasionally you face evidence that seems inconvenient, for example, the fact that wherever there are horses you will usually encounter lots of flies. I can't say that I feel as passionate about flies as I do about horses, but the image of

feeding flies (page 127) does give some insight into their symbiotic relationship. If nothing else, we can appreciate it as an intense act of recycling. The strange allure of the image for some perhaps tells us that if you look closely at anything you might be surprised at the aesthetic qualities that can emerge.

The breeding series (pages 214–239) divides and disturbs in more profound ways. The ten-day-old embryo, a life in transit from one mare to another, was less than four millimeters across but appears in the photograph as almost a universe in itself. All life is there in a tiny, mysterious sphere. The later-stage fetal images take on a different quality, like sculptures in Carrara marble by Canova or Michelangelo, or perhaps fine antique white porcelain. There is immense fragility in these almost translucent forms; perhaps these are things we should not see.

It is a strange quality of recording, of documenting life and forms as precisely as possible, that the more disciplined and stripped back the image is, then the more unnerving and even unreal the result can sometimes appear. With both the breeding series of images and the mask series (pages 258–267), my determining of a tight and highly reductive format within which to shoot developed an ambiguity of message that I am still musing on. Our eyes and expectations of a portrait might tell us that the horses are posing, when of course they are simply being horses. It is my structure and your assumptions that make us draw out whatever ideas we care to find. For example, we may fetishize the appeal of the head protector, the fly net, or the gas mask, but this would be entirely of our devising.

By stripping back and freezing time and space, photography can take us into a very different relationship with the subject. Over the course of numerous trips around the world and into the world of the horse, I have evolved my relationship with equus. I can but modestly hope the images might offer something evolutionary for your experience of the species. If at times the photographs seem to surprise with darkness as well as light, that might be just as well. It is something I have become used to as I have dug into some of the issues around the development of the animal.

As ever with a picture, all is not what it seems. Only here the manipulation is not so much in the photographs, it is in the relationship we have with the species. The illusion is the horse.

The more I worked on taking the pictures for this book, the more I found myself asking: What is a horse? How has it evolved? What is it becoming? The questions might seem a little curious and the answers might even seem obvious at first. But if that is your view, bear with me and see if I can shift your thoughts as mine were moved. I have come to sense that at one level this project is no more or less than an assembling of evidence and you, the reader and viewer, are the judge. The case in question concerns why and how we have forged this intense relationship with another species. It's a relationship that shapes us and reflects intensely on our humanity, but in these pages you will see how it has also absolutely shaped the horse. The next question might be: What are we going to make of the horse now?

In addition to asking questions, working on these images has allowed me to look deeply into the symbolism, myths, and clichés that we associate with the horse. This reached a peak while I was photographing mustangs and took the opportunity of doing part of the project around Monument Valley in the American Southwest. Few of us can look at

those unique rocky outcrops, the buttes known as the Mittens, without our consciousness and subconscious throbbing with mass-media memories. Westerns and other movies, Marlboro ads and fine art, pop videos and postcards, even computer games, have all perpetuated this scene as emblematic of the American West—and the mustang is hitched to it, even though it is not really where most of them live or ever have lived.

There are, of course, no rules as to how you should approach this book. However, I hope that you will find enough of interest to start making connections between images, between different horses, locations, subjects, and issues that I have covered. You don't have to share my thinking on the subject, but if you start to formulate questions about any of the images, you may seek out more information from the supporting text. Perhaps that is why you finally landed here, at the introduction. If you are like me, it is rarely the place you begin or get to very quickly. Books are for exploring in four dimensions and this one is no different. It is not for the artist or author to entirely dictate the sequence for reading. Make of it what you will. Find your own path through the pages.

We have tried to dictate the wonder that is equus over tens of thousands of years. While man has had a significant impact on the species and constructed a whole edifice of breeds, at the same time there is something powerful and unknown still at work in this relationship. The images juxtaposed on the following two pages, of a donkey with distinctive cross-markings and the symbolic hot-branding of a Lusitano, capture the conflicting nature of our bond: The images are charged with both the intensely material and the elusively spiritual. Look at the brand with its symbolism; speculate on the origins of the donkey's markings, which legend links with the idea of a shadow falling from Christ on the cross to mark the donkey forever. We might sense that the idea of the living creature as specific property conflicts with the notion that each animal is a being representative of a species with an ancestry that is as deep if not more so than that of the human master.

As a species, we too are changing and being changed by our contact with horses. We are perhaps the first generation to fully separate from vital, functional dependencies on these animals, and something new is emerging. Across the aesthetics, heritage, and science of the horse, we can expect to see rapid development.

As humanity confronts the wider issues of genetic research—of DNA know-how, control, and manipulation—the story of the horse is an interesting point for reflection. With selective breeding, we have manipulated the genes of horses and donkeys for several thousand years. What was once done in a field or stable, now often has its key moment in a test tube. Perhaps soon it might be via a software program that can splice just the right properties together for the ultimate performance animal. However these issues progress, and whatever the moral, aesthetic, or economic climate dictates, one thing is certain: We will continue to find a place for the horse in our lives and dreams. From the cave wall to the betting hall, this is a species that has excited our passions for as long as we have known of them. These images are one more chapter in the chronicle of that relationship.

Tim Flach

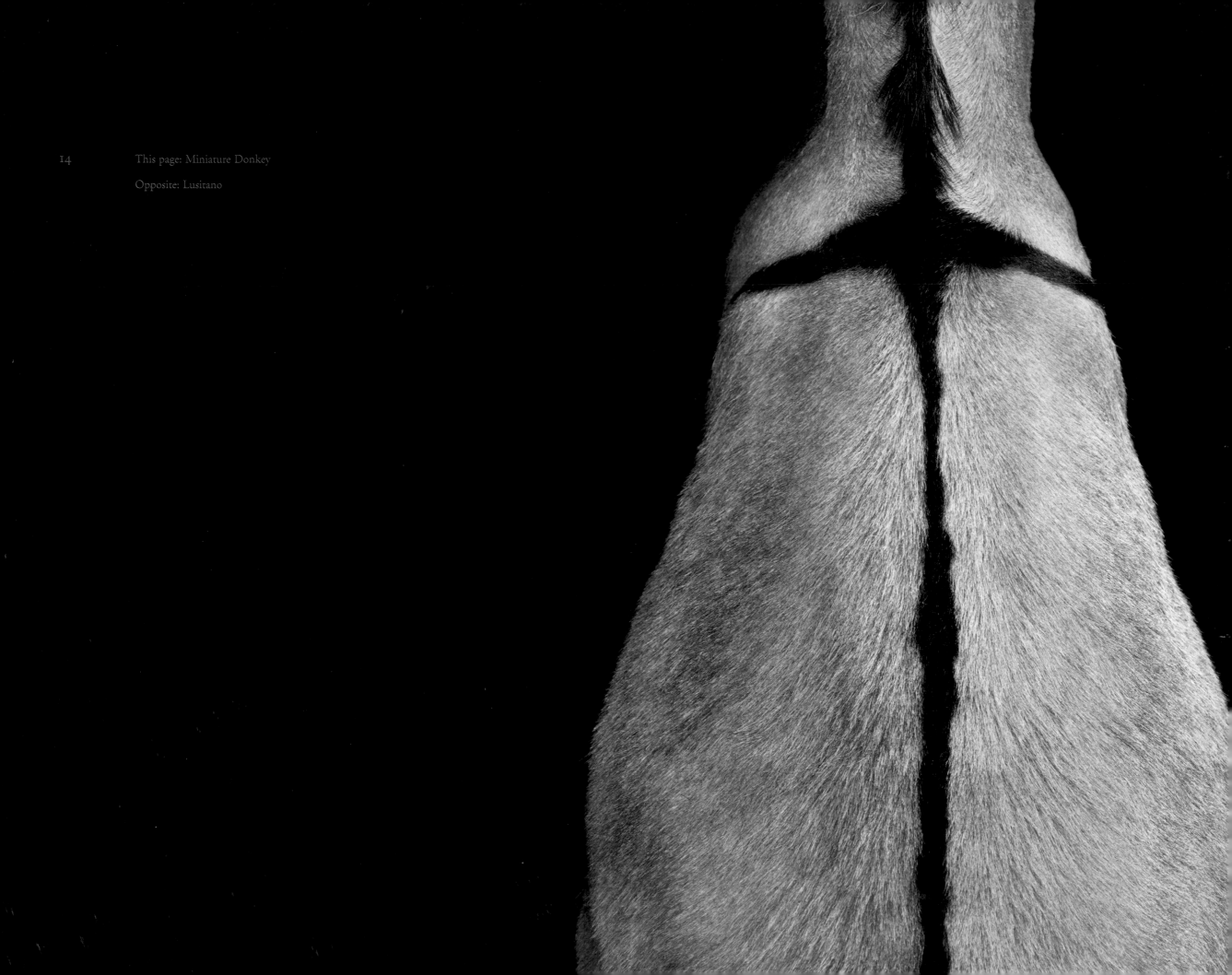

This page: Miniature Donkey

Opposite: Lusitano

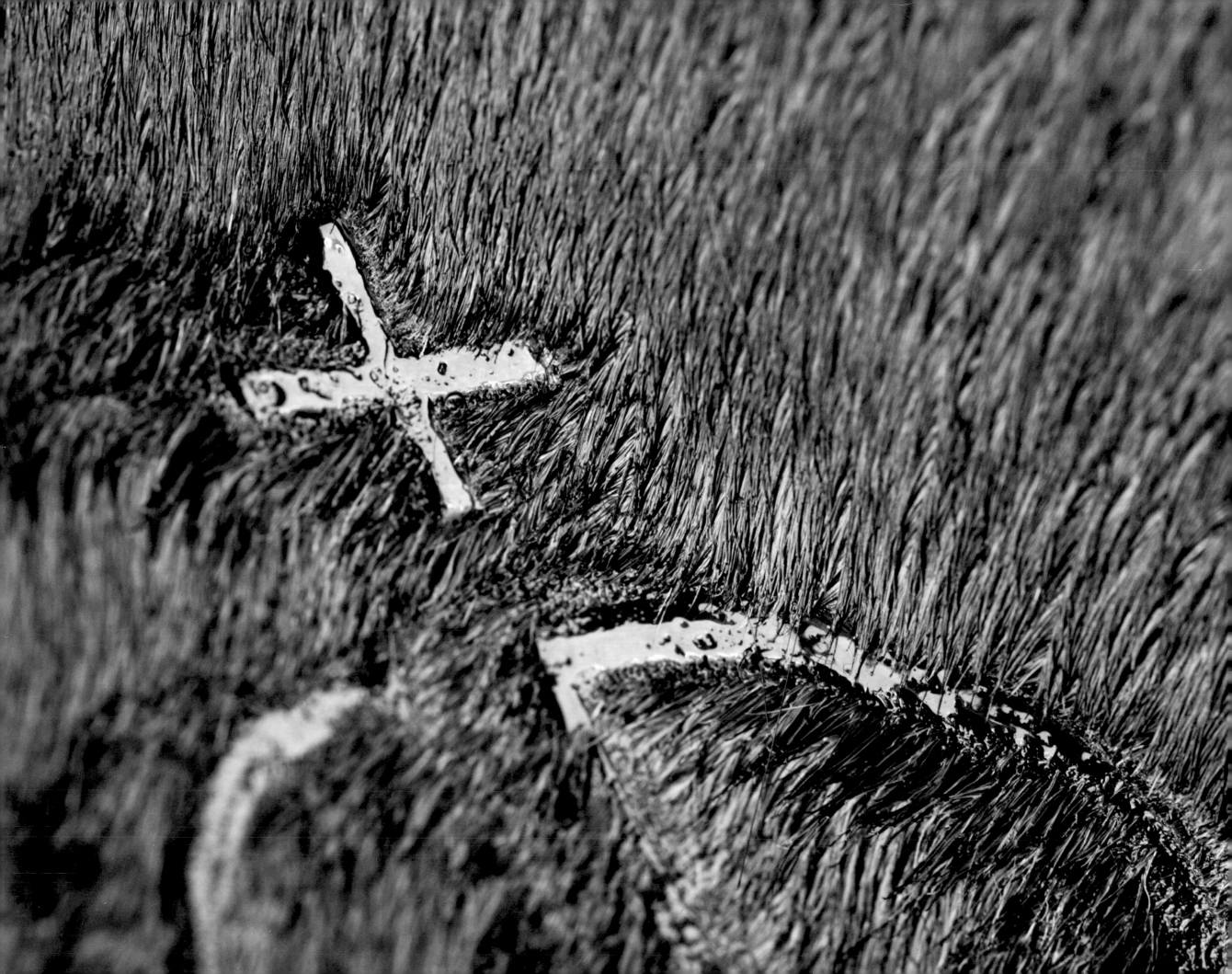

Equus: The family of animals that goes from Ass to Zebra, but is mostly Horses.

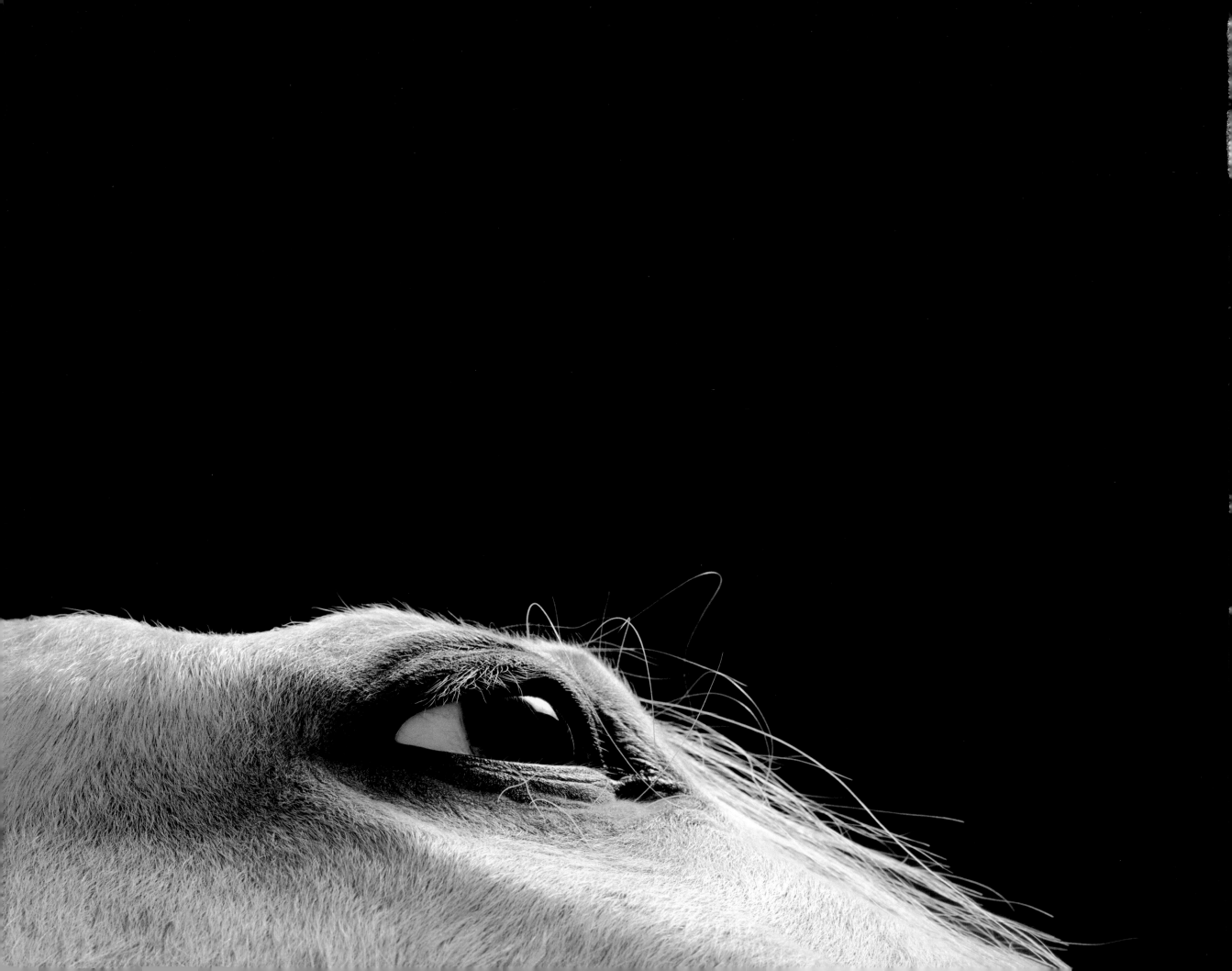

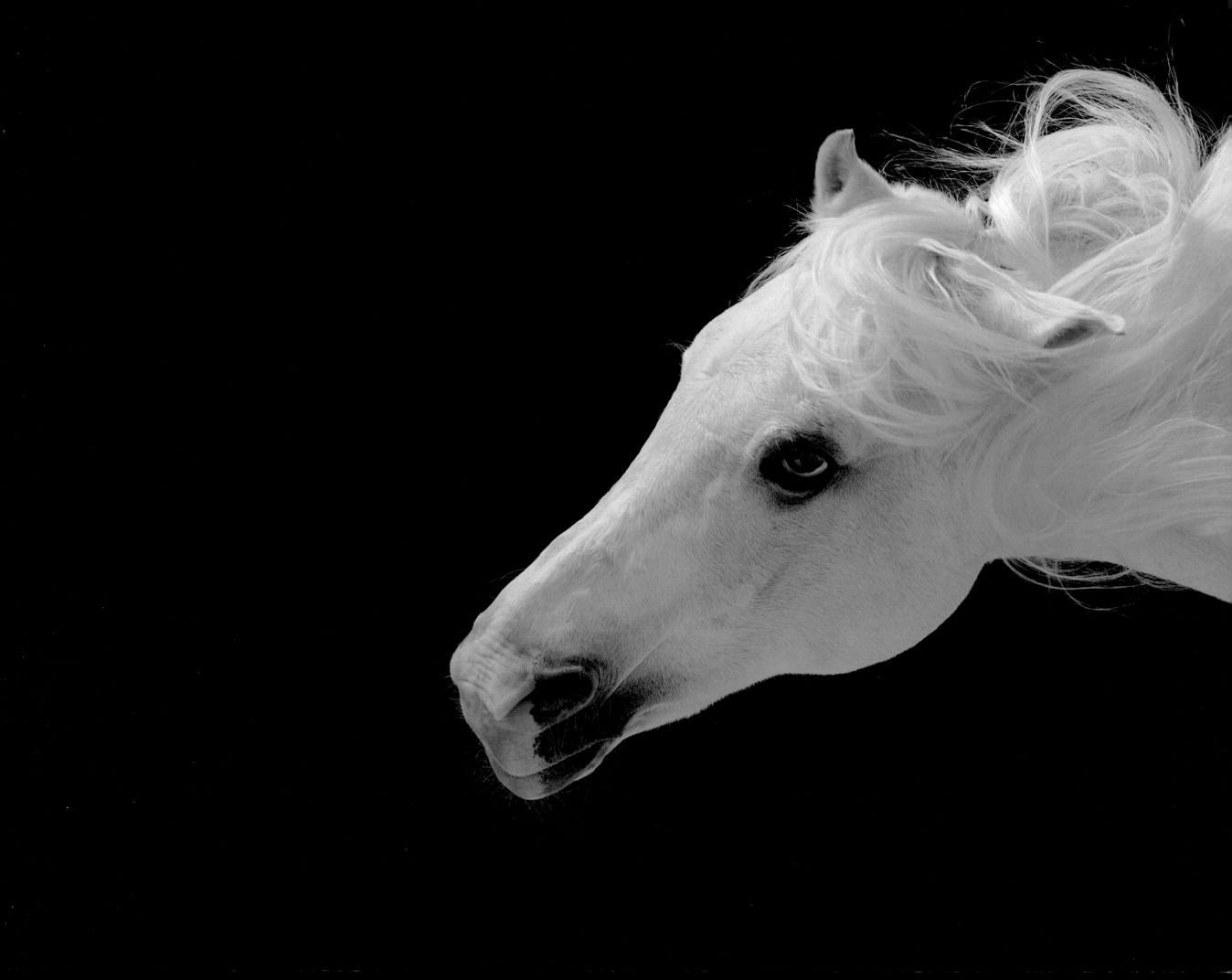

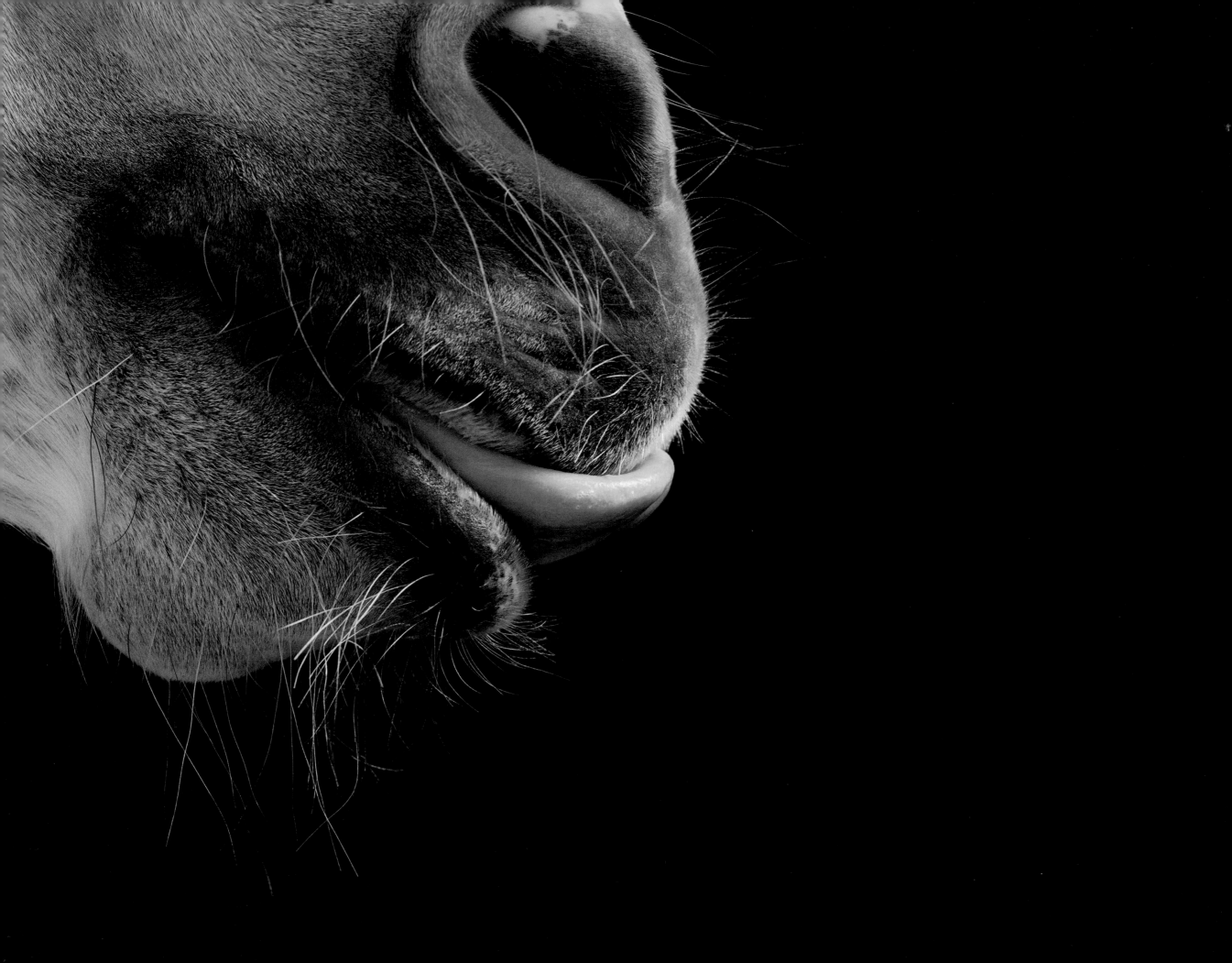

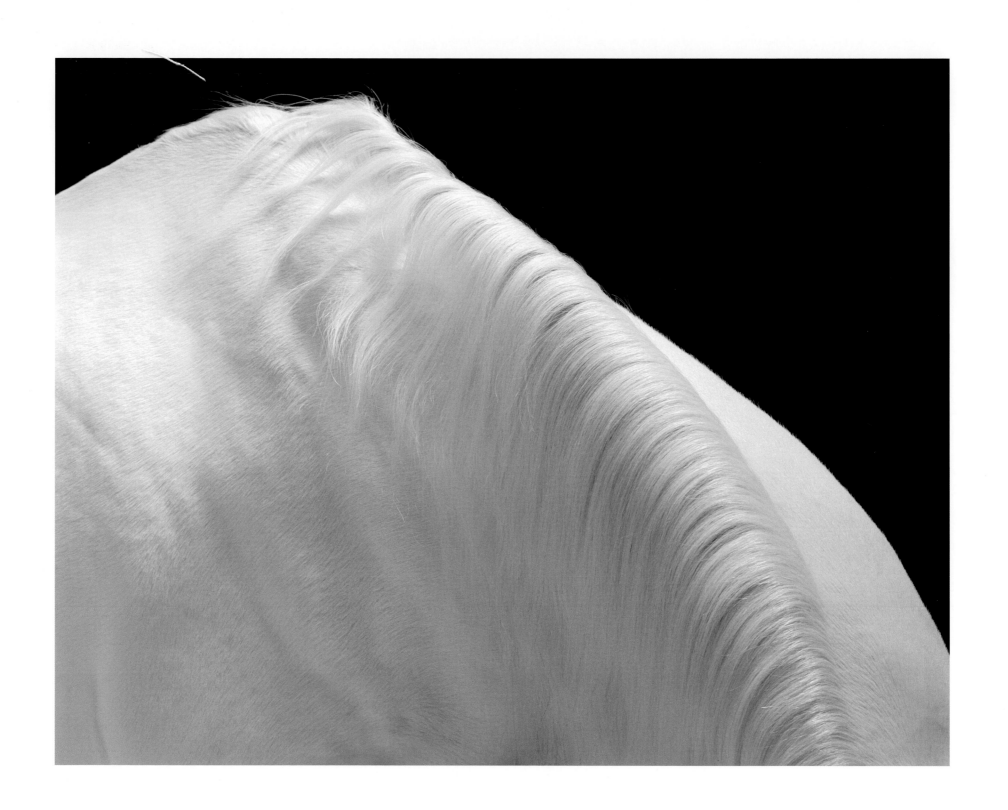

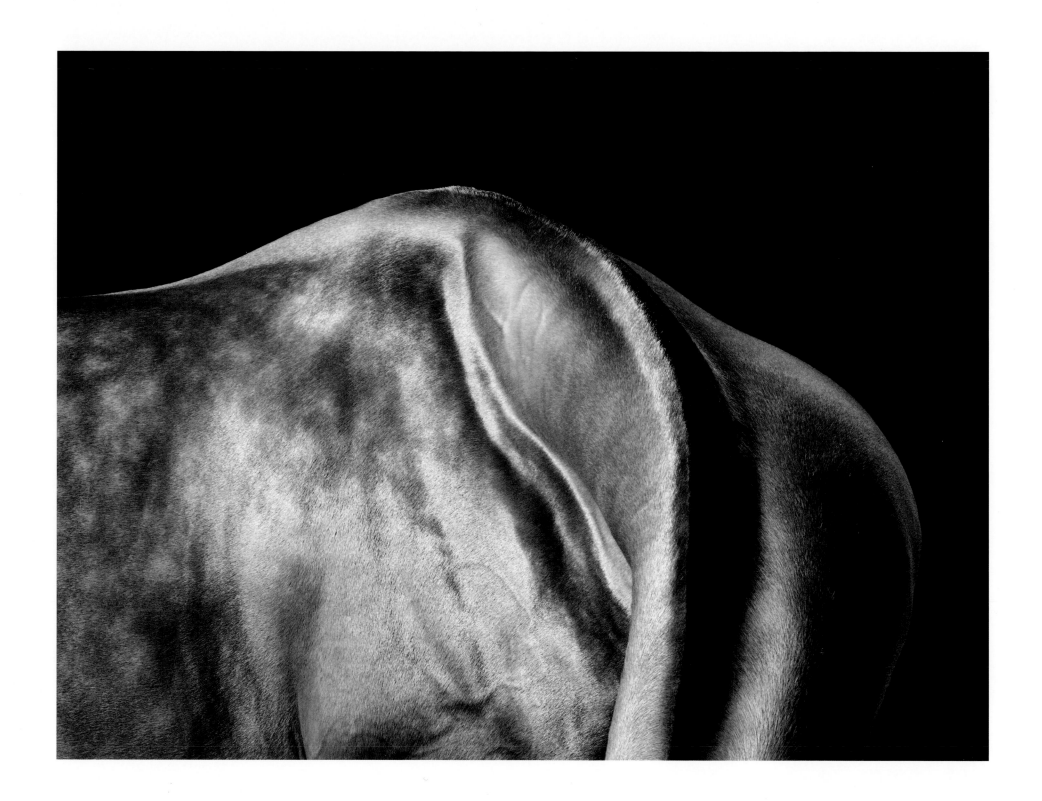

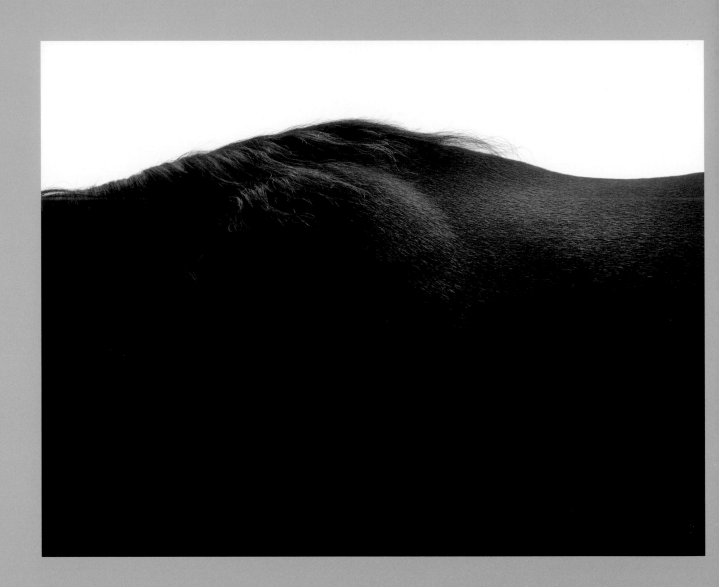

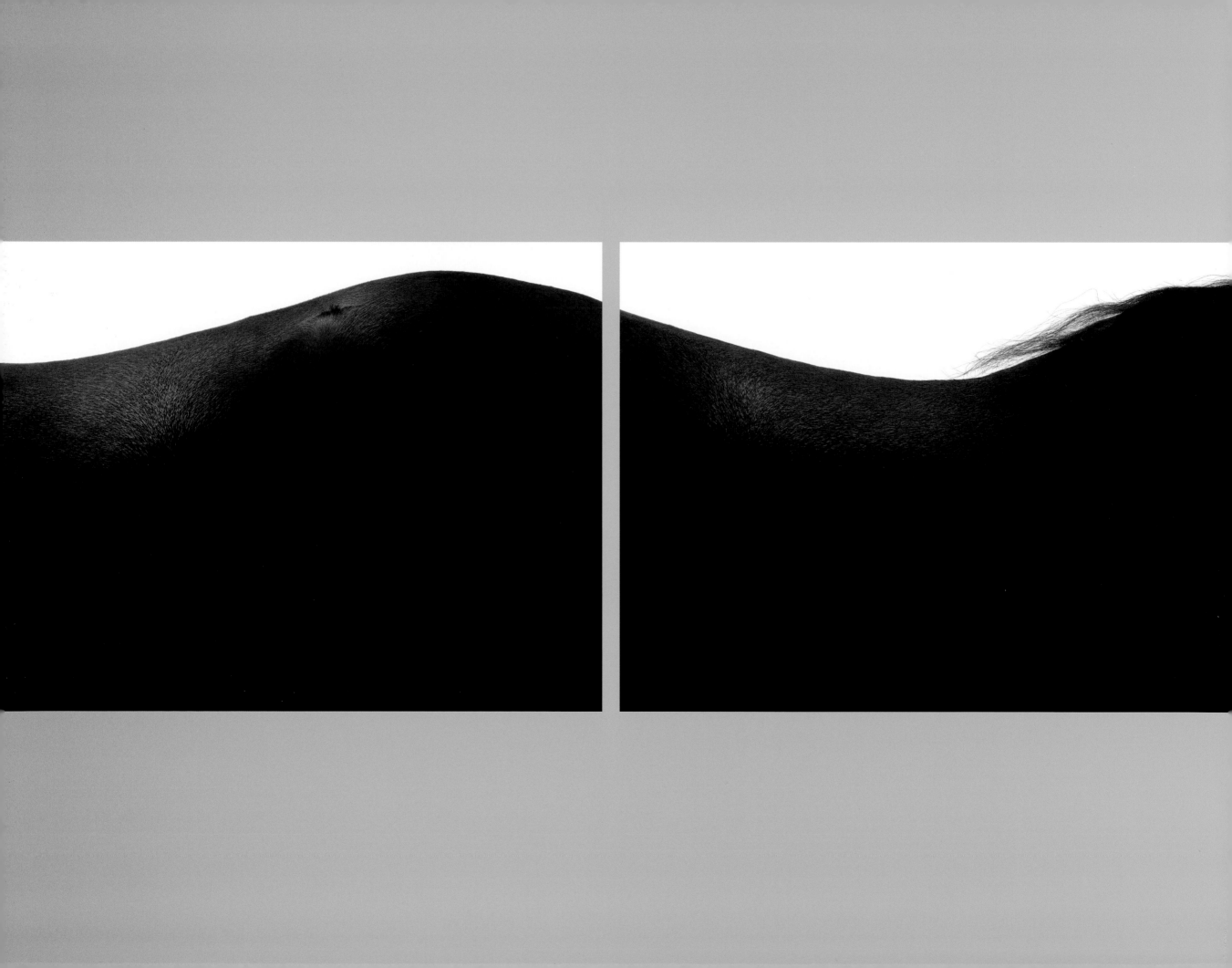

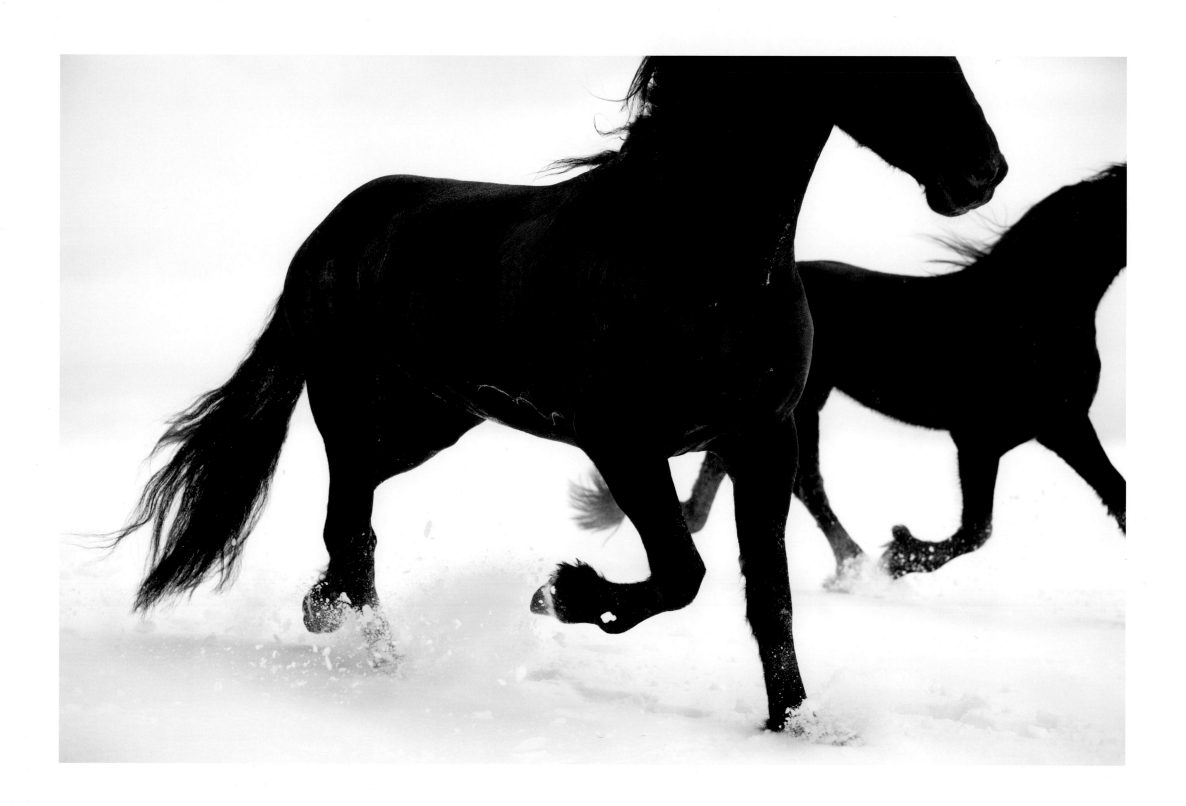

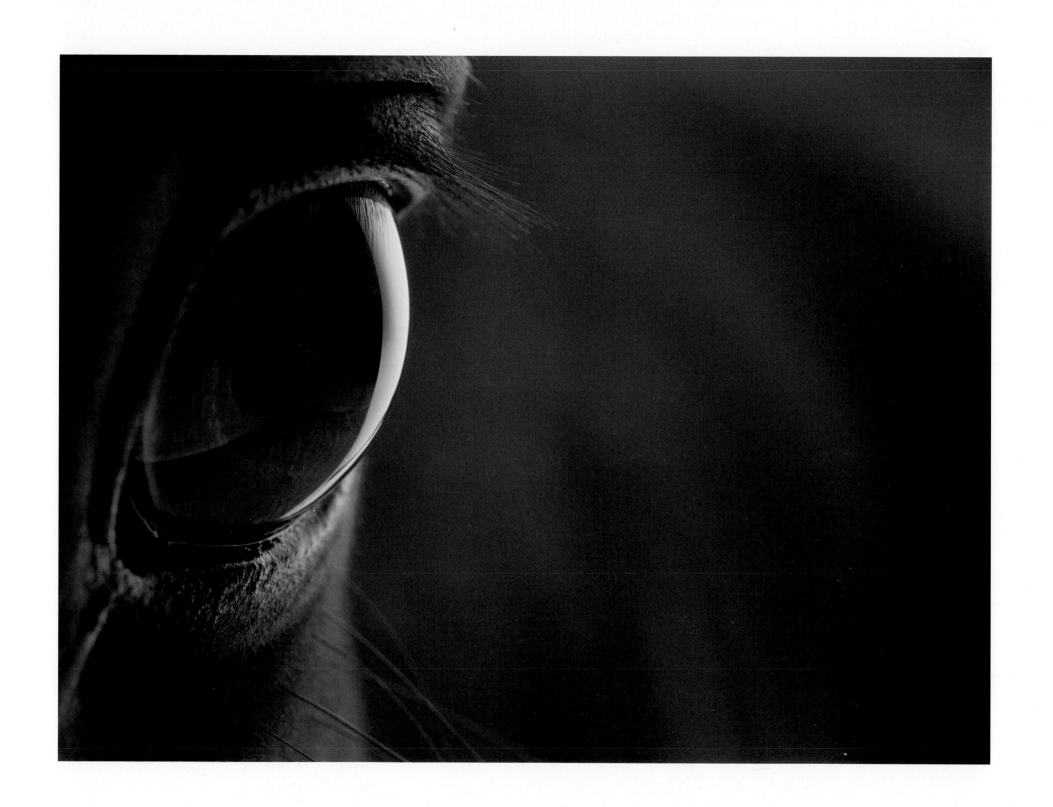

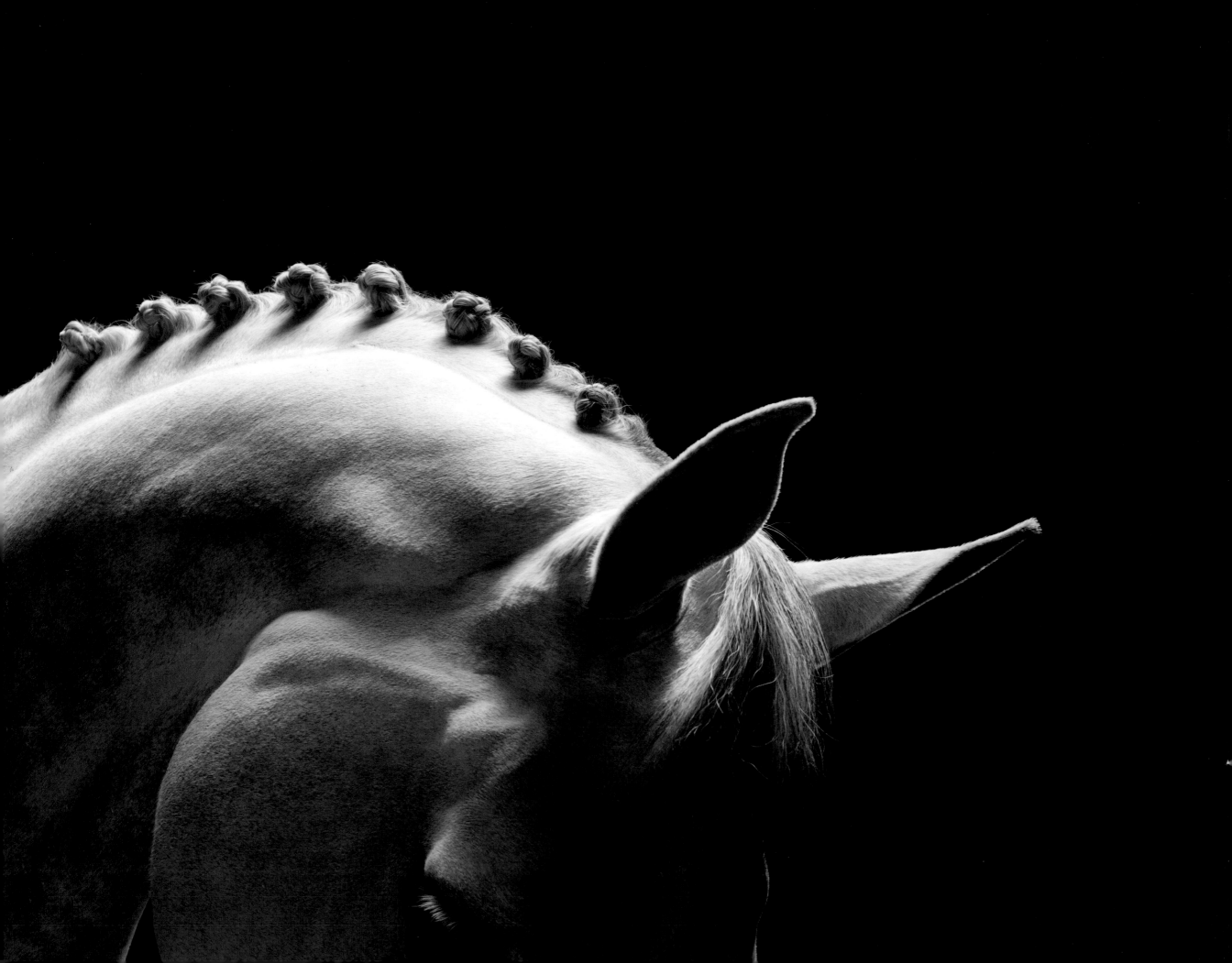

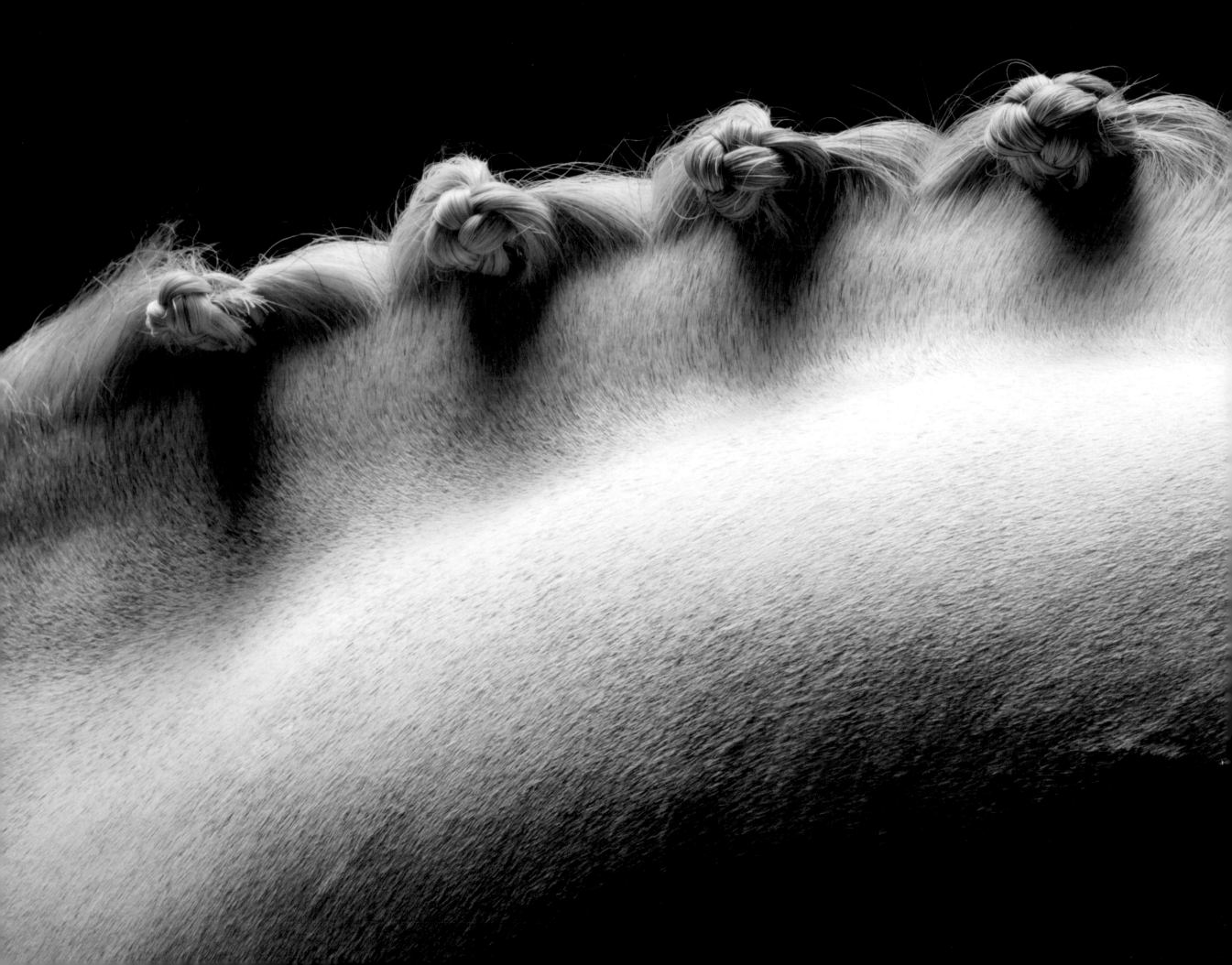

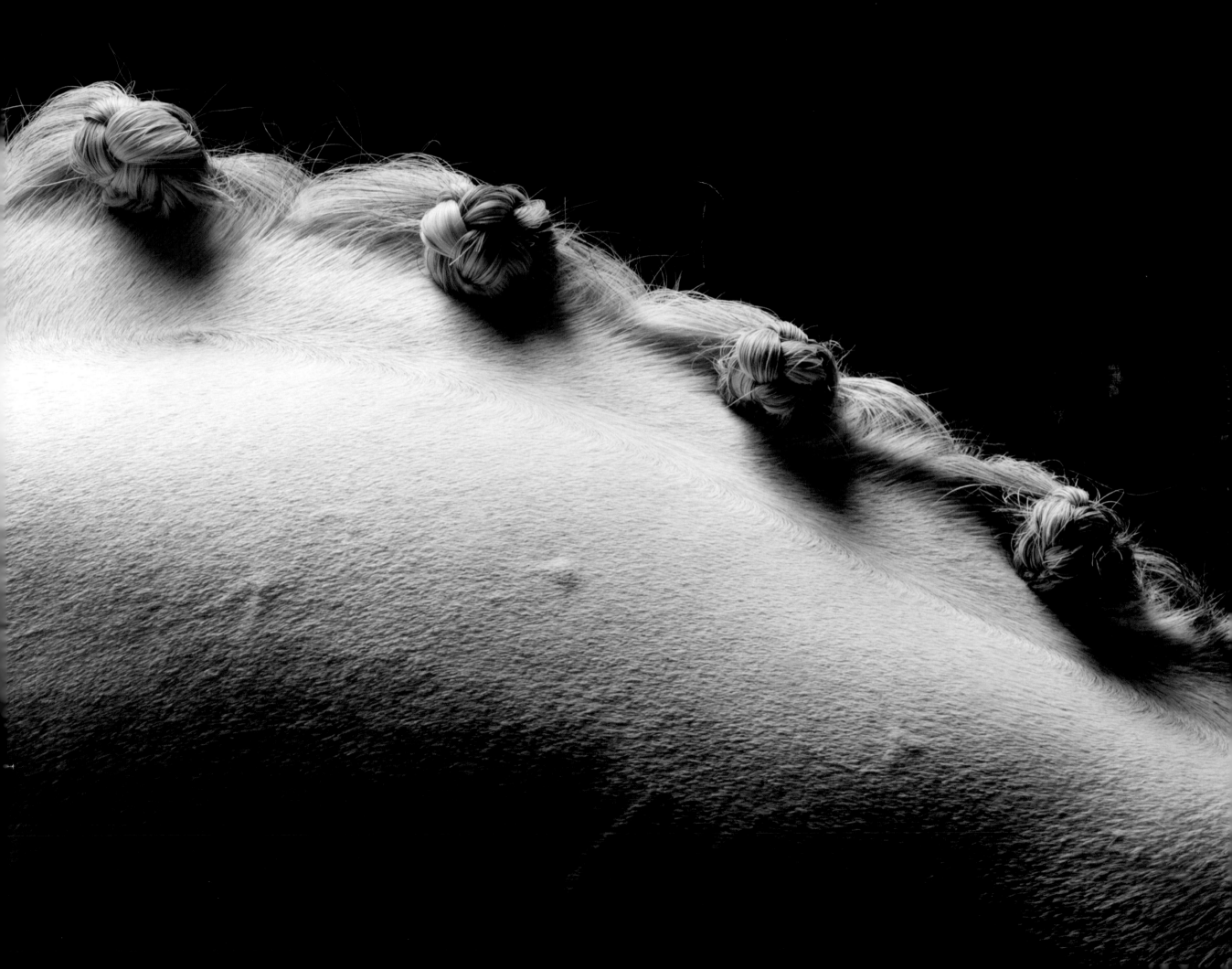

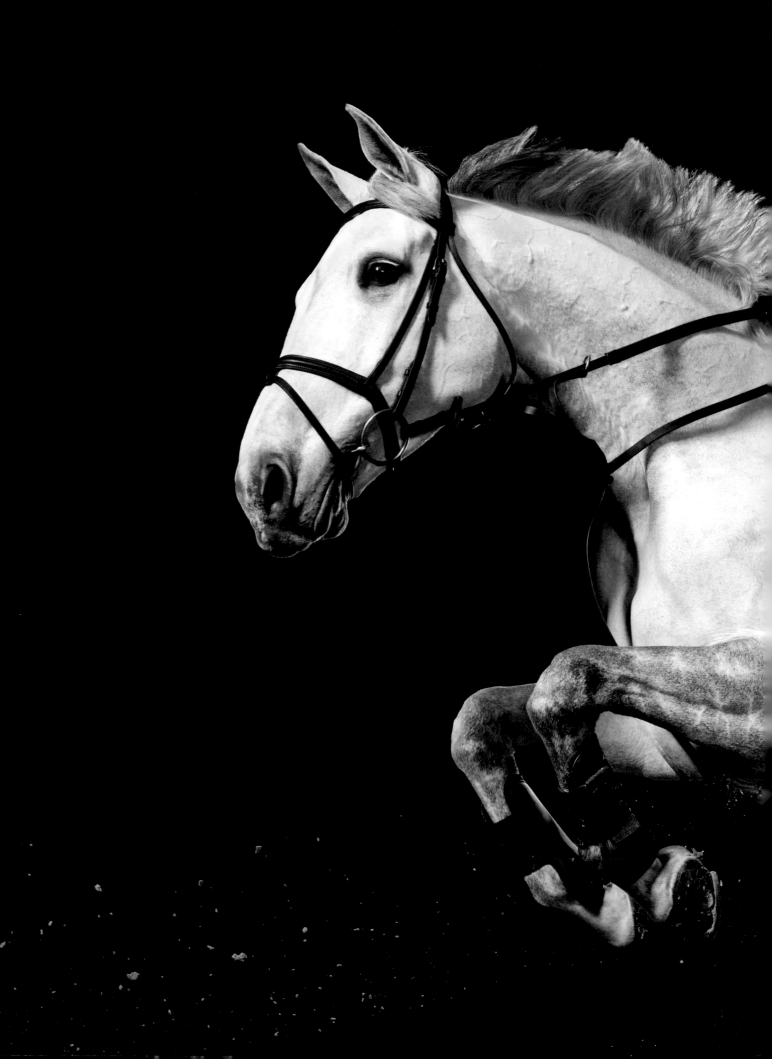

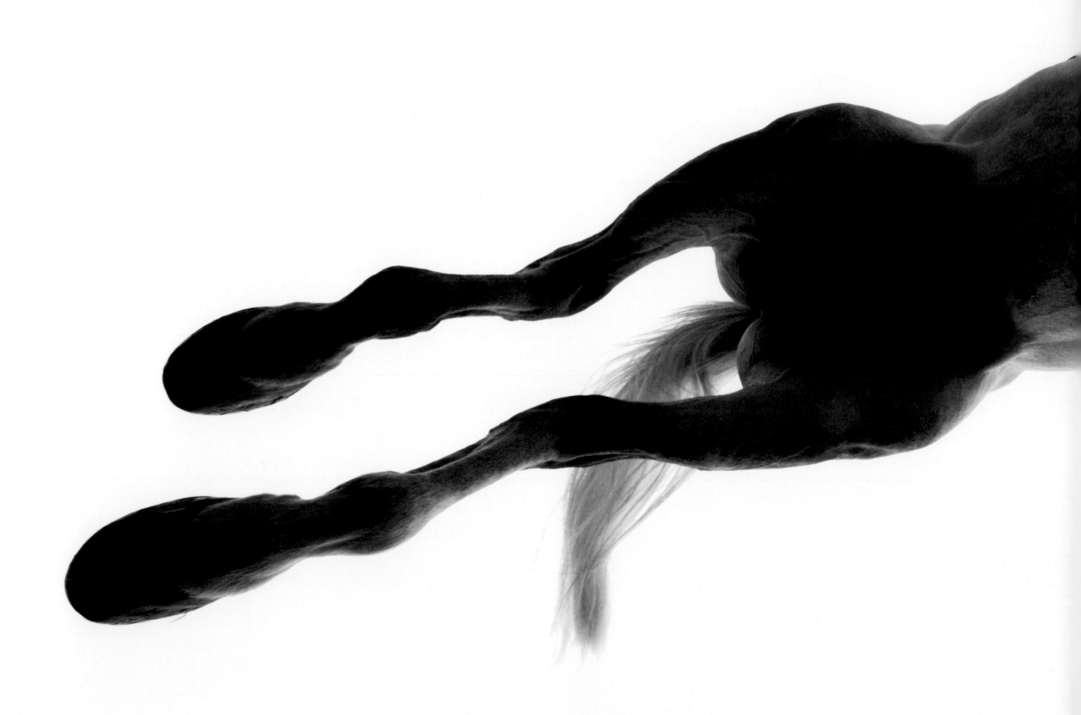

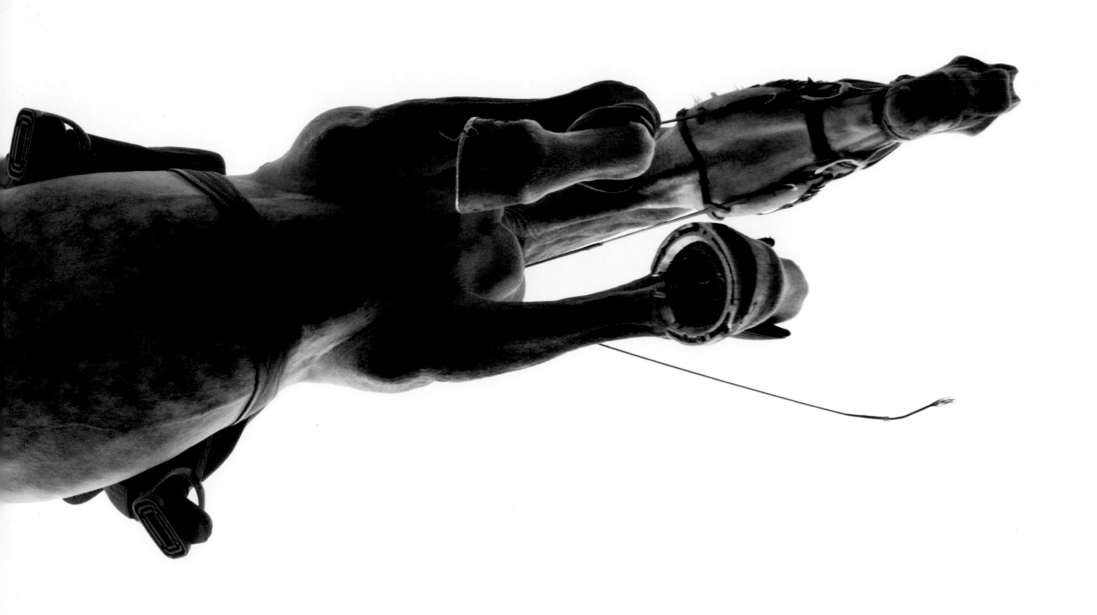

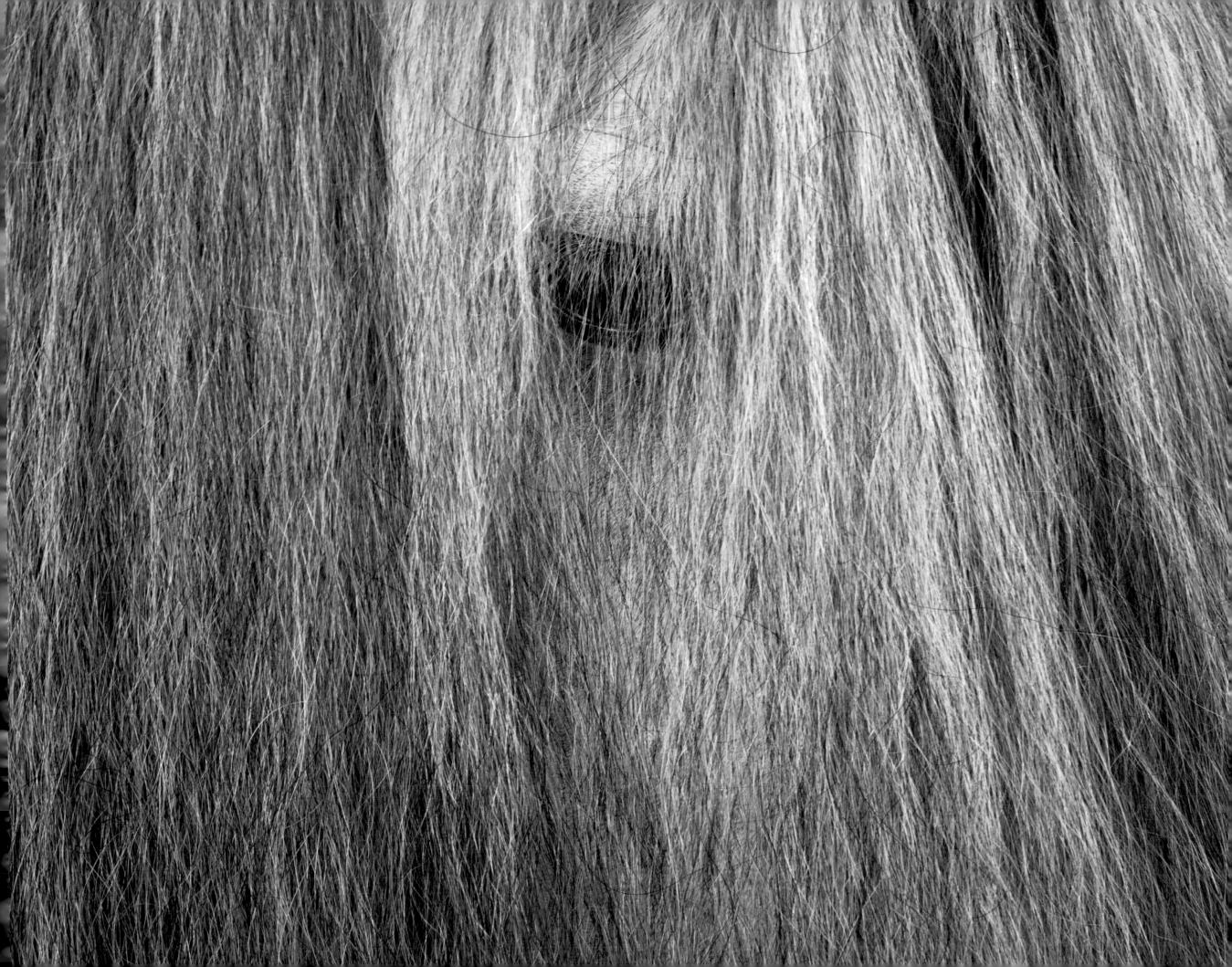

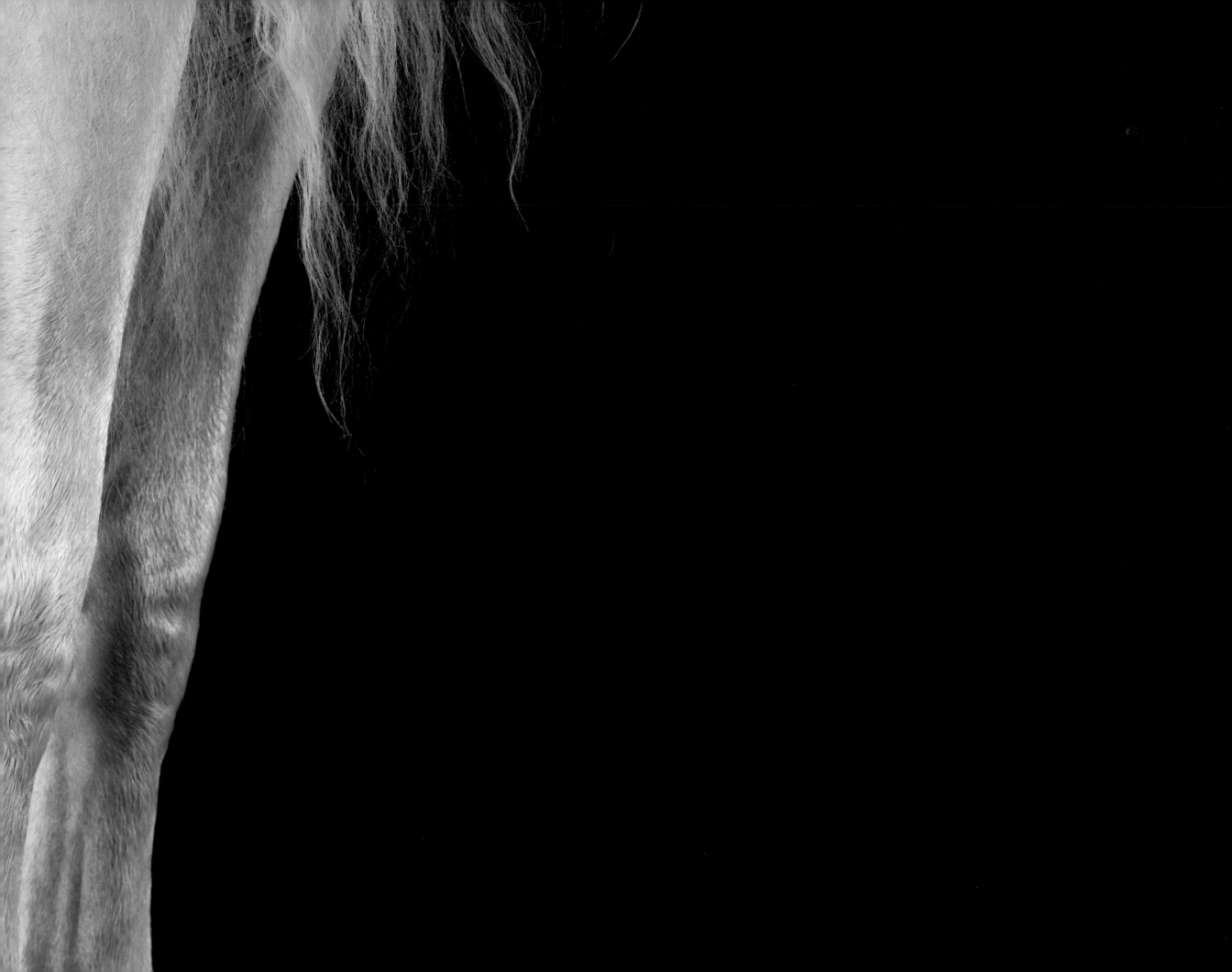

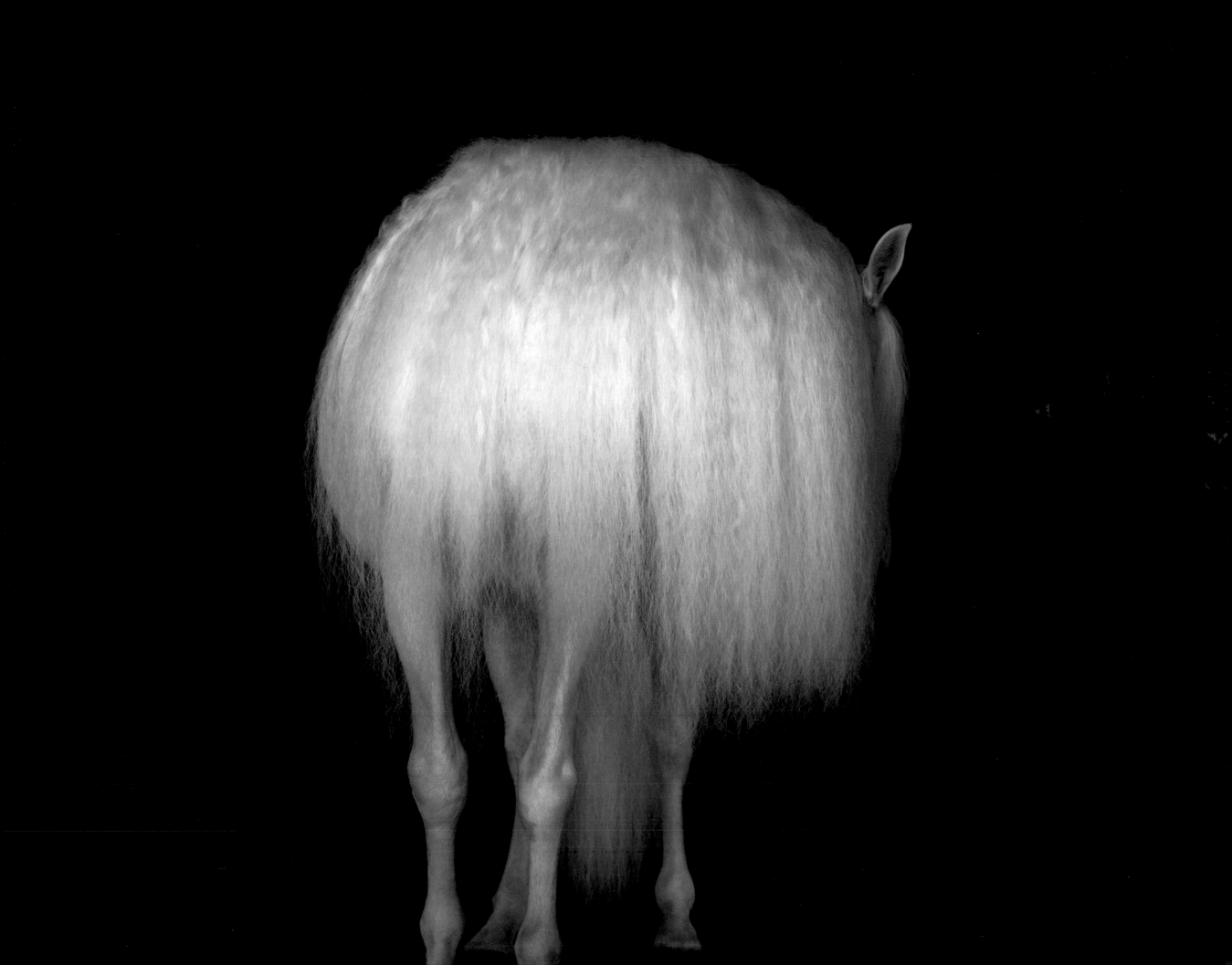

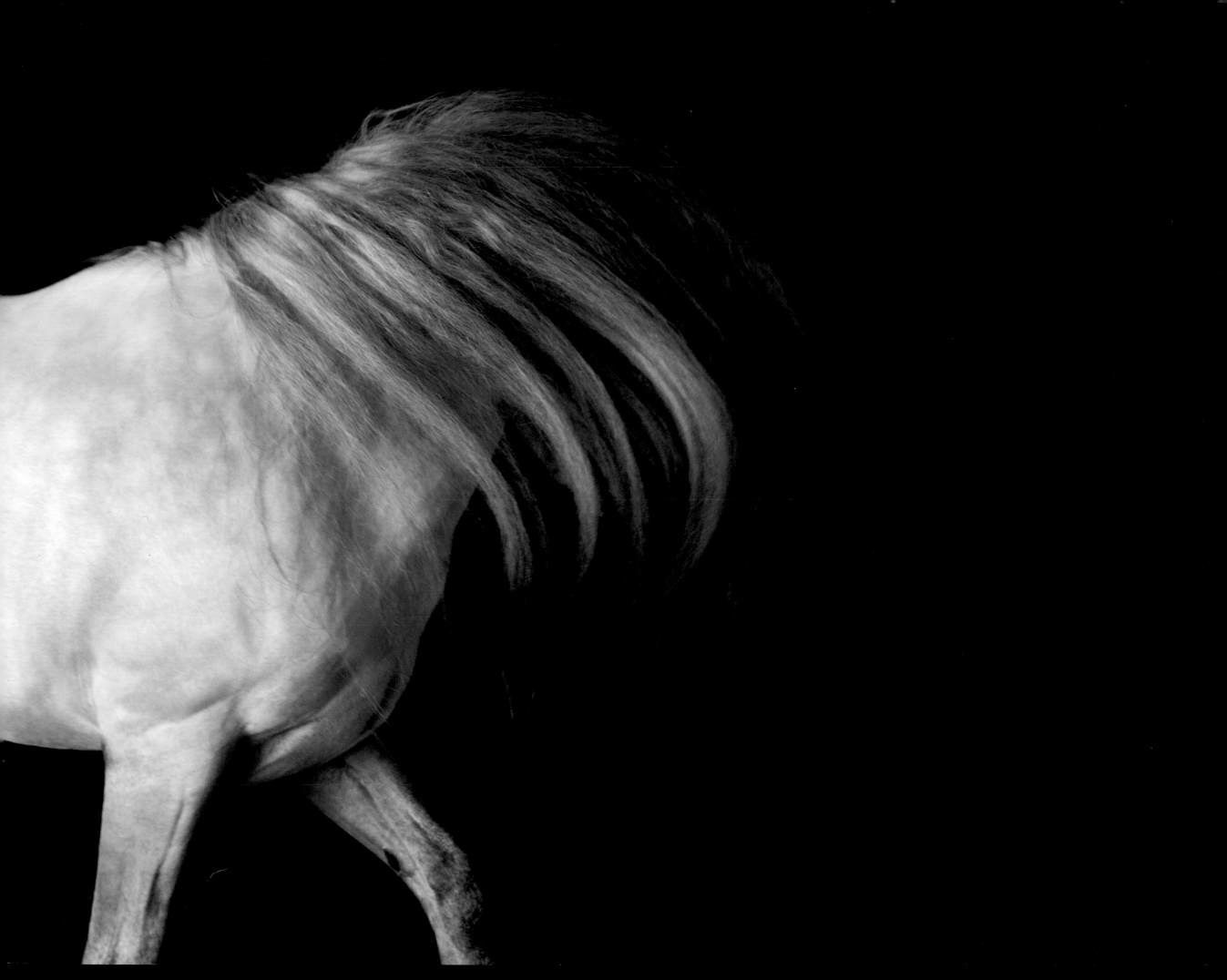

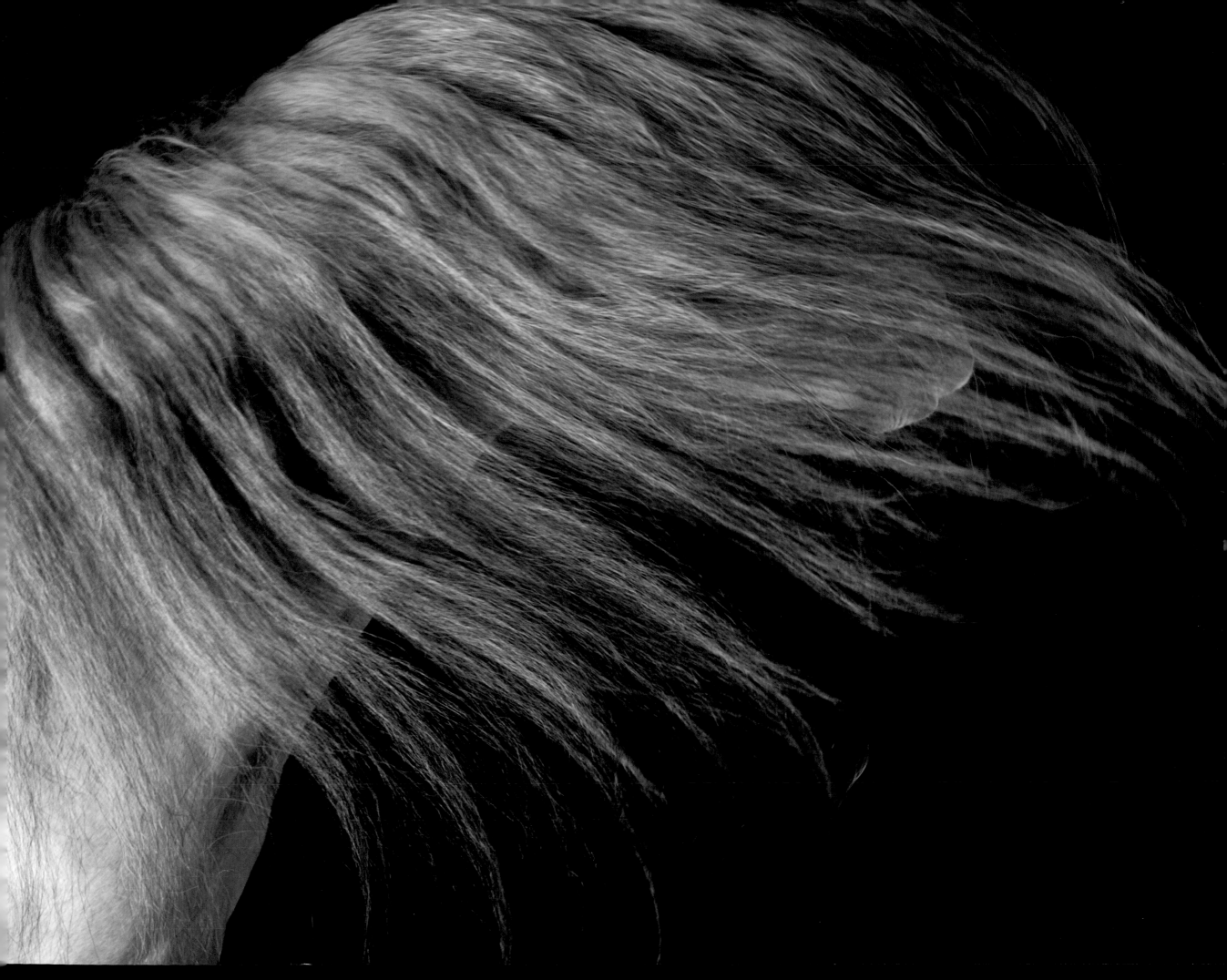

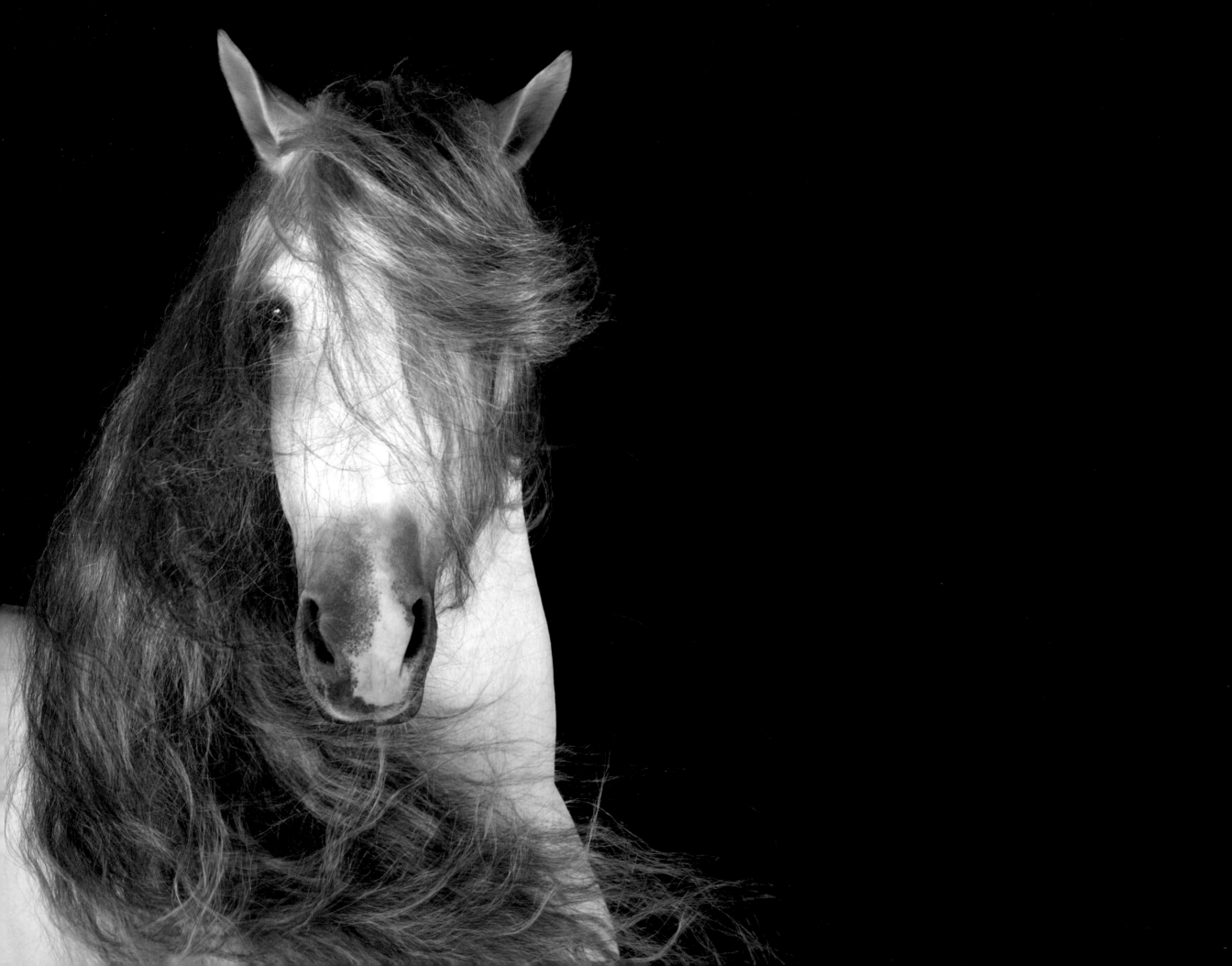

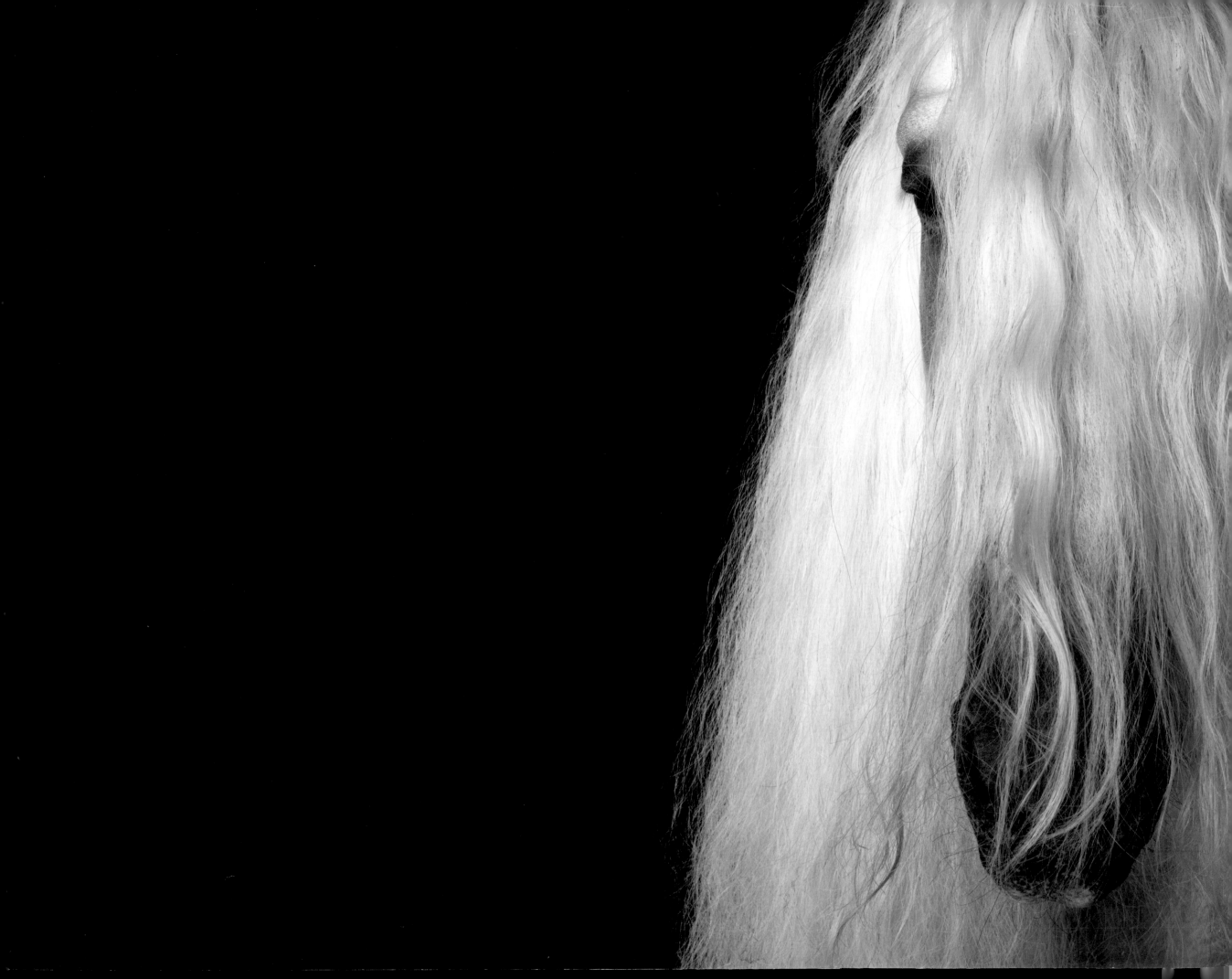

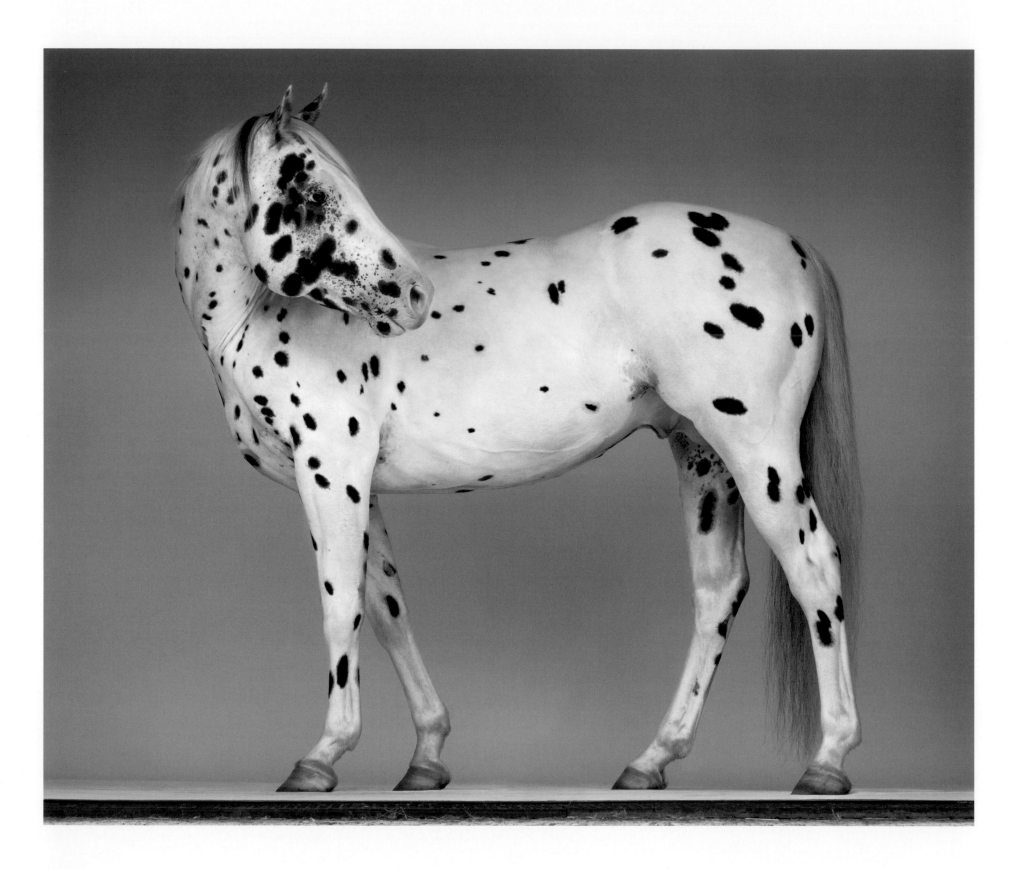

Appaloosa

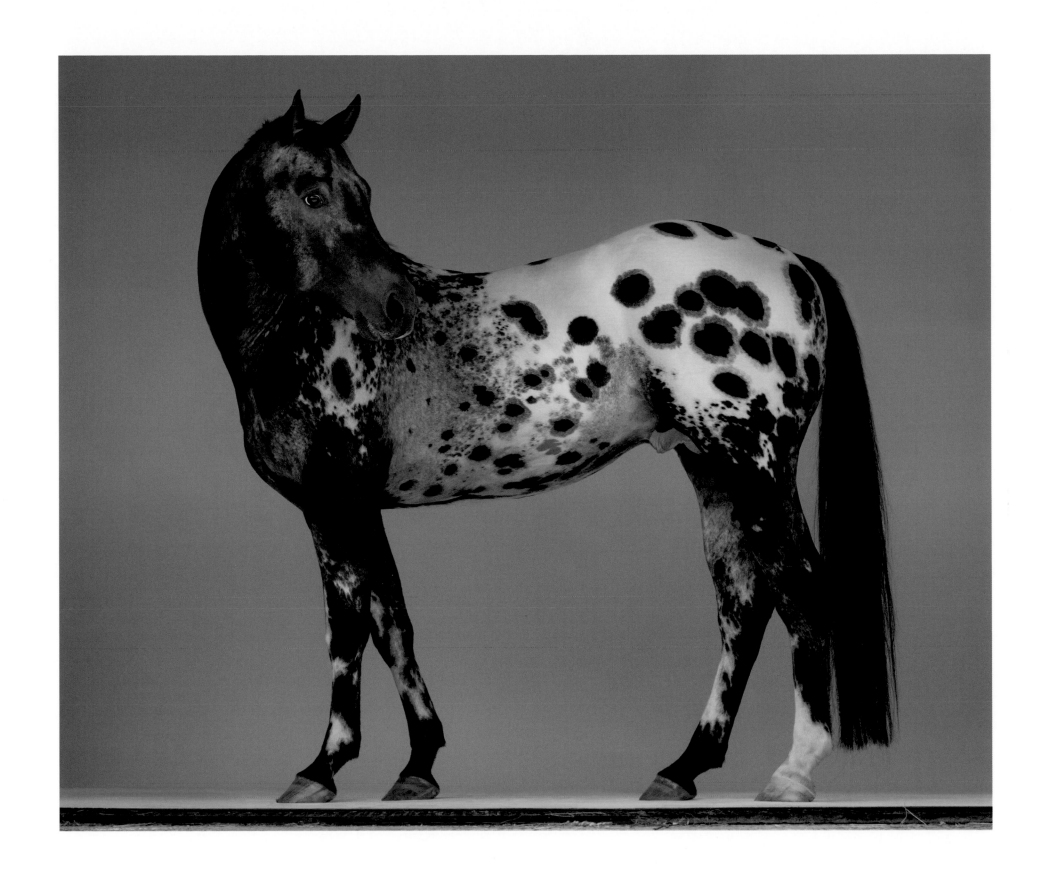

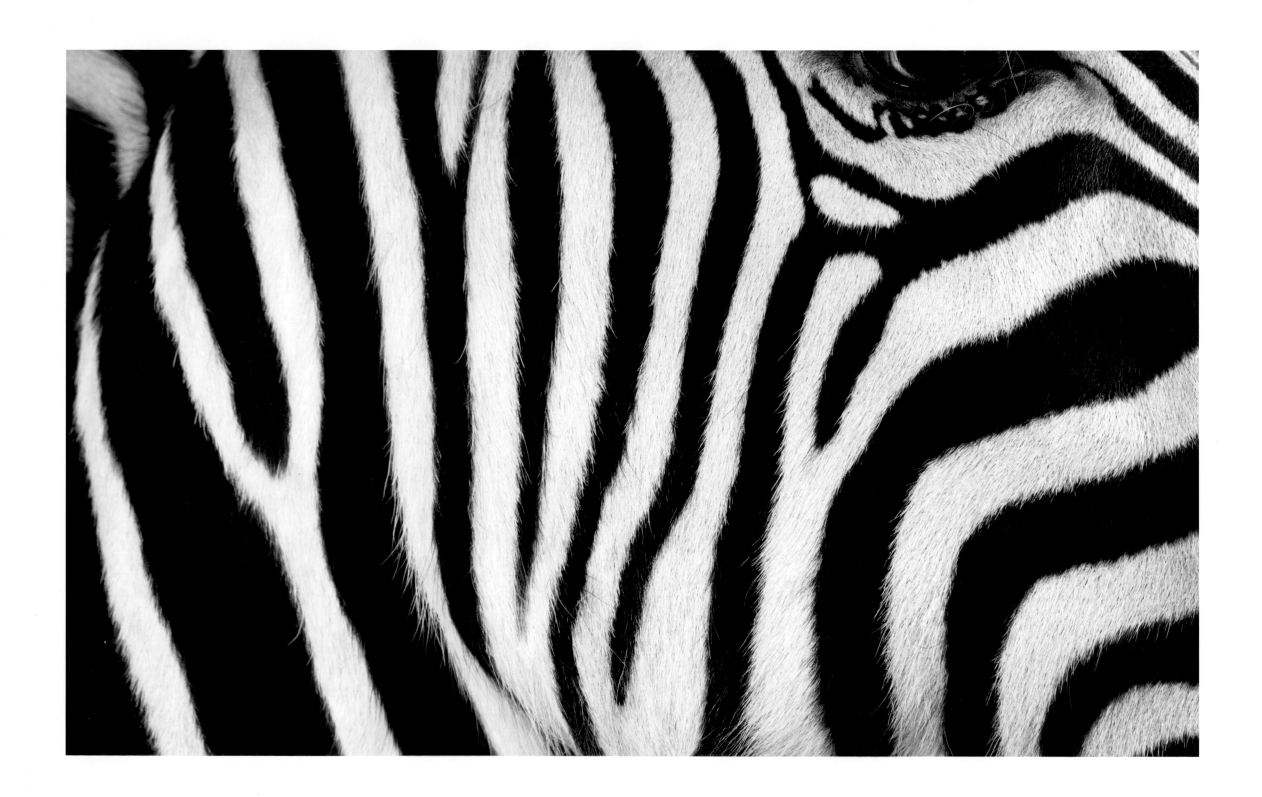

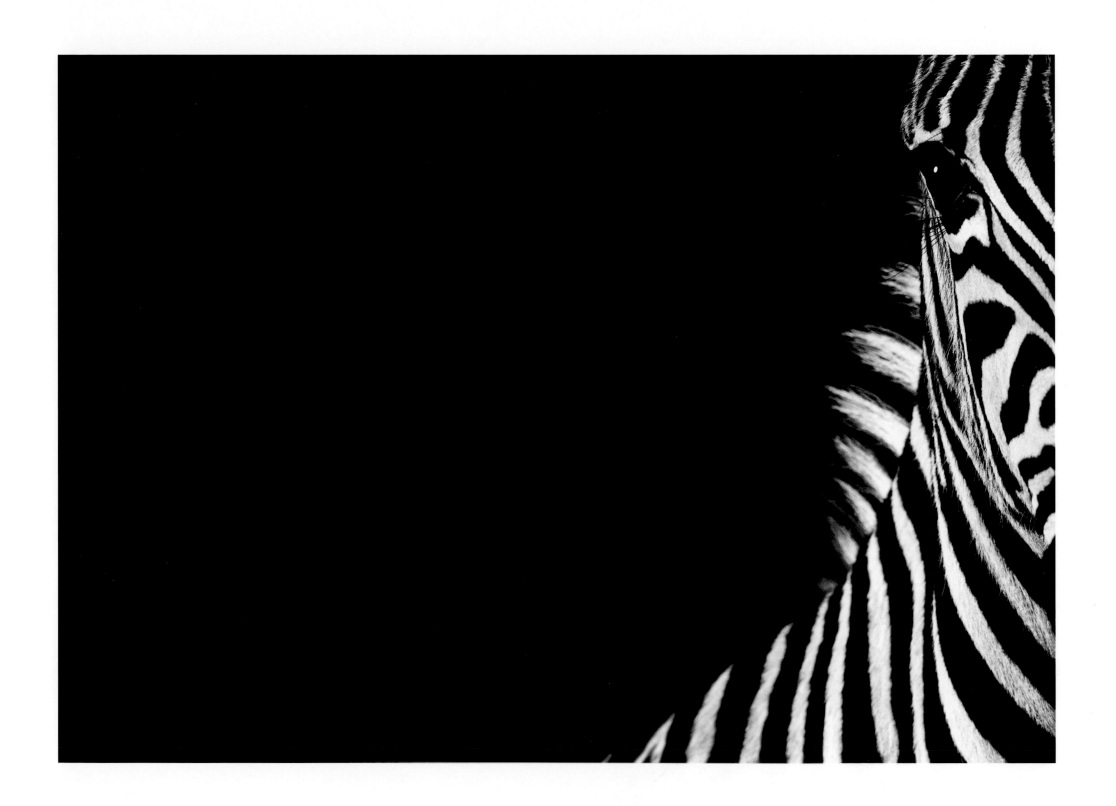

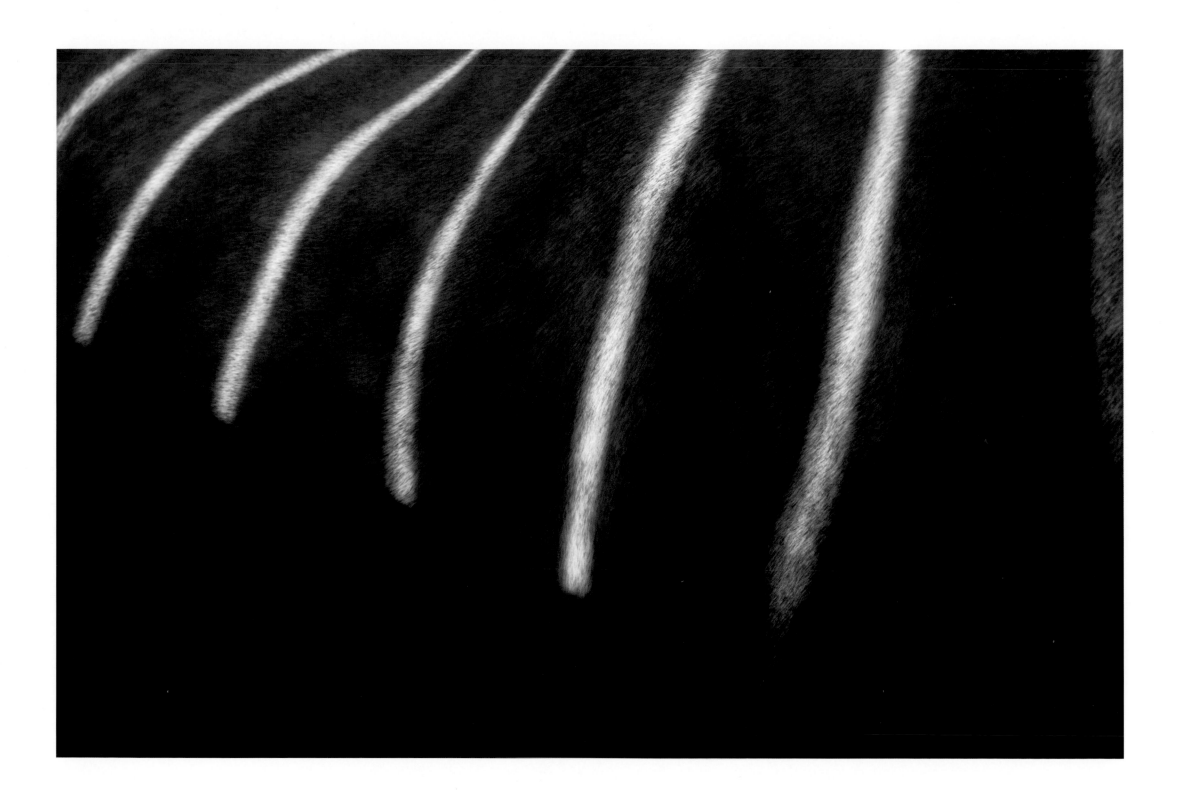

Lusitano

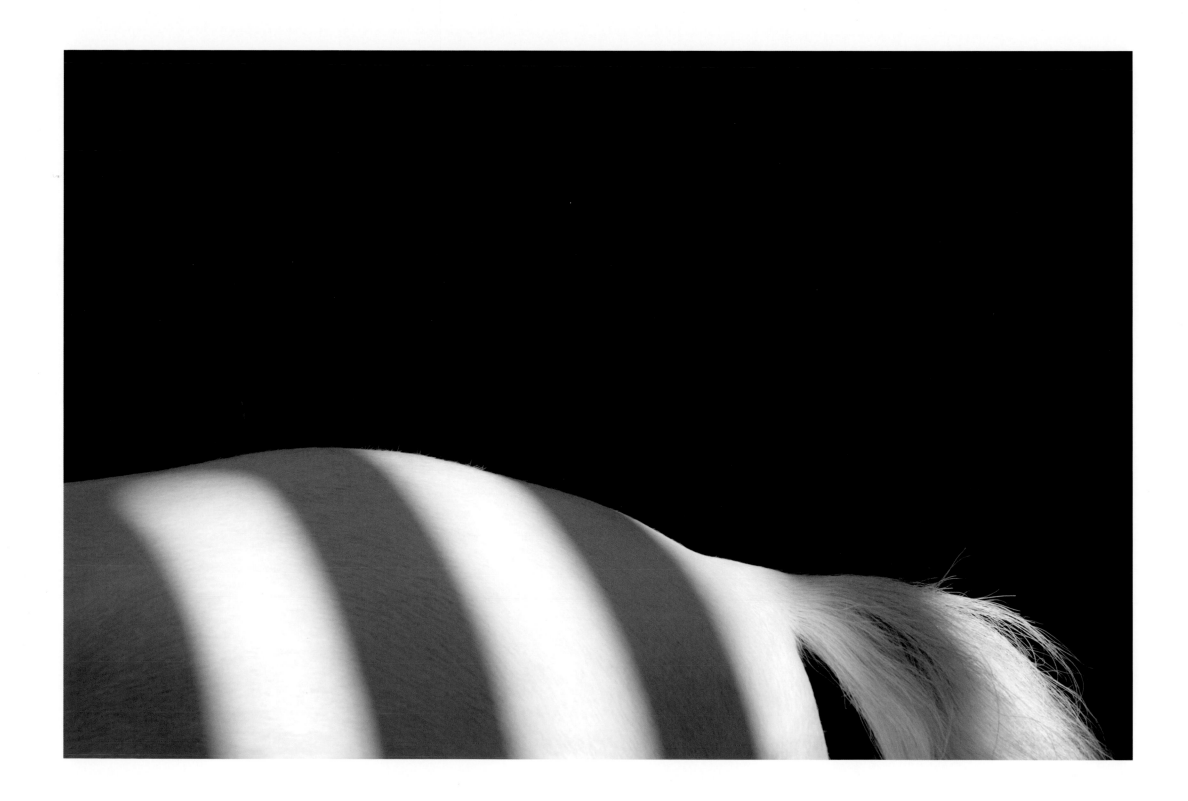

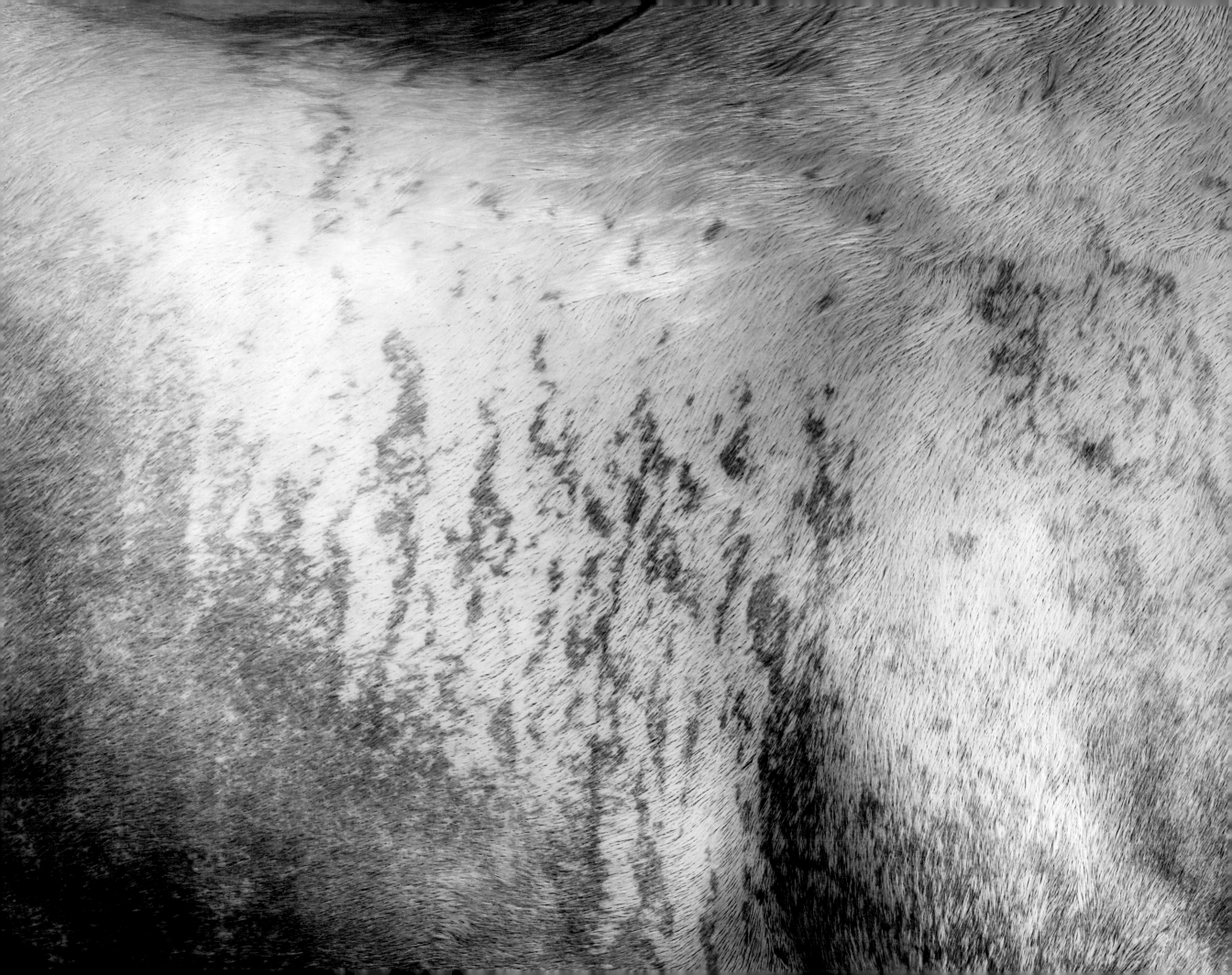

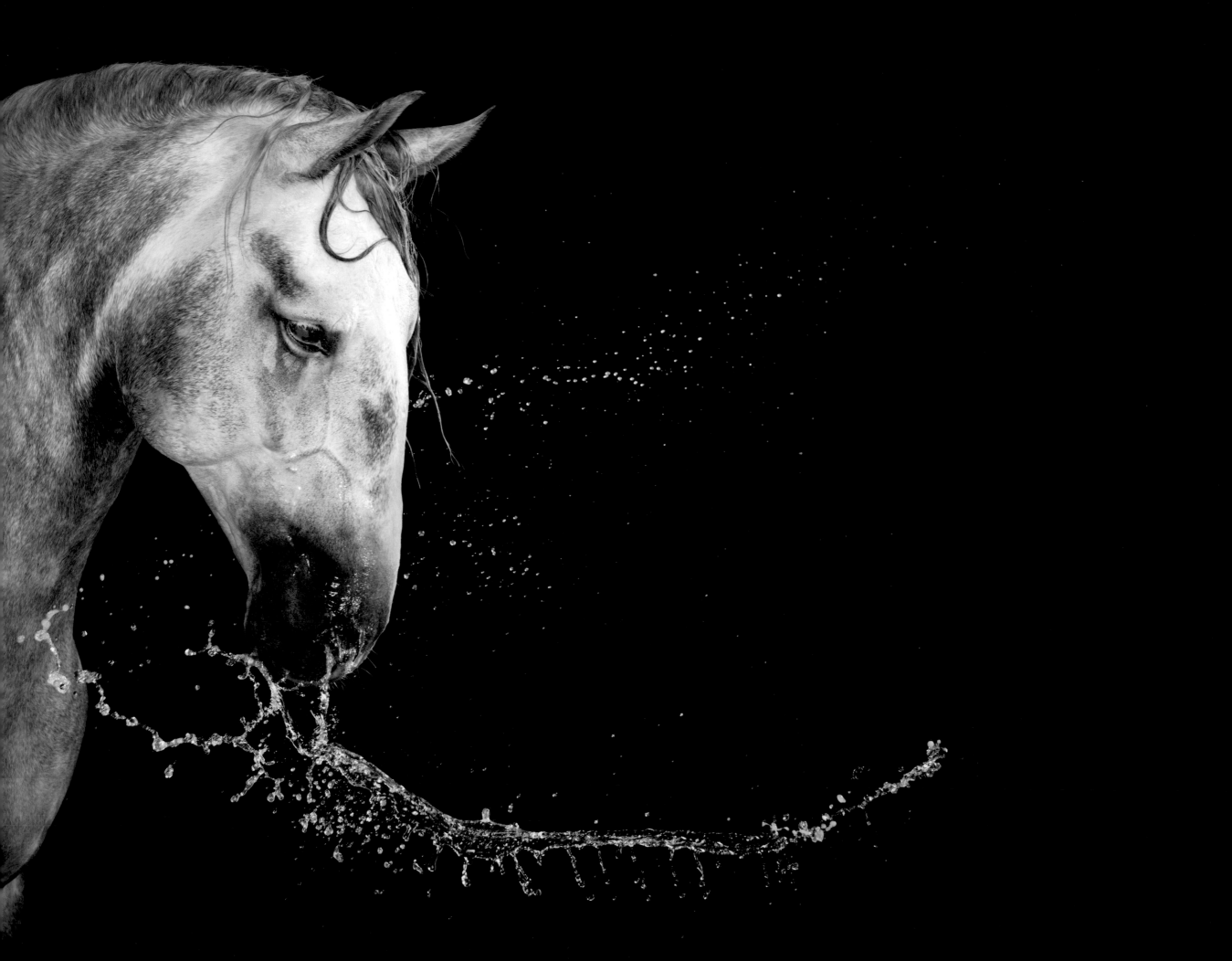

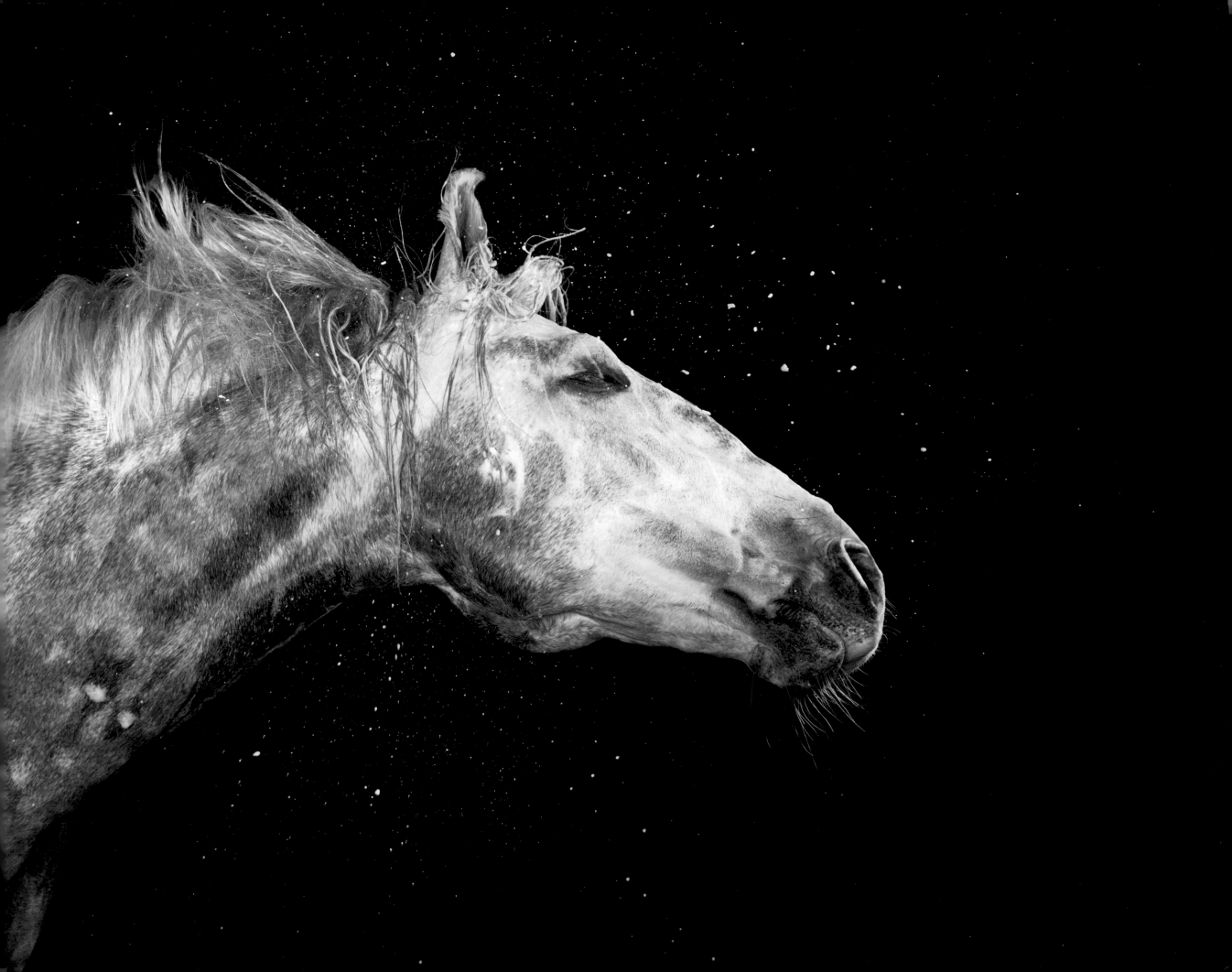

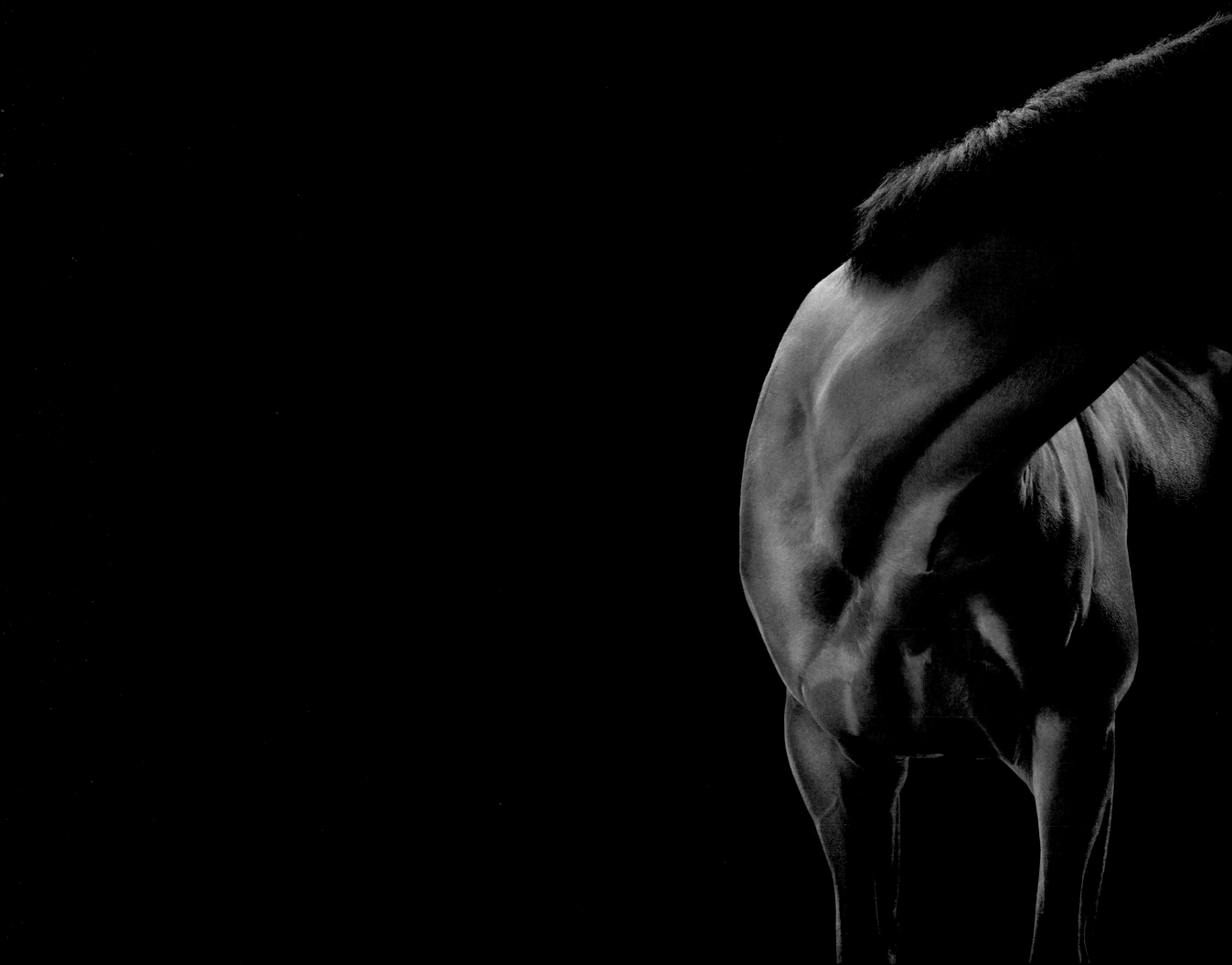

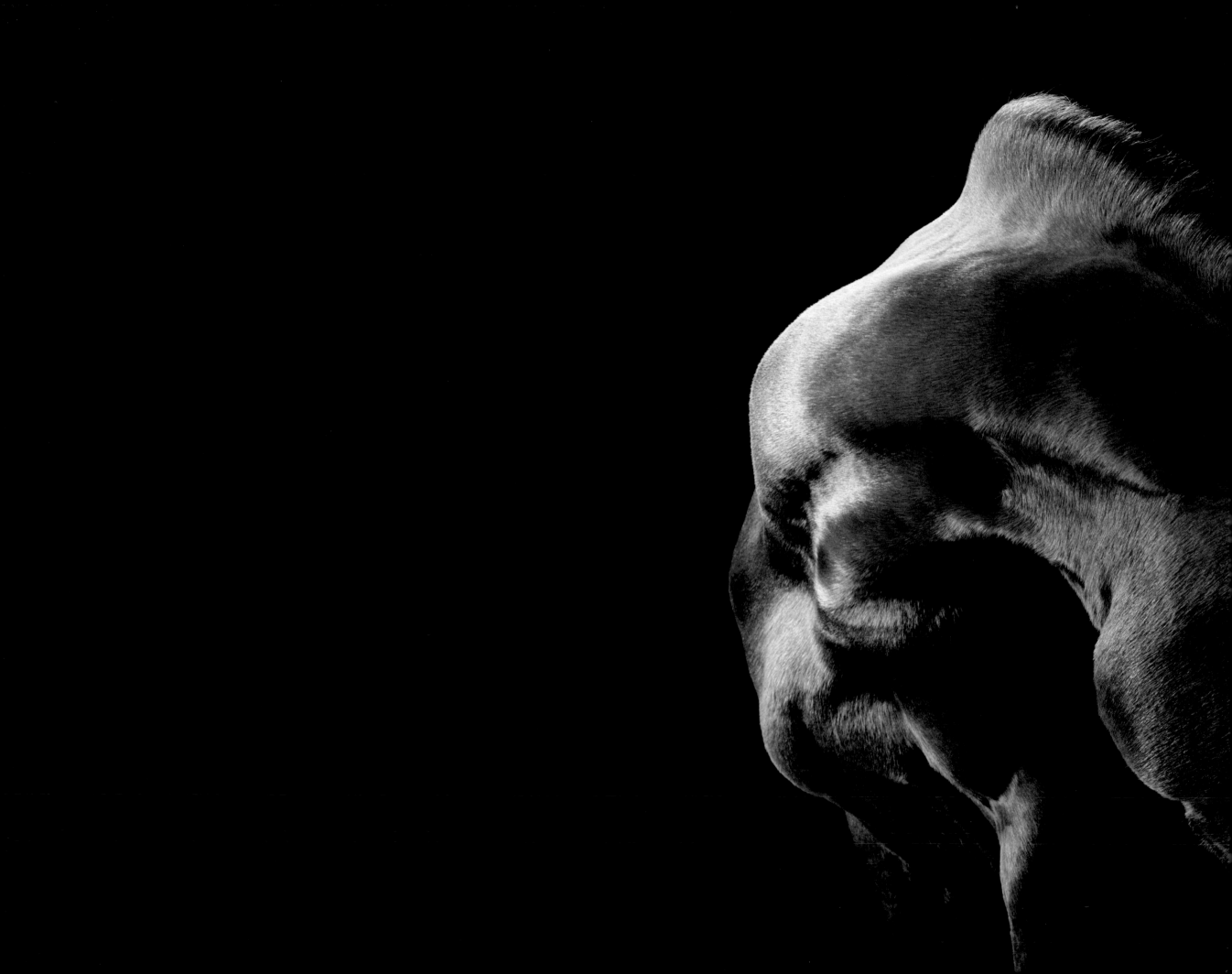

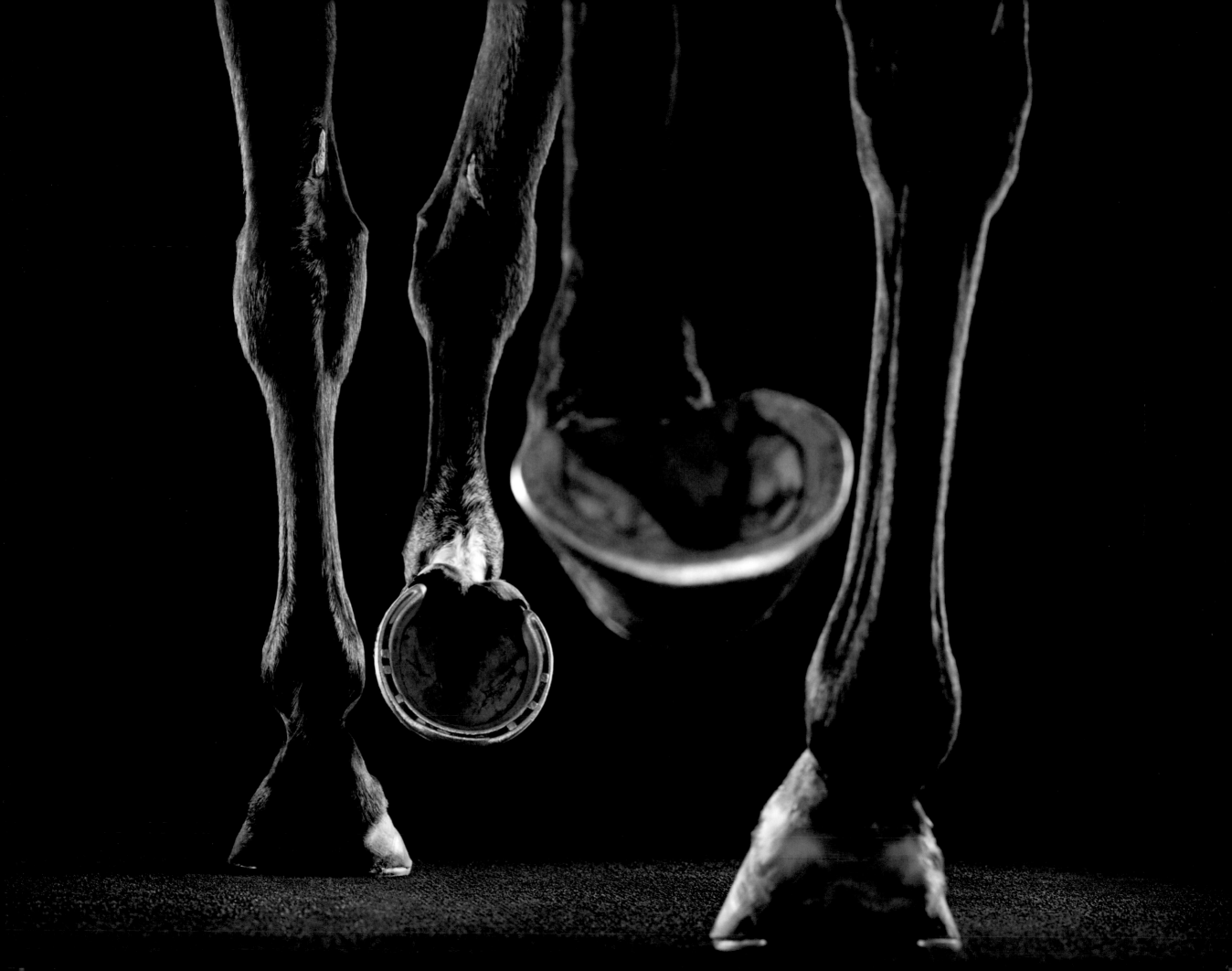

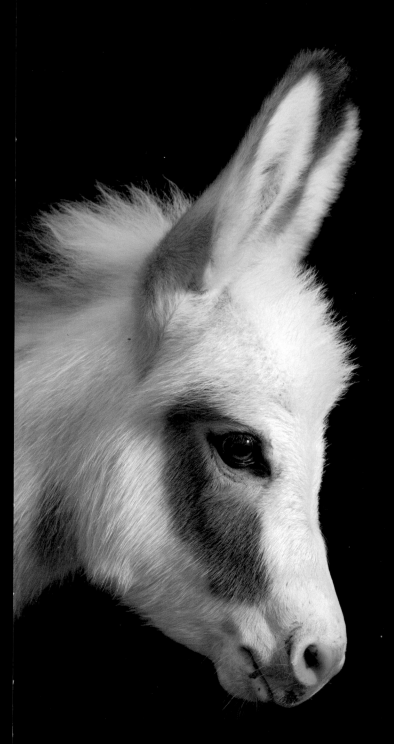

Miniature Donkey (Spotted)

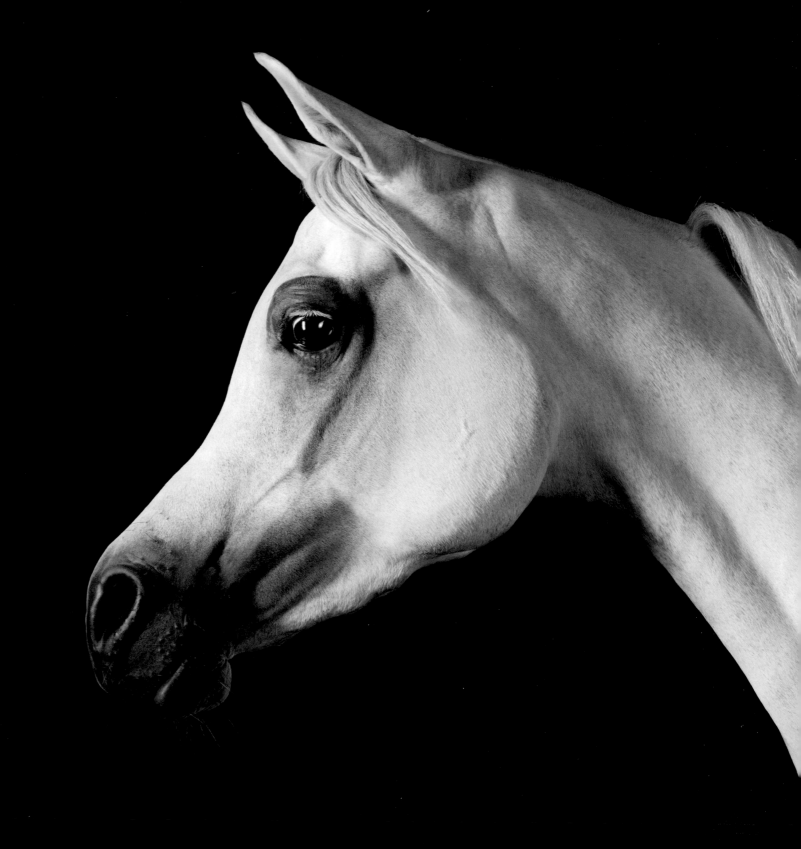

Arabian

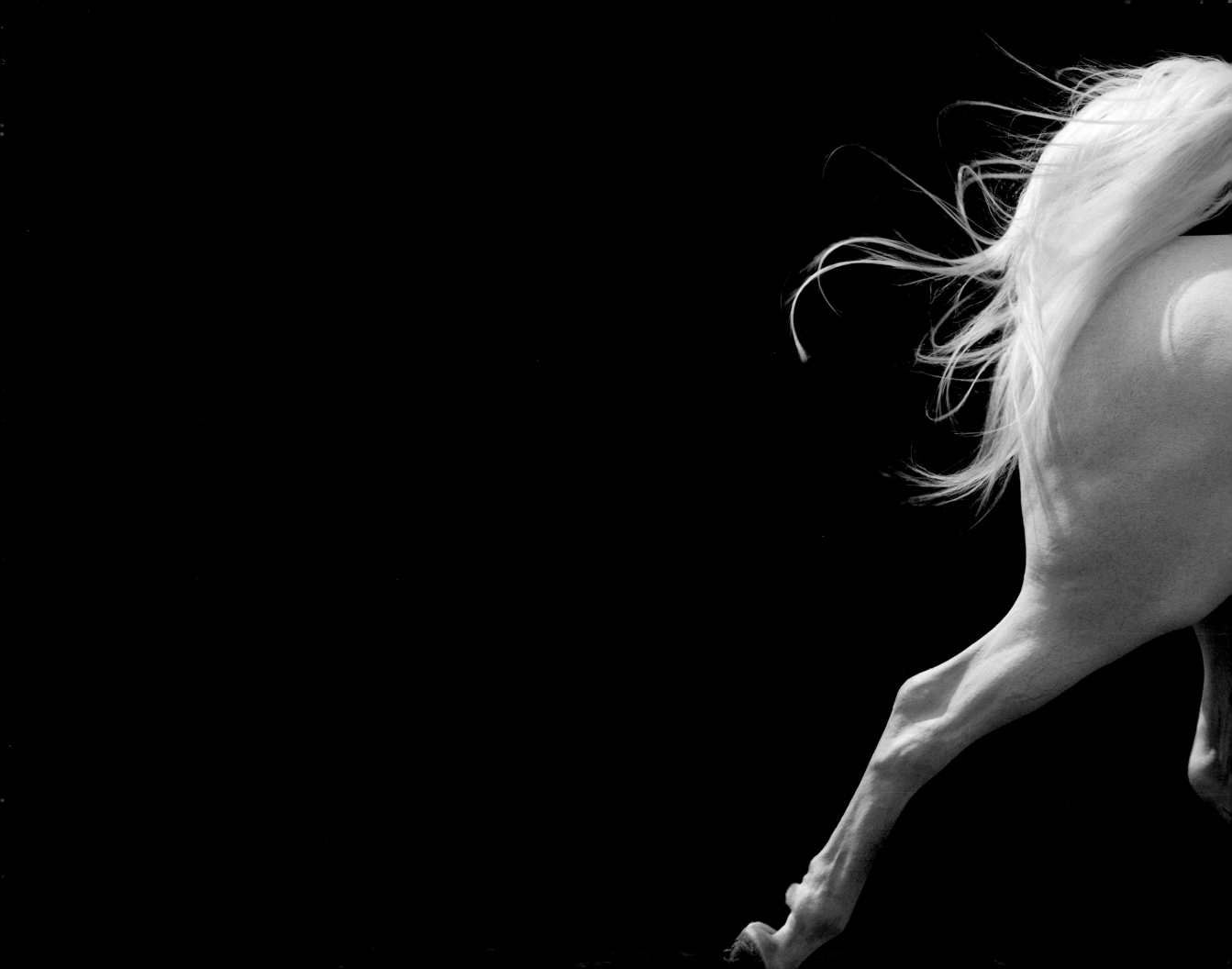

As I traveled in search of the living story of equus, I became fascinated with how the horse is a product of the environment, indeed of many environments, over a long time. No factor has been more influential on the nature of this family of animals than human beings. Man has changed the environment and conditions under which animals relate to him to suit his needs. When we look at a horse, we see a mirror of our own civilizations, past and present. I begin this journey with the wild horse, the Przewalski—but it is only as wild as we make it. This horse's revival, existence, and territory today is a symbol of our concerns with conservation and the global activities that support it, and it benefits from a political situation that provides a safe haven . . . for the time being.

84 Przewalski's Horse
Hustai National Park, Mongolia

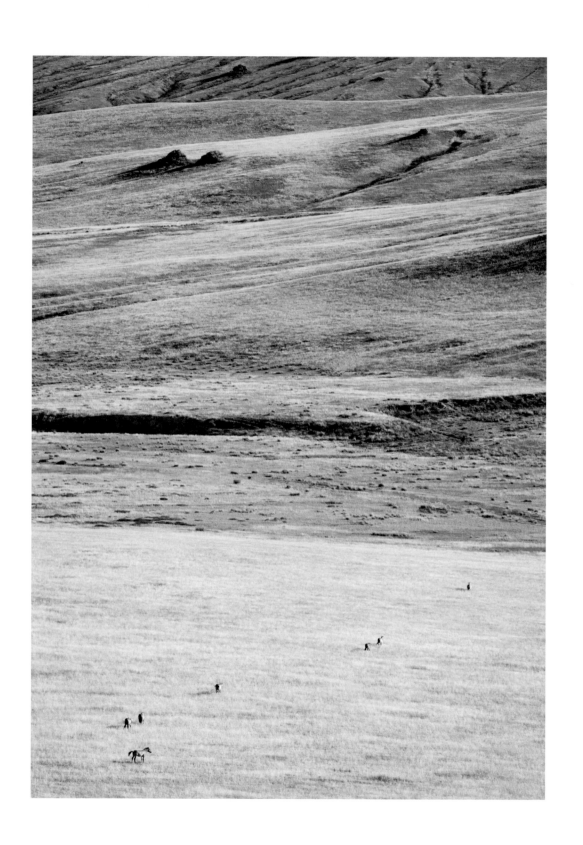

Przewalski's Horse
Hustai National Park, Mongolia

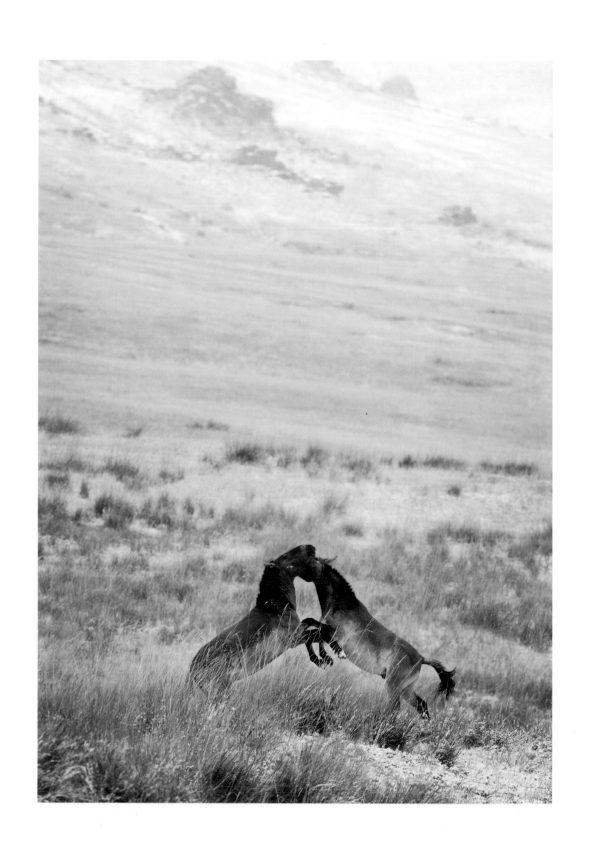

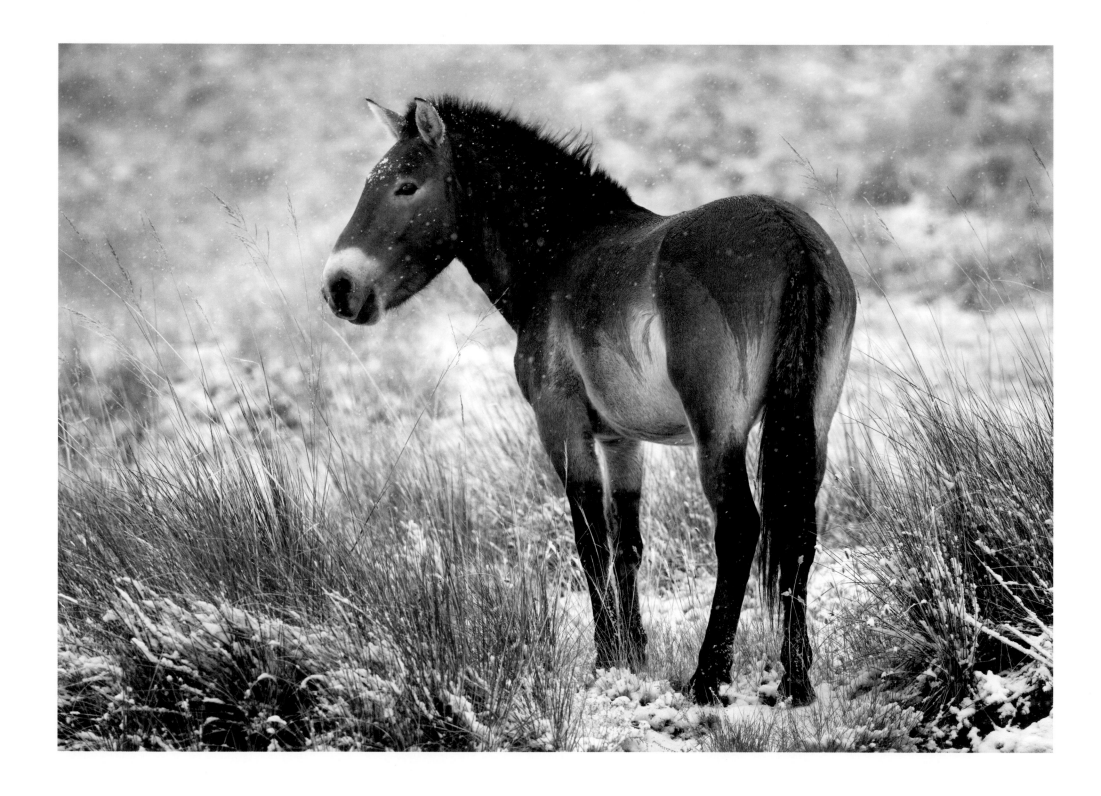

Przewalski's Horse
Hustai National Park, Mongolia

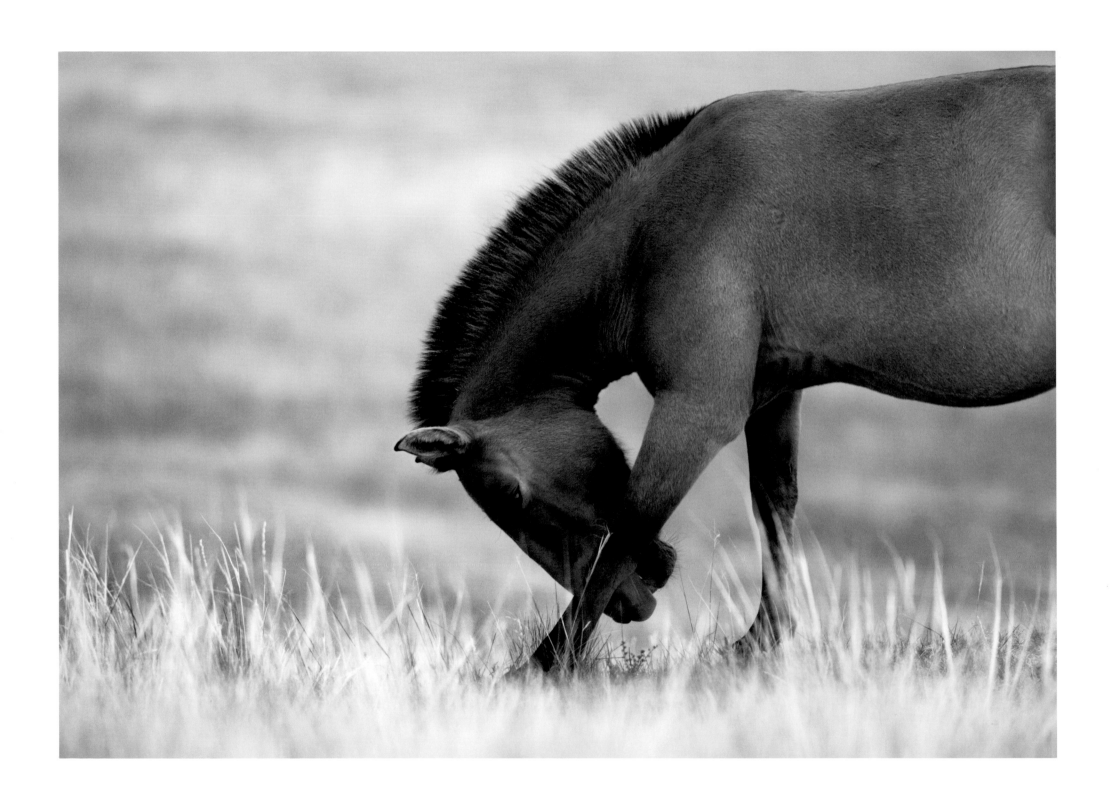

90 Icelandic Horse
 Jökulsárlón Lagoon, Iceland

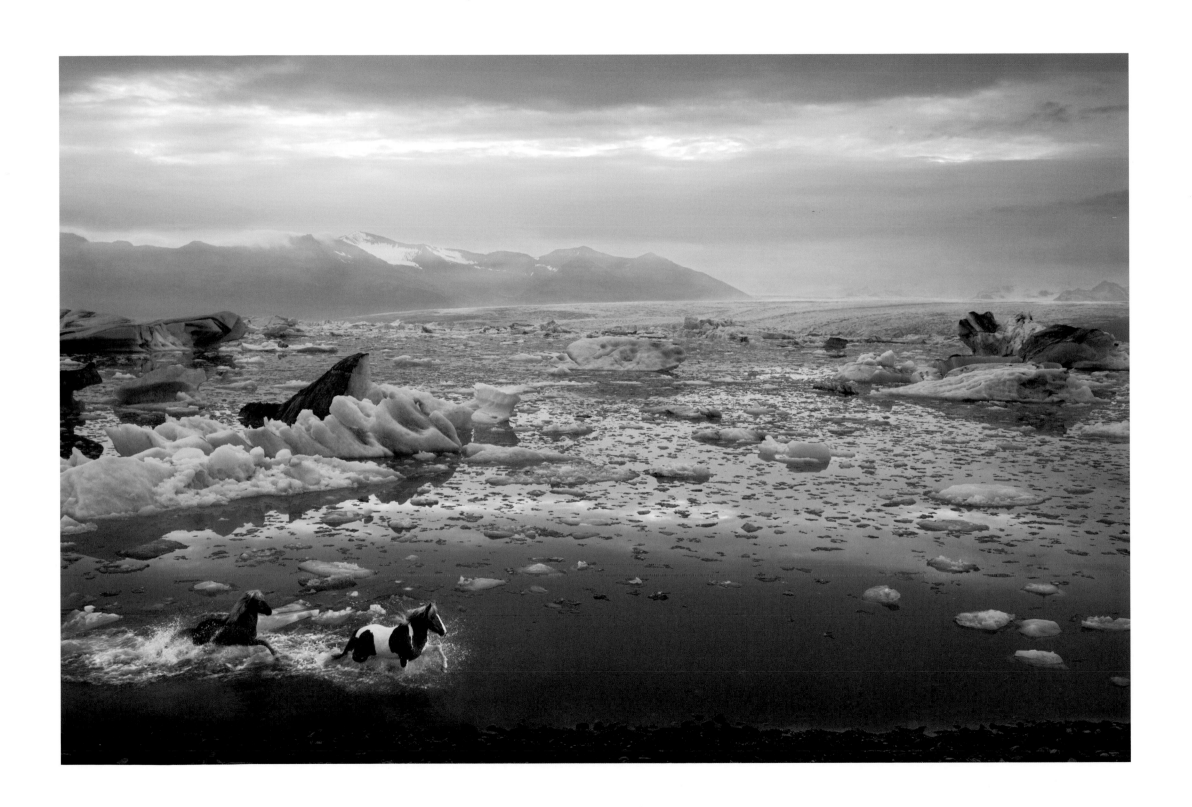

Icelandic Horse
Vatnajökull ice cap, Iceland

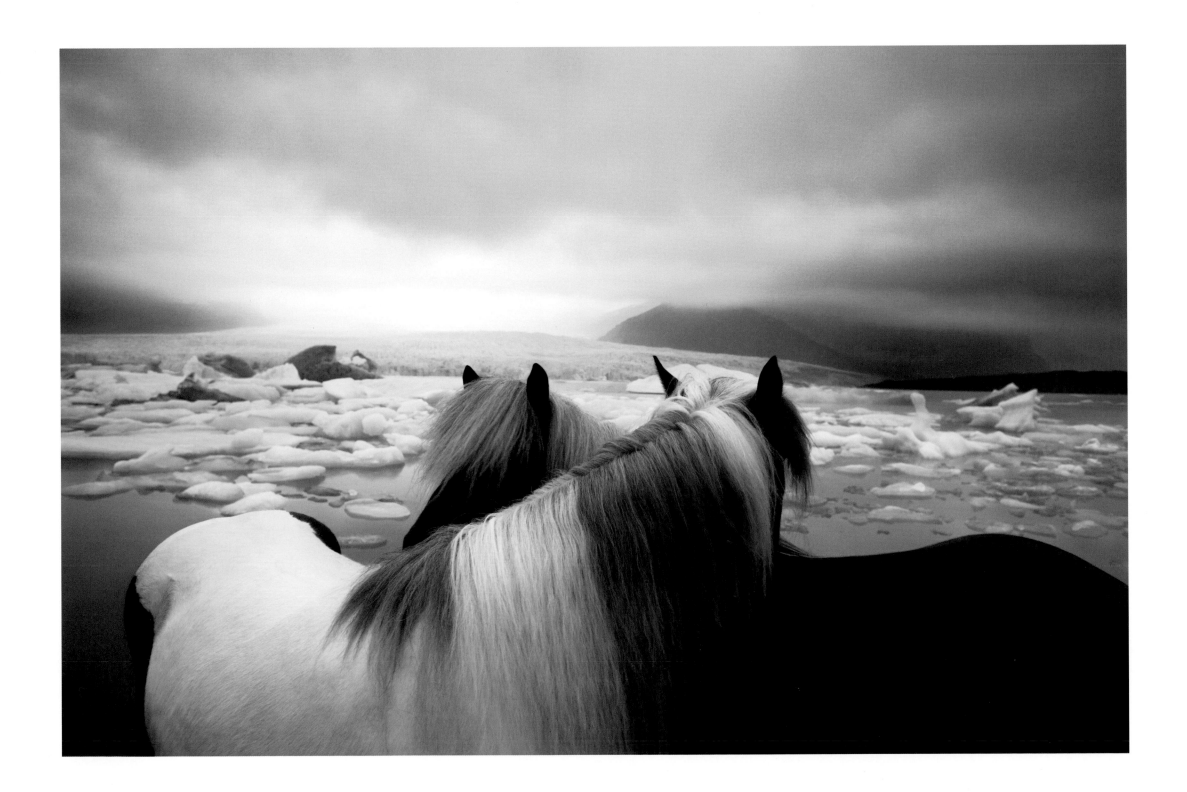

Icelandic Horse
Iceland

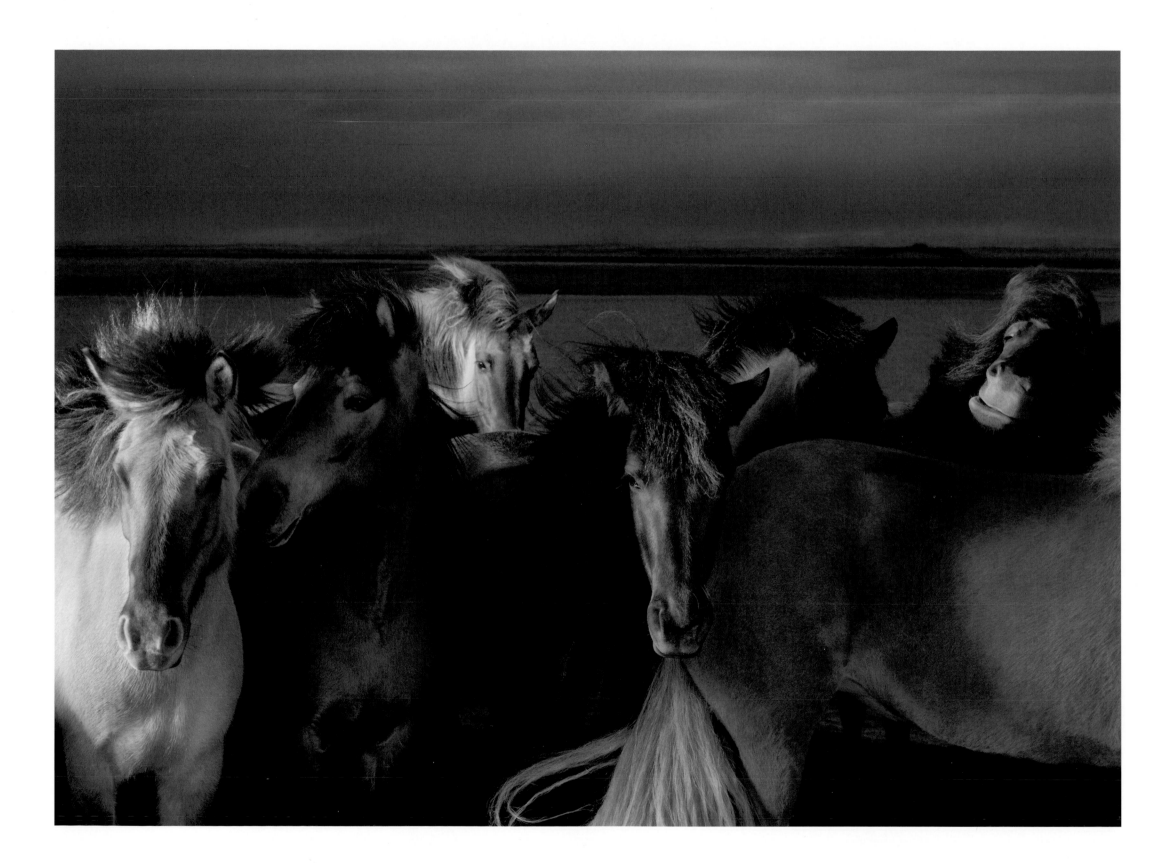

Icelandic Horse
Iceland

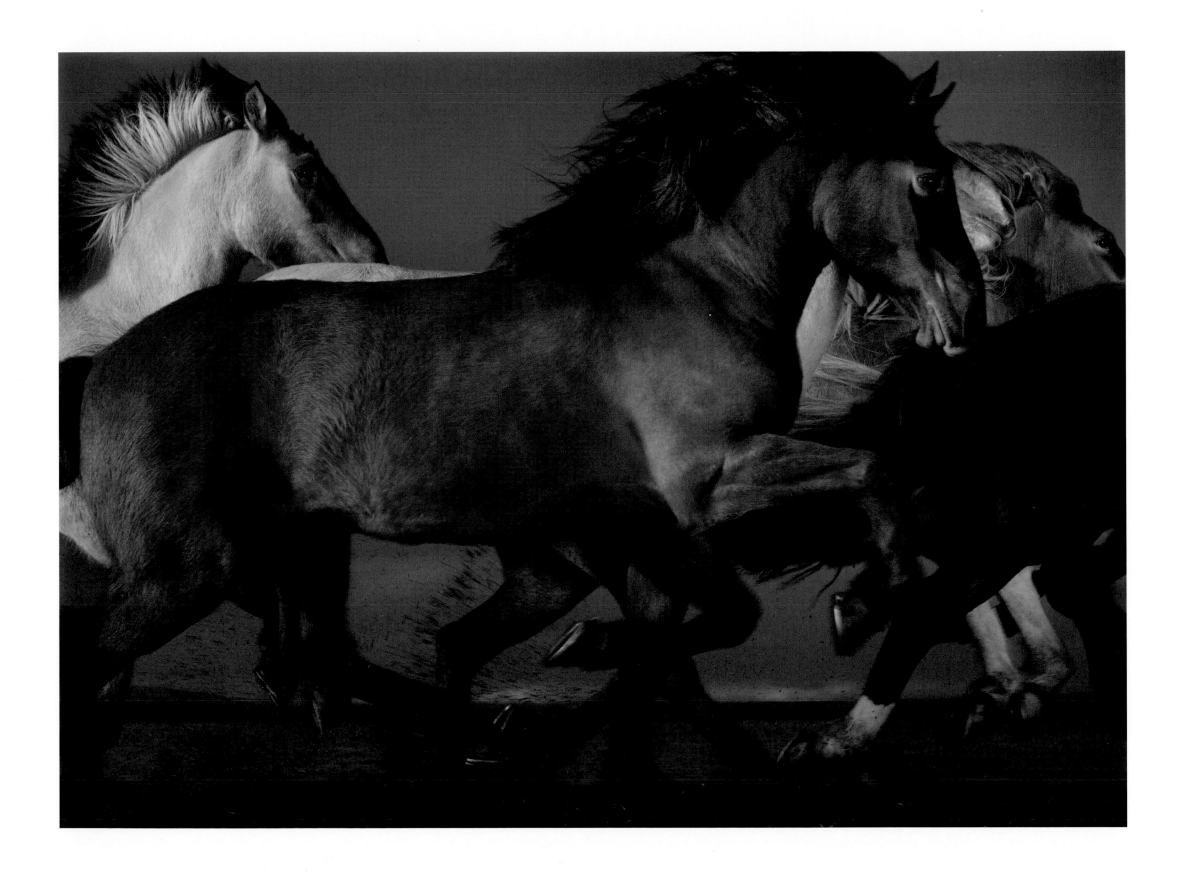

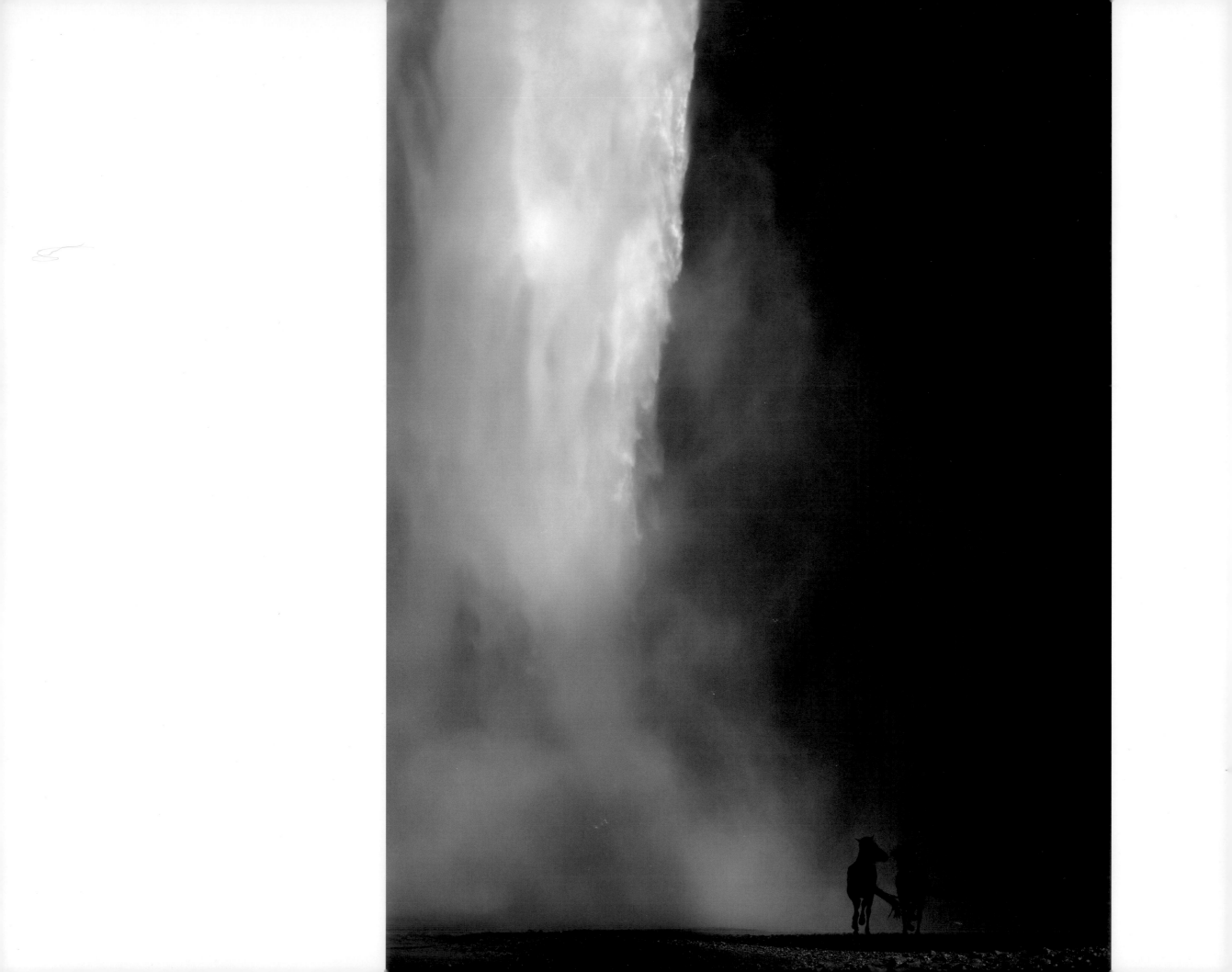

100 Fjord
Nordfjordeid, Norway

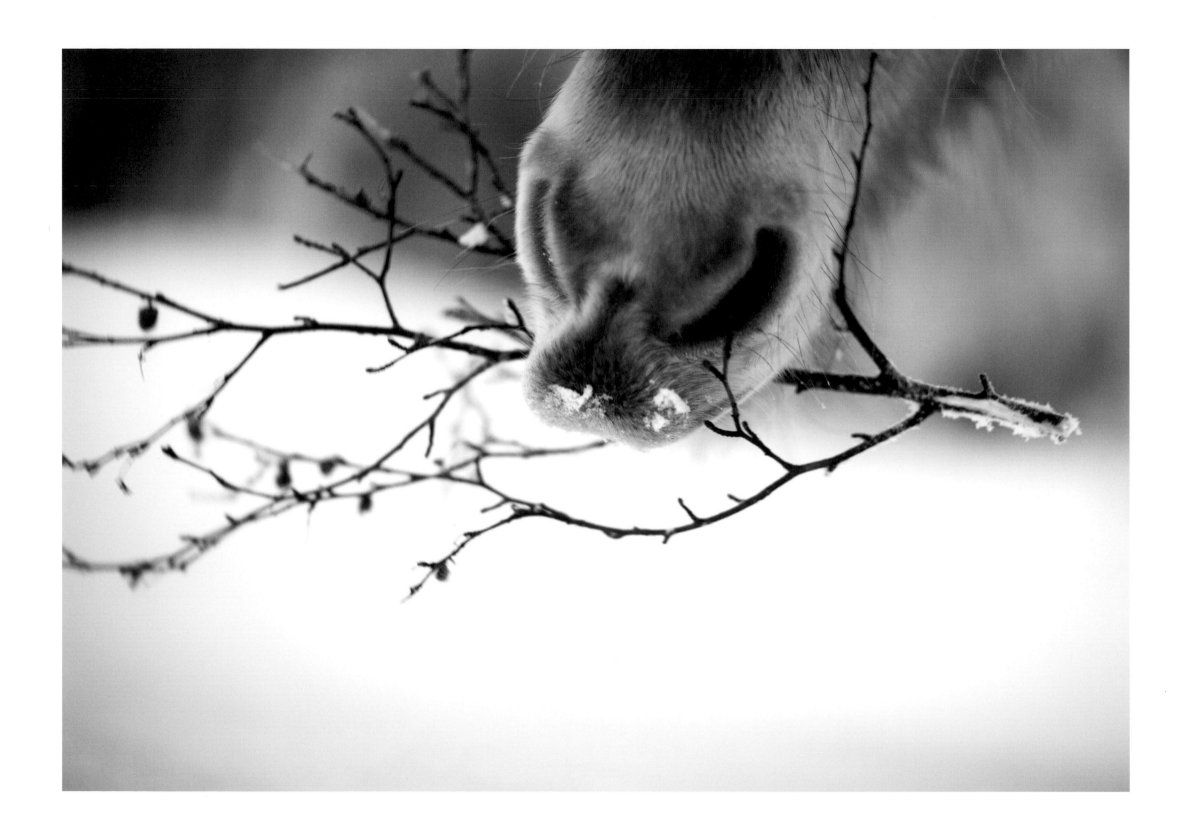

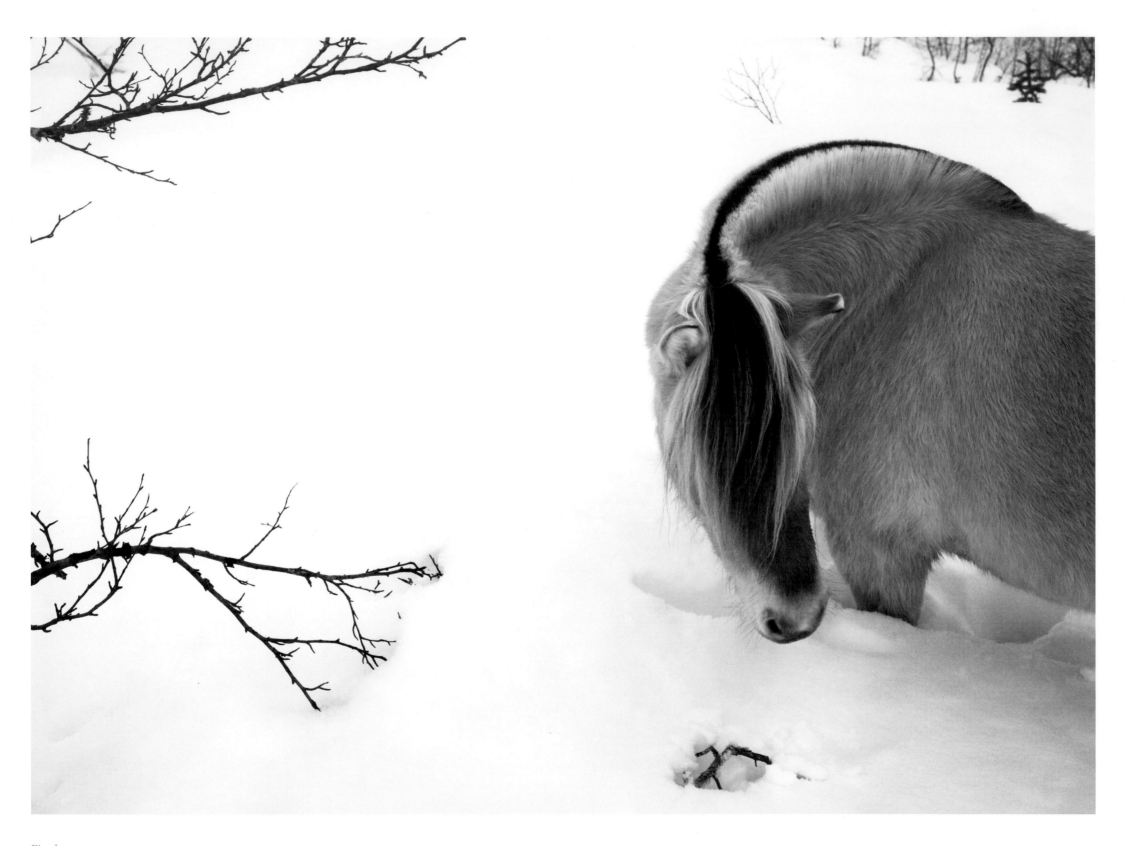

Fjord
Nordfjordeid, Norway

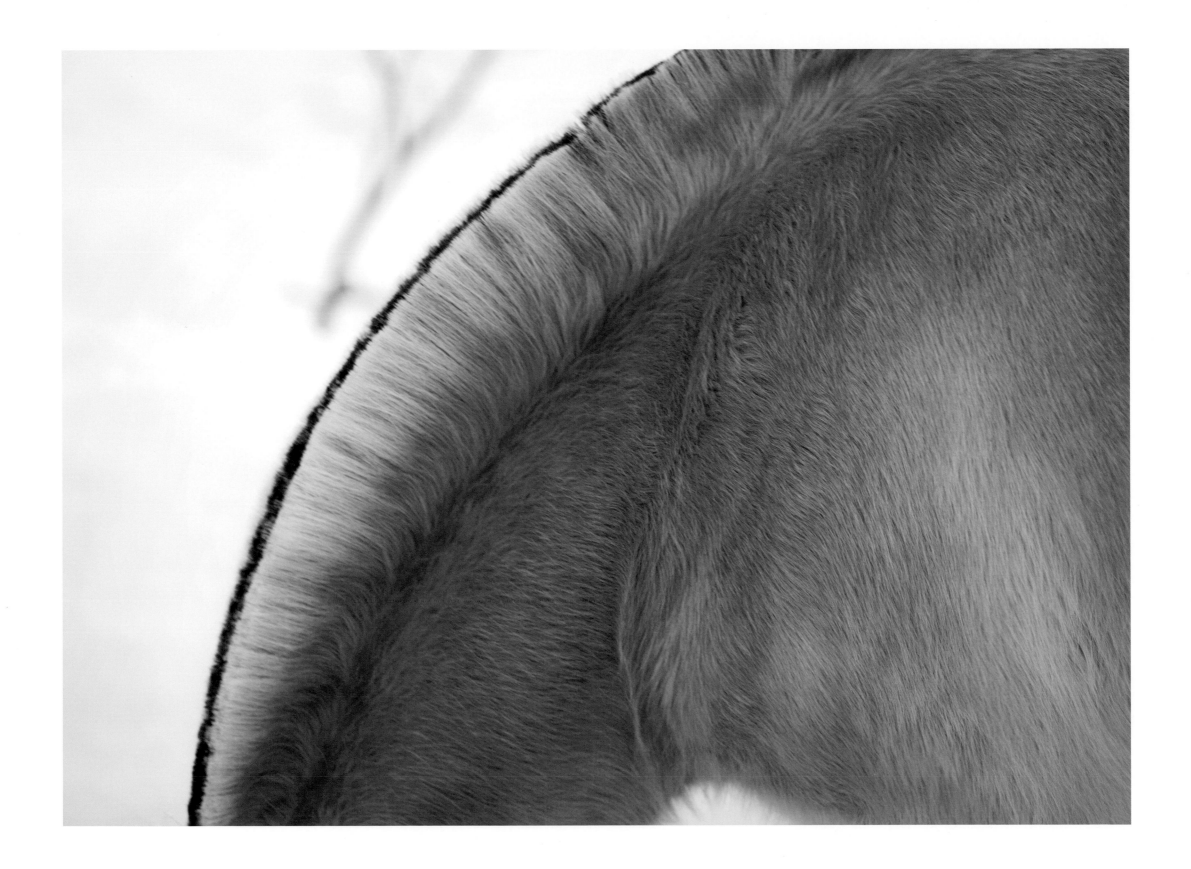

104 Fjord
Nordfjordeid, Norway

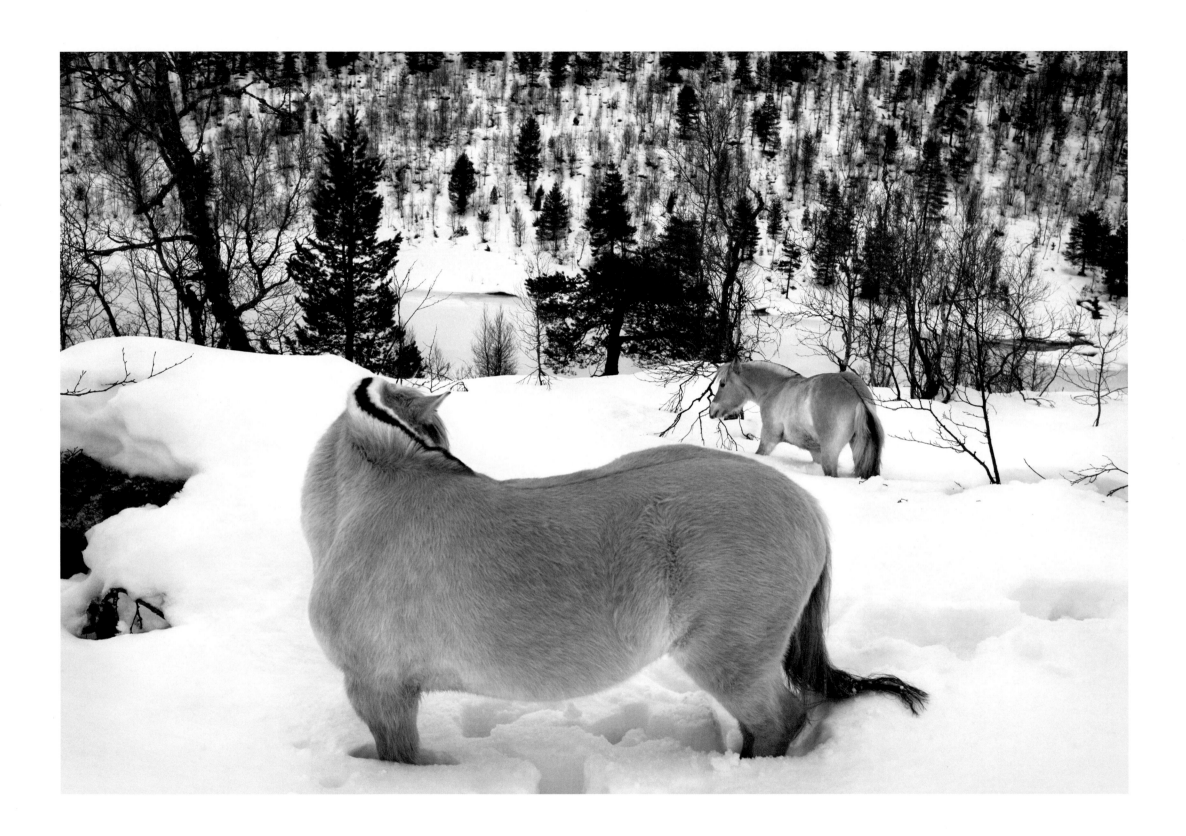

Fjord
Nordfjordeid, Norway

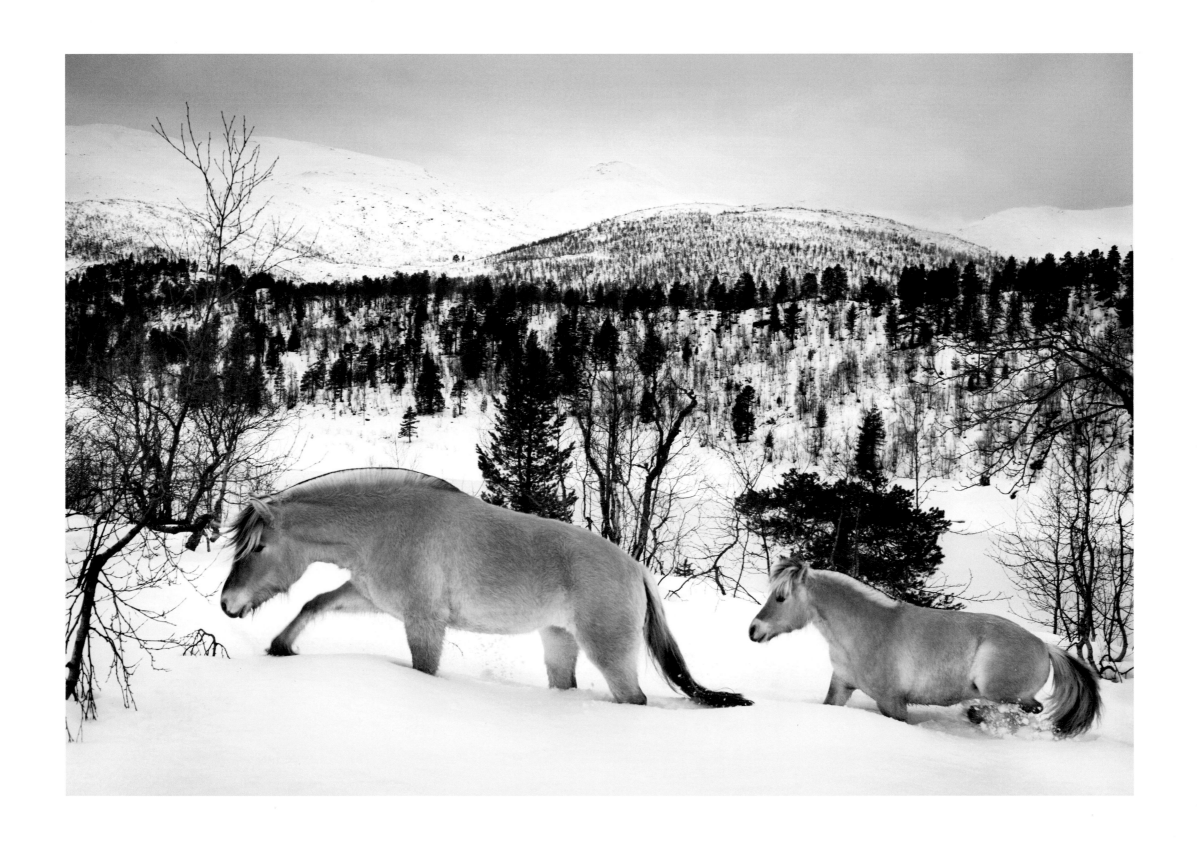

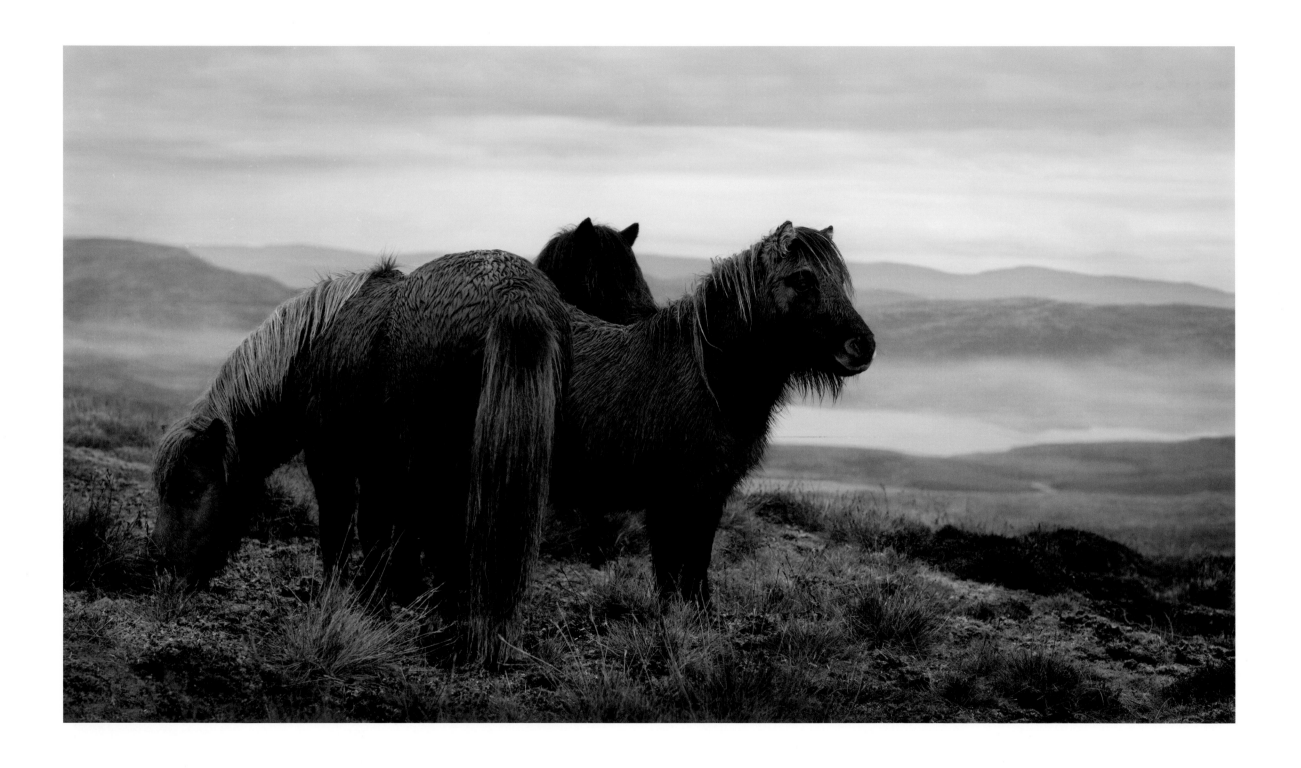

110 Shetland Pony
Shetland, UK

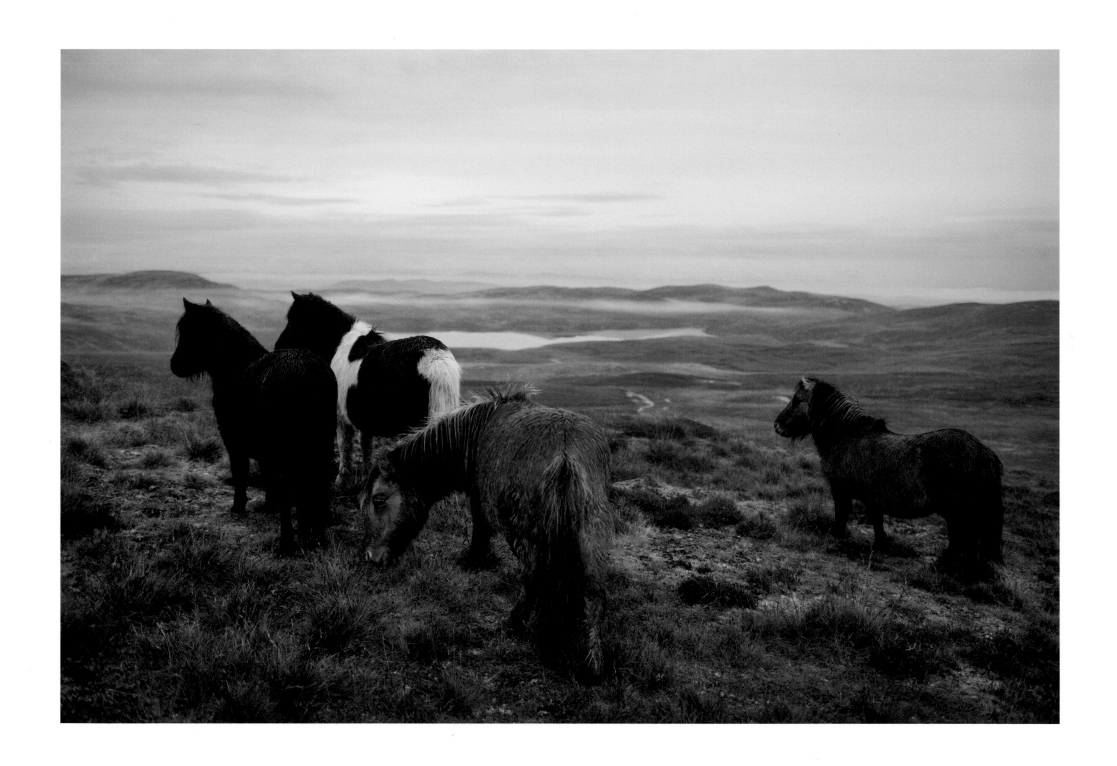

112 Burchell's Zebra
 Masai Mara, Kenya

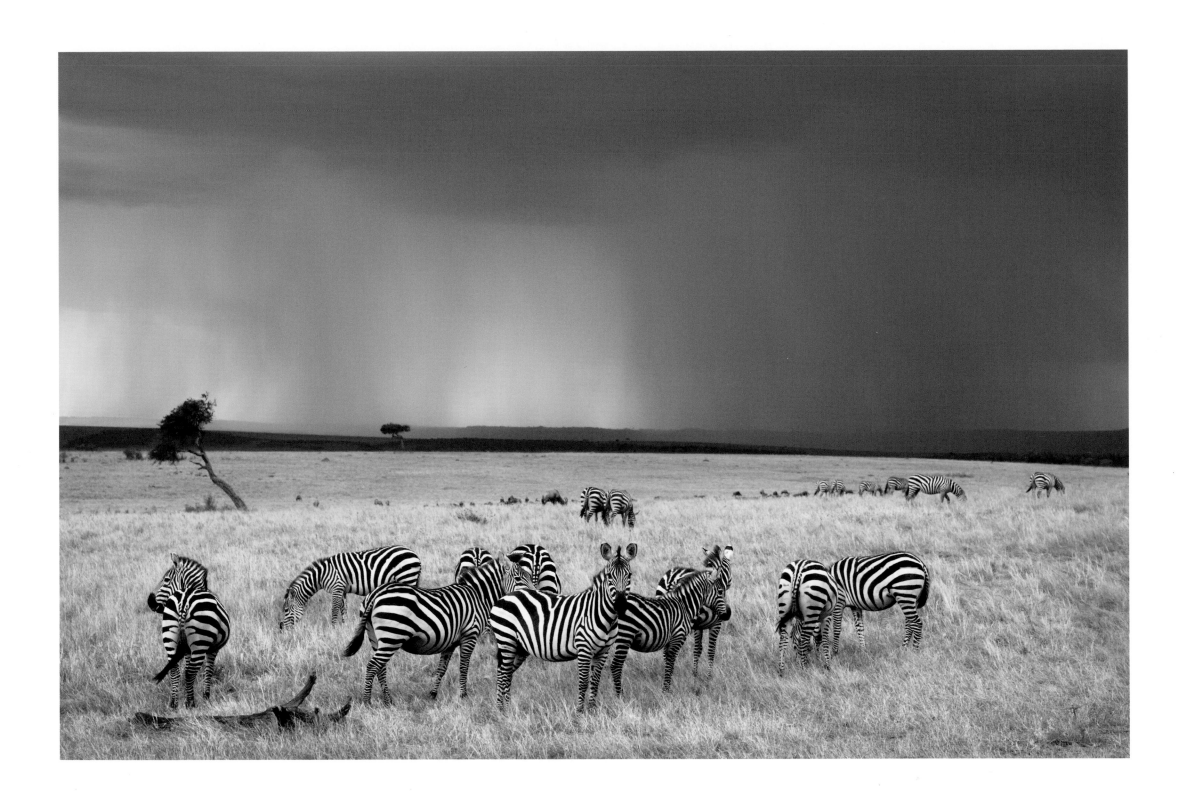

114 Burchell's Zebra
Masai Mara, Kenya

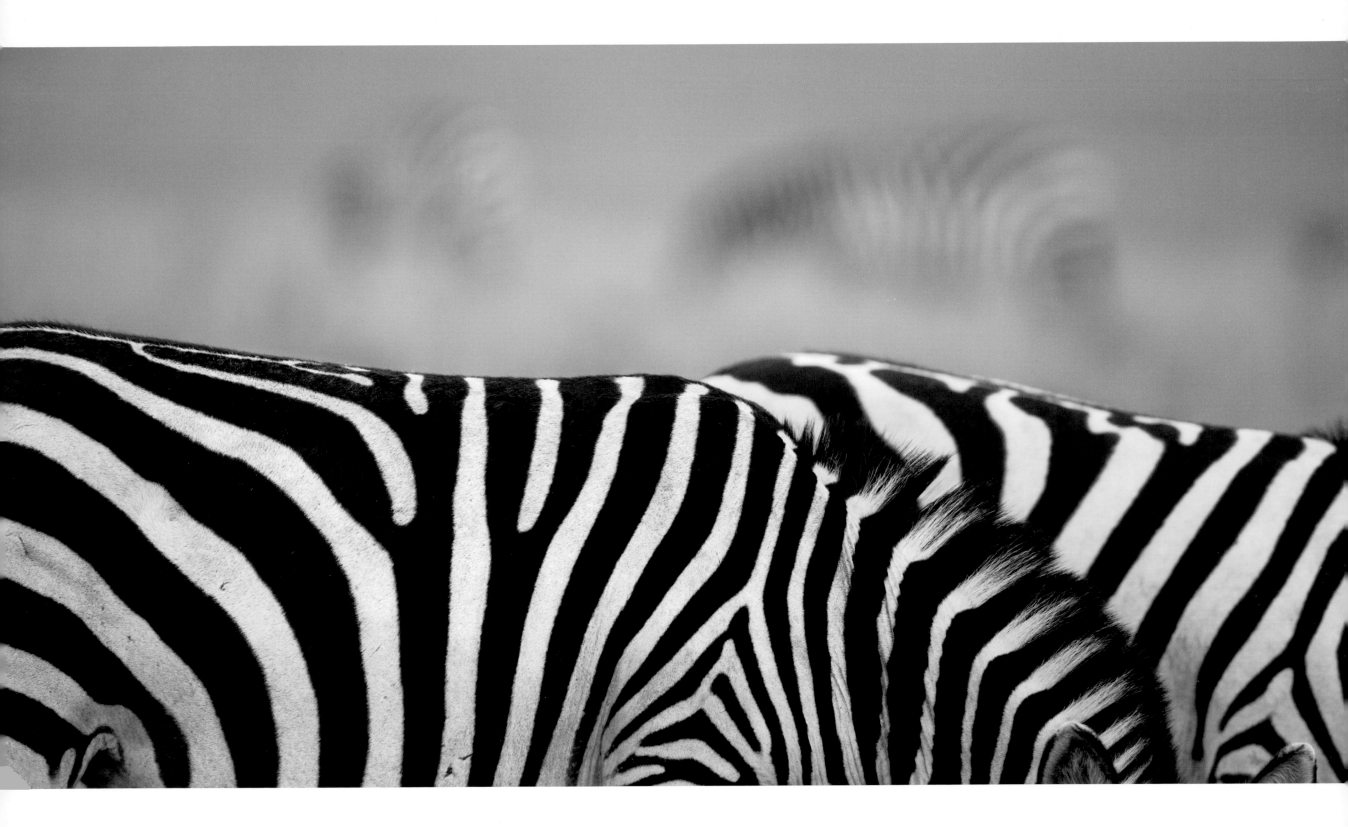

Burchell's Zebra
Masai Mara, Kenya

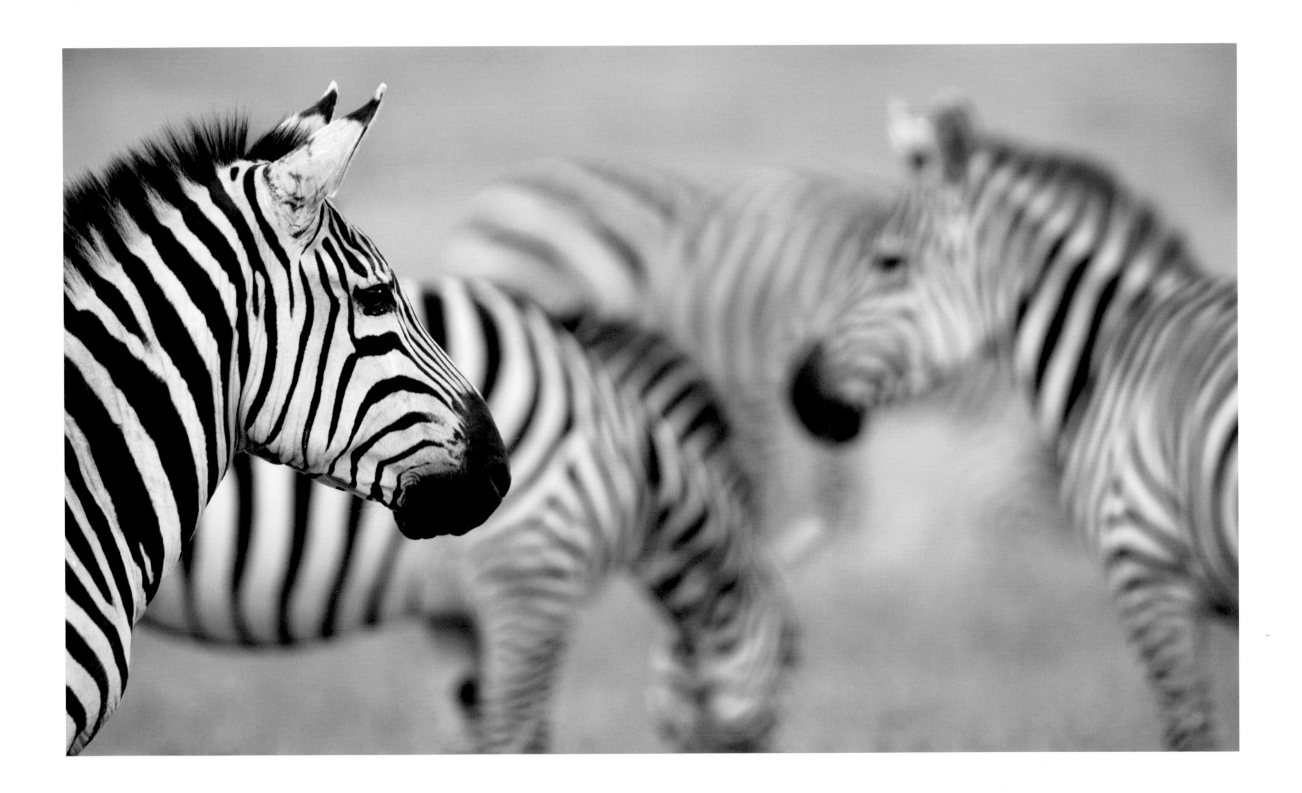

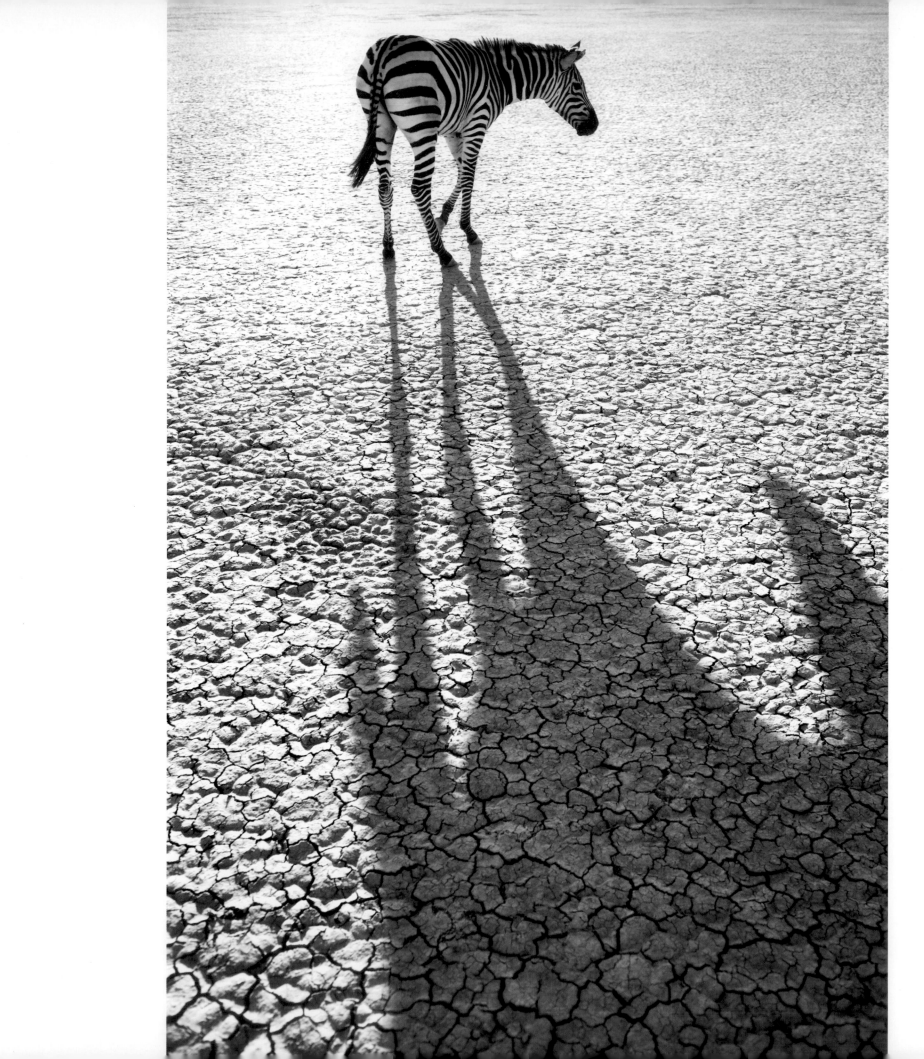

120 Burchell's Zebra
 Masai Mara, Kenya

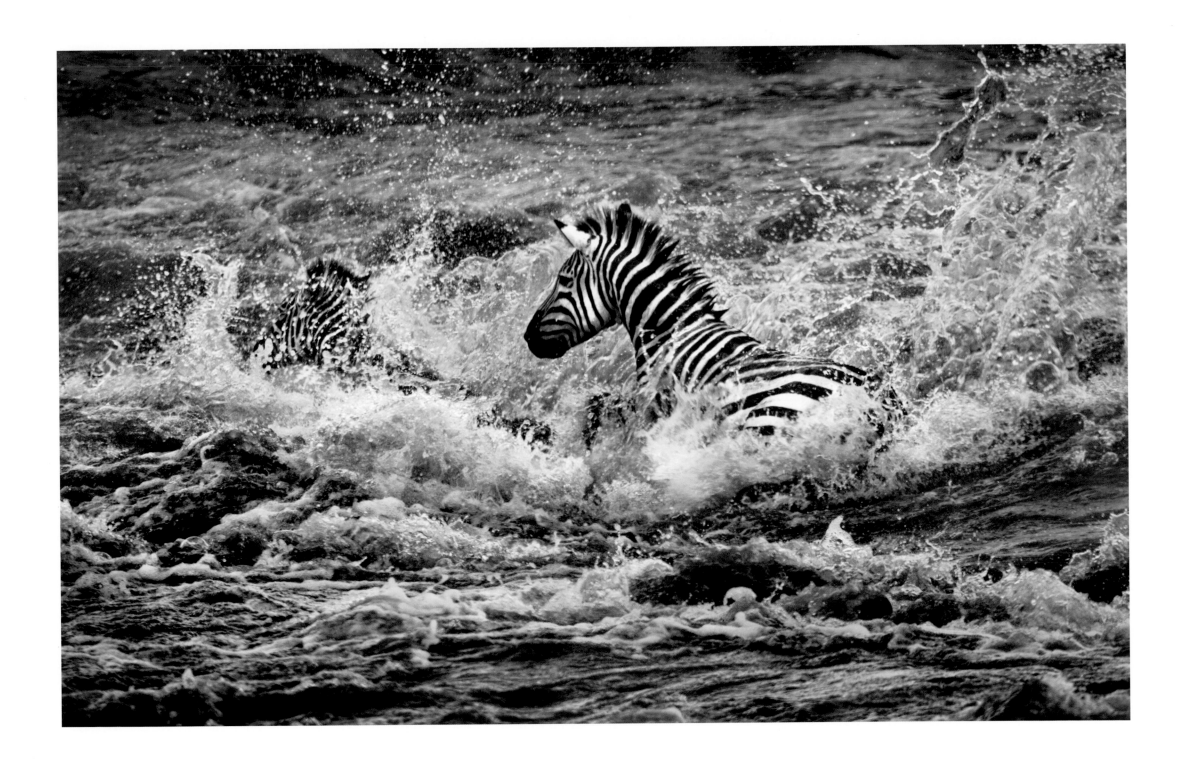

122 Burchell's Zebra
 Masai Mara, Kenya

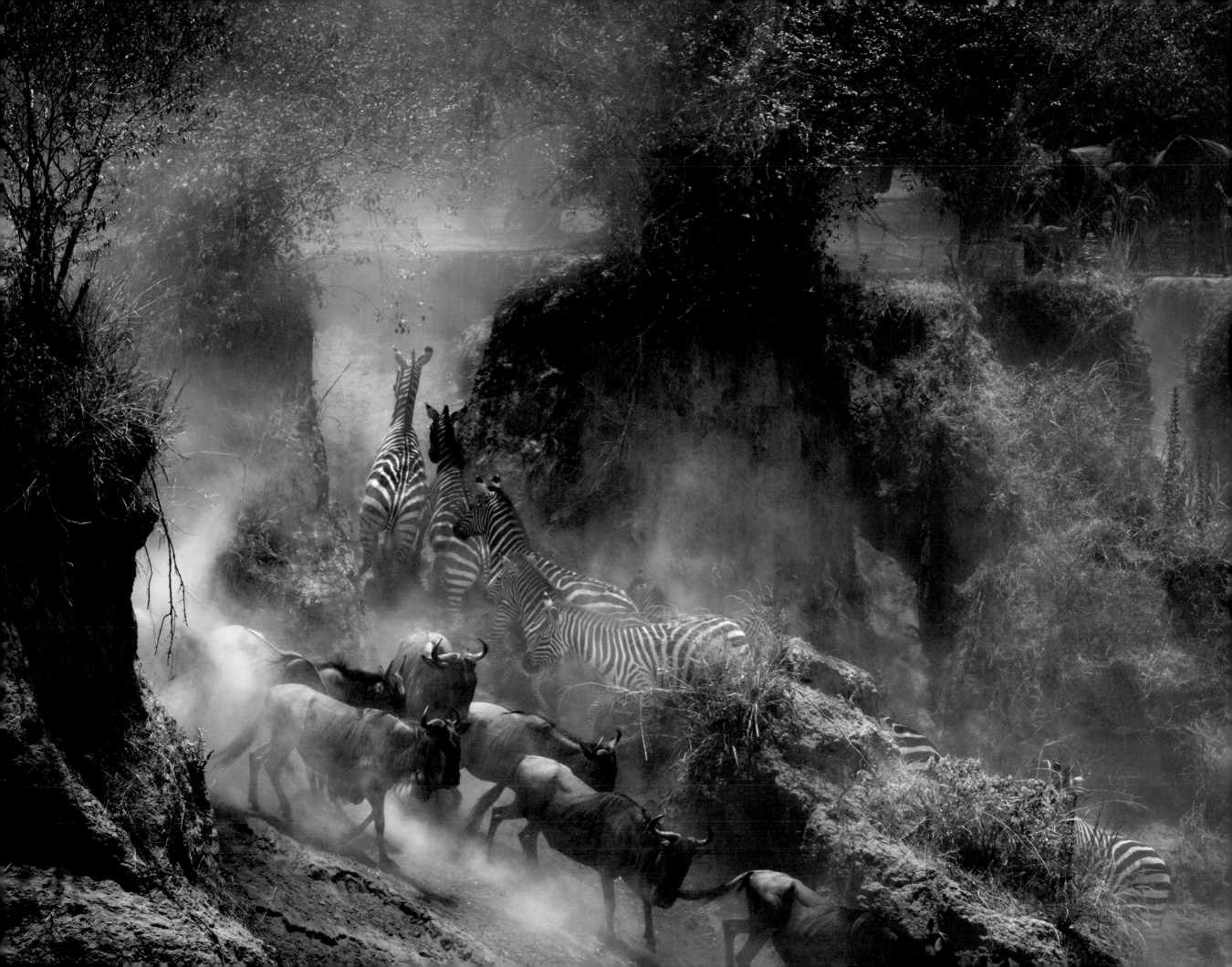

Grant's Zebra
California, USA

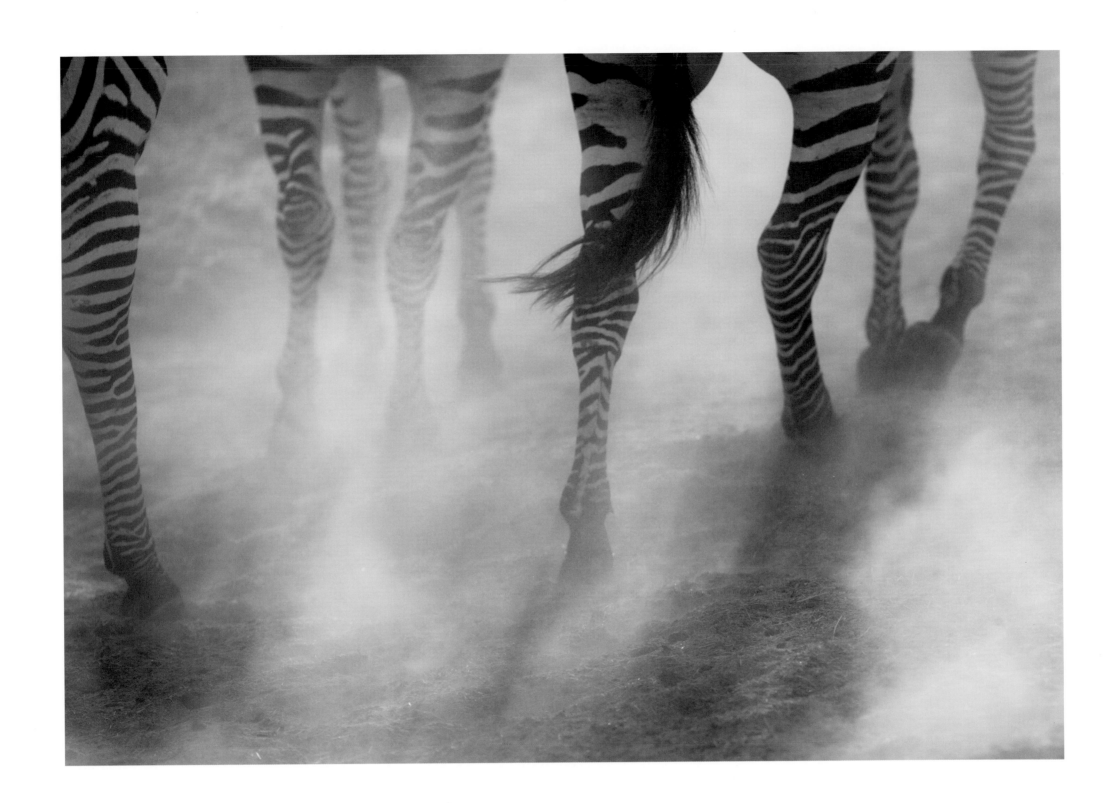

126 Flies, horse manure
East Tyrol, Austria

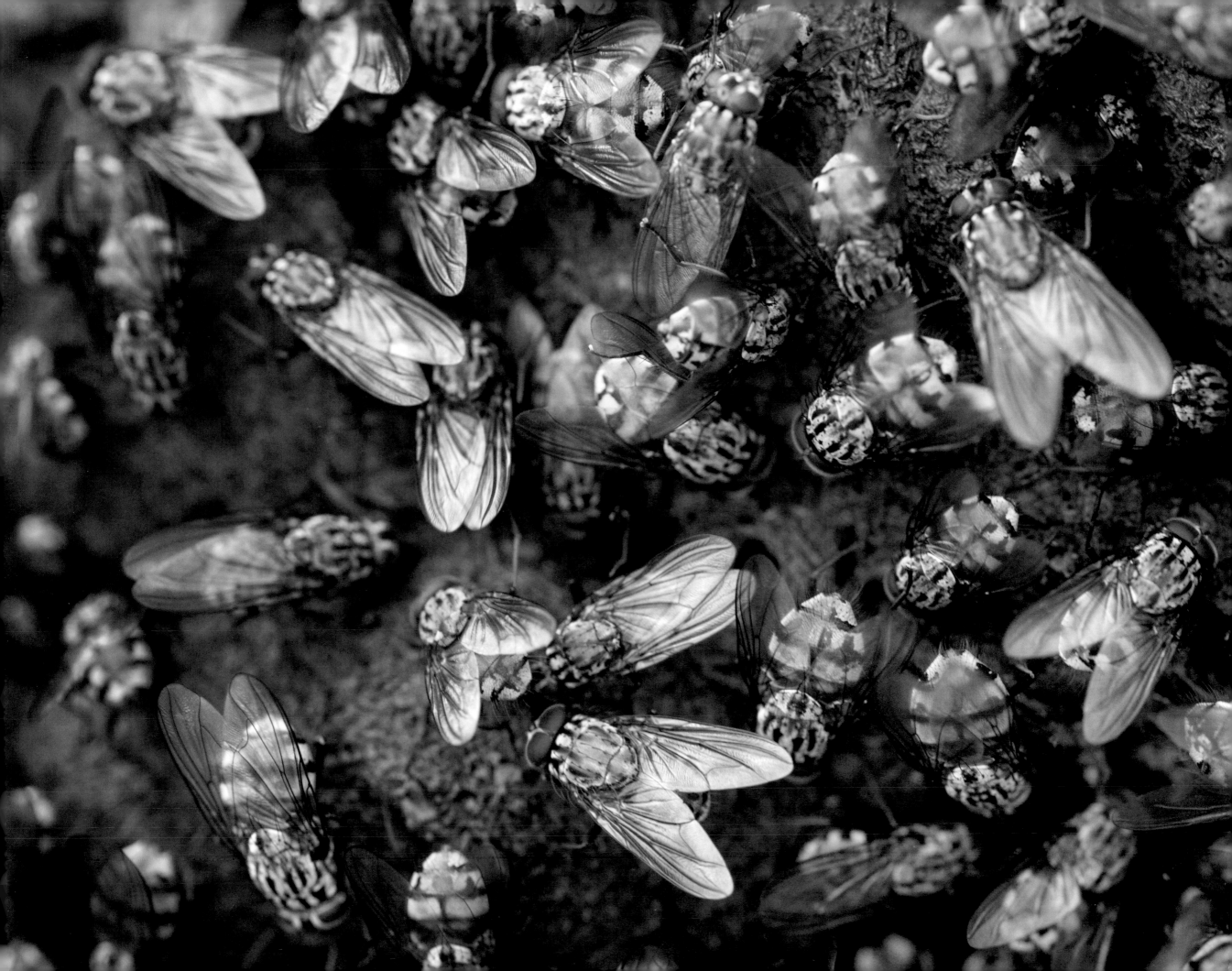

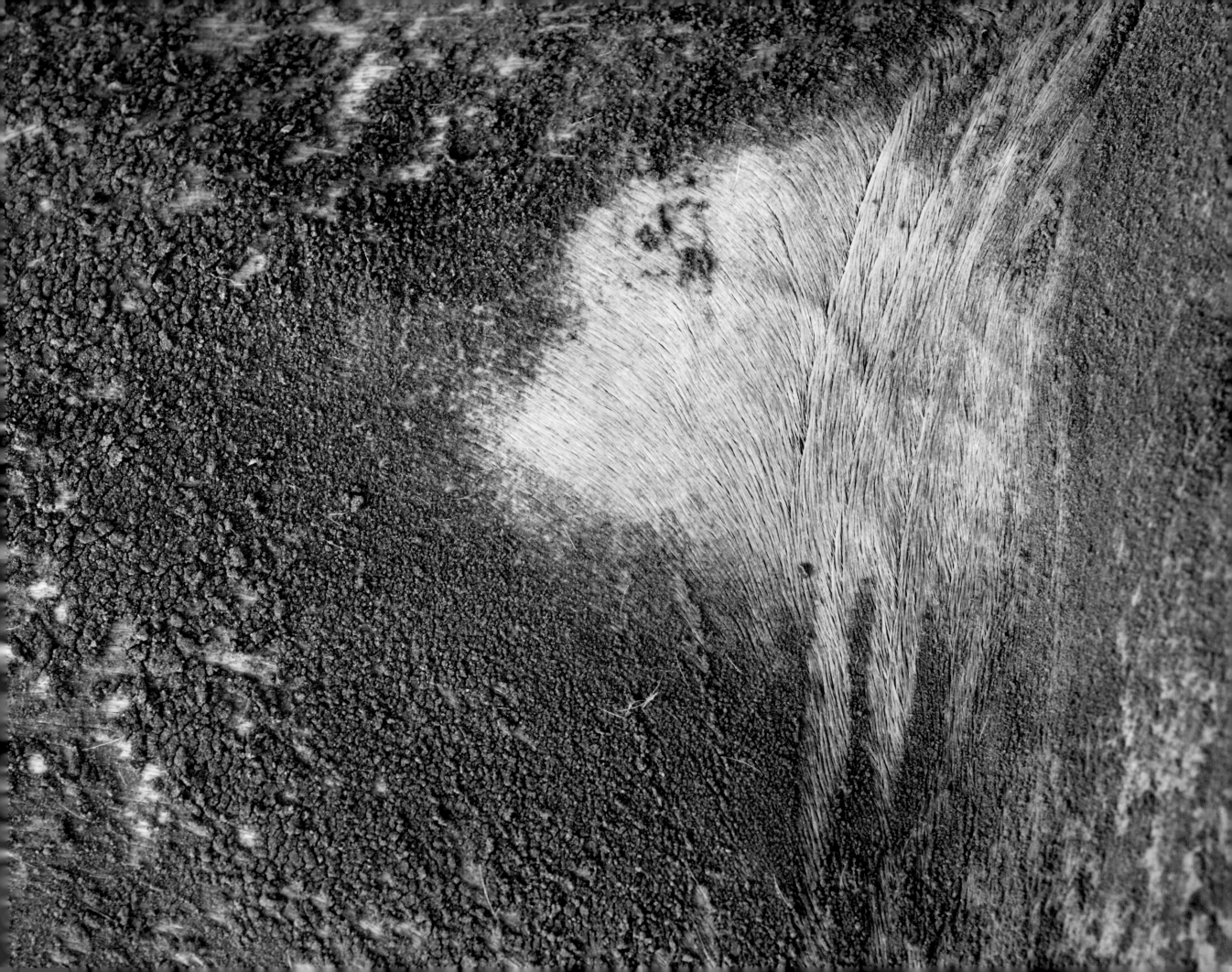

130 Marwari
Rajasthan, India

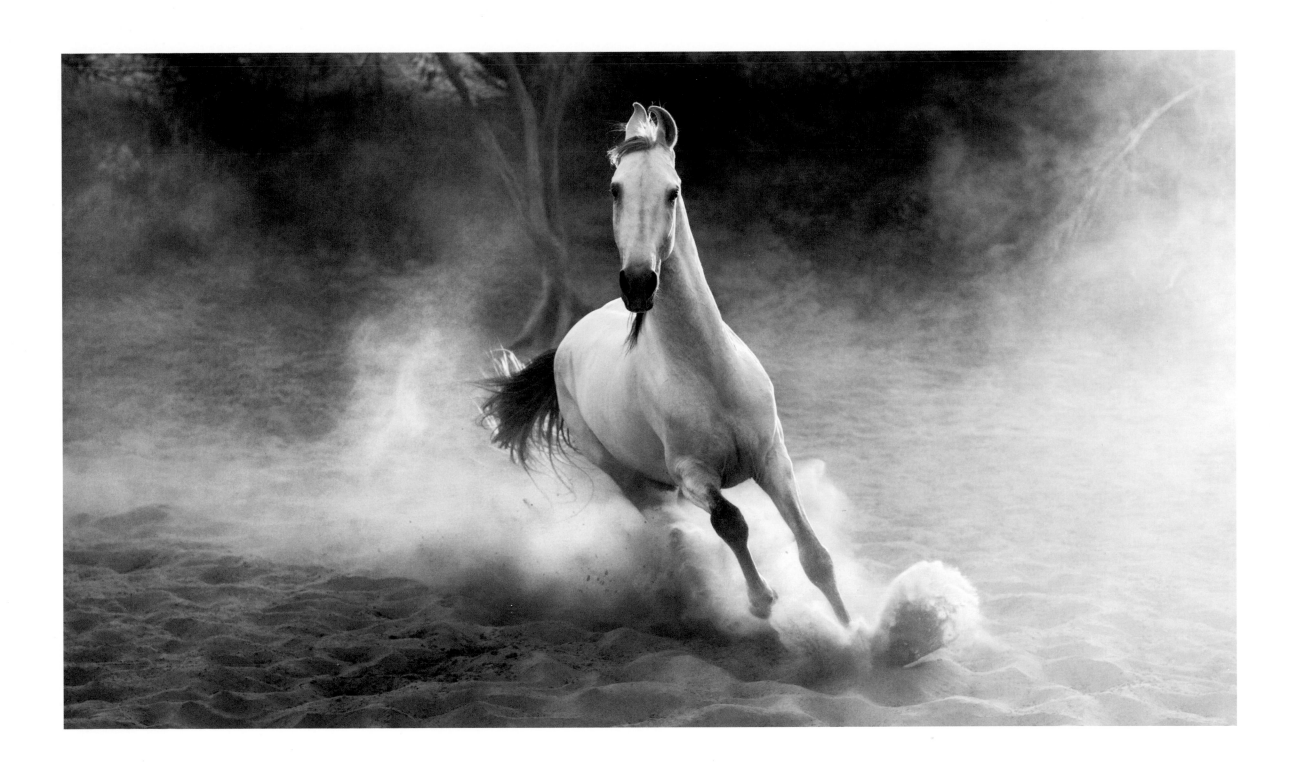

Marwari

Rajasthan, India

Marwari
Rajasthan, India

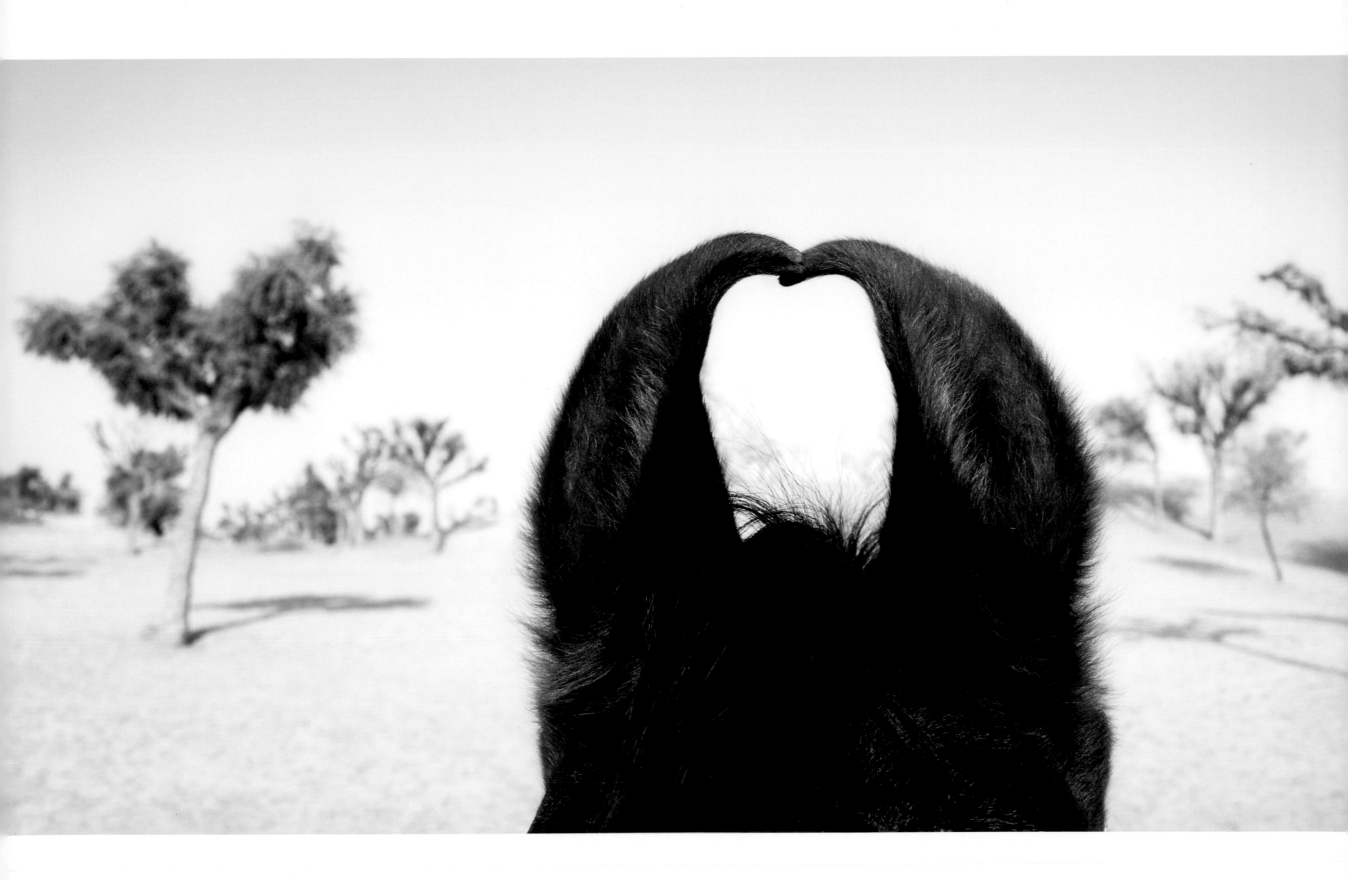

136 Marwari
Rajasthan, India

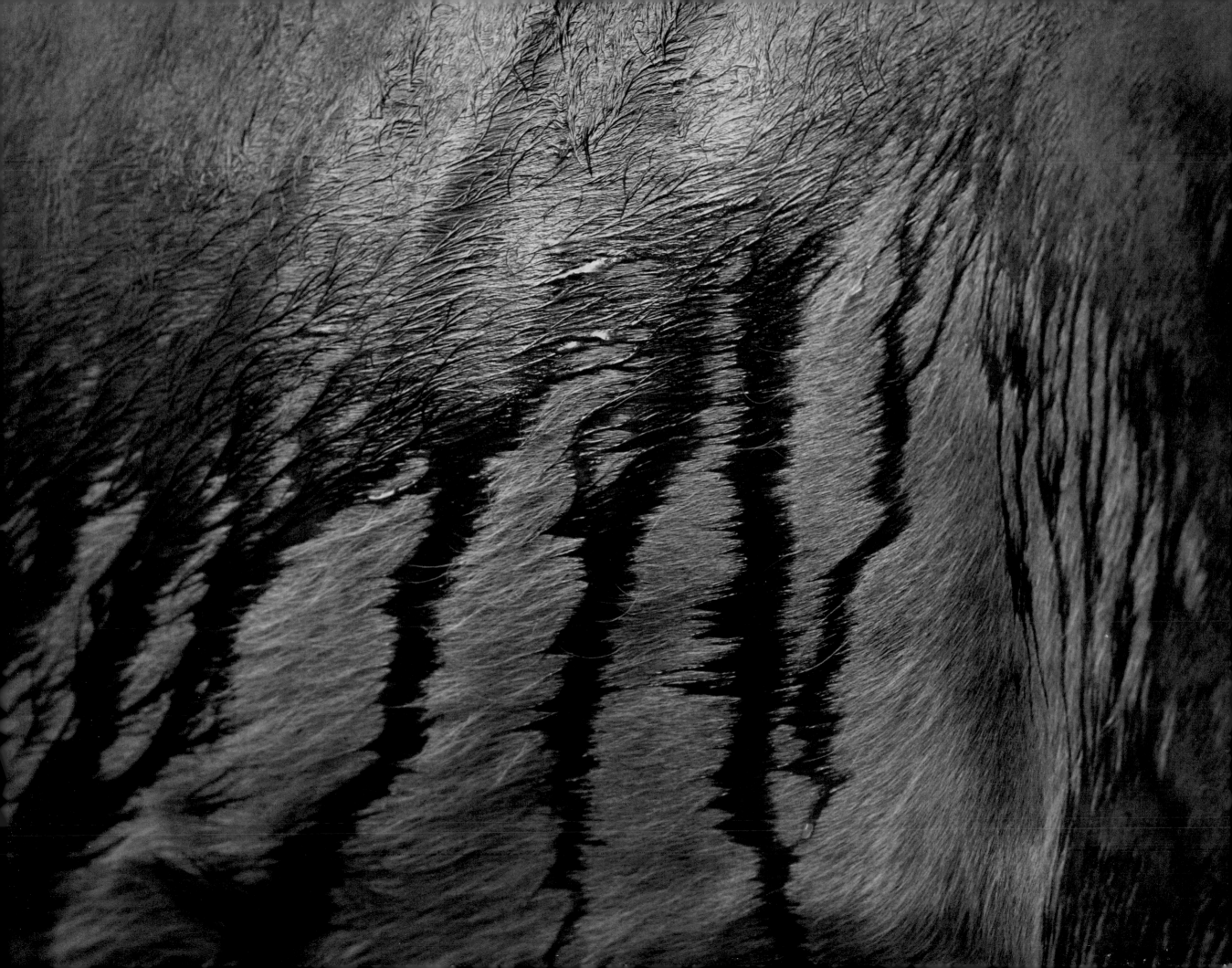

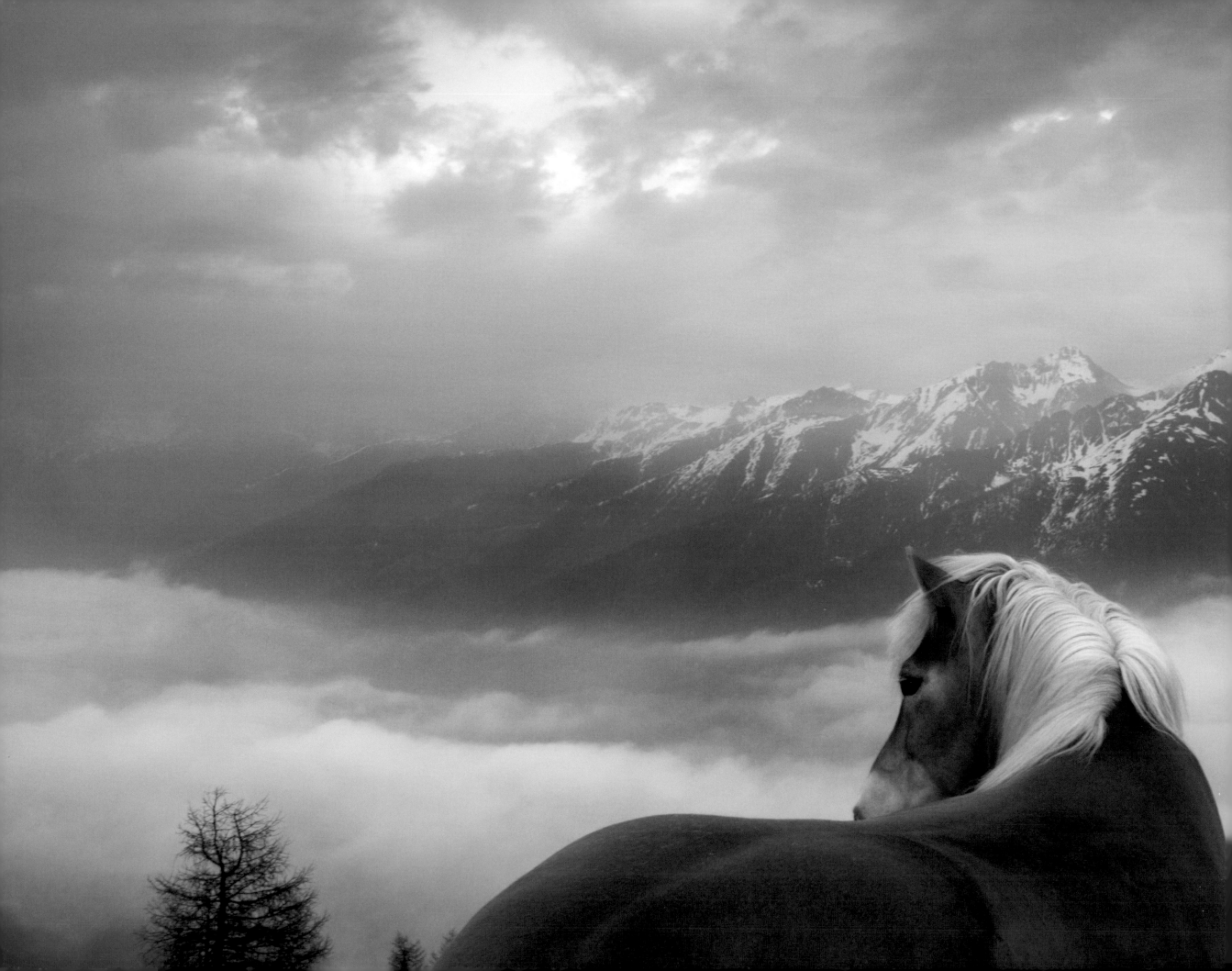

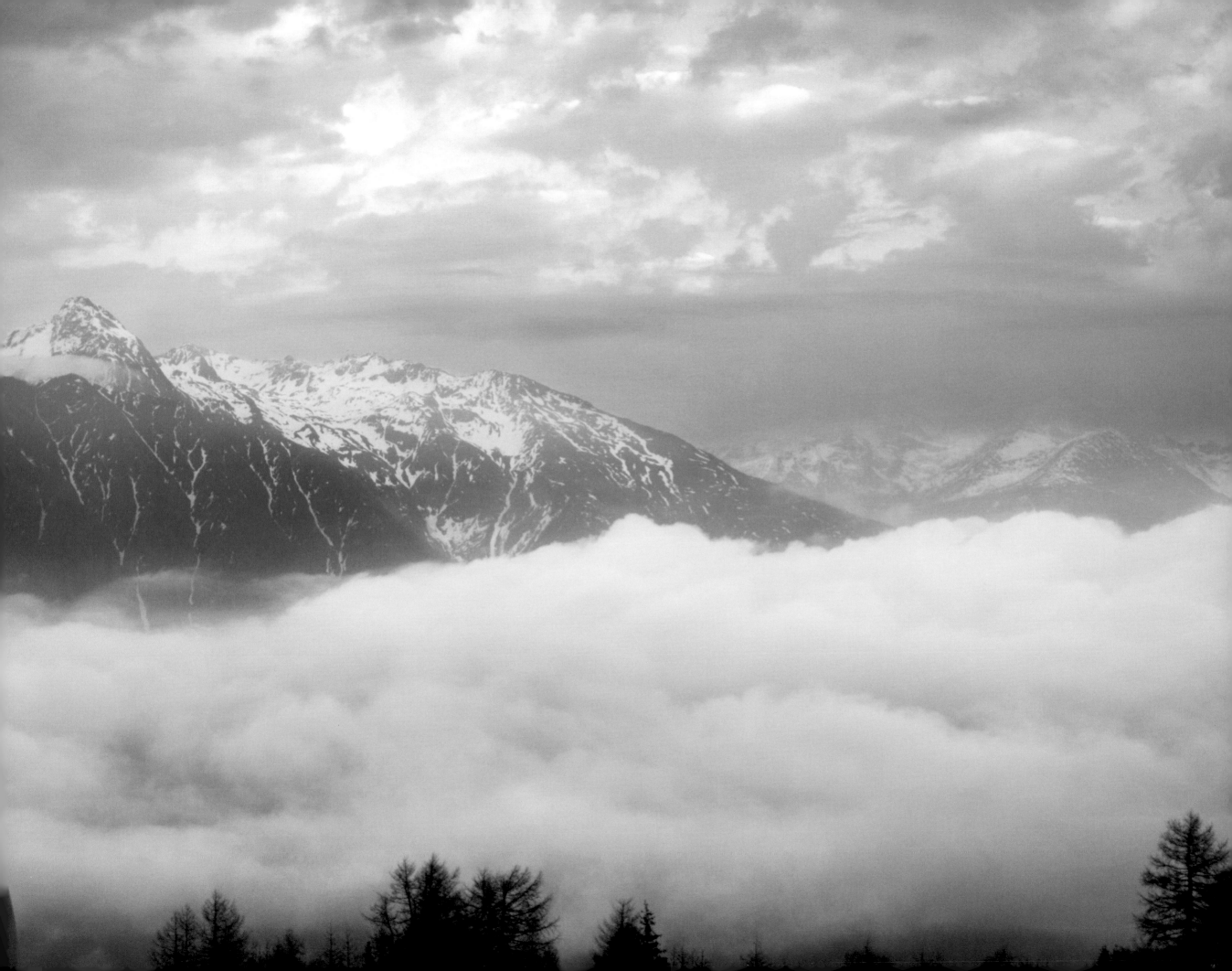

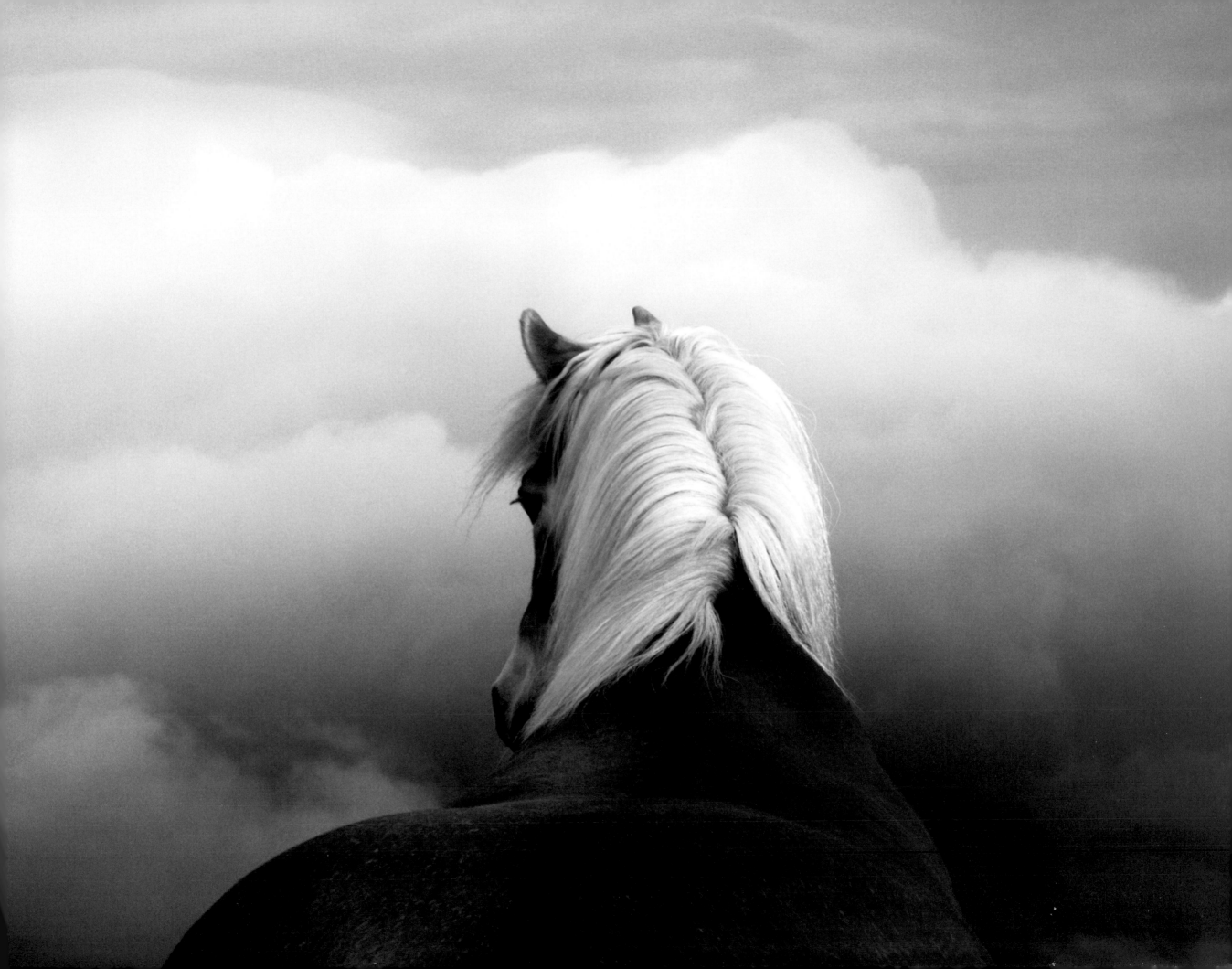

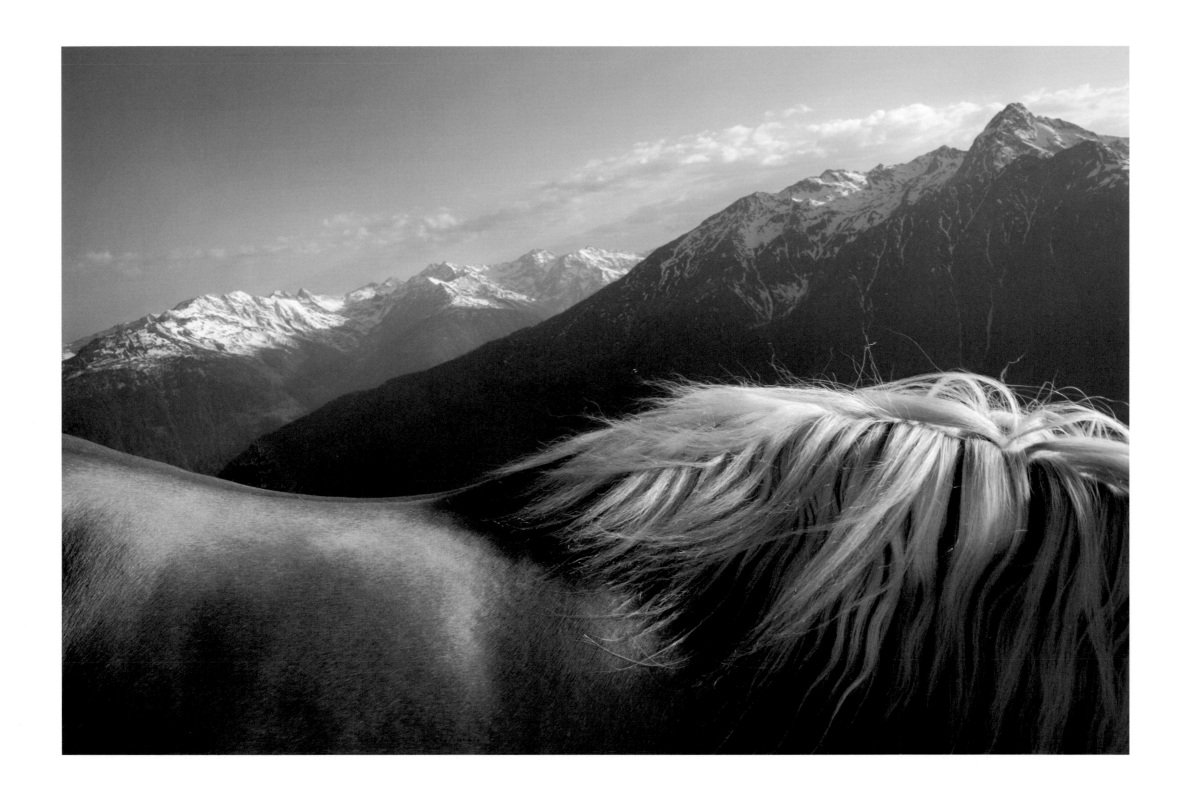

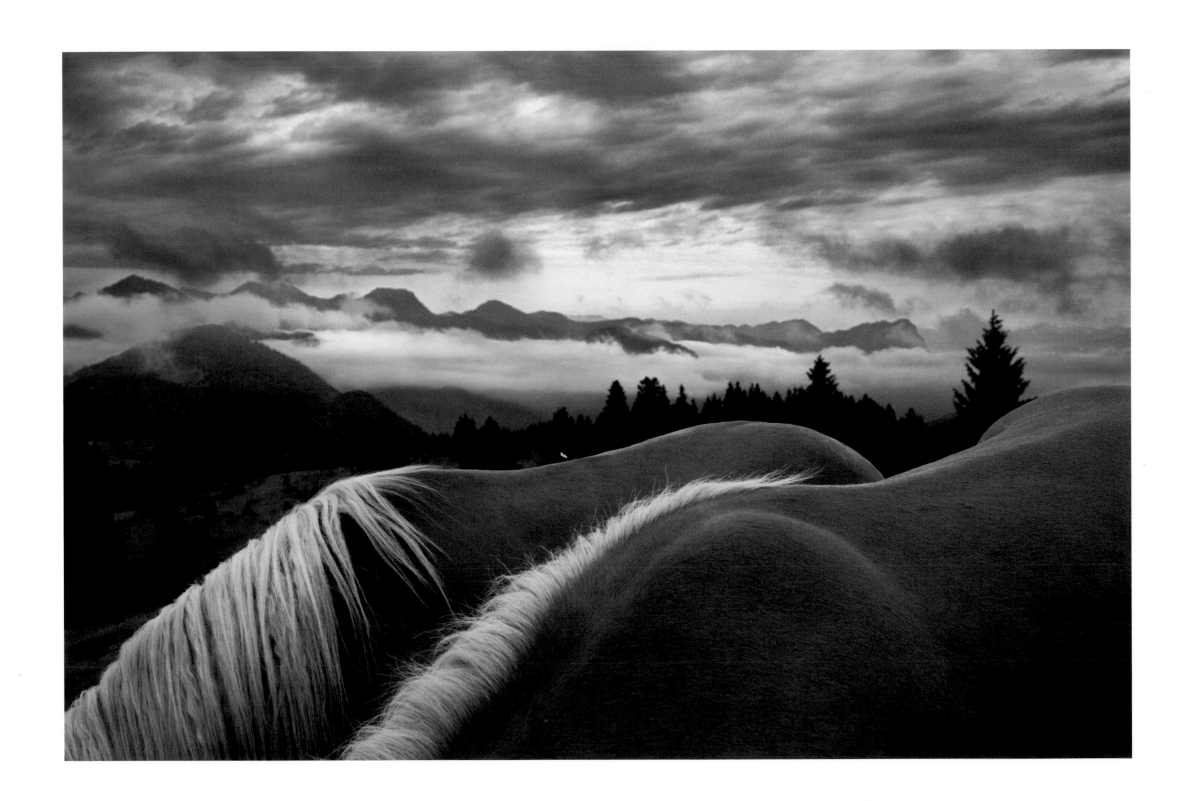

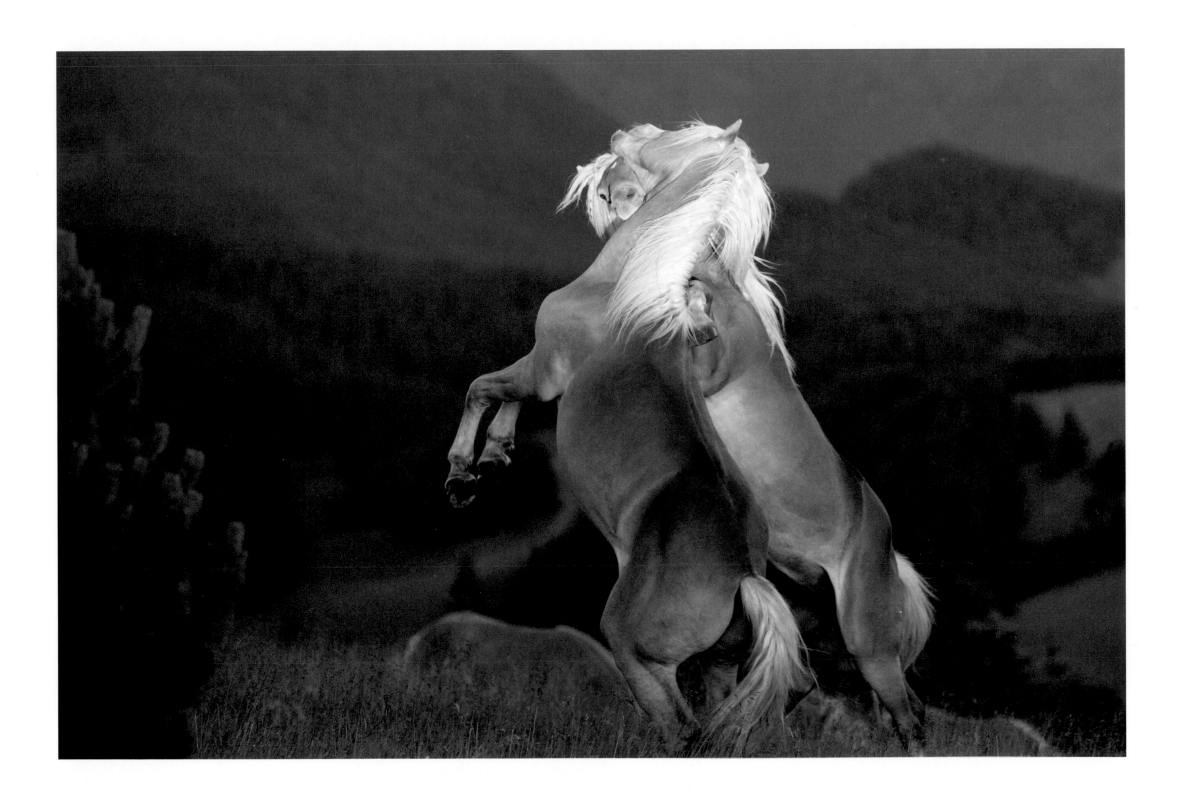

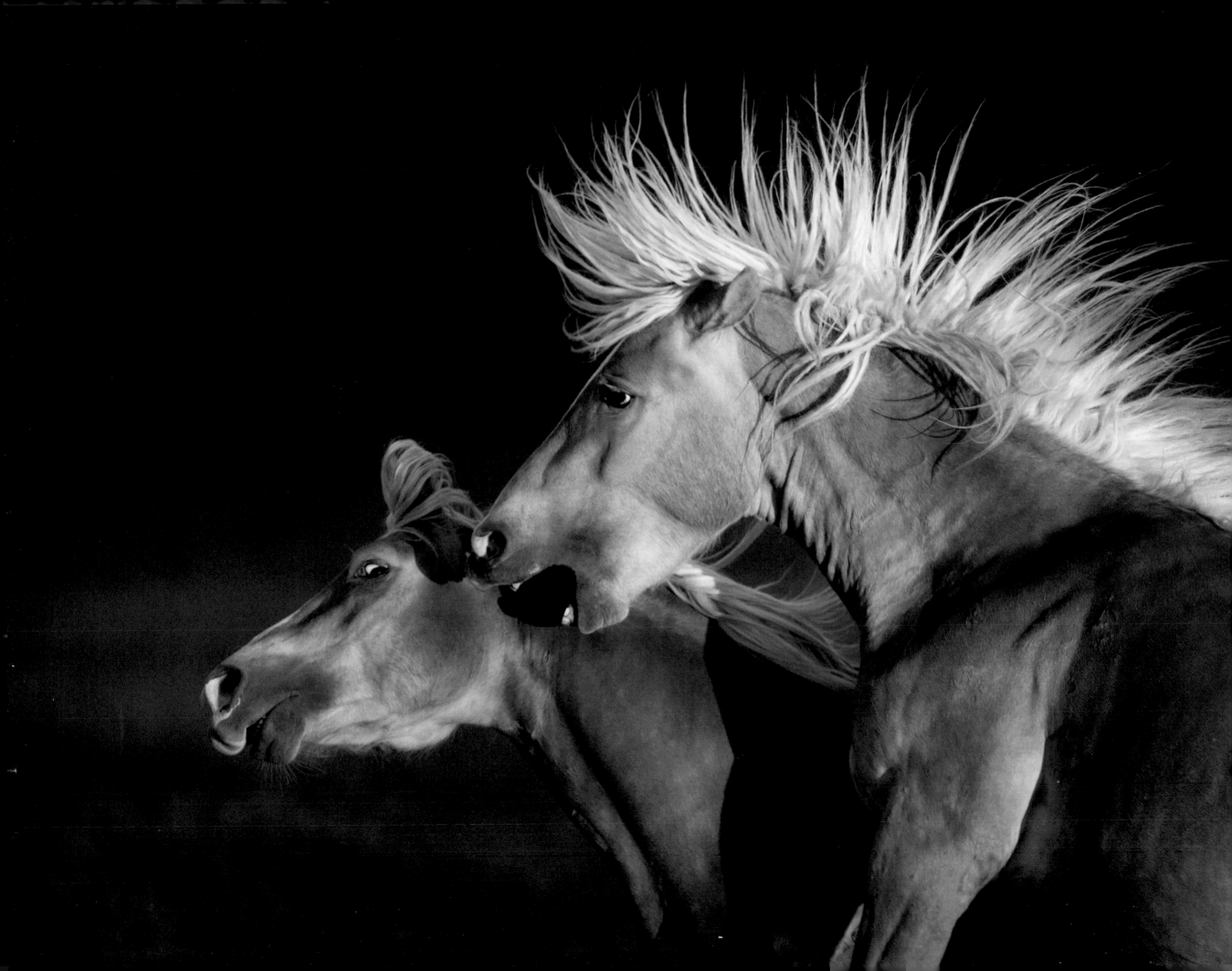

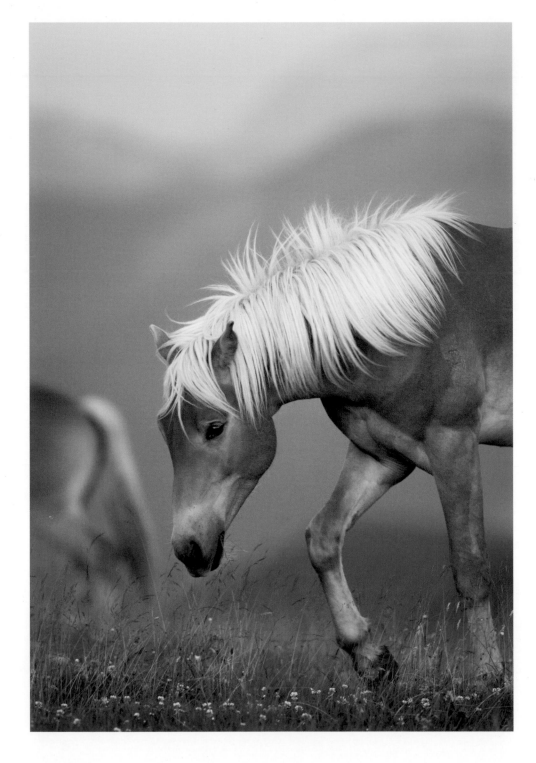

Haflinger
Ebbs, Austria

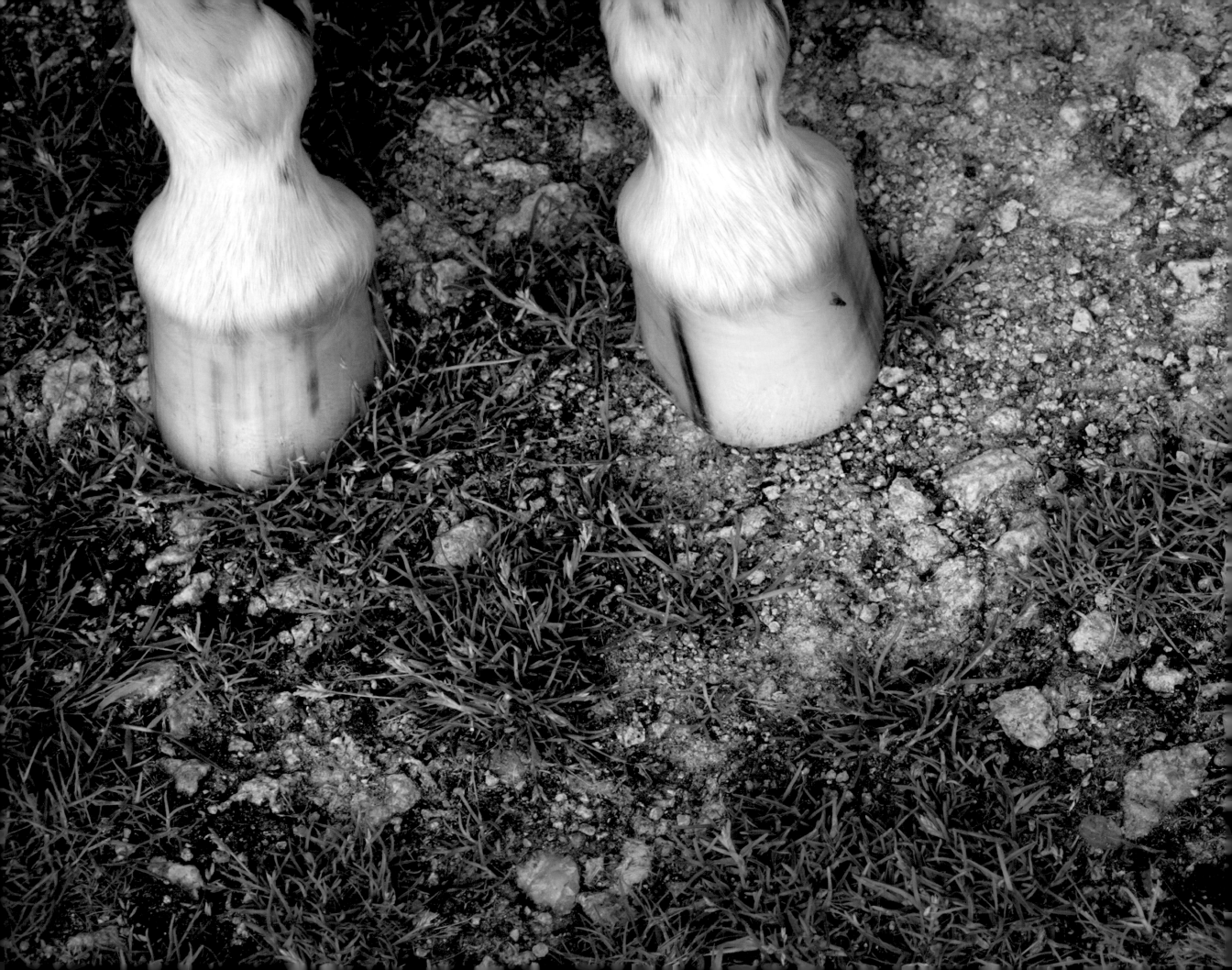

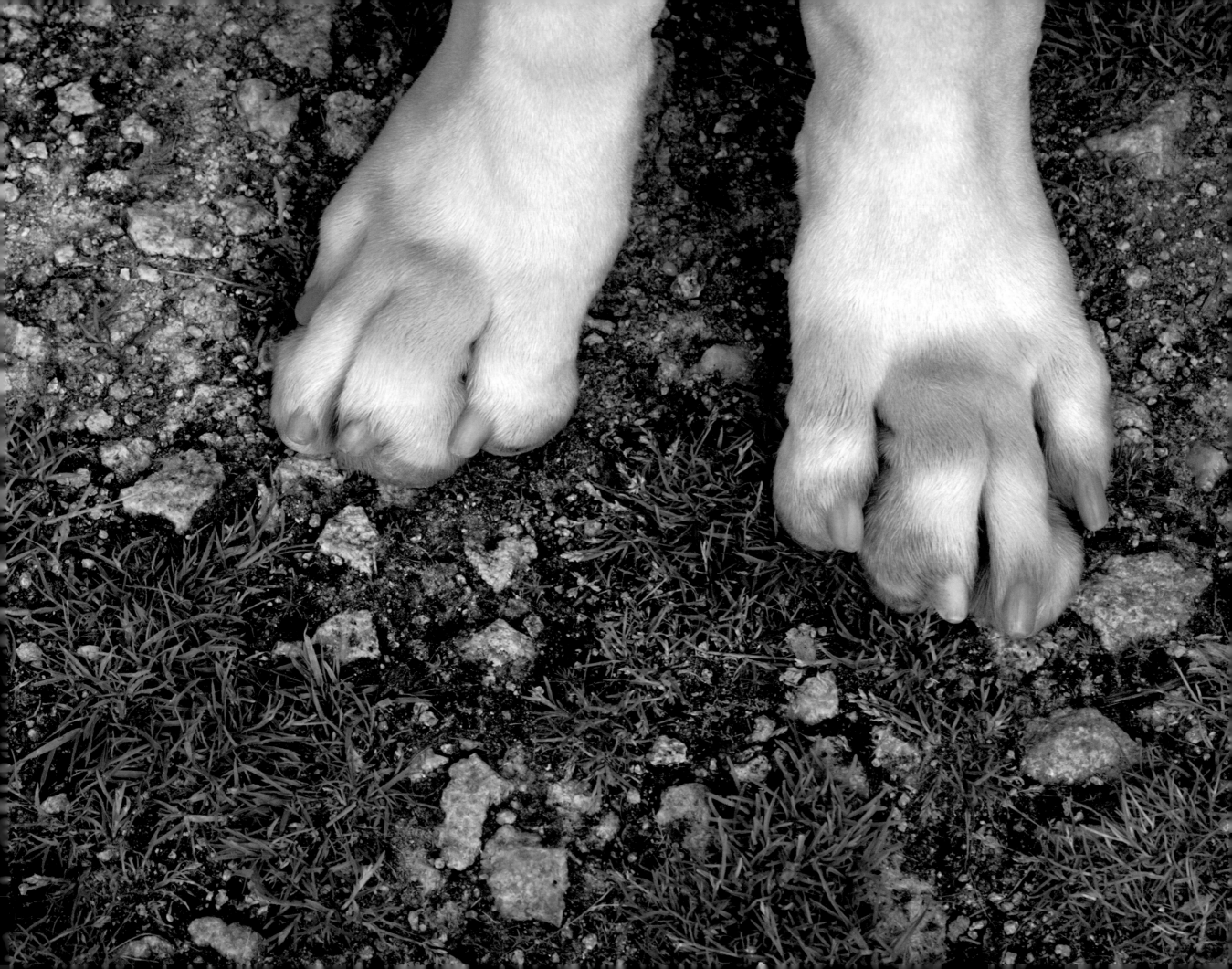

154 Suffolk Punch
Suffolk, UK

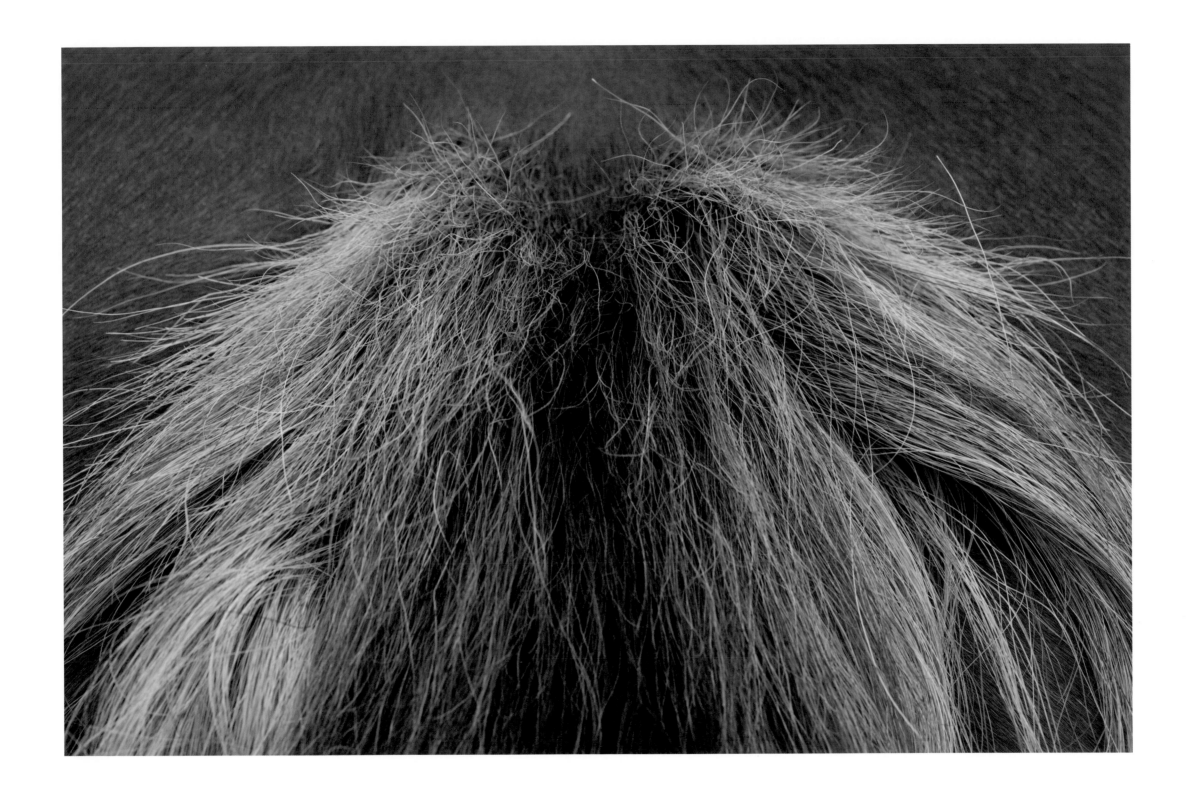

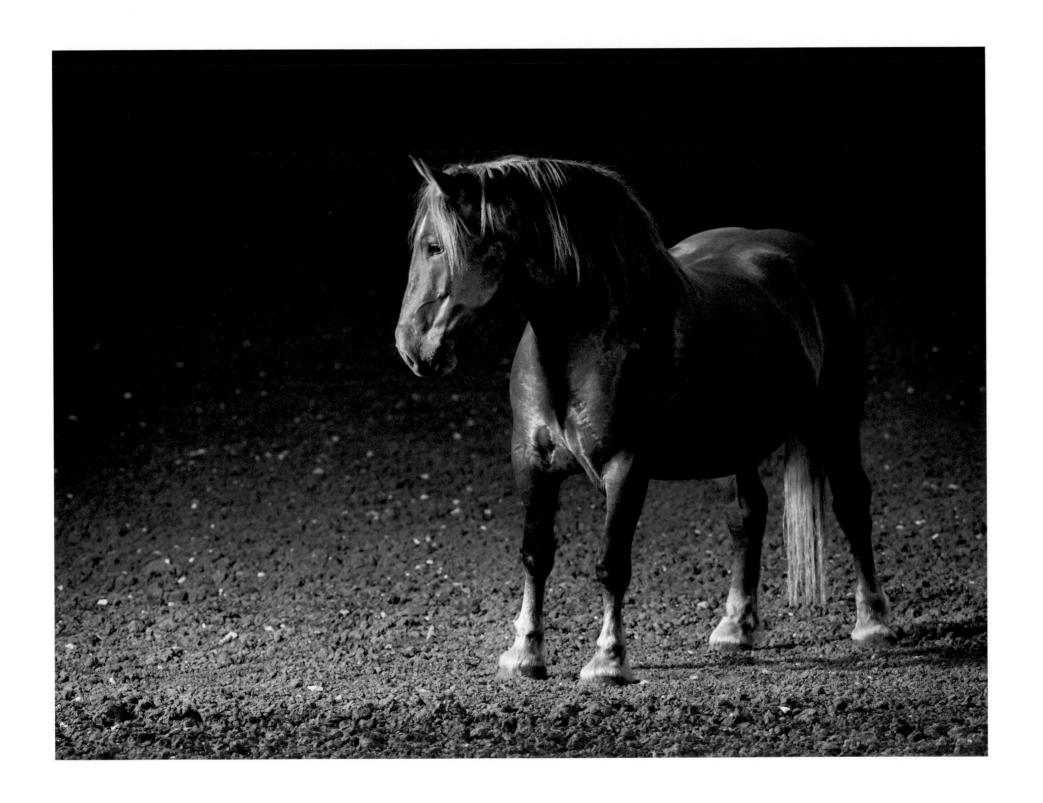

Latvian
Moscow, Russia

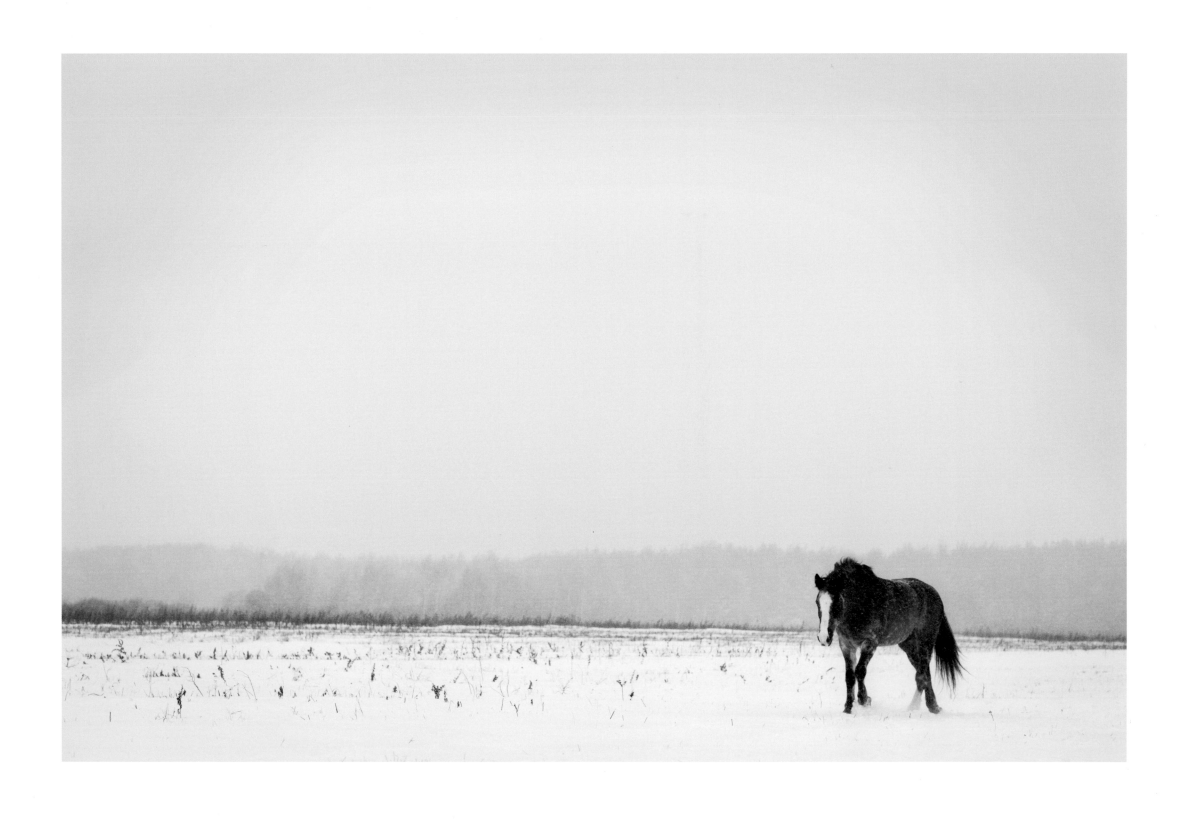

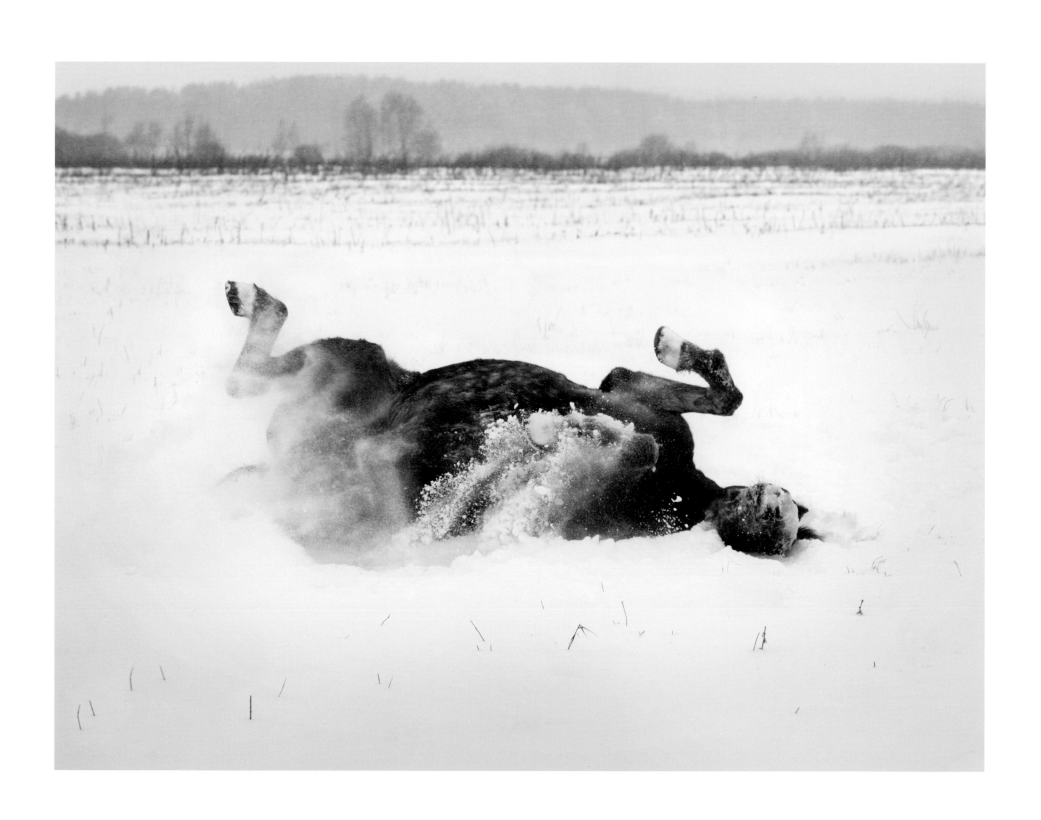

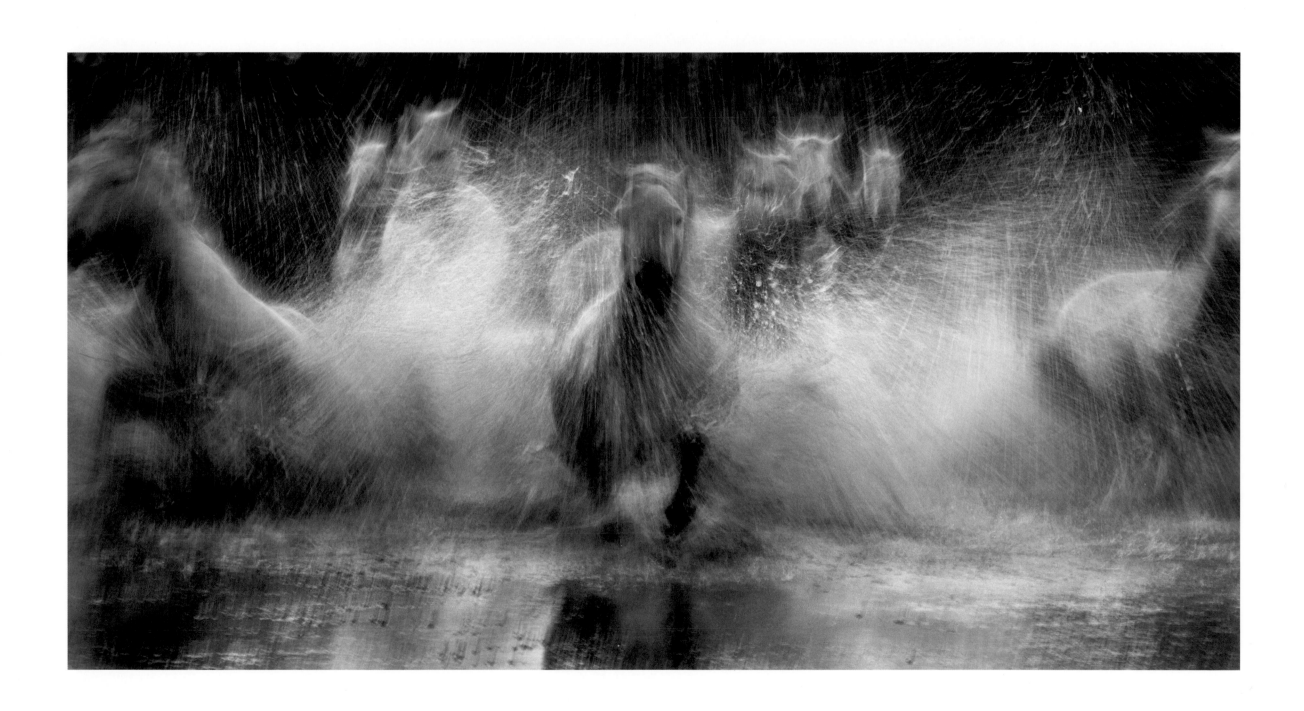

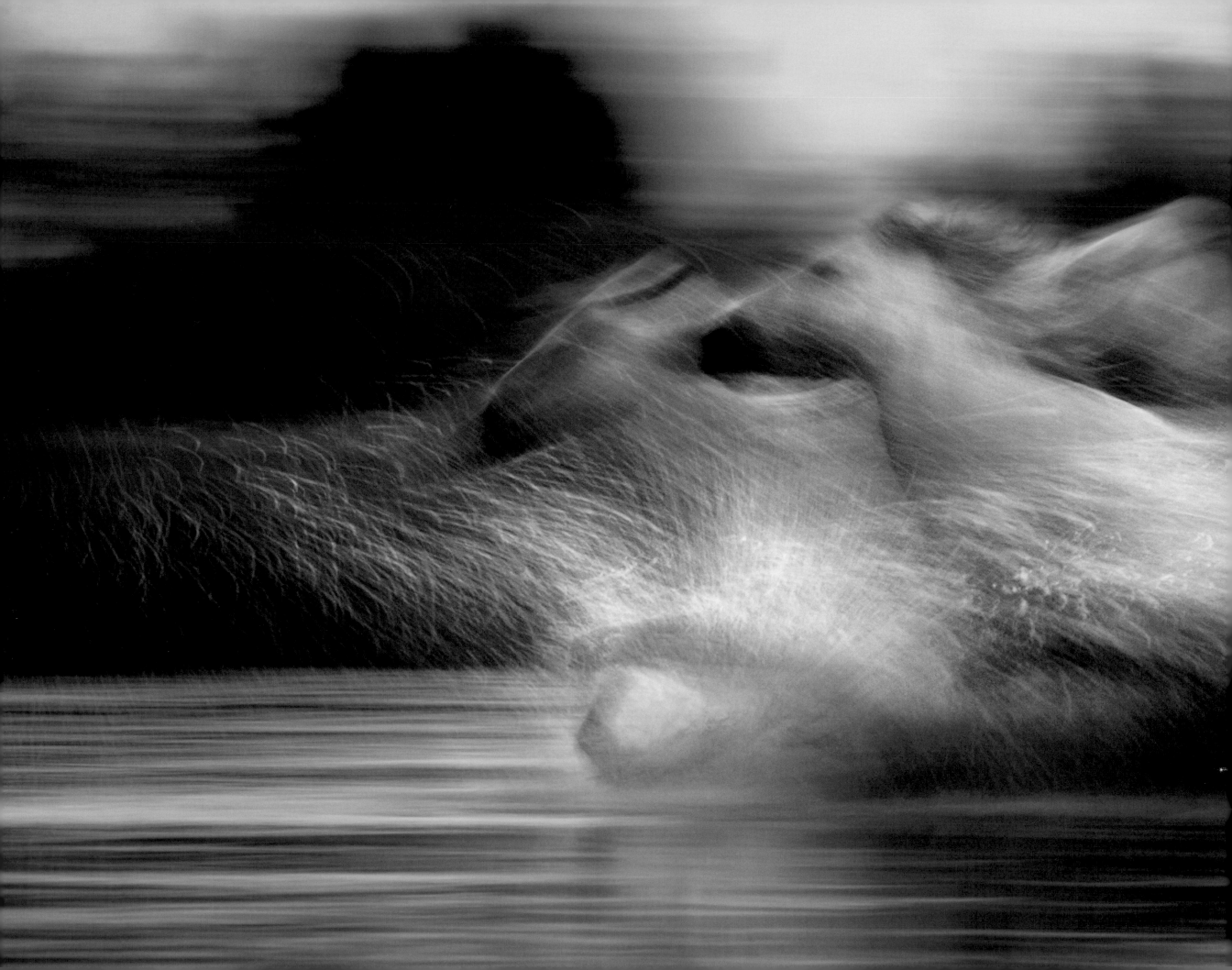

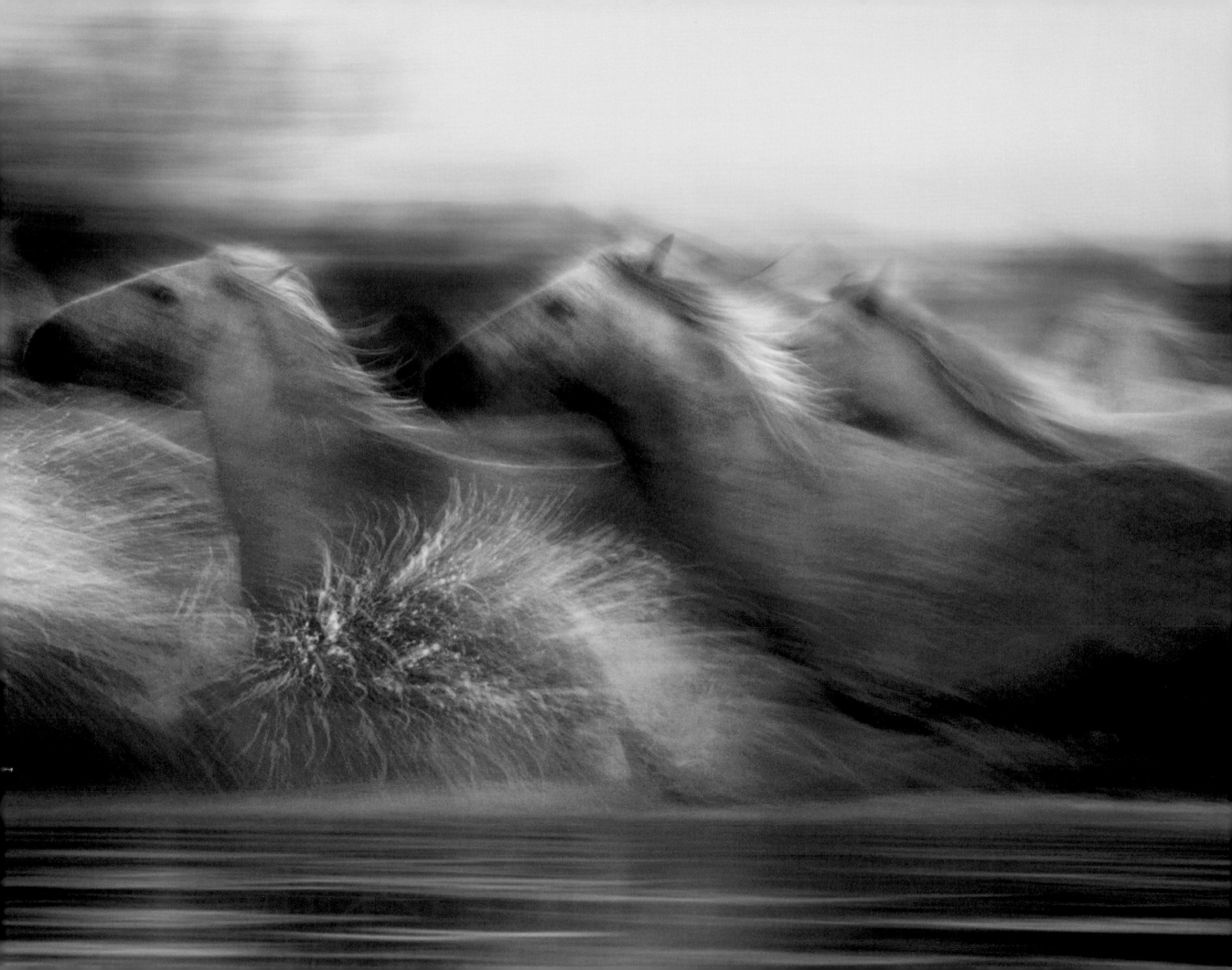

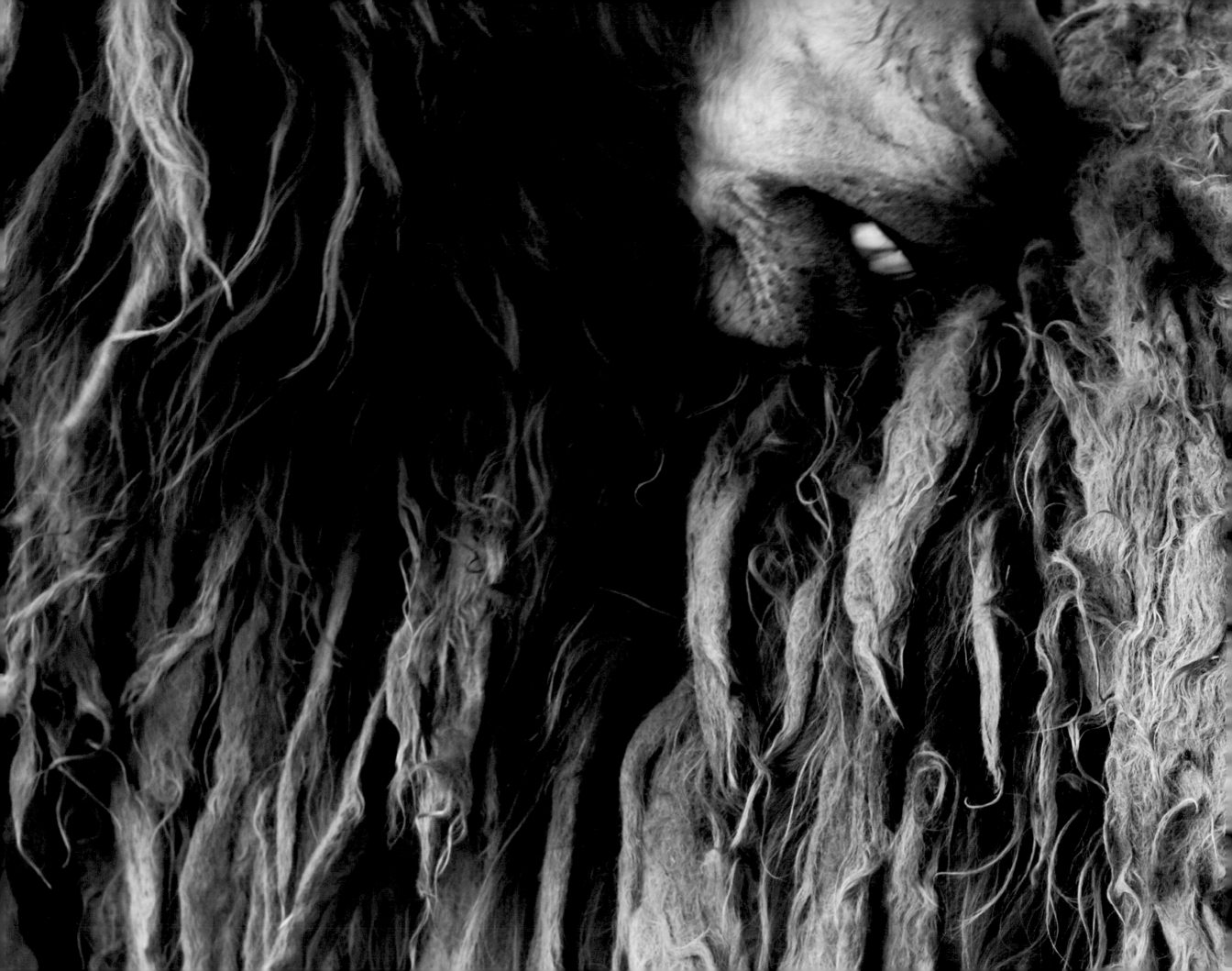

Poitou Donkey
Poitou-Charente, France

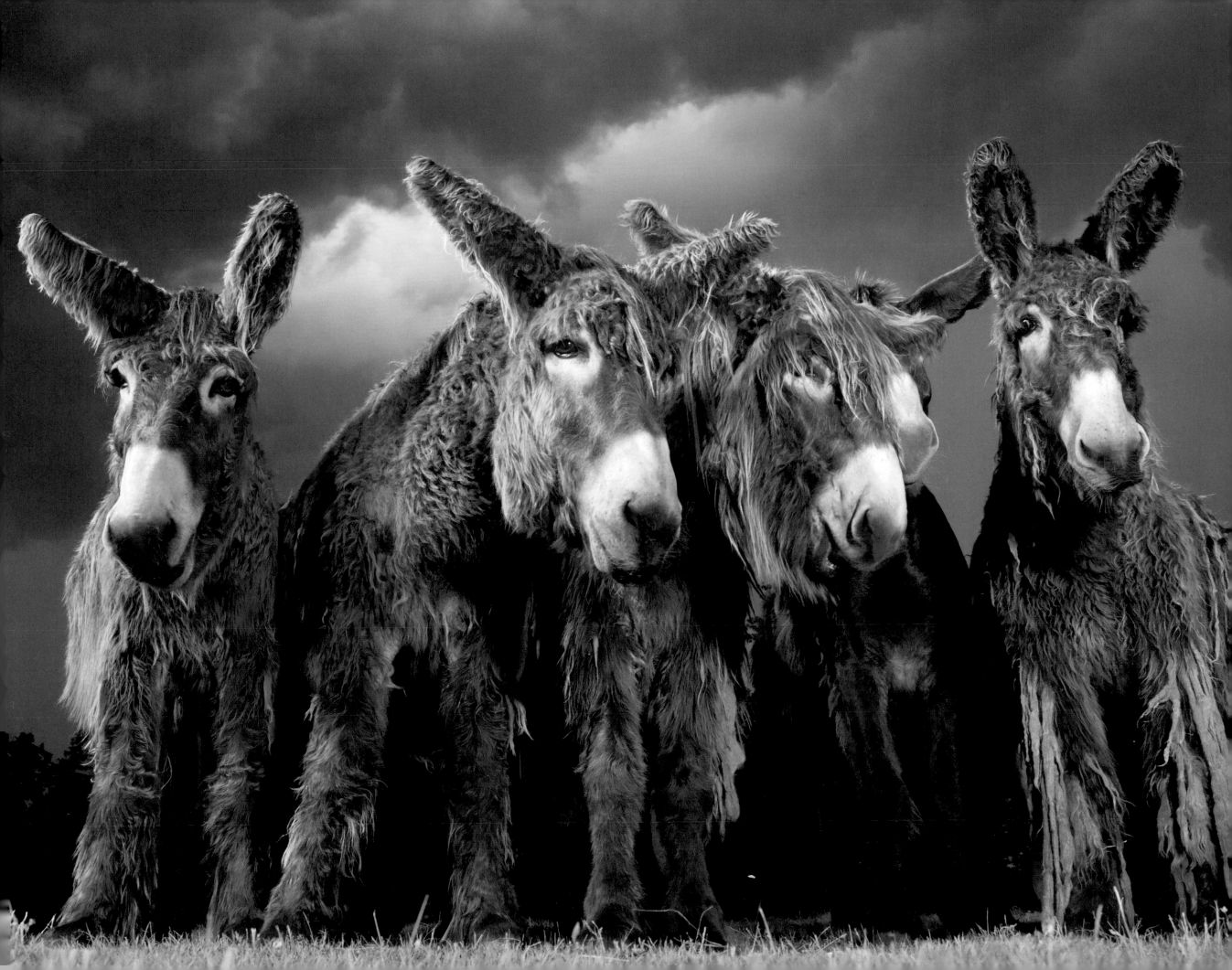

172 Mustang
Northern California, USA

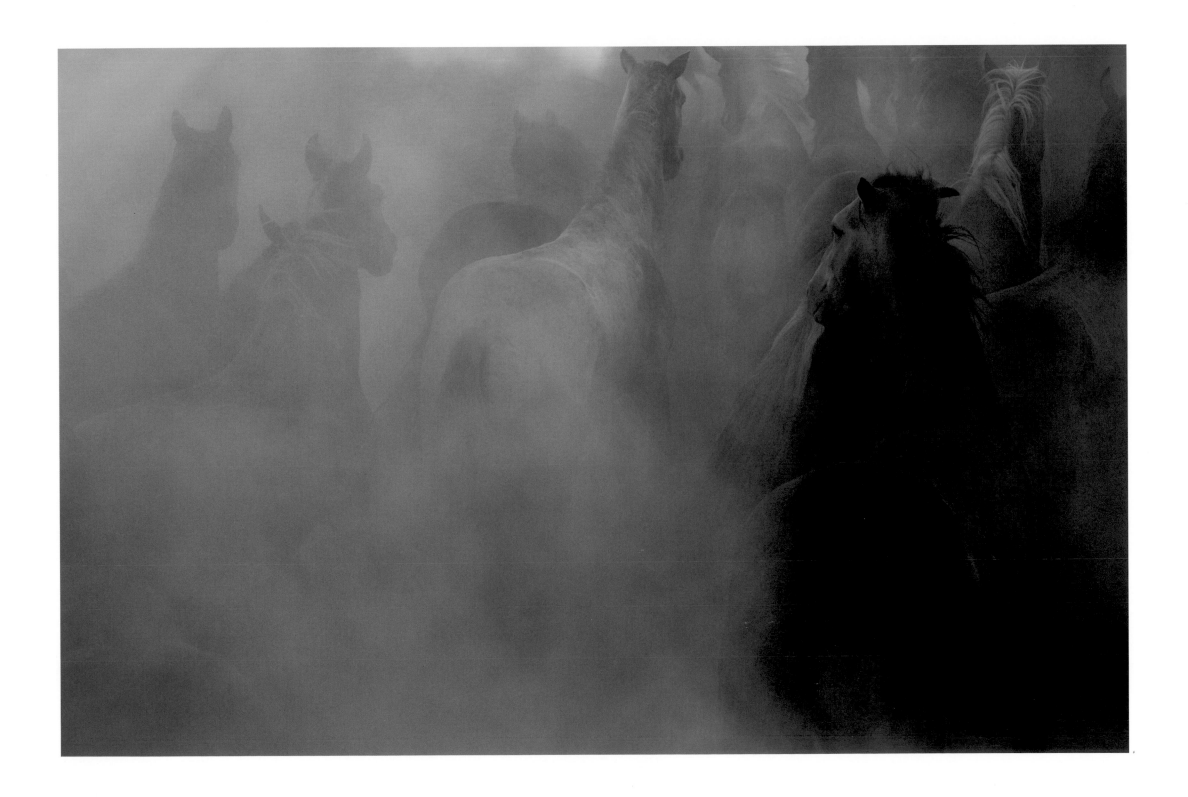

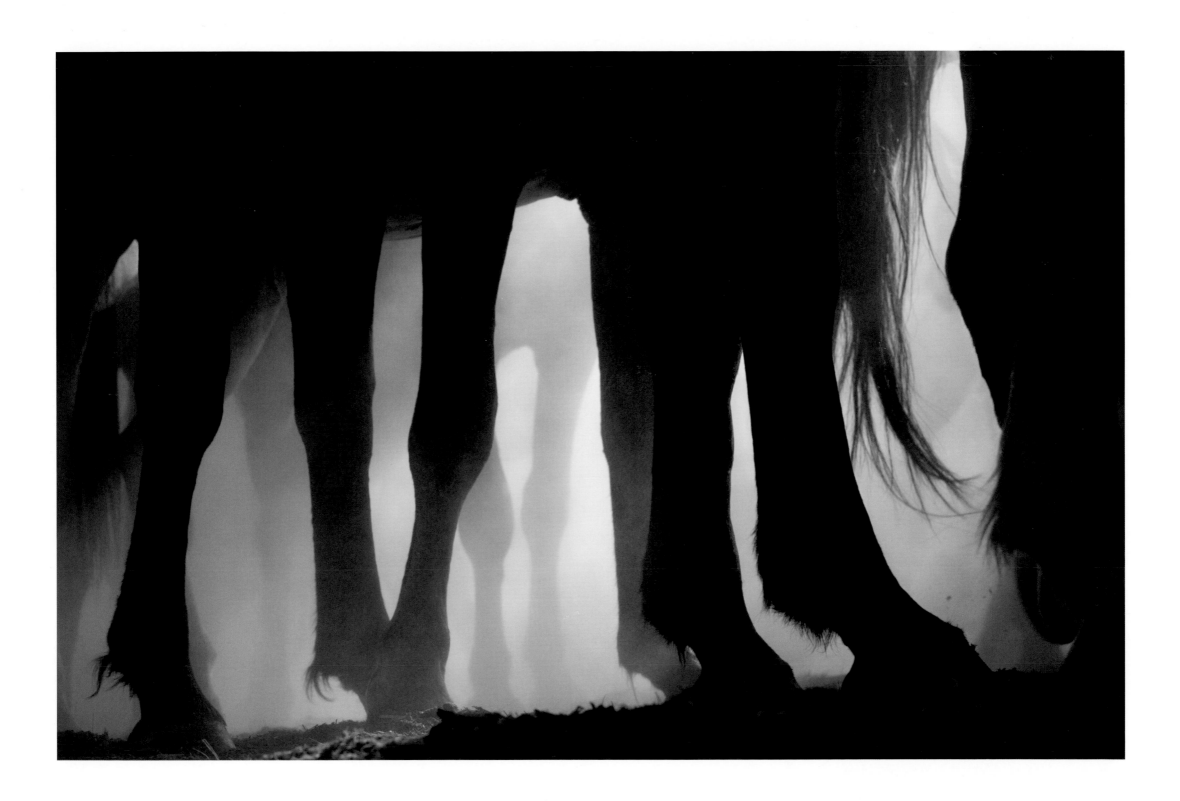

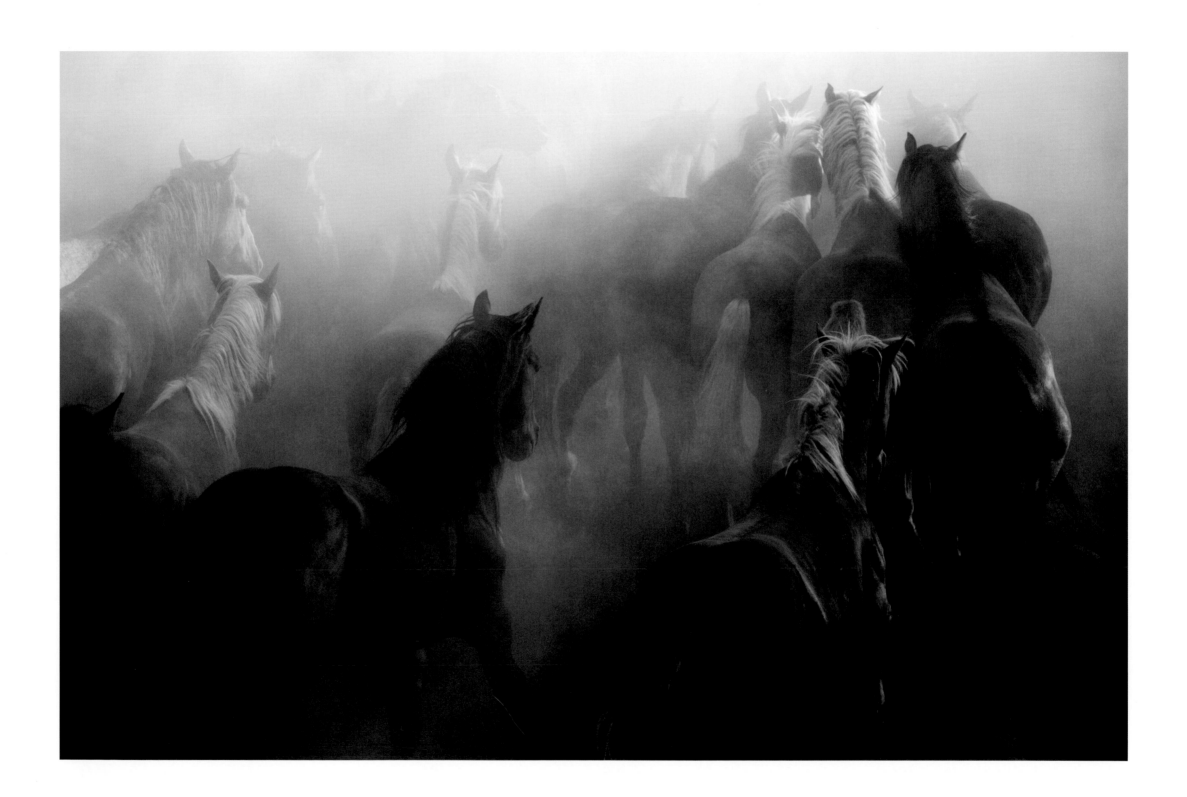

Mustang
Utah, USA

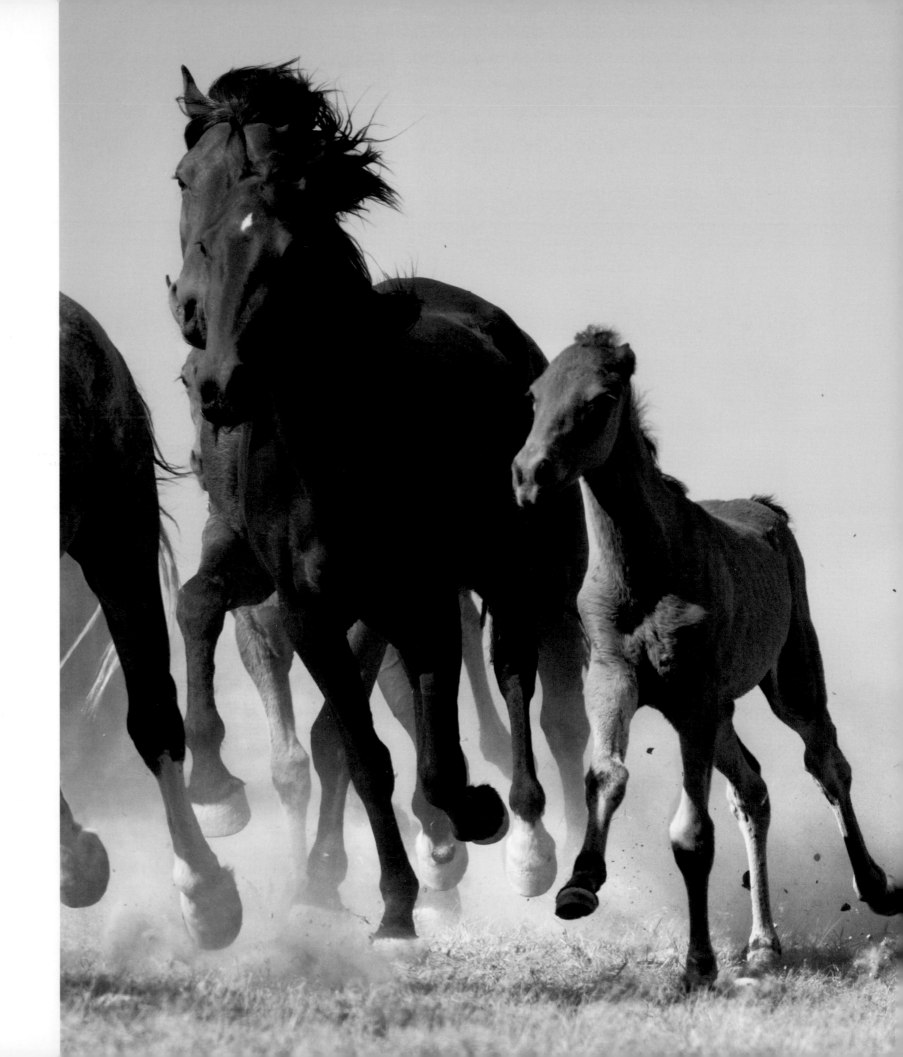

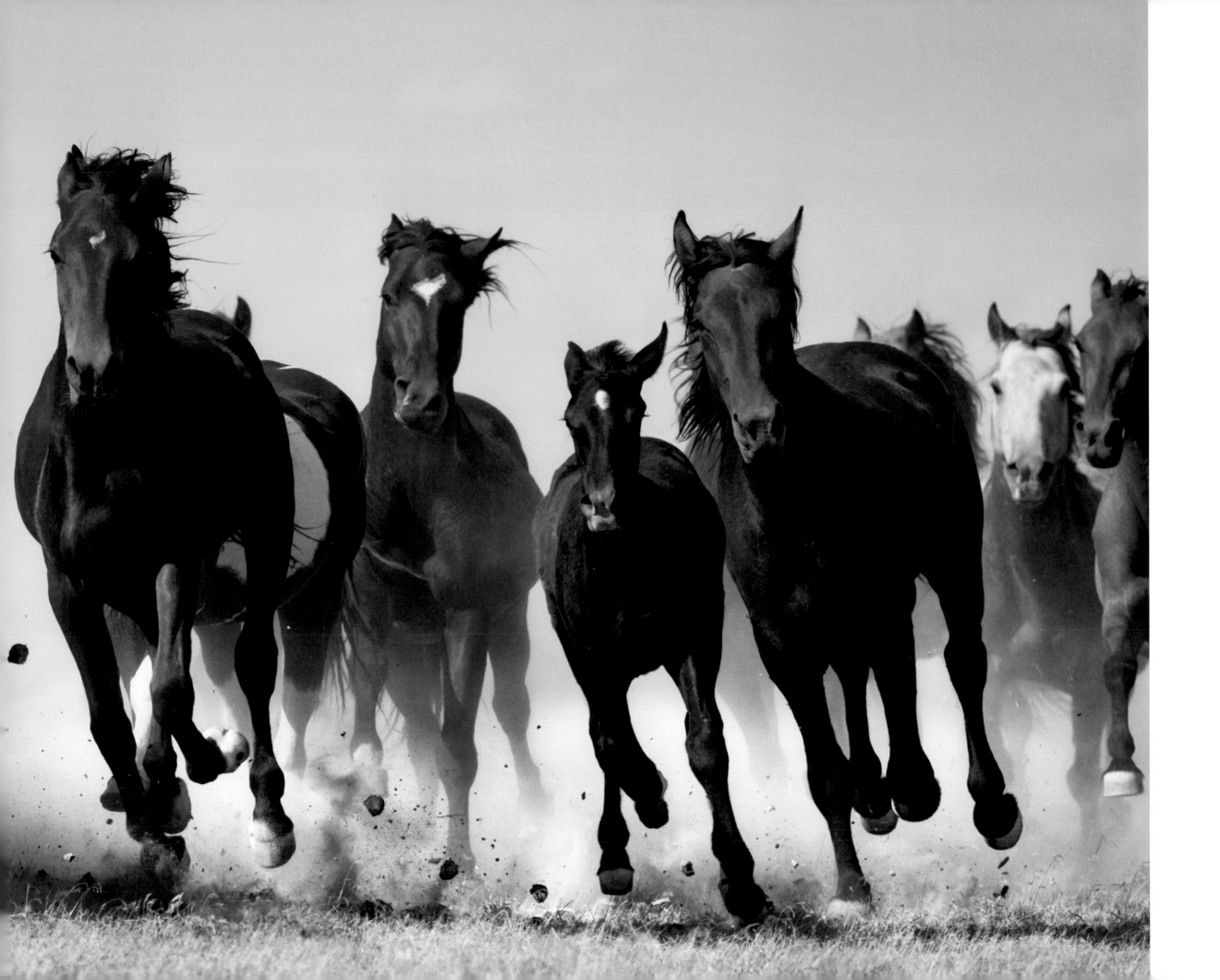

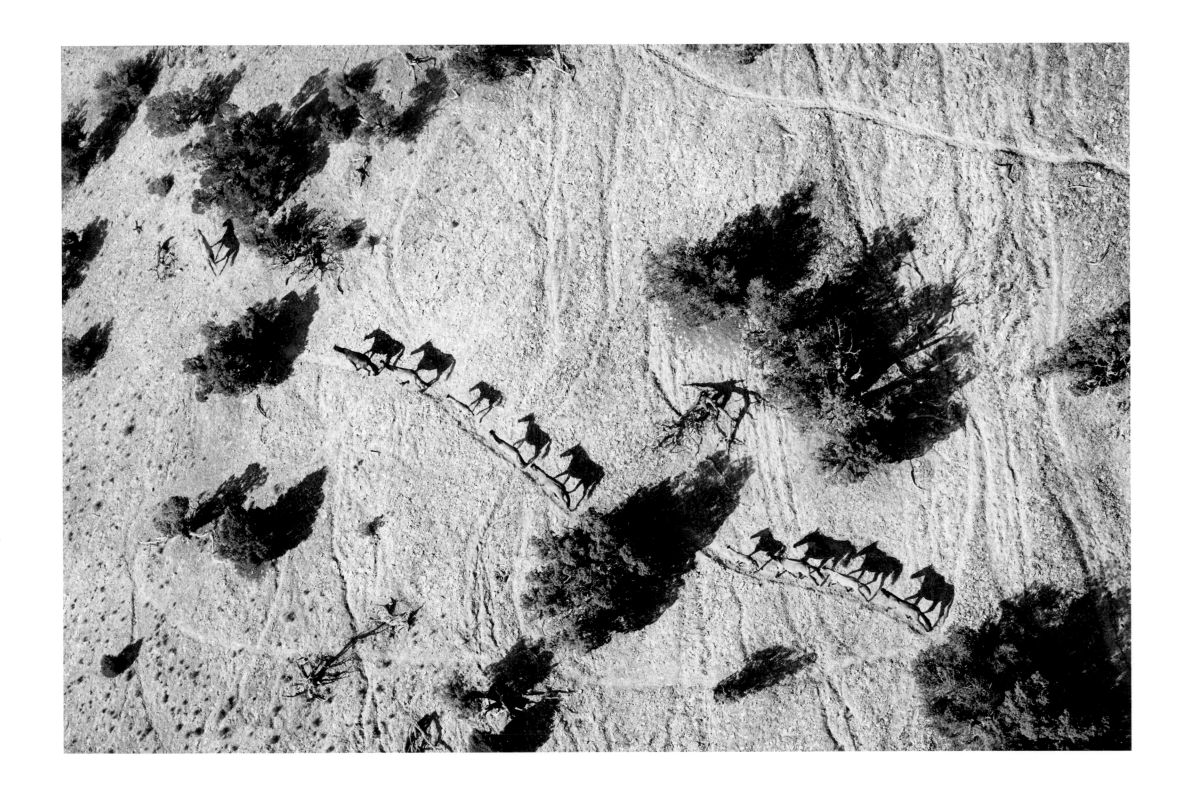

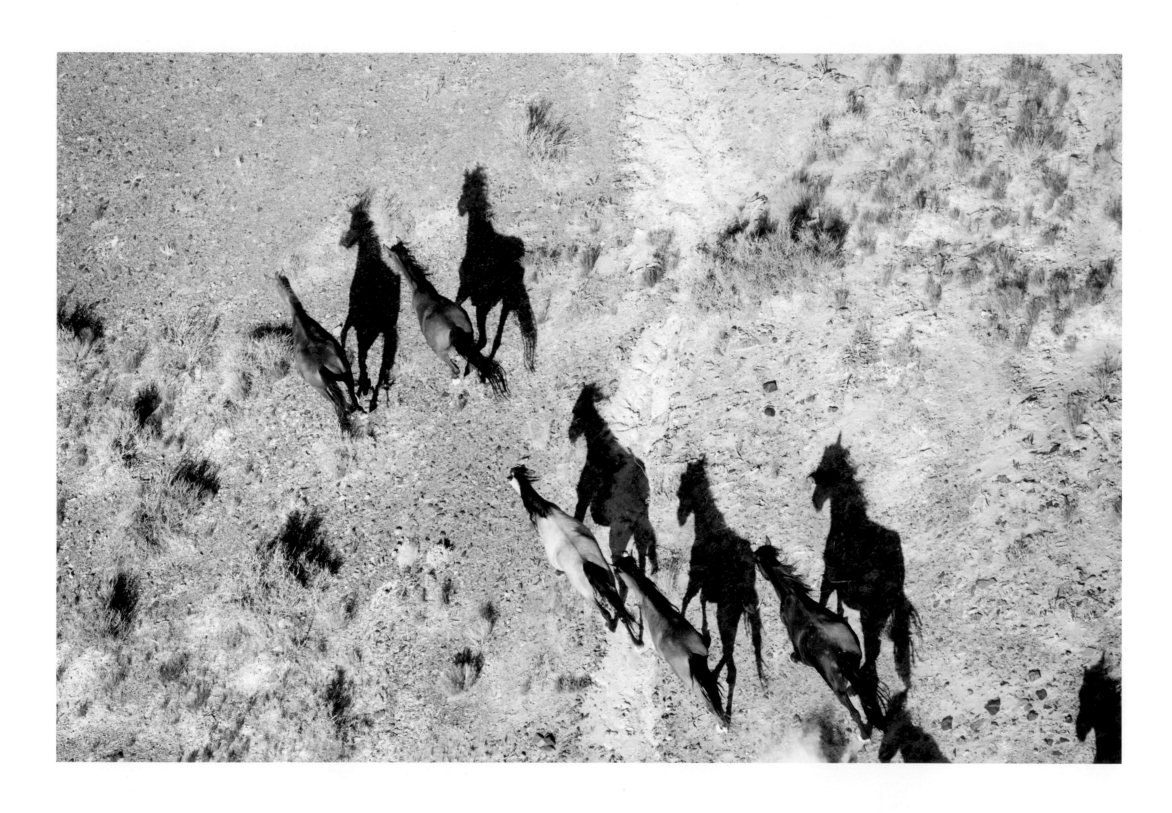

Mustang
Utah, USA

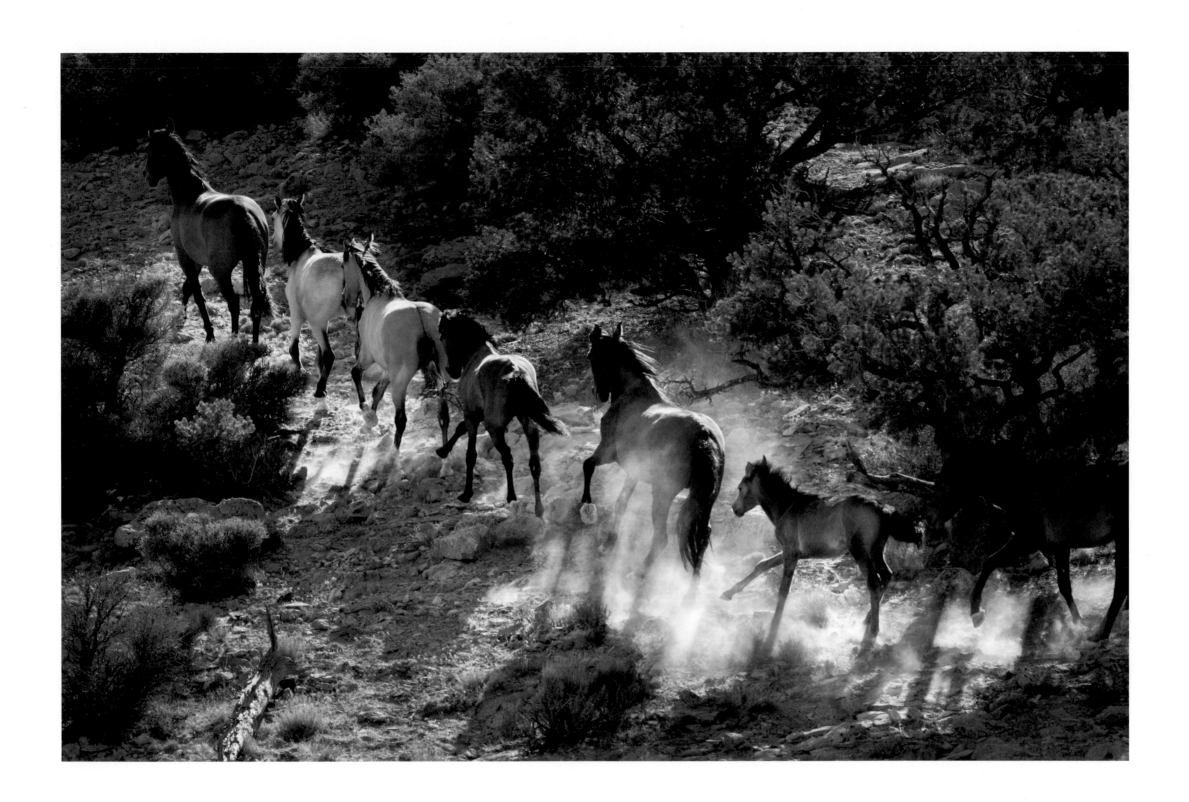

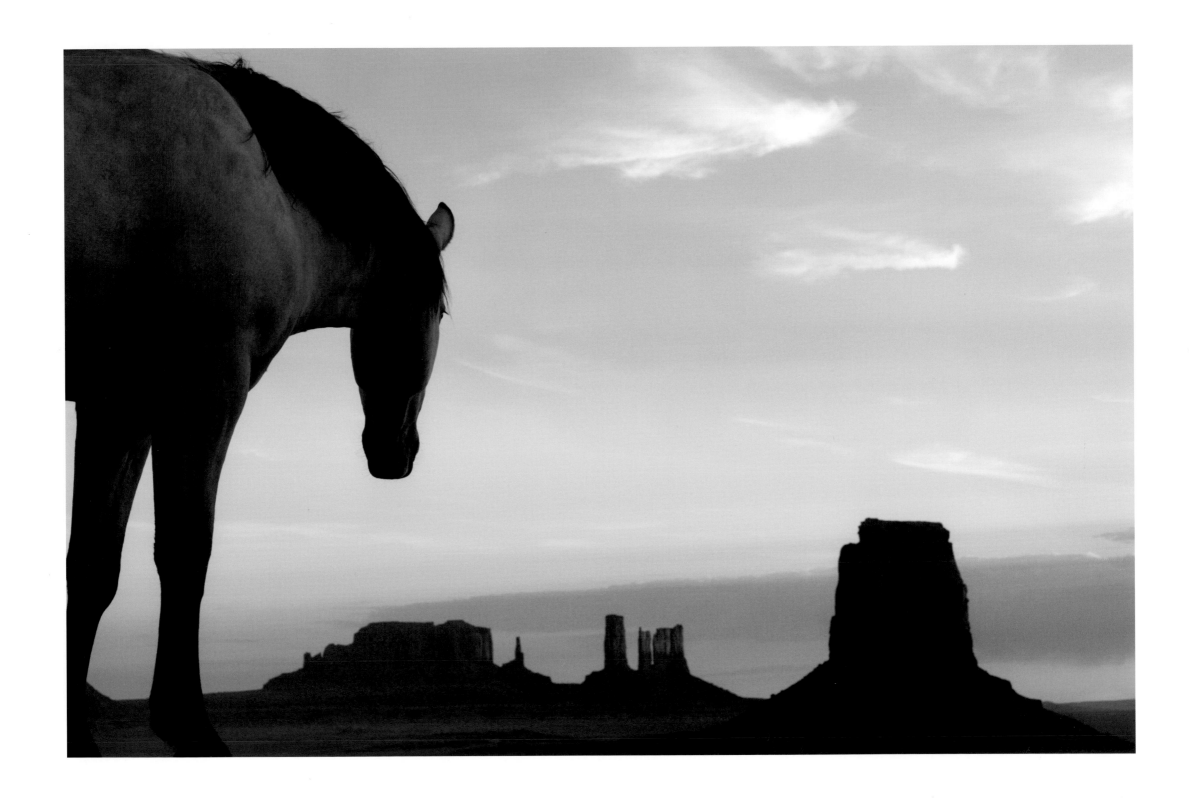

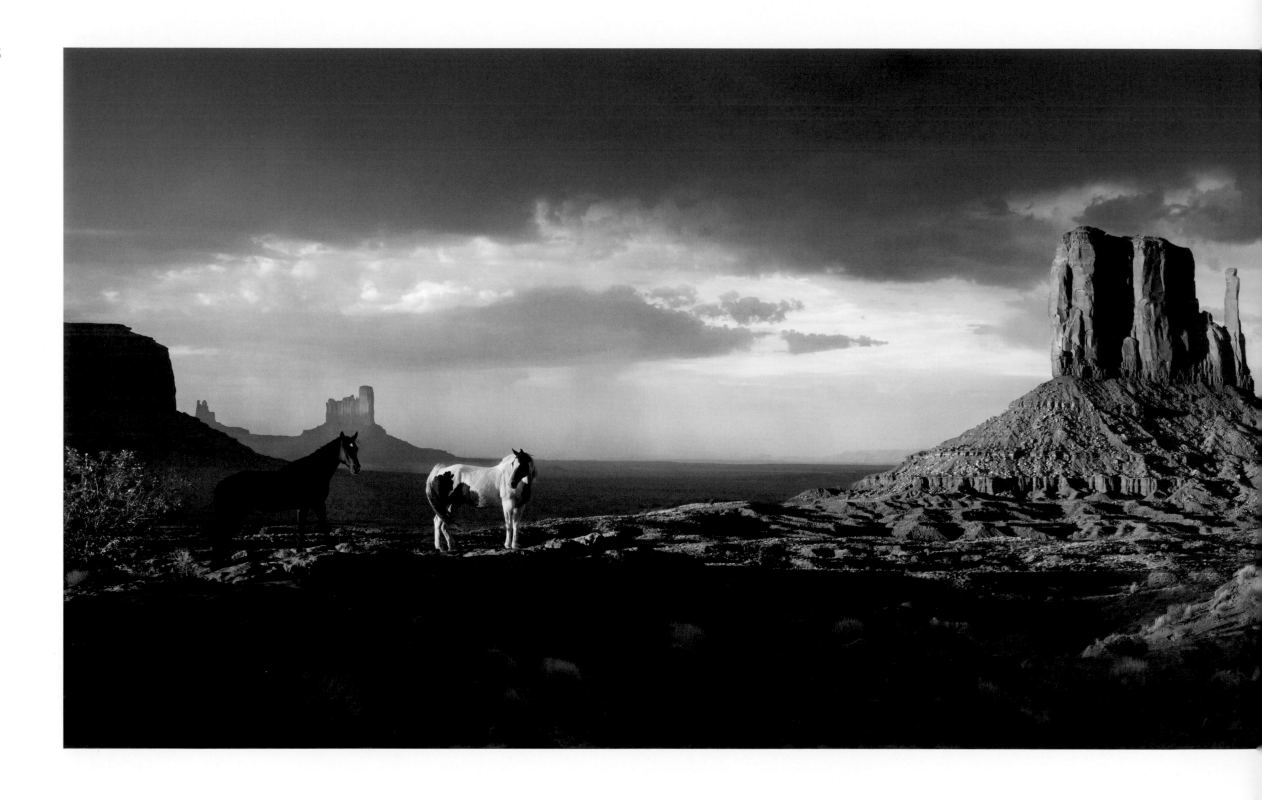

Mustang
Monument Valley, USA

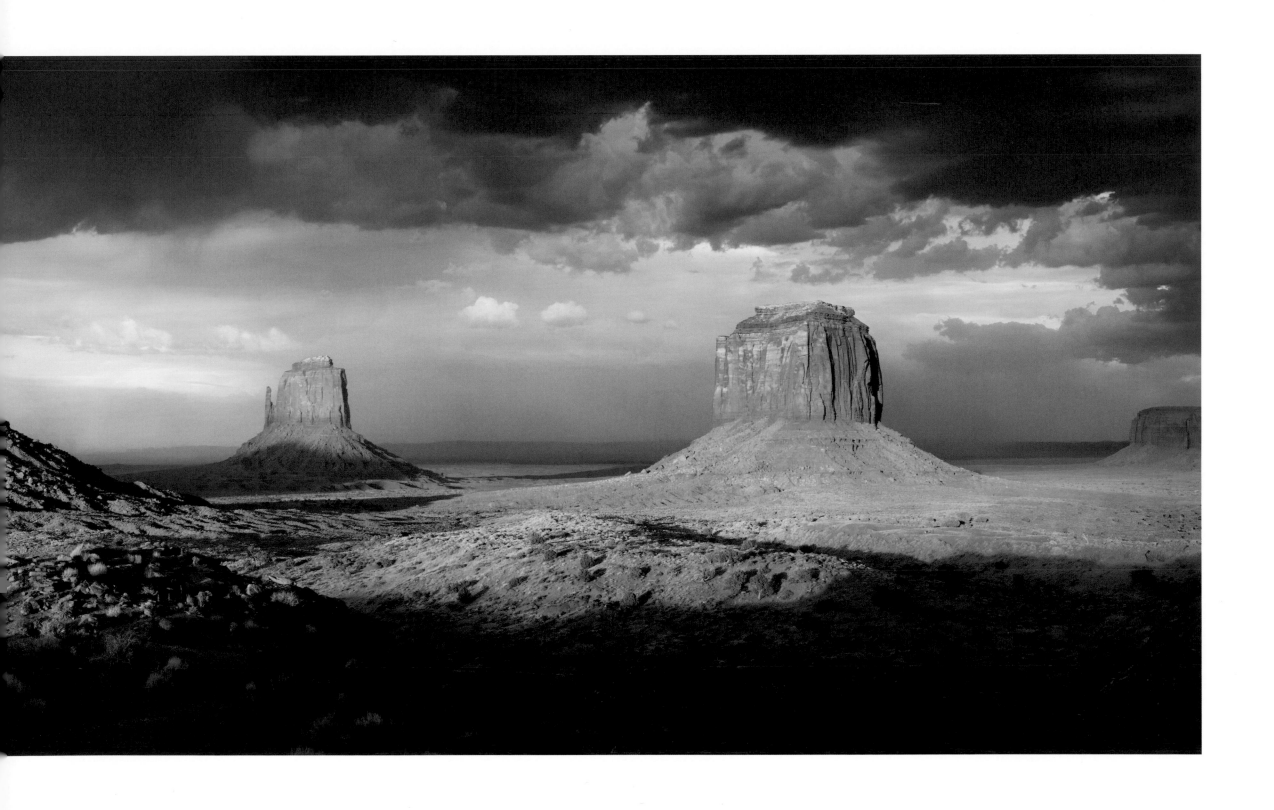

Mustang
Monument Valley, USA

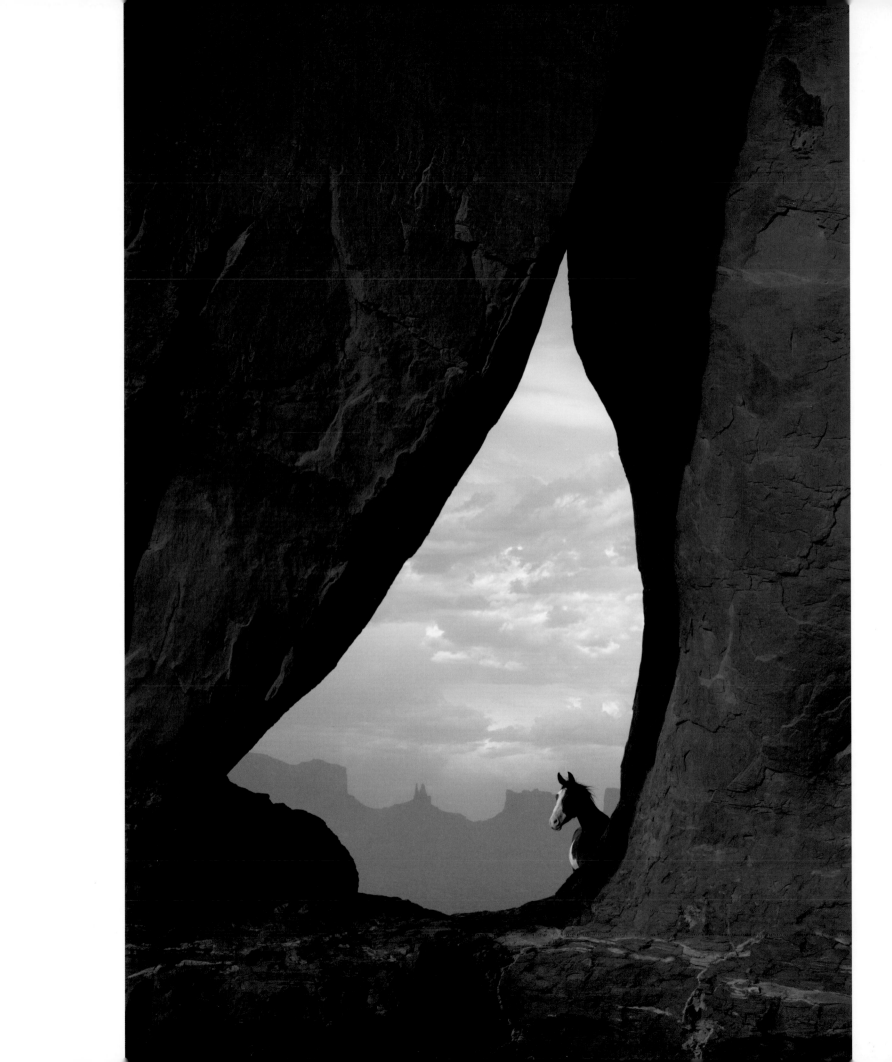

190 Arabian
 Abu Dhabi, UAE

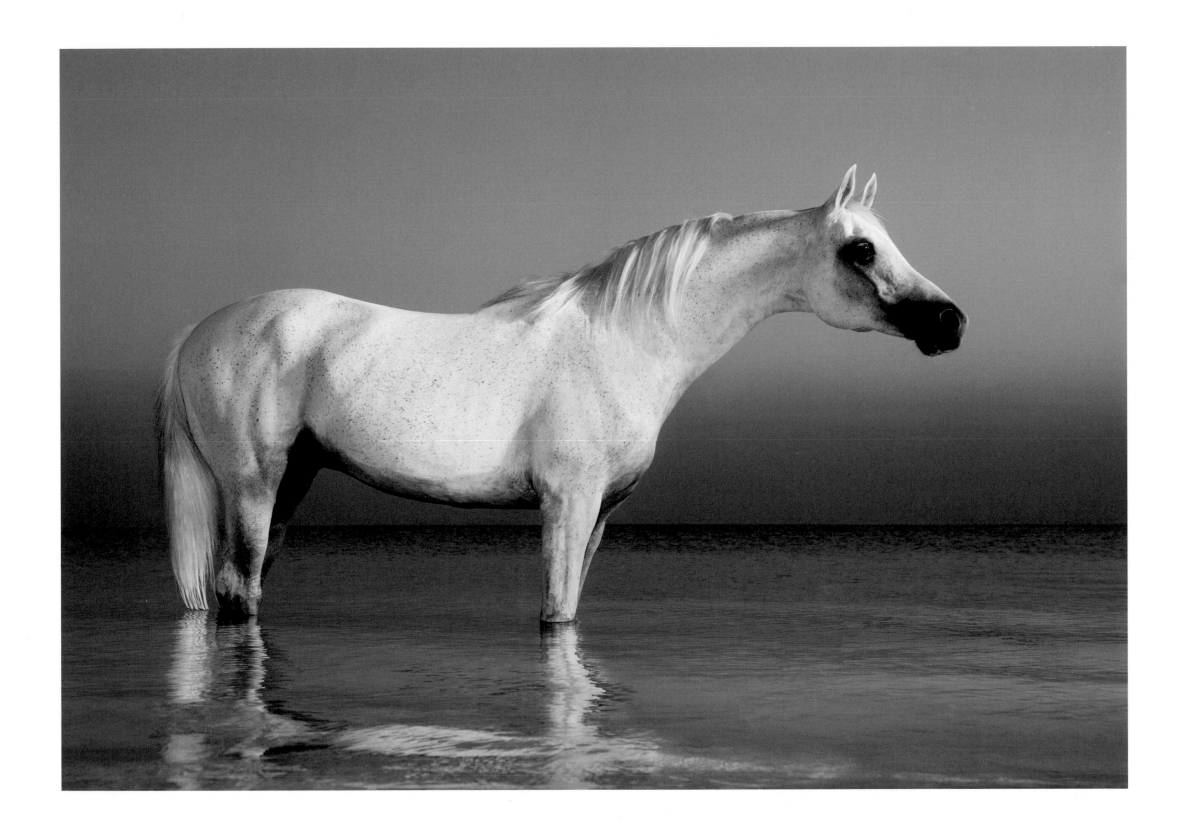

192 Arabian
Abu Dhabi, UAE

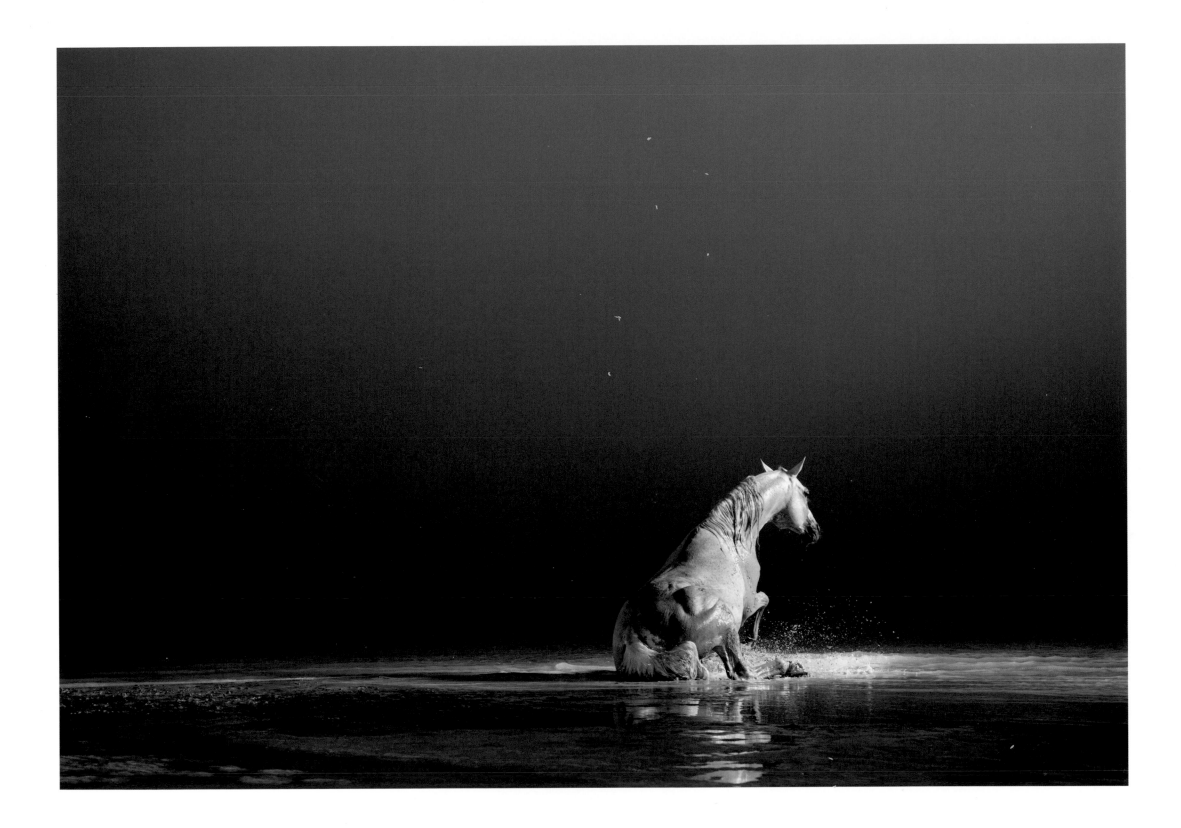

194 Arabian
Abu Dhabi, UAE

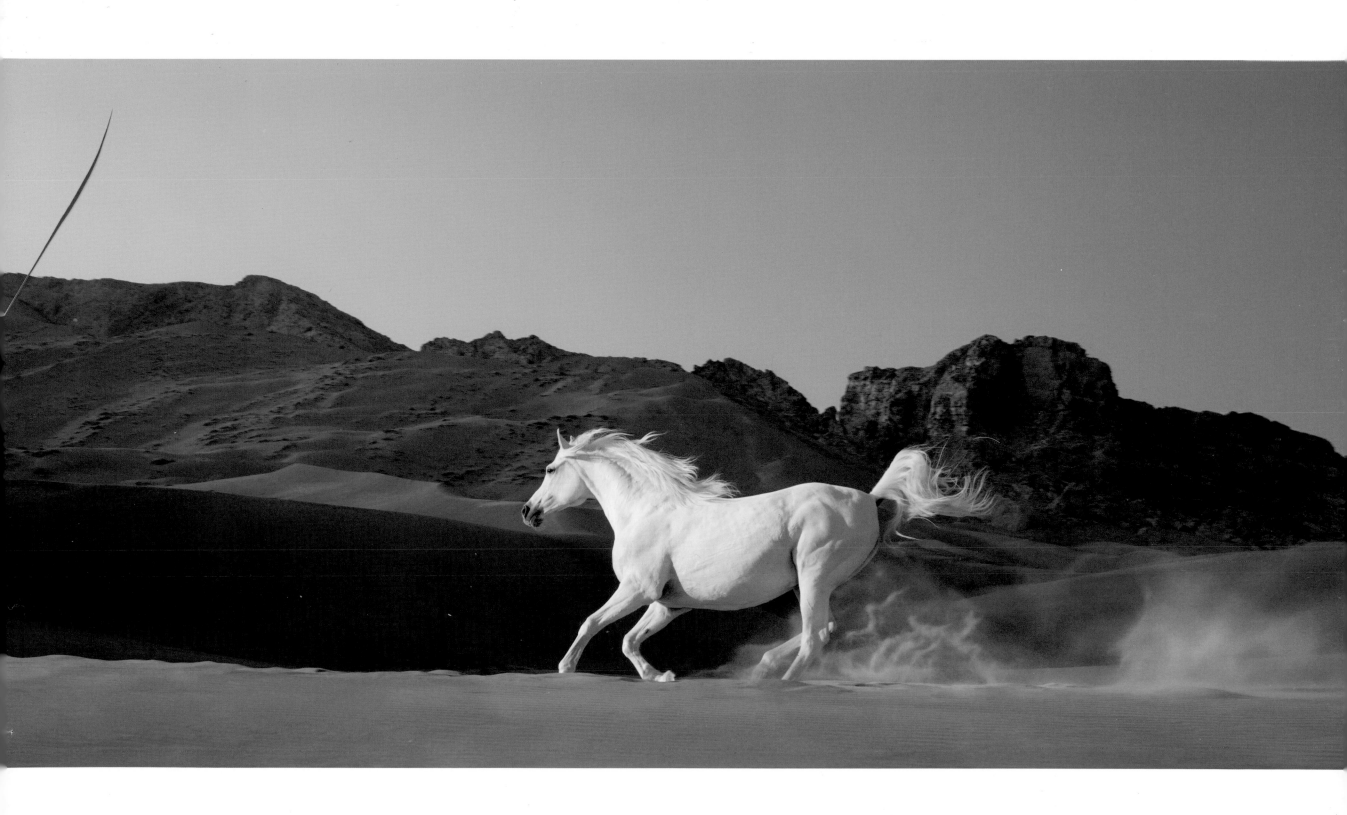

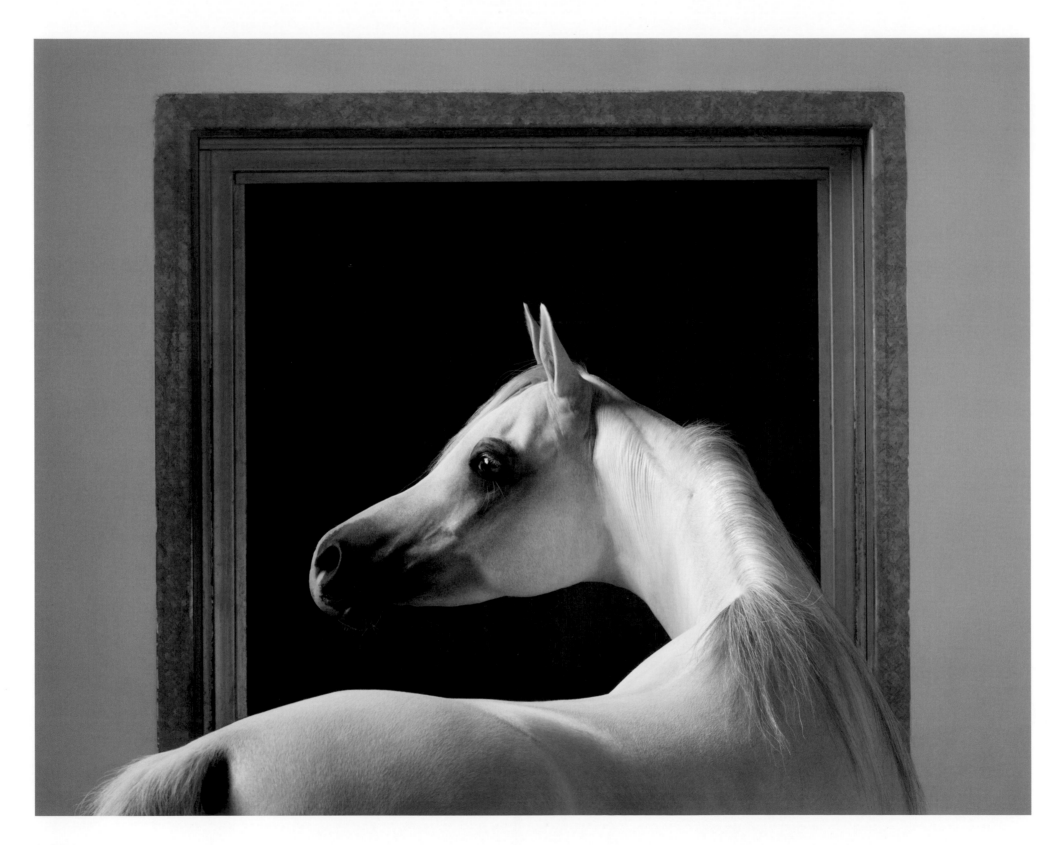

Arabian
Ajman, UAE

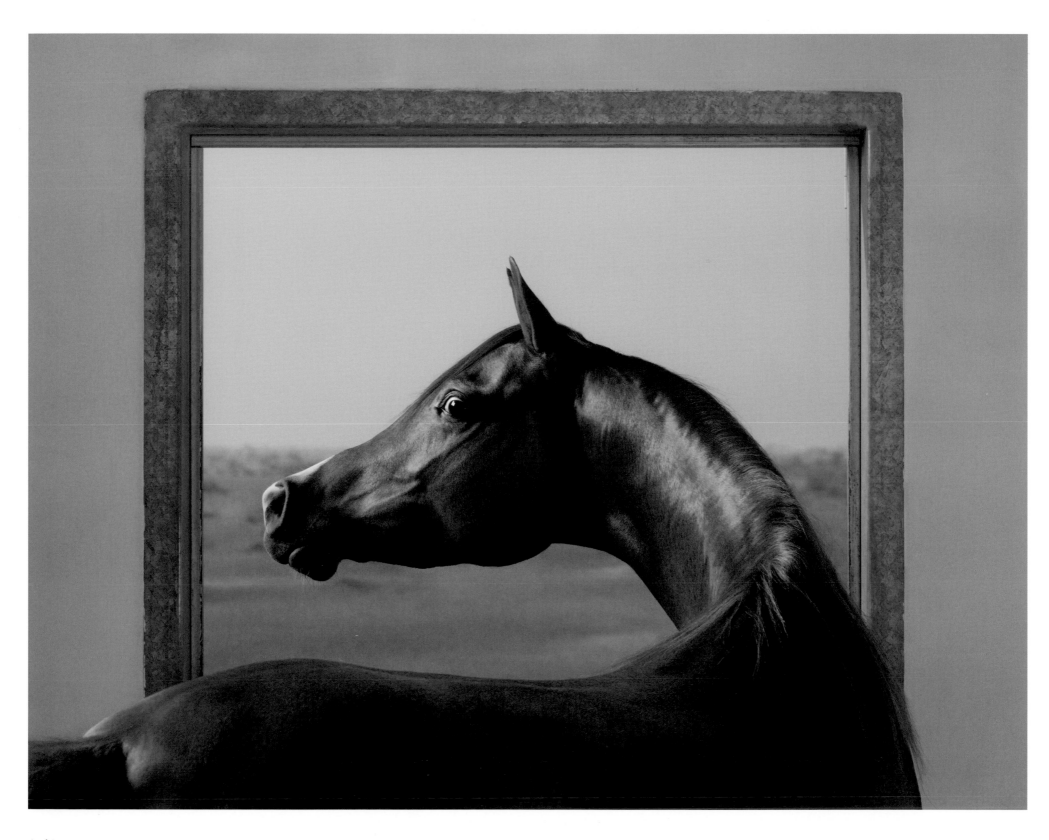

Arabian
Ajman, UAE

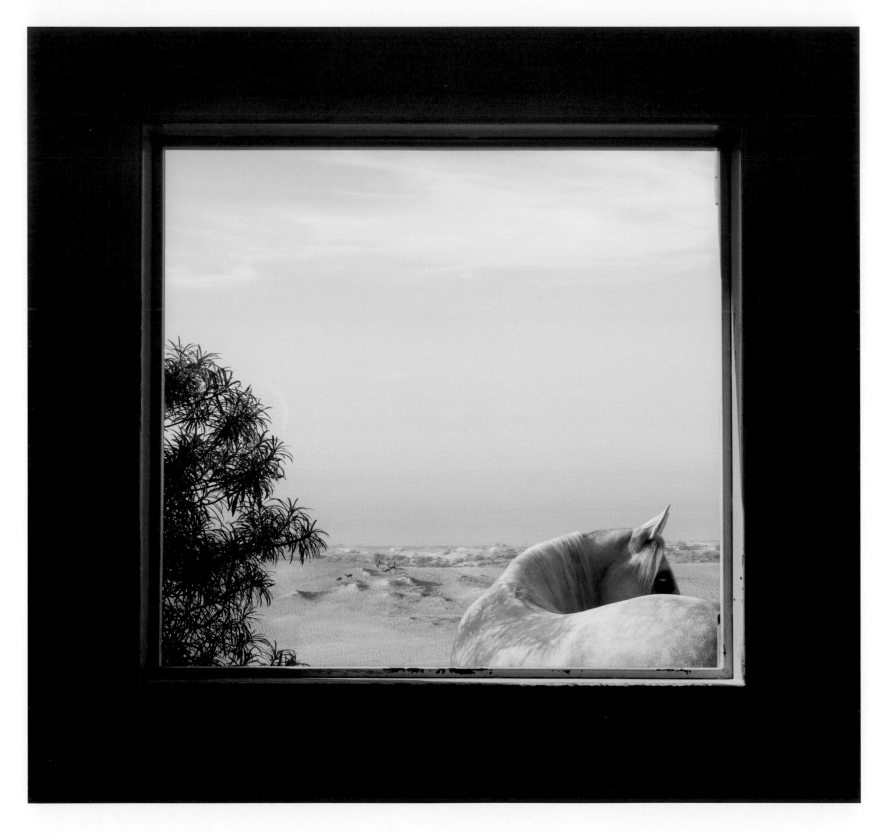

Arabian
Ajman, UAE

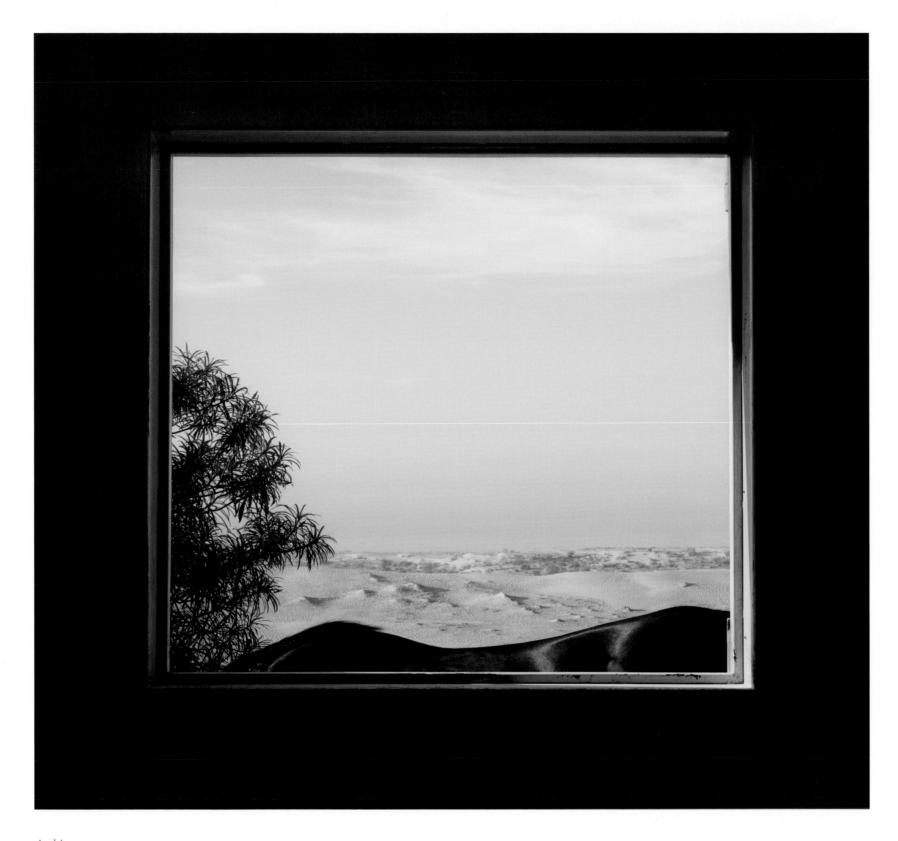

Arabian
Ajman, UAE

Thoroughbred
Berkshire, UK

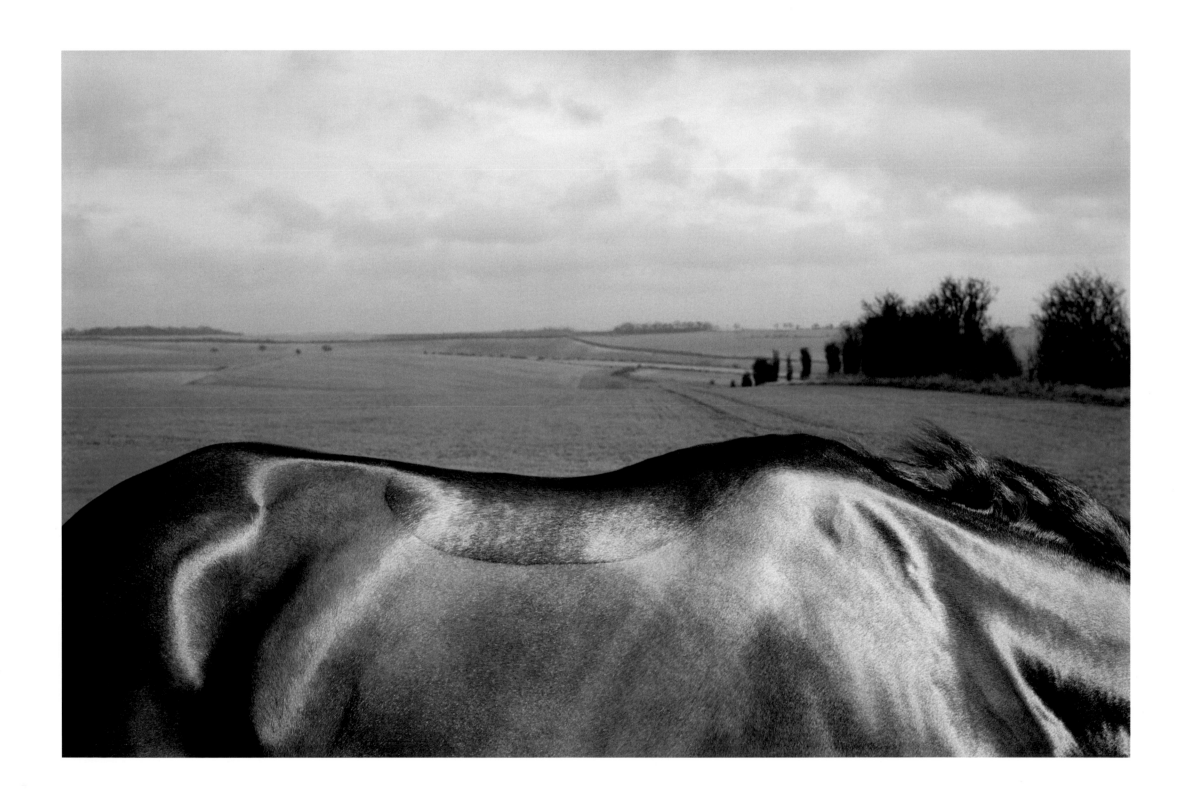

204 Arabian
Dubai, UAE

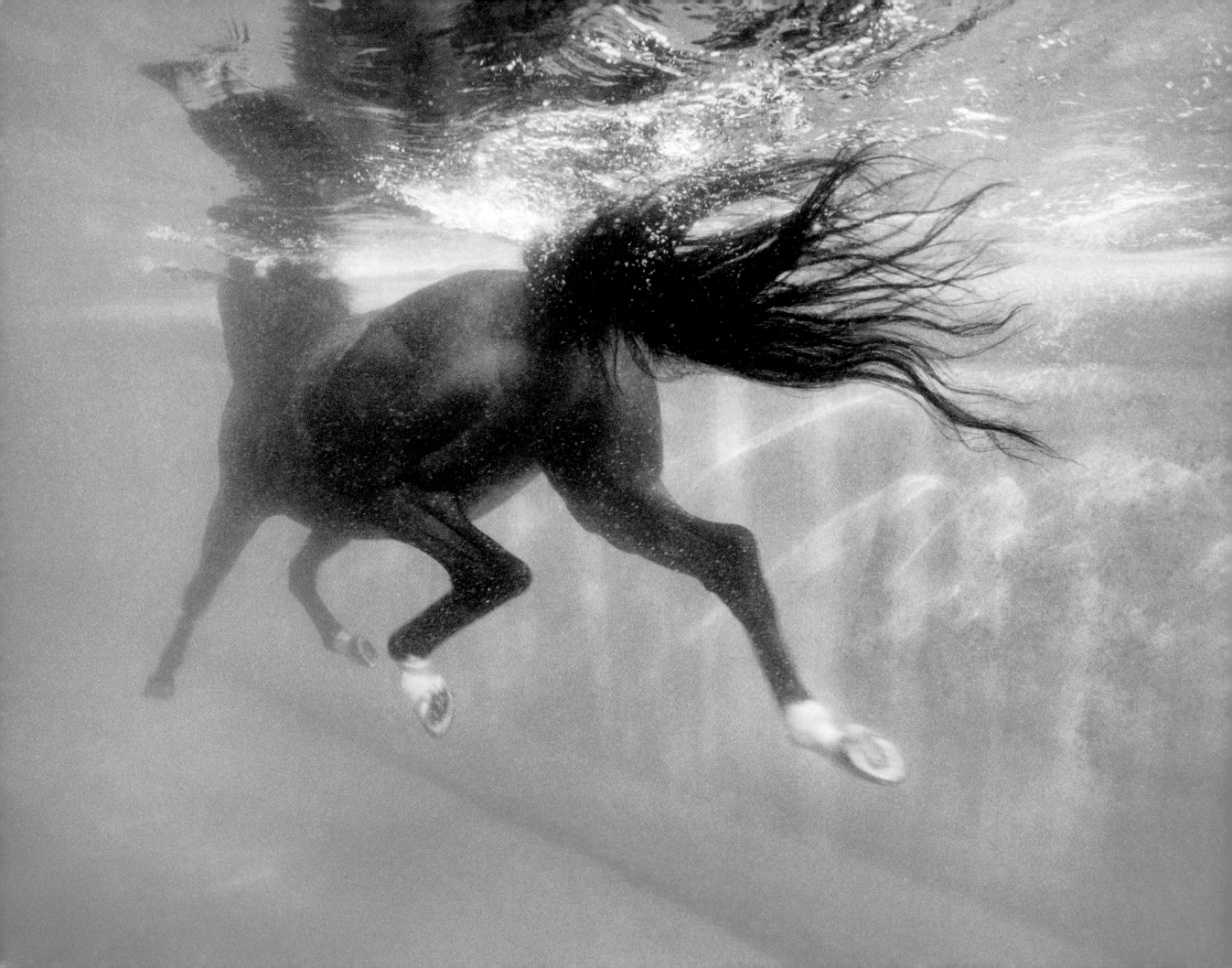

208 Thoroughbred
 Dubai, UAE

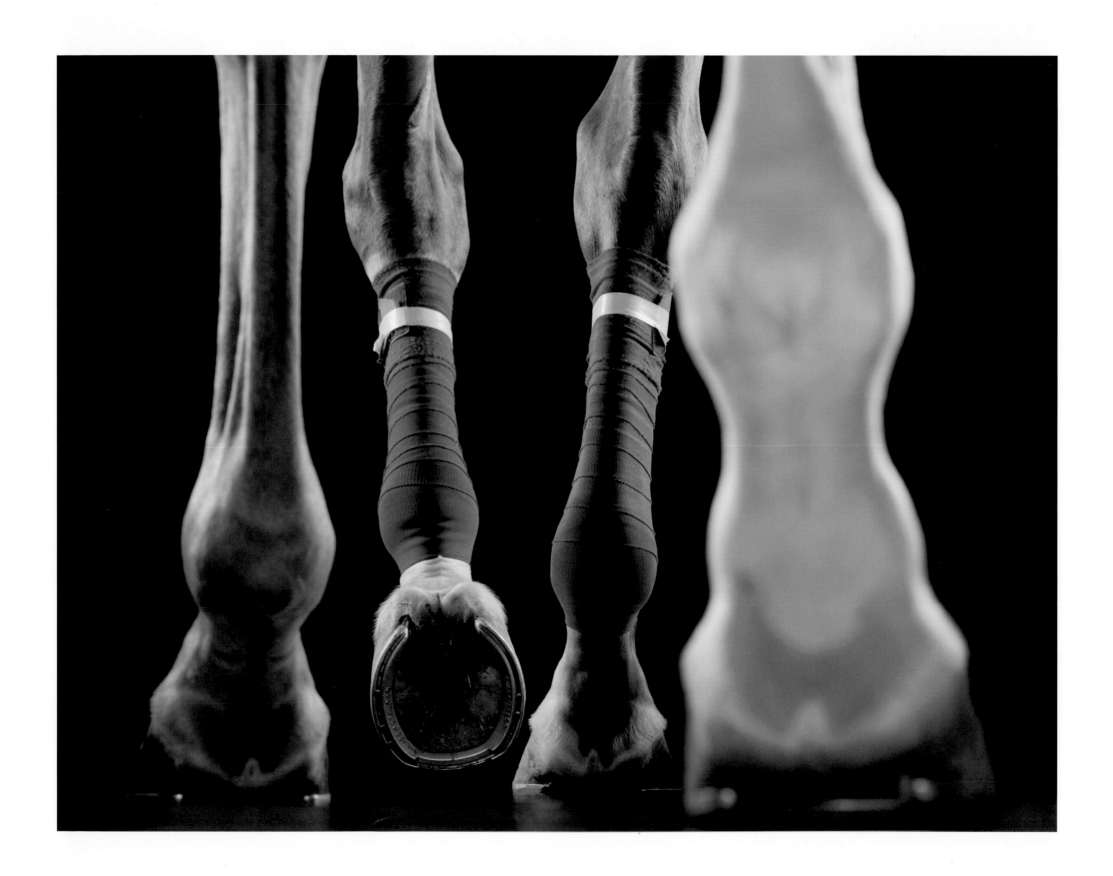

Arabian
Abu Dhabi, UAE

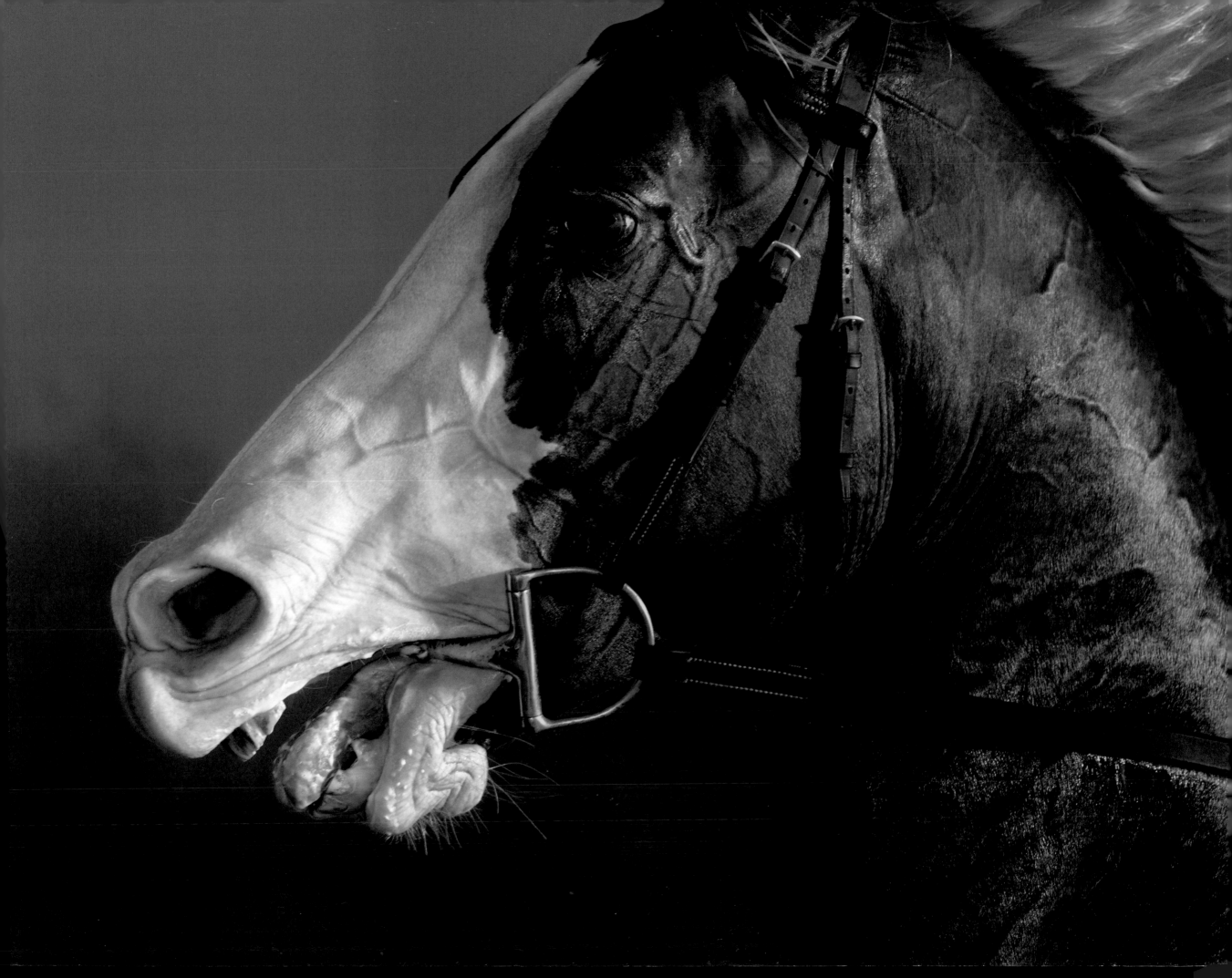

The domestication and selective breeding of the horse dates to before 5,000 BCE. Through increasing control over the genetic mix, we shaped what we see in these pages, what we have used, and what we believe makes for a better horse. So it came as no small surprise to read that, at the end of 2007, scientists at the University of Edinburgh reported that the correlation between careful breeding and winning on the track is no more than ten percent. They had studied the performance of 4,500 Thoroughbred foals born between 1922 and 2003 and came to the following conclusion: Nurture is more important than Nature. Have we been on the wrong track for 7,000 years?

Of course, one percent, let alone ten percent, is enough to differentiate between winners and losers. In this final section we go on a journey beyond the horse to explore what humanity does to shape and see the animal. I've looked into the lengths to which we go to adapt and perfect, or just play with, the potential of equus. From the modes of modern conception, through the development of the embryo and fetus, we are on the doorstep of remarkable (and perhaps troubling) control over birth. The horse has for a long time been chiefly a product of our manipulation of breeding and I wanted to find a way to depict that. From an infinite variety, I settled on just a few stark intimations of how crossbreeding produces everything from the most functional mule to the curio of a zonkey. Masks are another form of manipulation—we modify the horse's shortcomings by using armor, an elegant fly net, or even a gas mask. The final modification to consider is how we record and visualize the achievements of the horse, such as through the photofinish, or the thermal image camera, which extends our vision into milliseconds and temperature, beyond the mere light spectrum that enabled us to first connect with the horse.

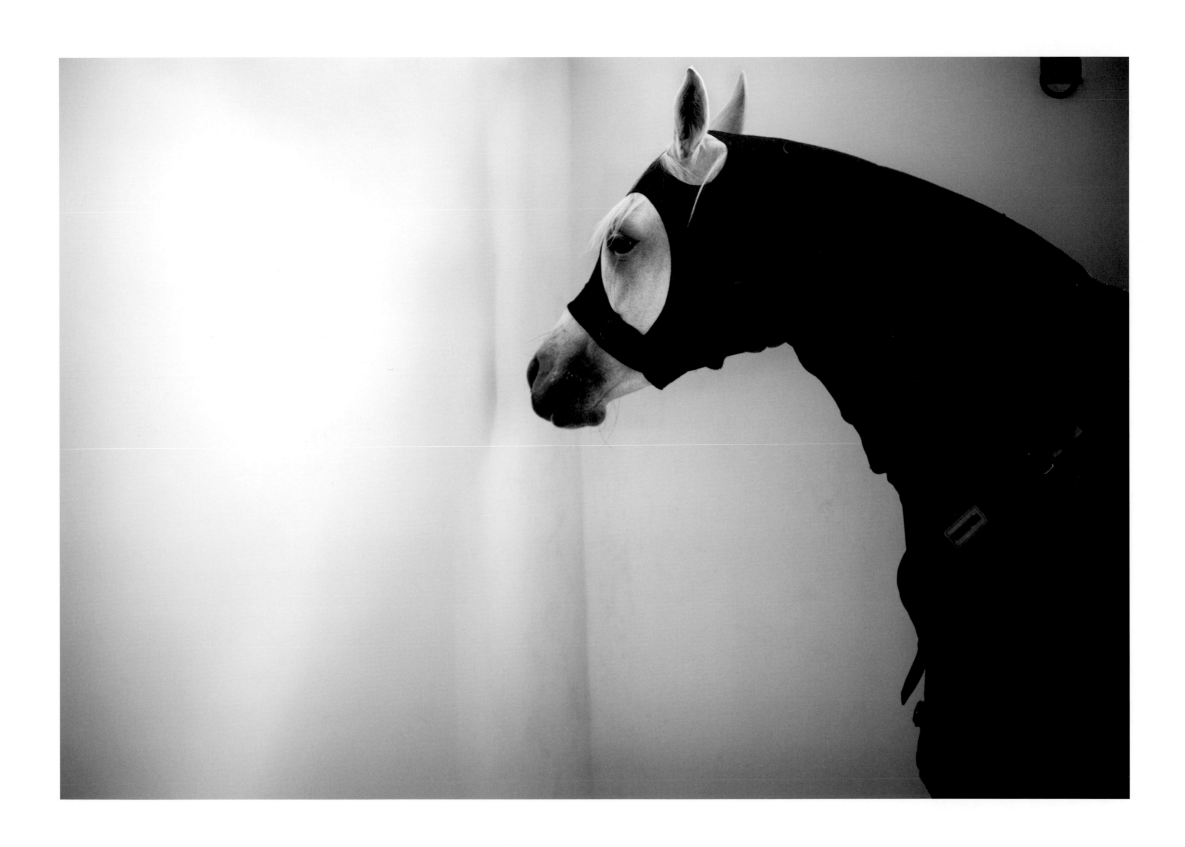

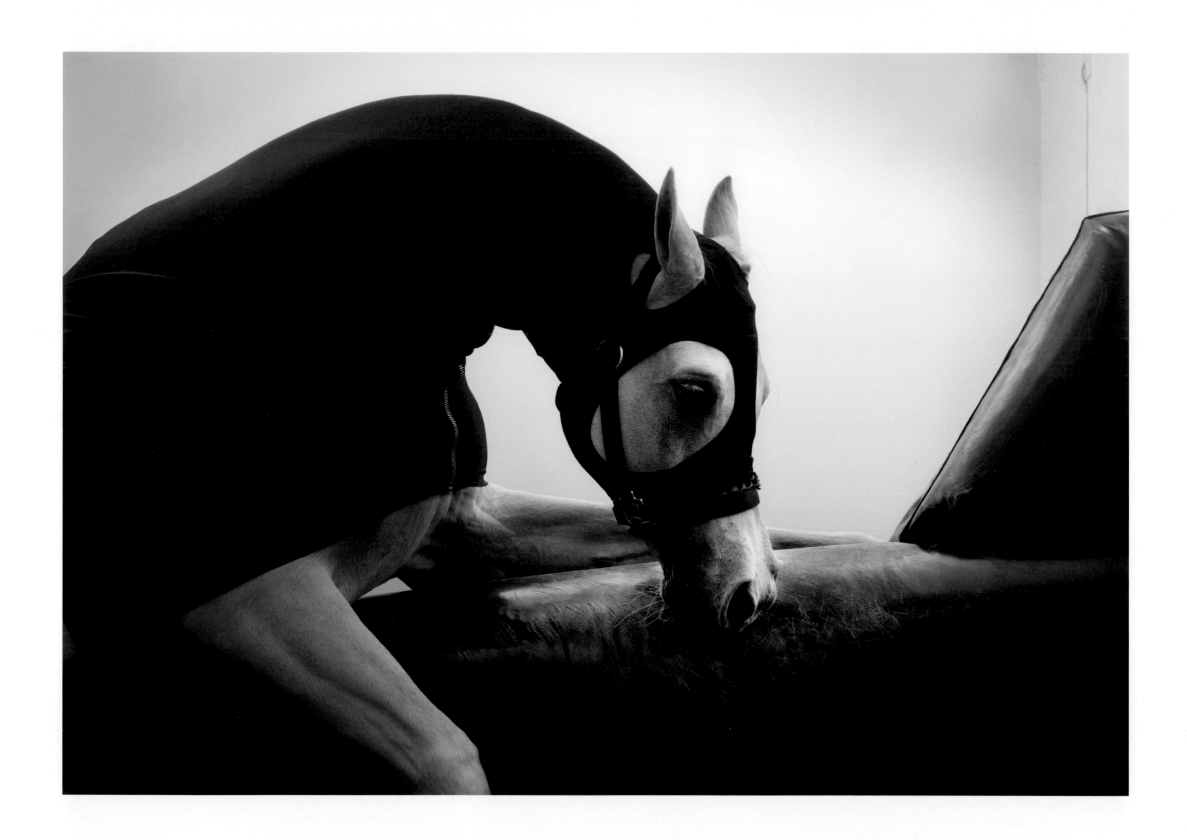

Thoroughbred embryo

3.8 mm

Day 10

Thoroughbred embryo
12 mm

DAY 30

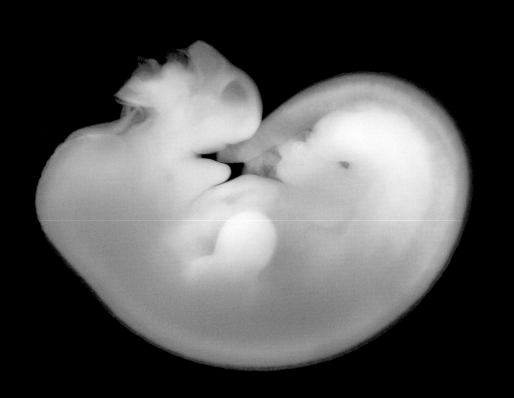

Thoroughbred fetus
69 mm

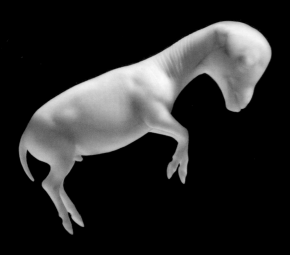

Day 65

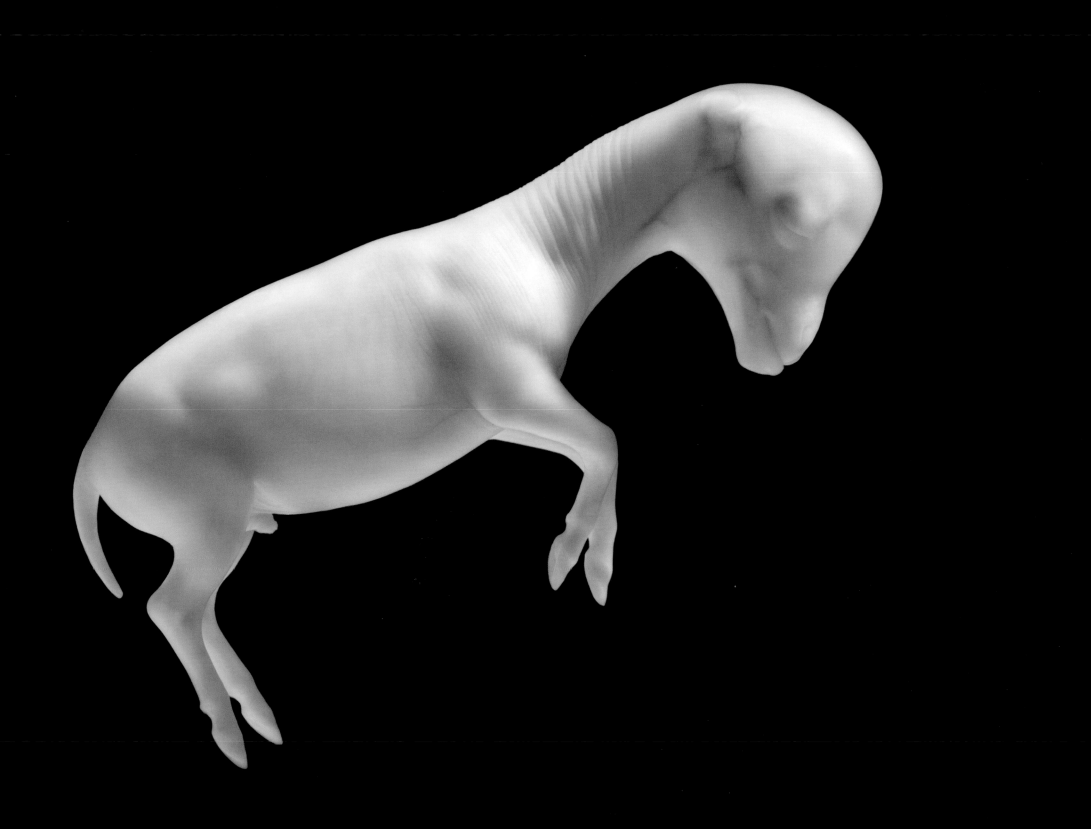

DAY 75

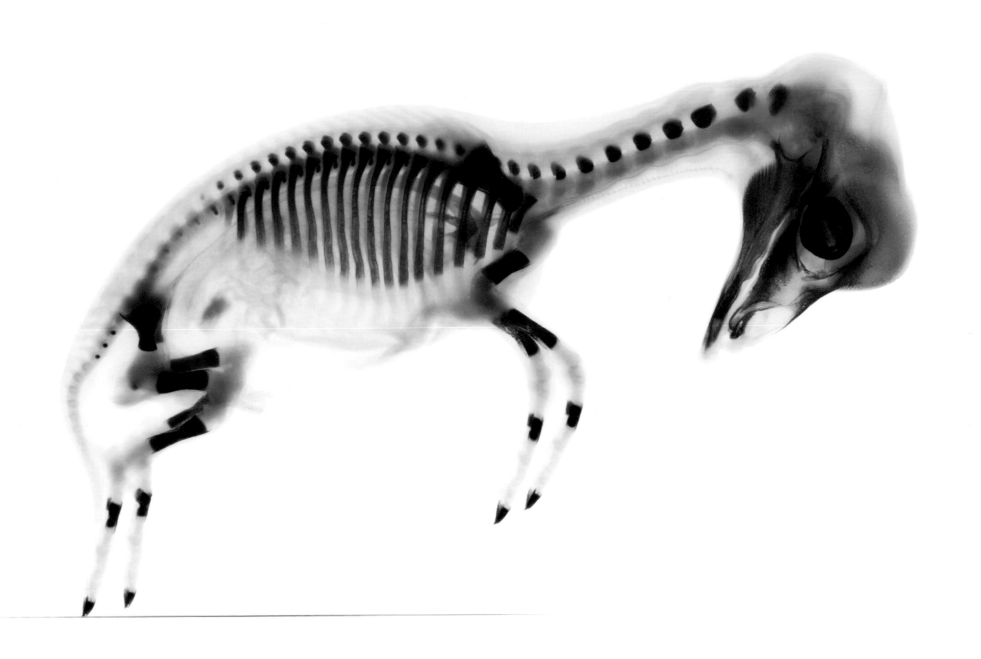

Day 85

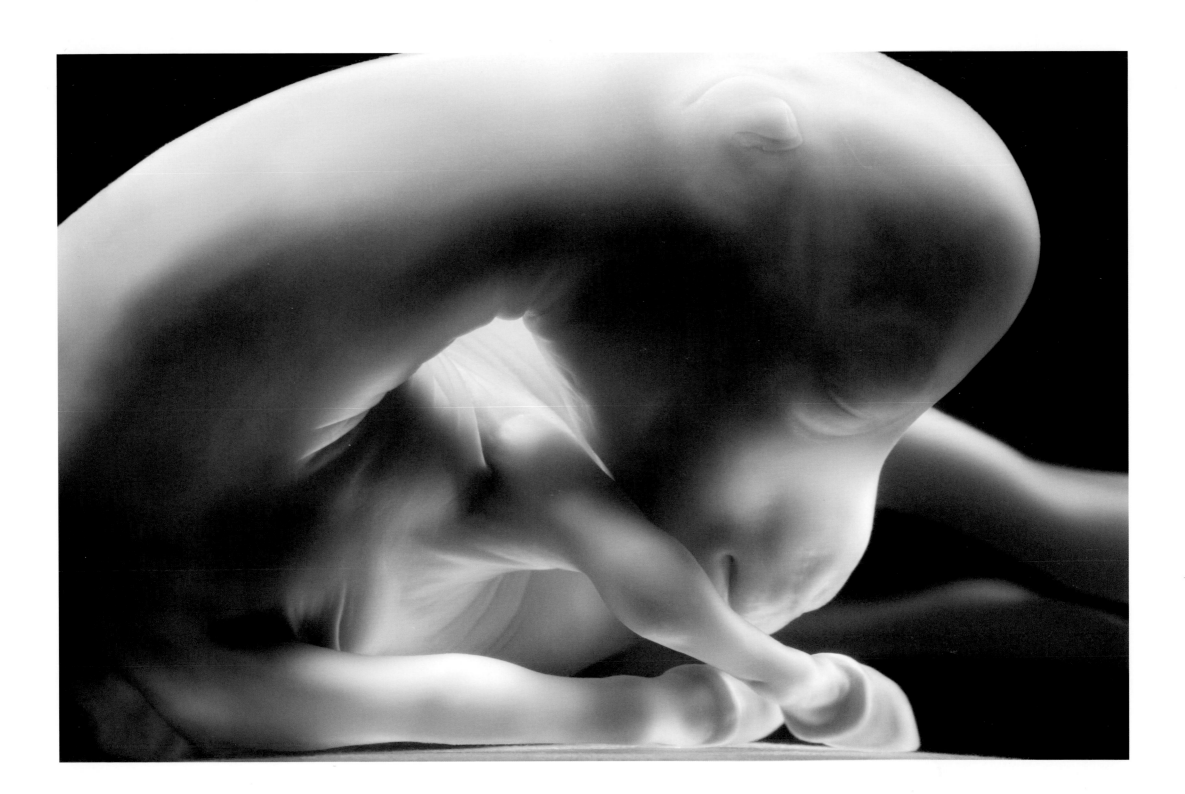

Thoroughbred fetus
Day 85

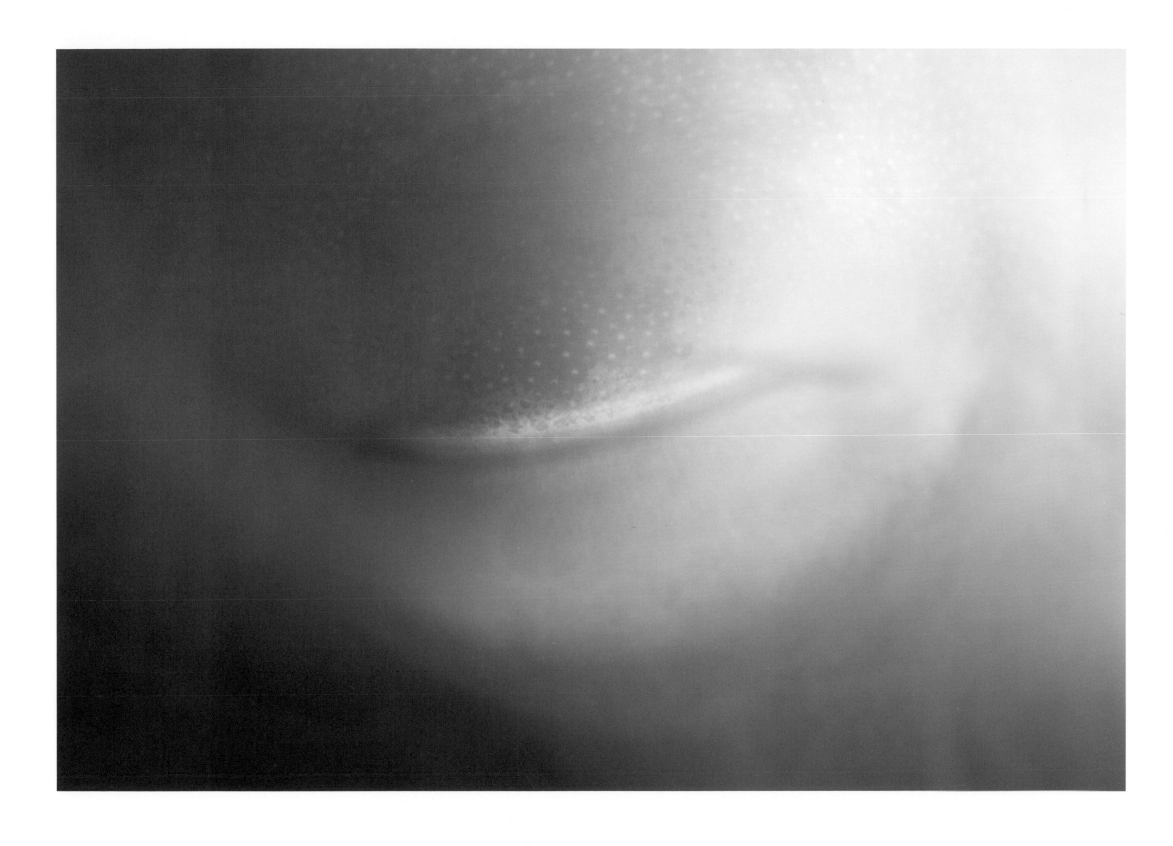

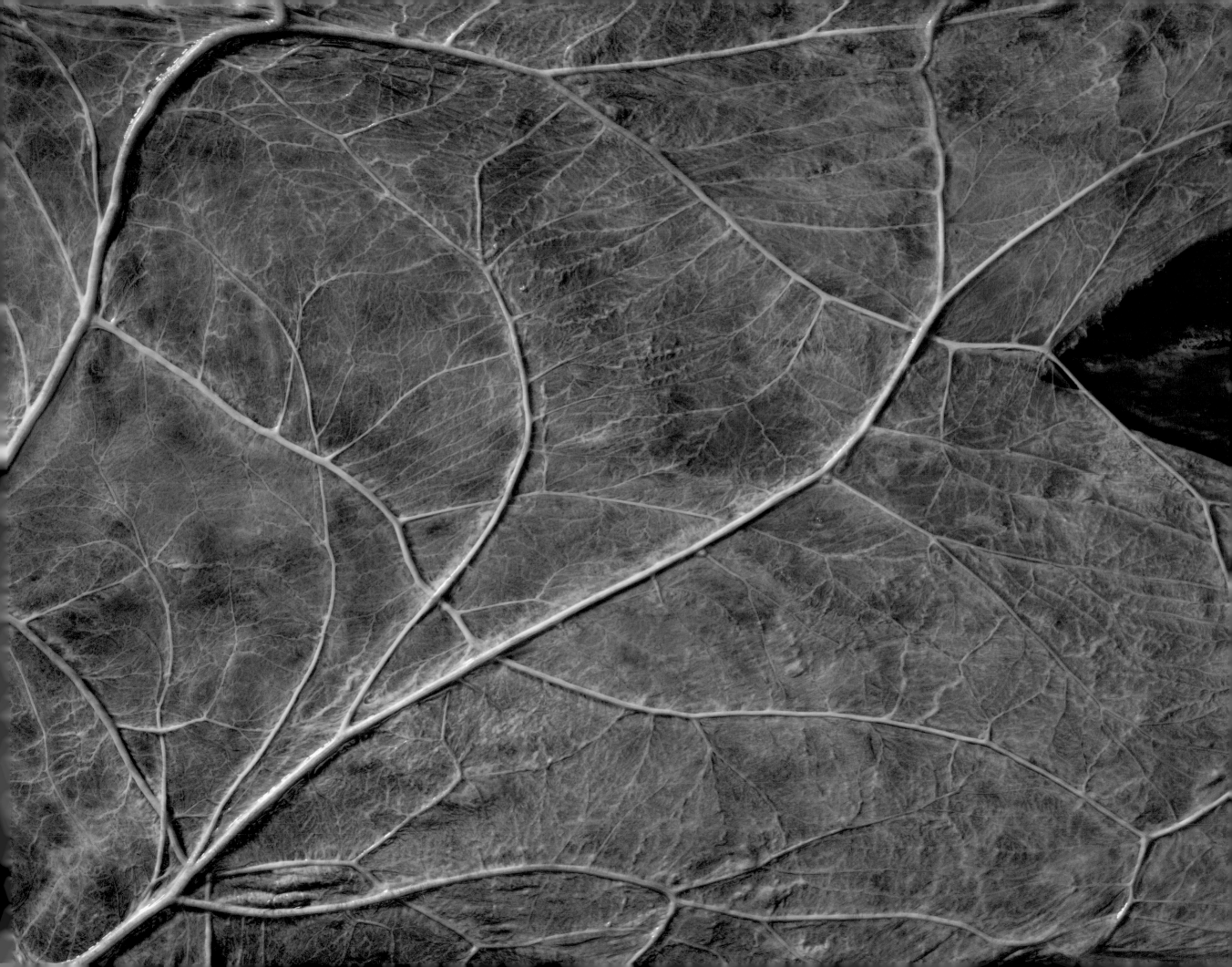

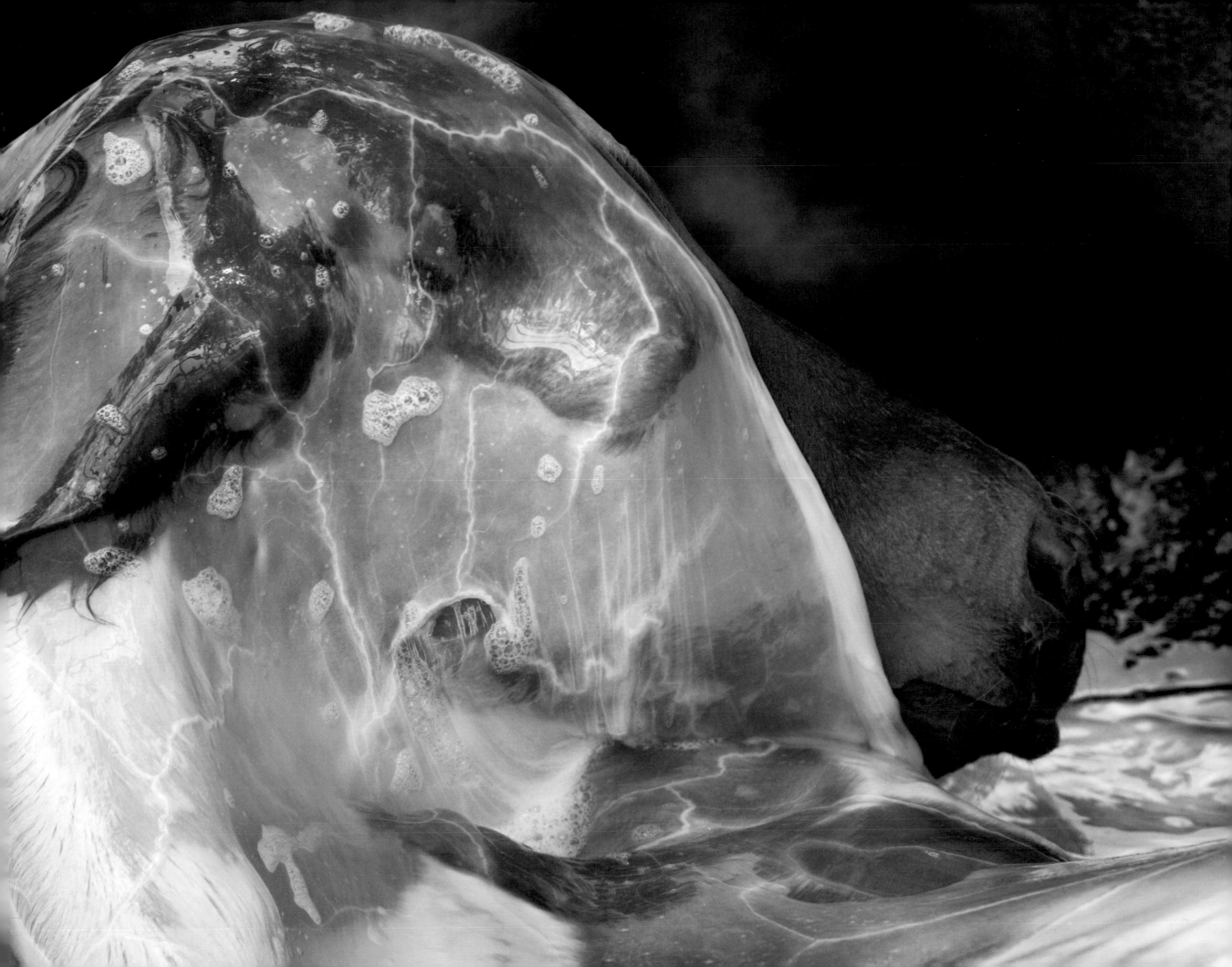

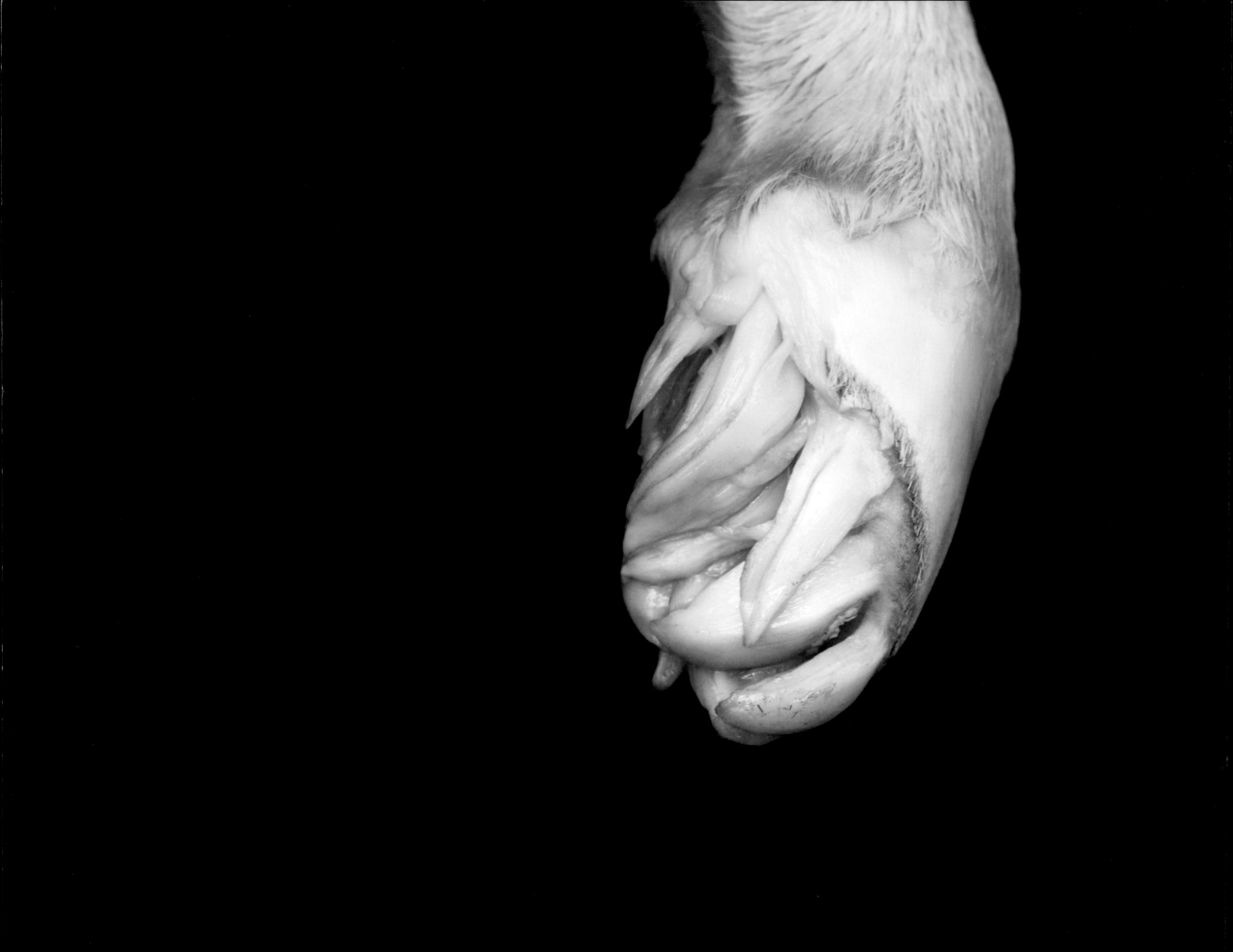

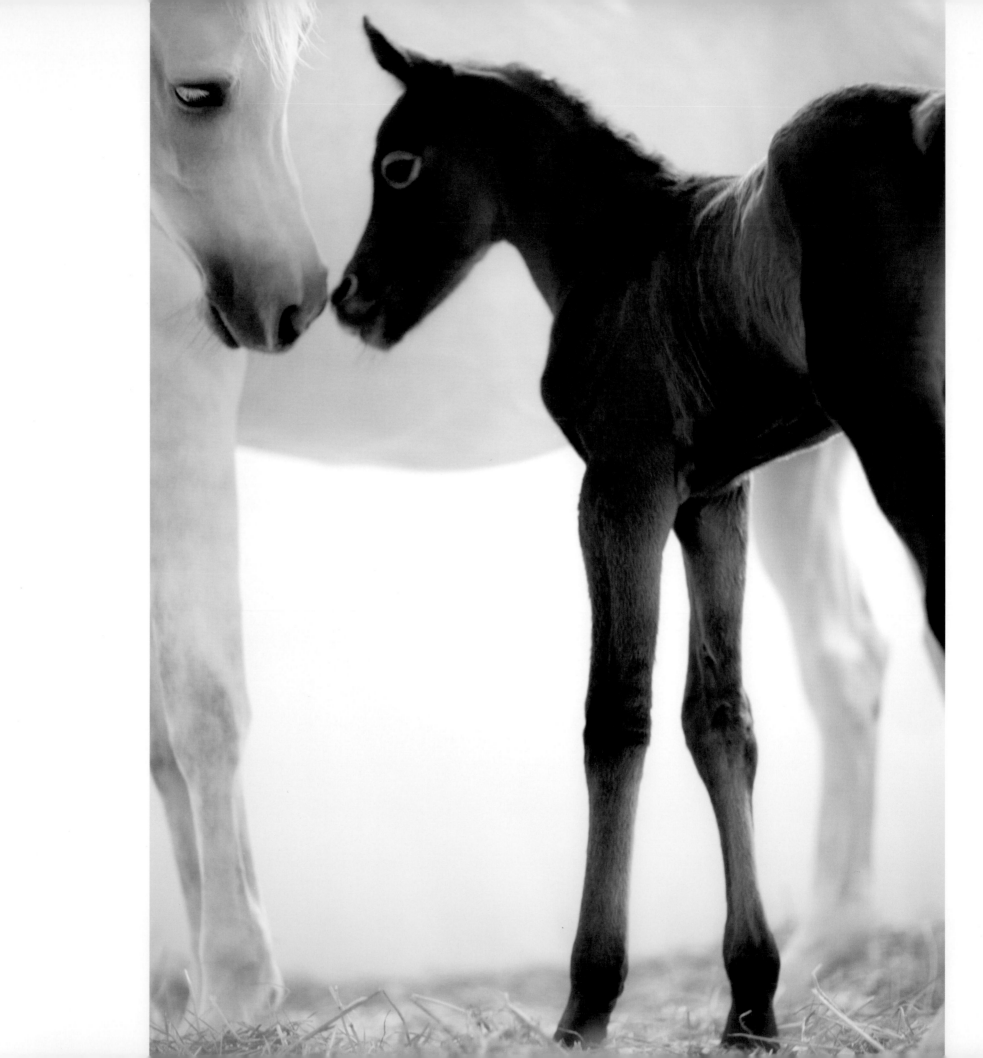

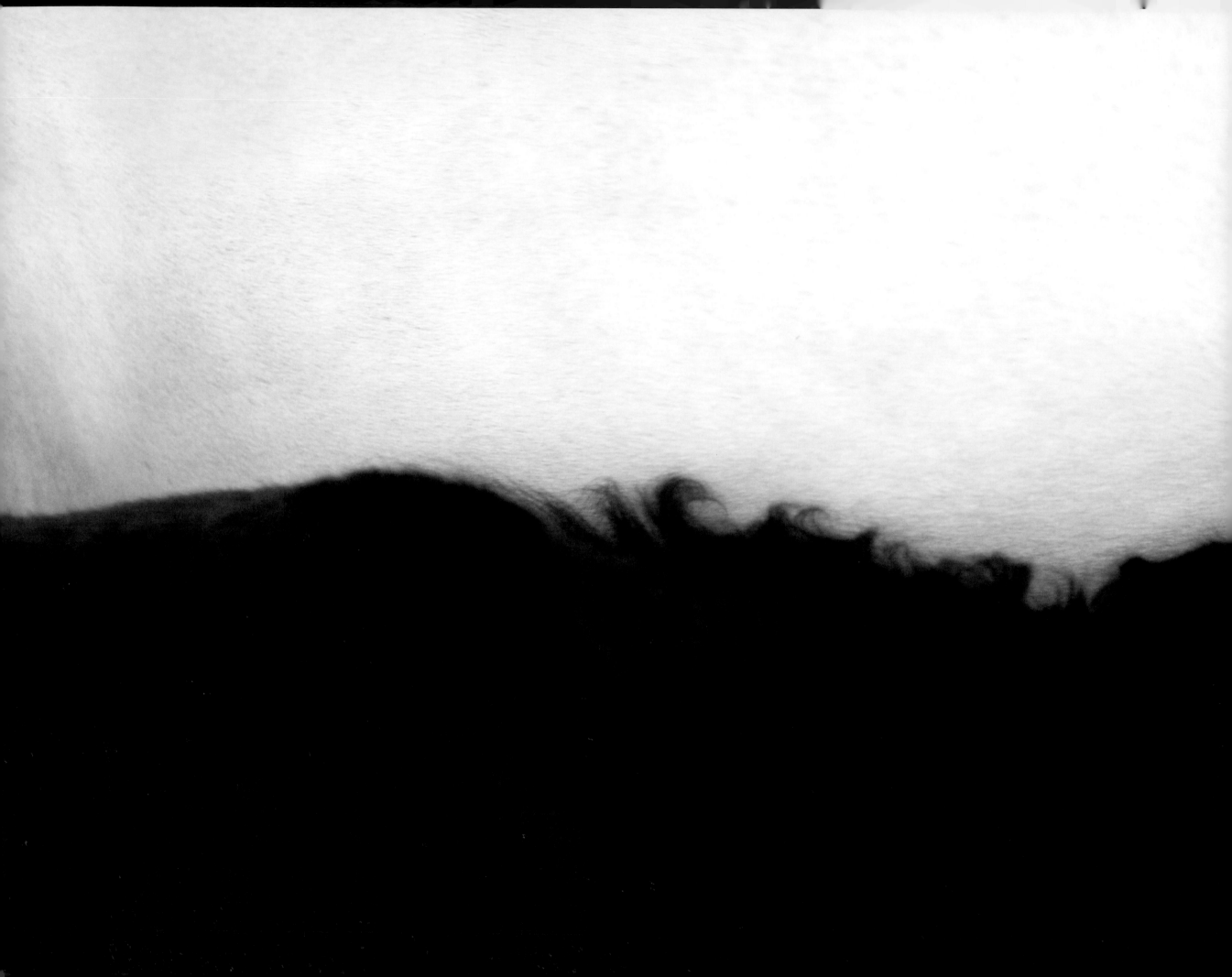

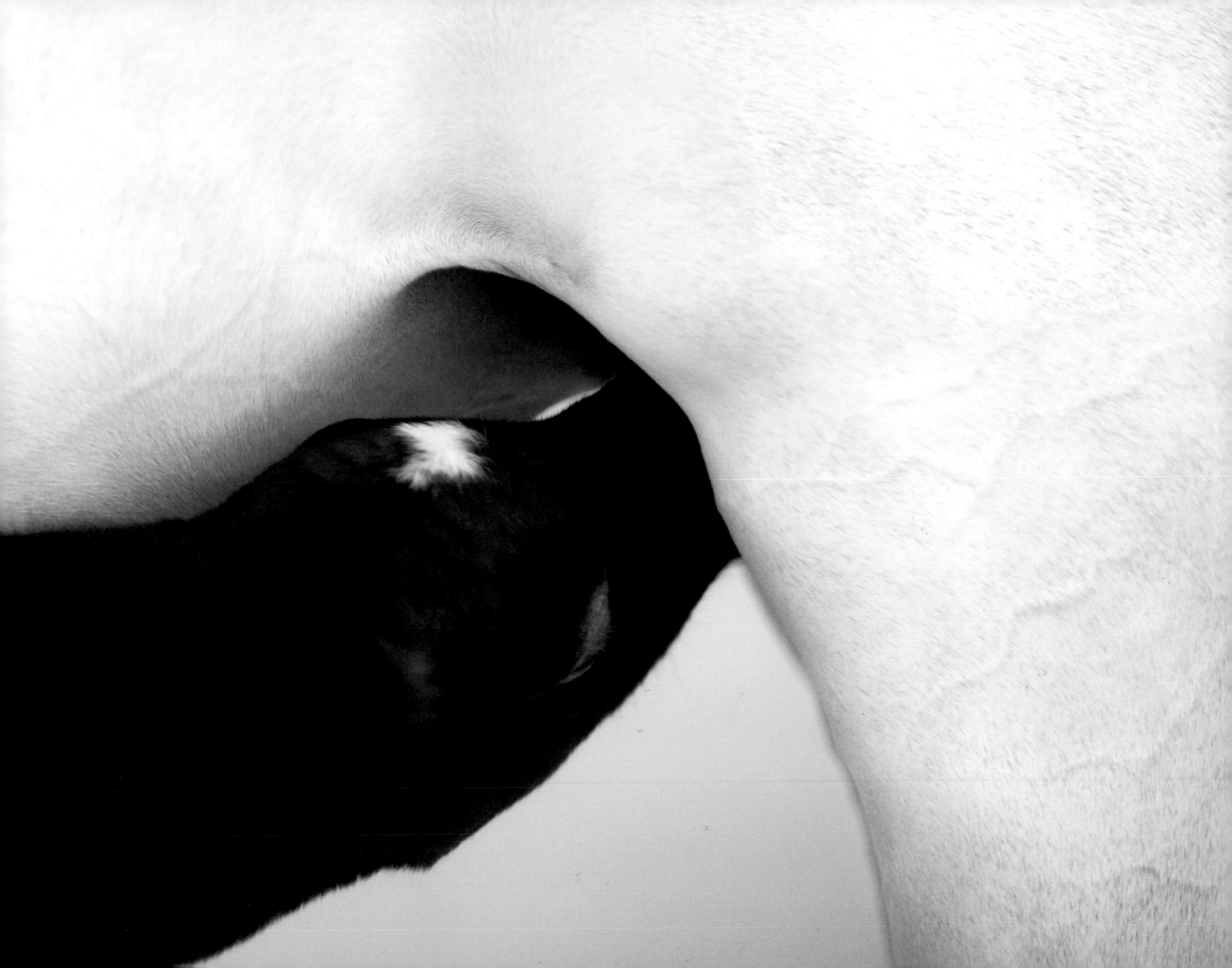

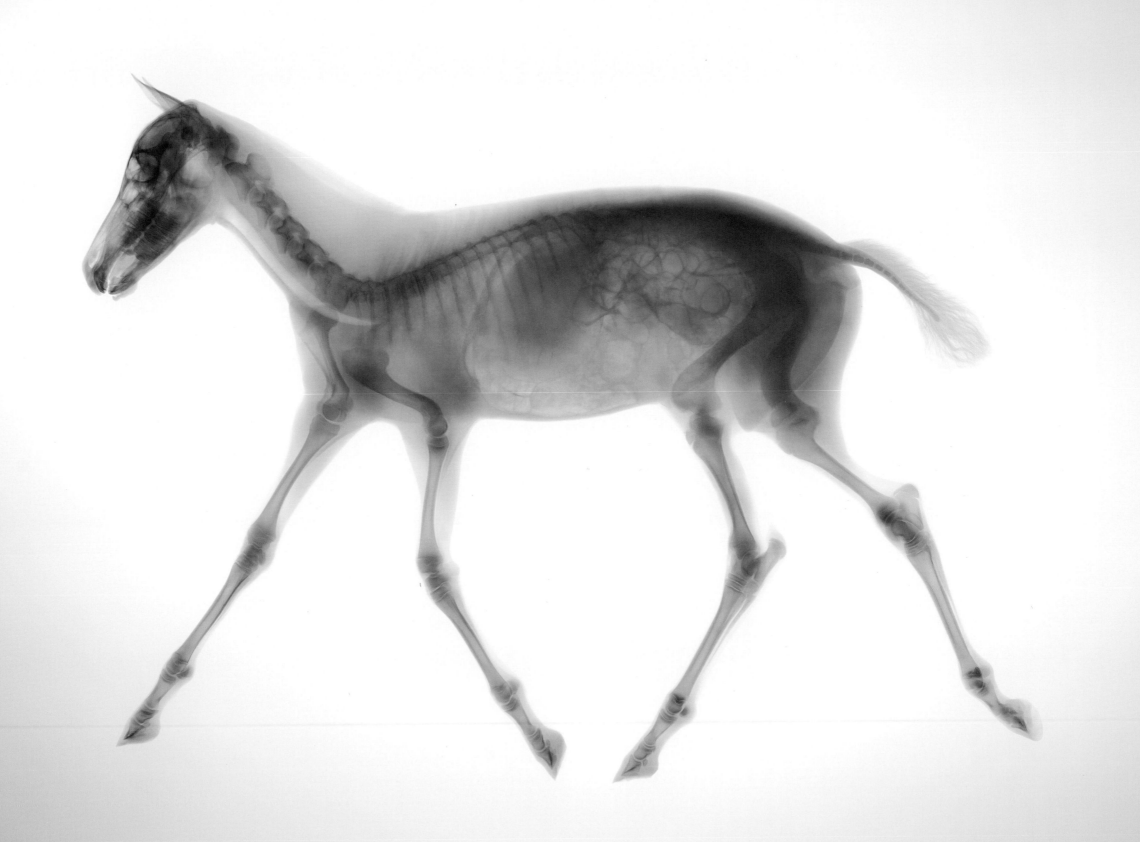

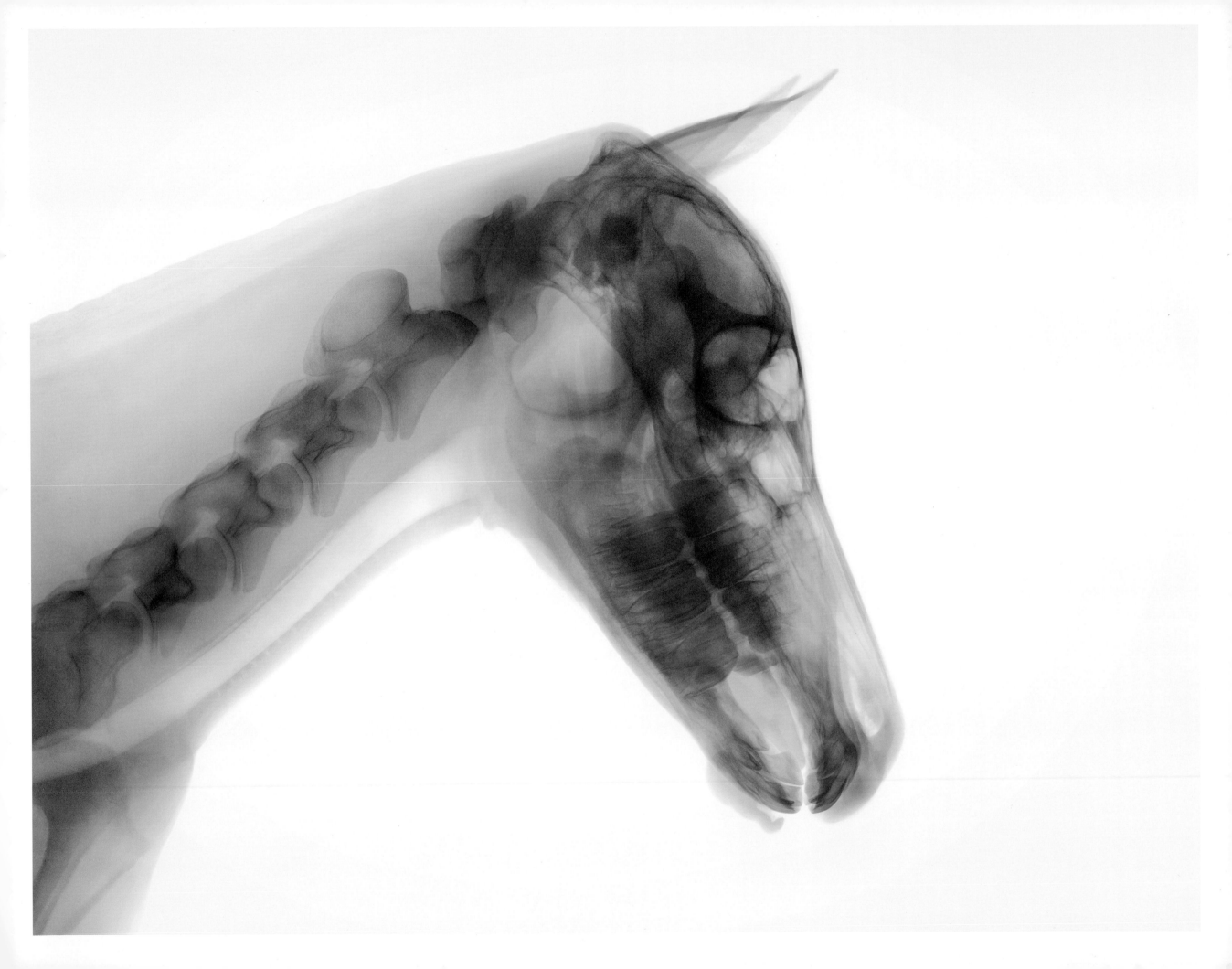

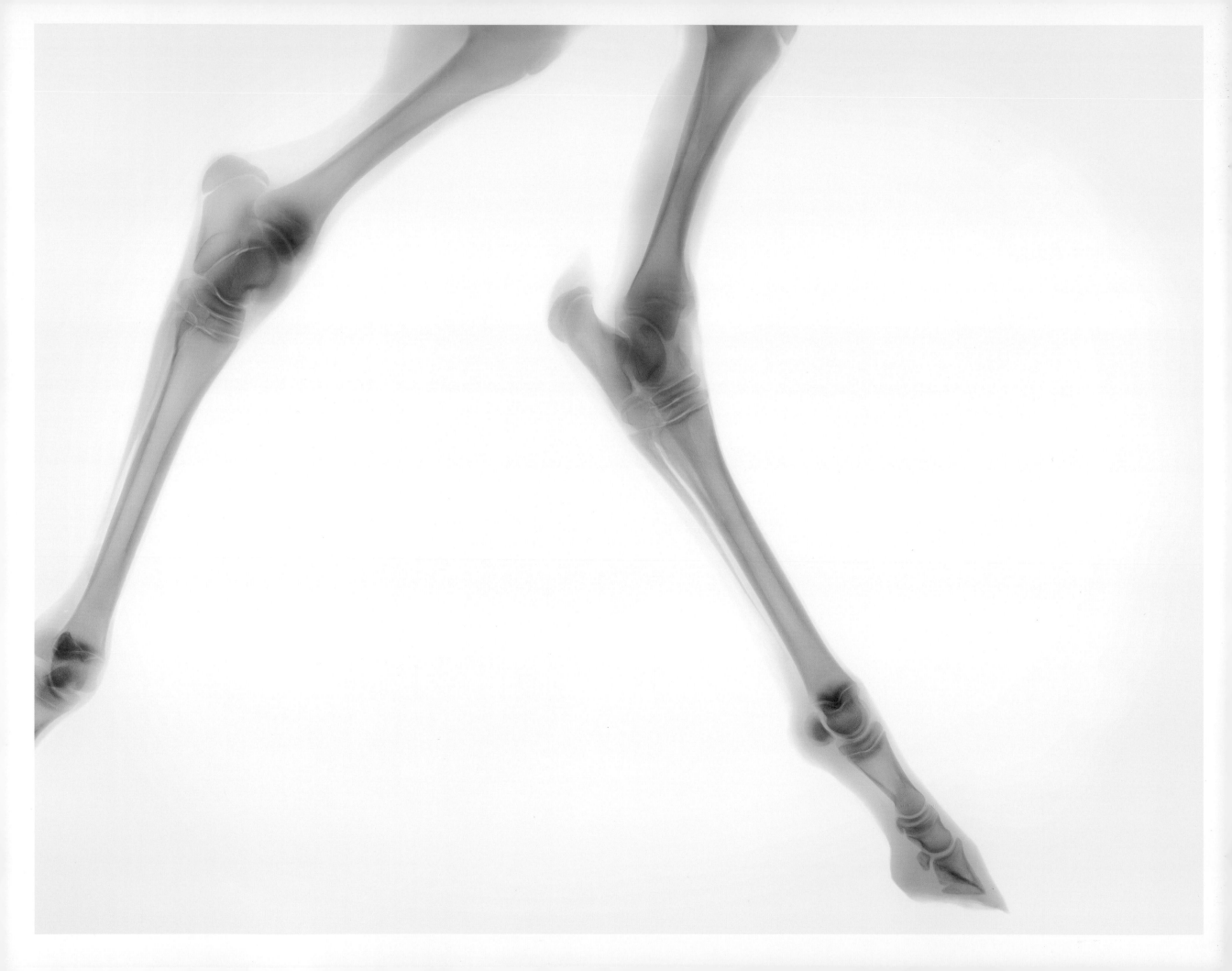

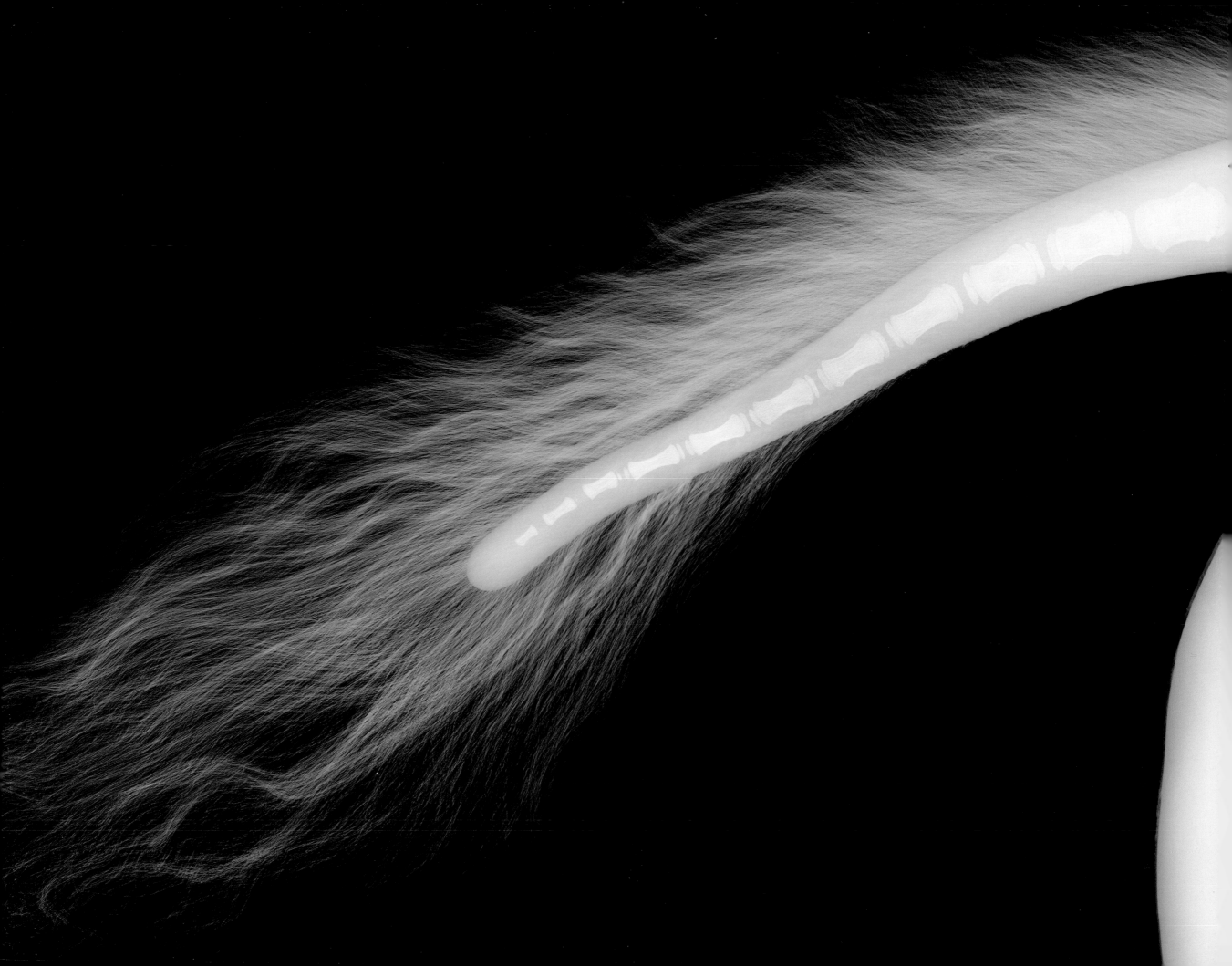

Poitou Donkey

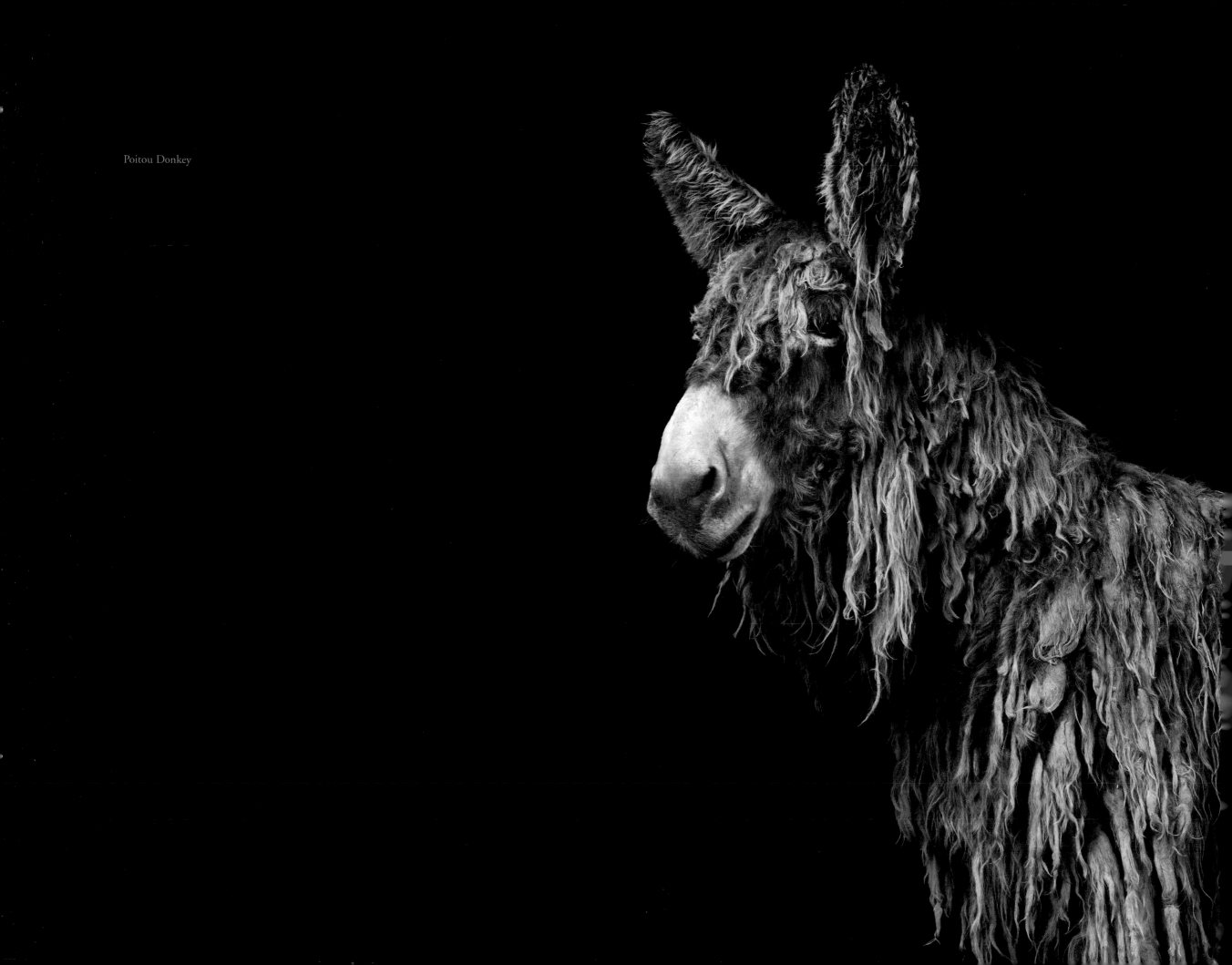

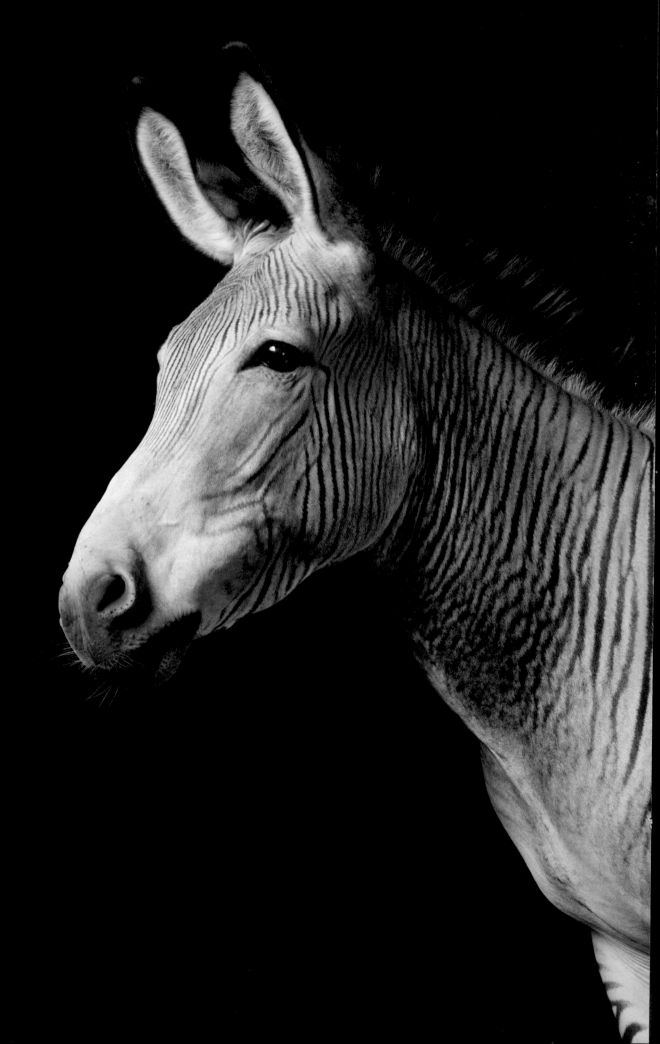

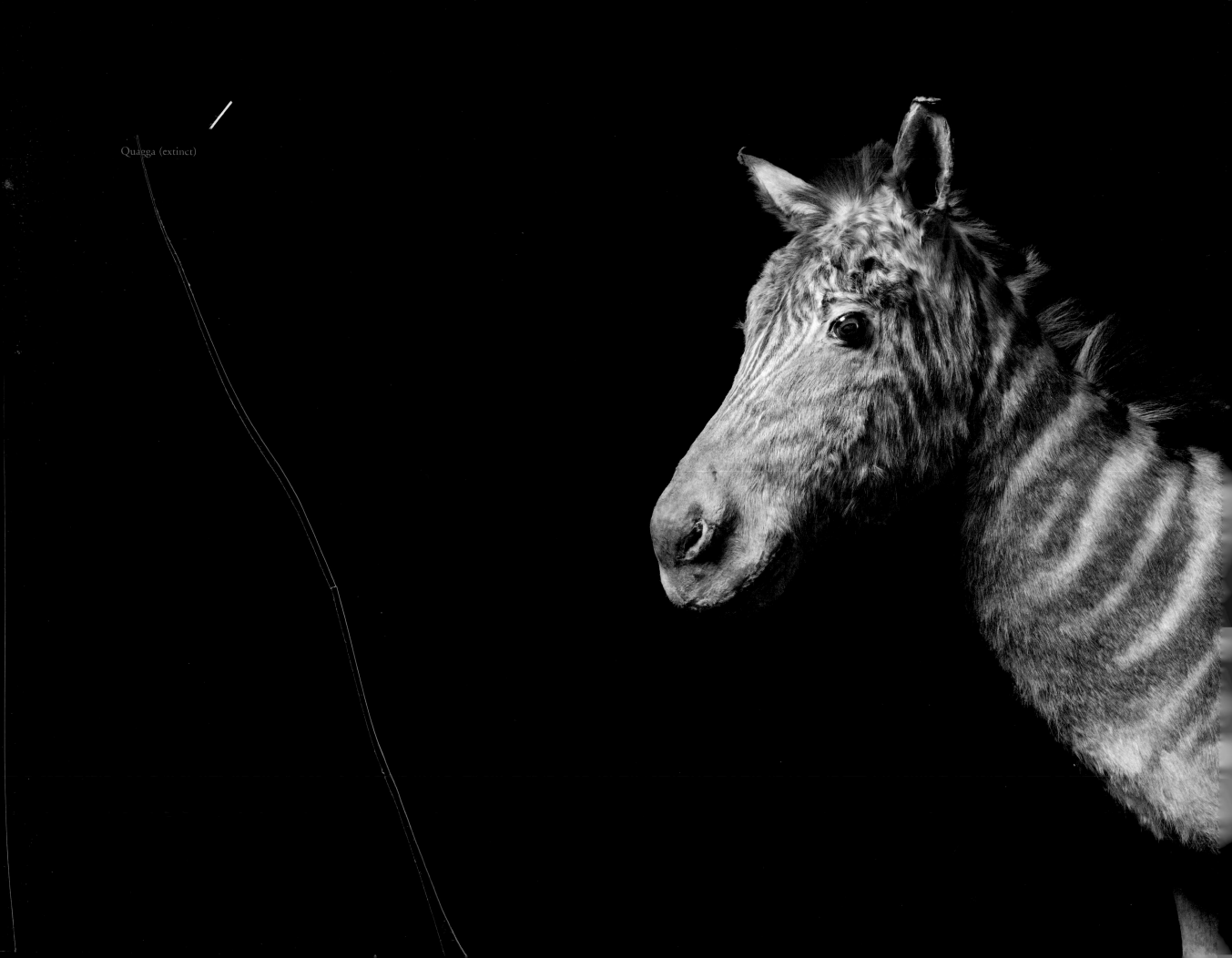

Quagga (extinct)

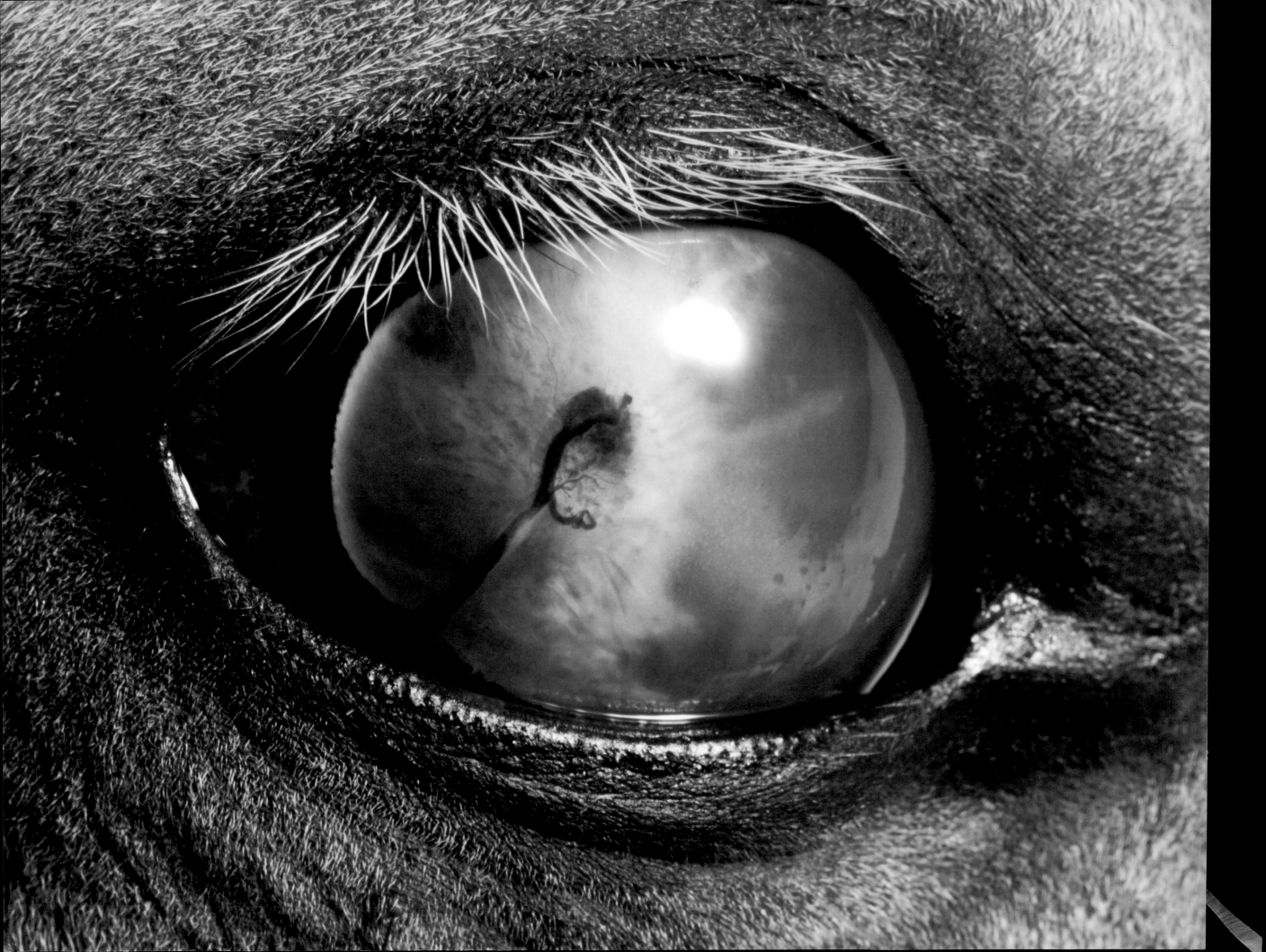

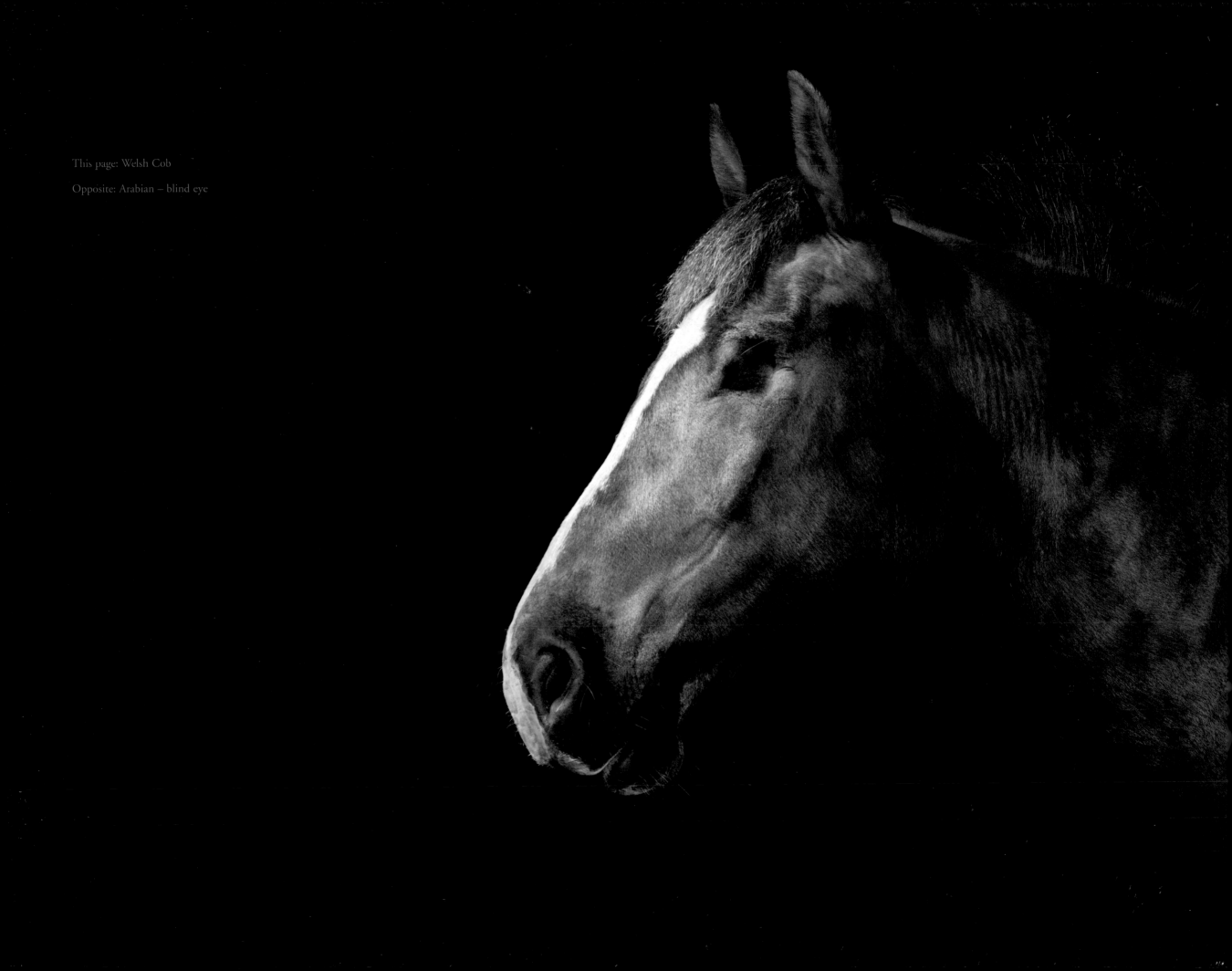

This page: Welsh Cob

Opposite: Arabian – blind eye

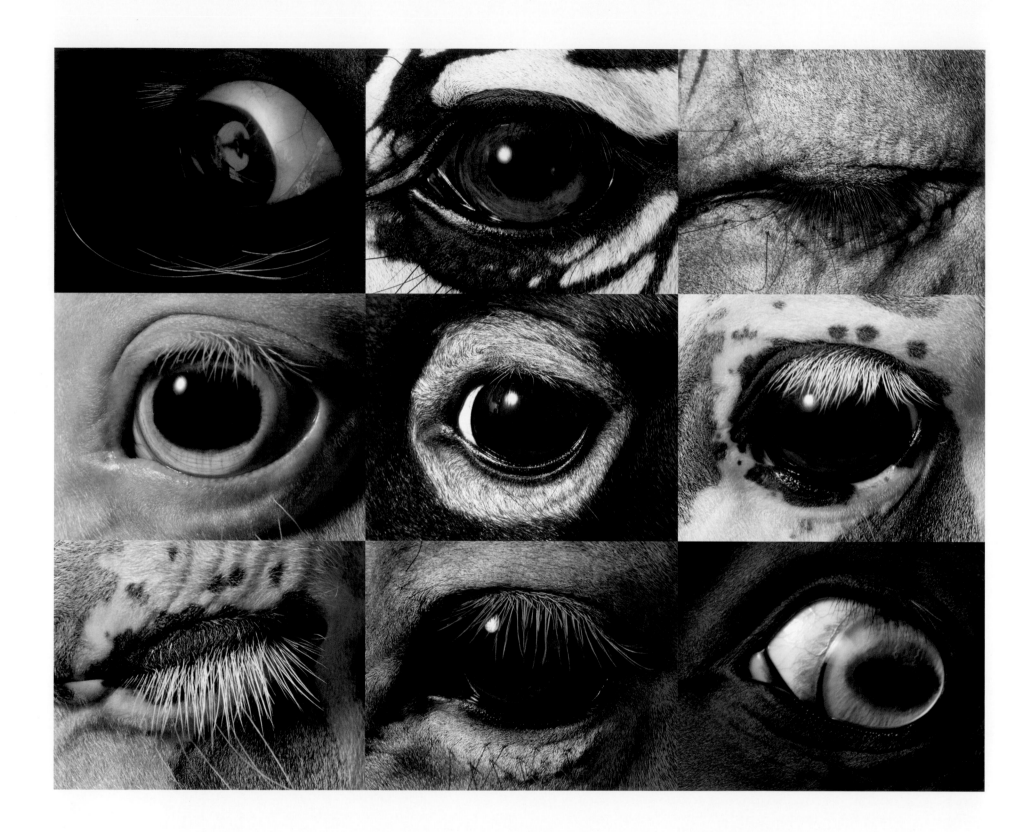

Top row, from left: American Paint Horse, Grant's Zebra, Zonkey
Middle row: Perlino, Arabian, Appaloosa
Bottom row: Appaloosa, Zorse, Grulla

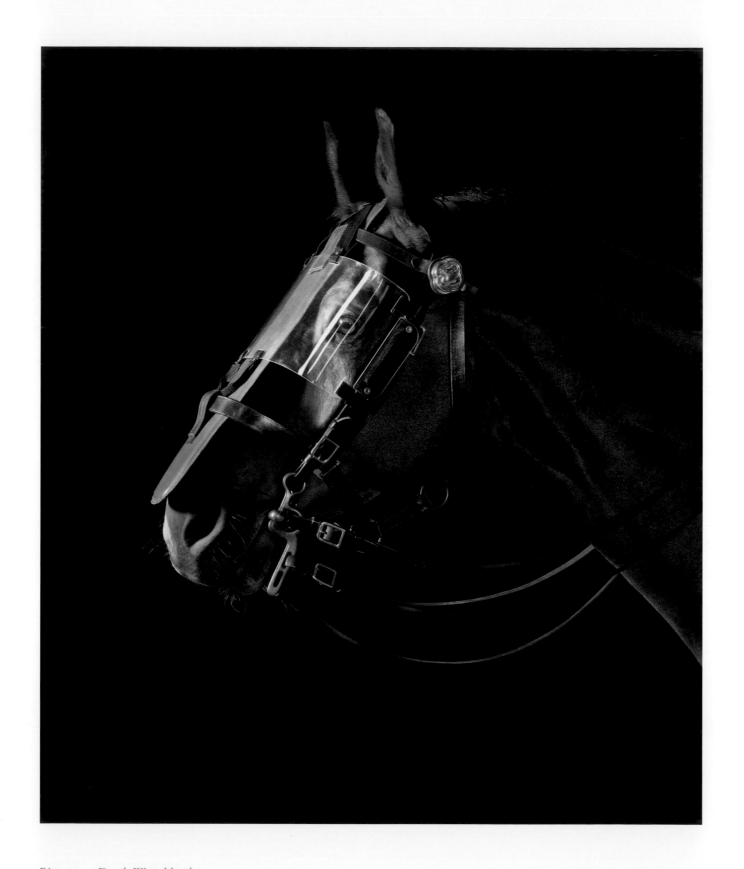

Riot gear – Dutch Warmblood

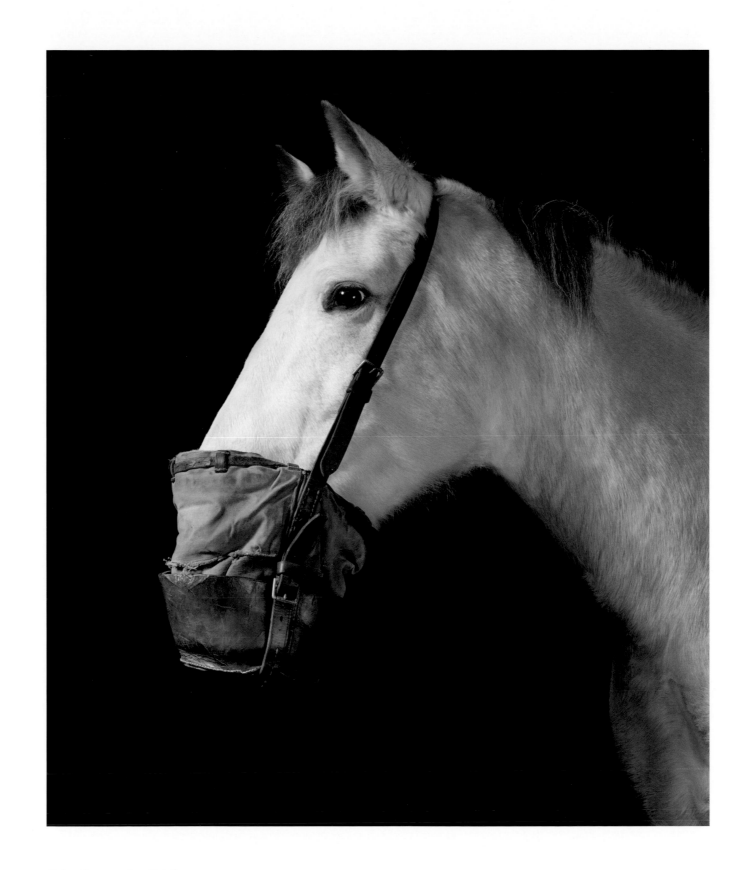

Chloroform mask – Criollo

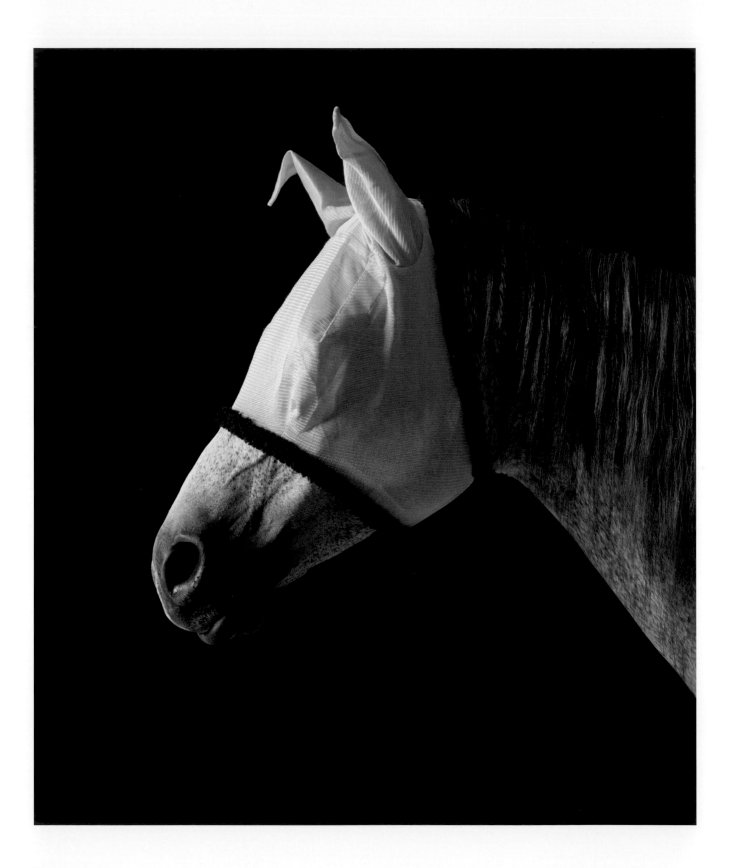

Fly net – Arabian

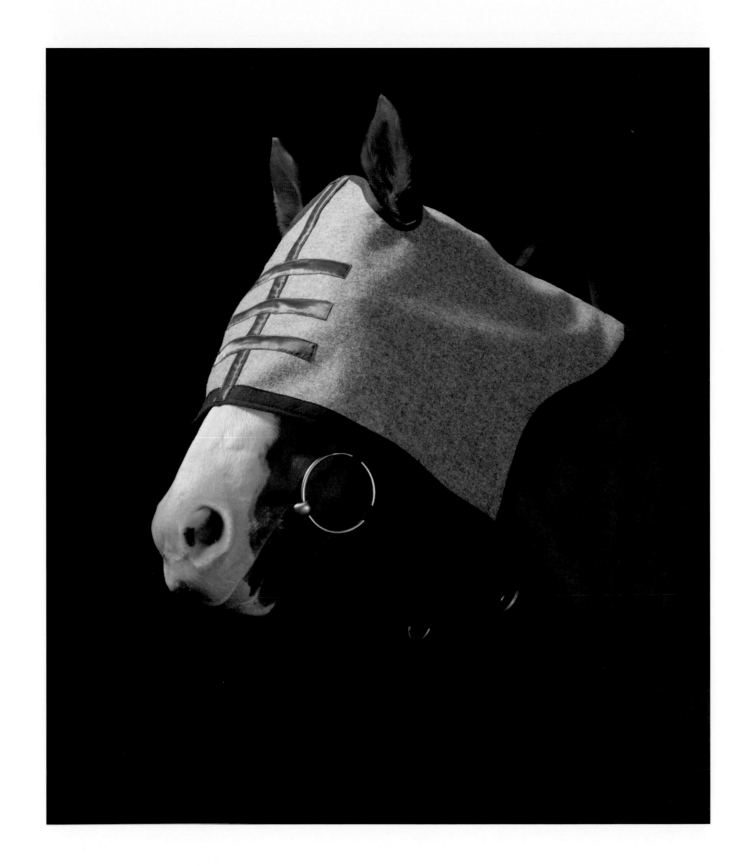

Blindfold hood – Thoroughbred

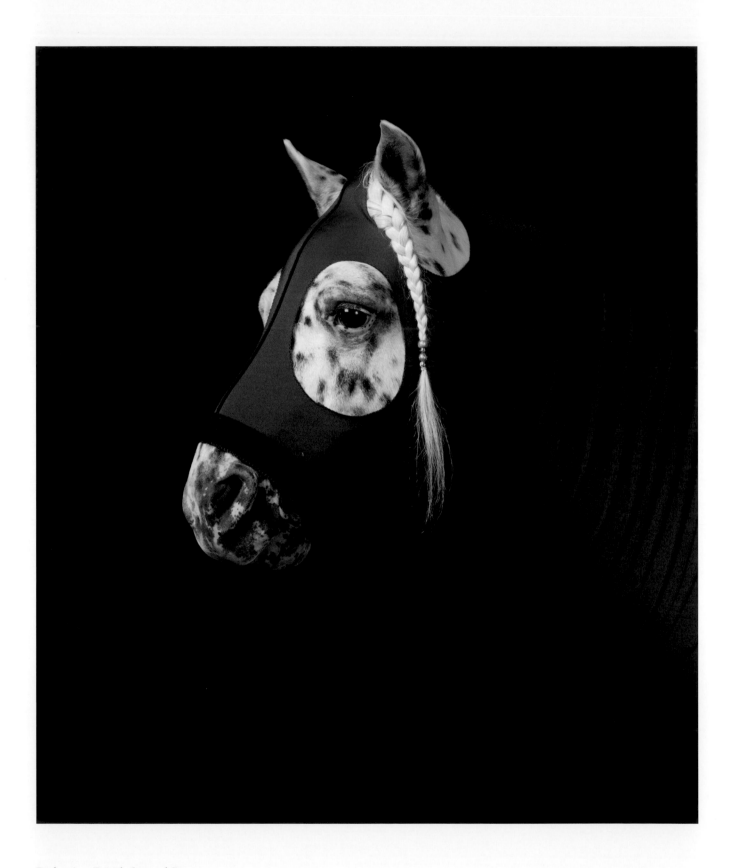

Bodysuit – British Spotted Pony

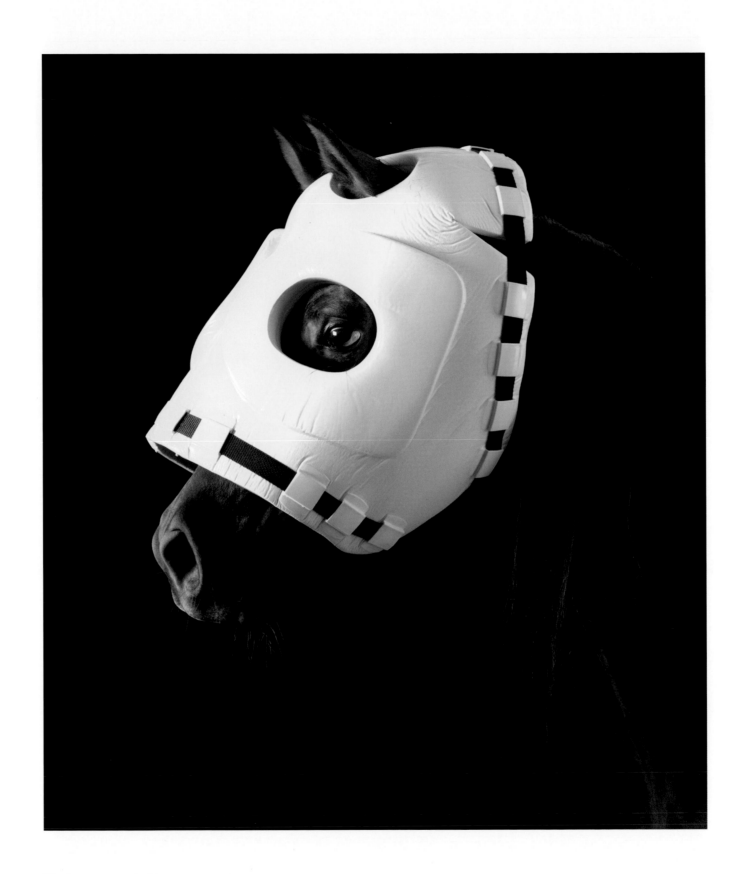

Head protector – Arabian

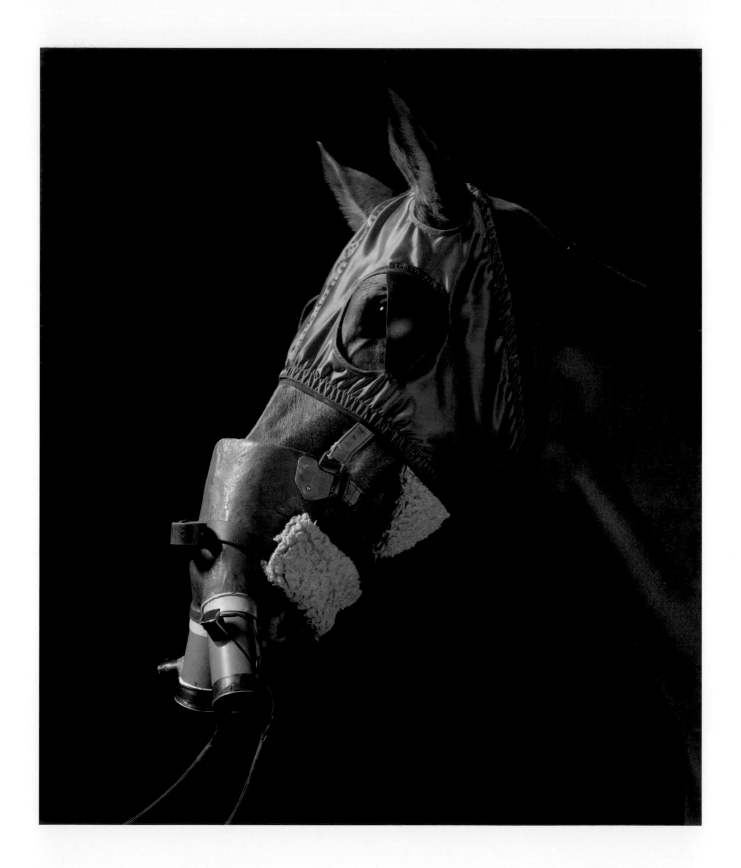

Respiratory measurement – Thoroughbred

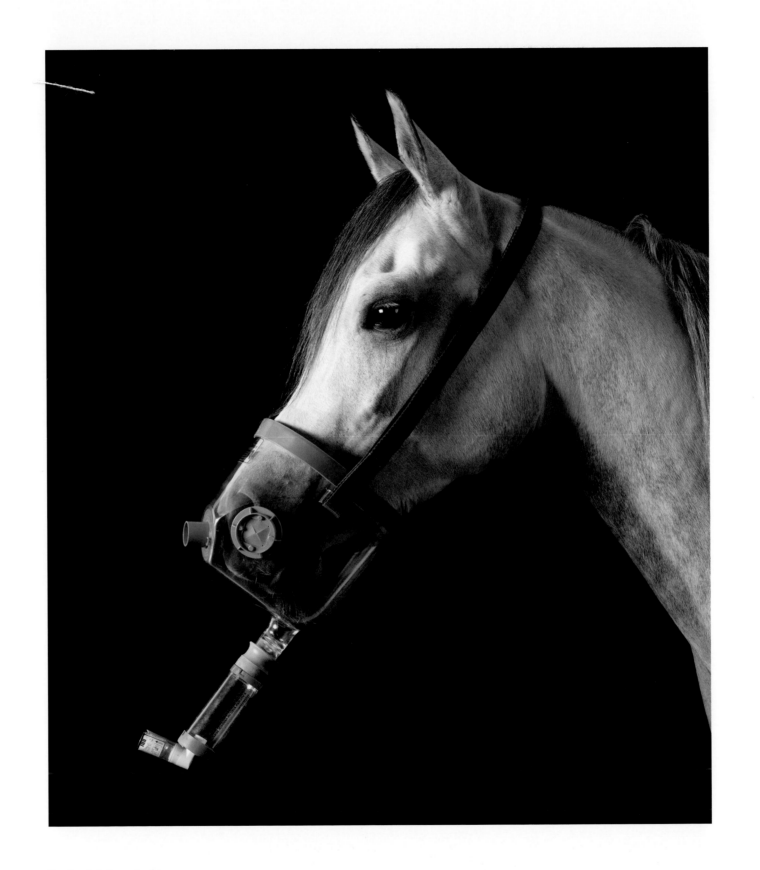

Equine inhaler – Arabian

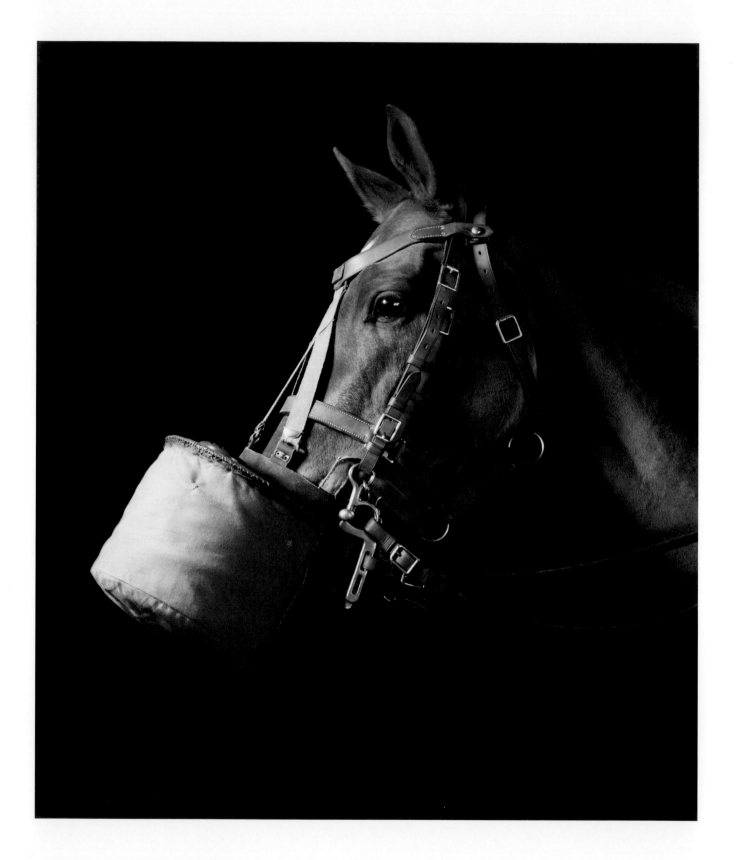

Gas mask – Thoroughbred x Polo Pony

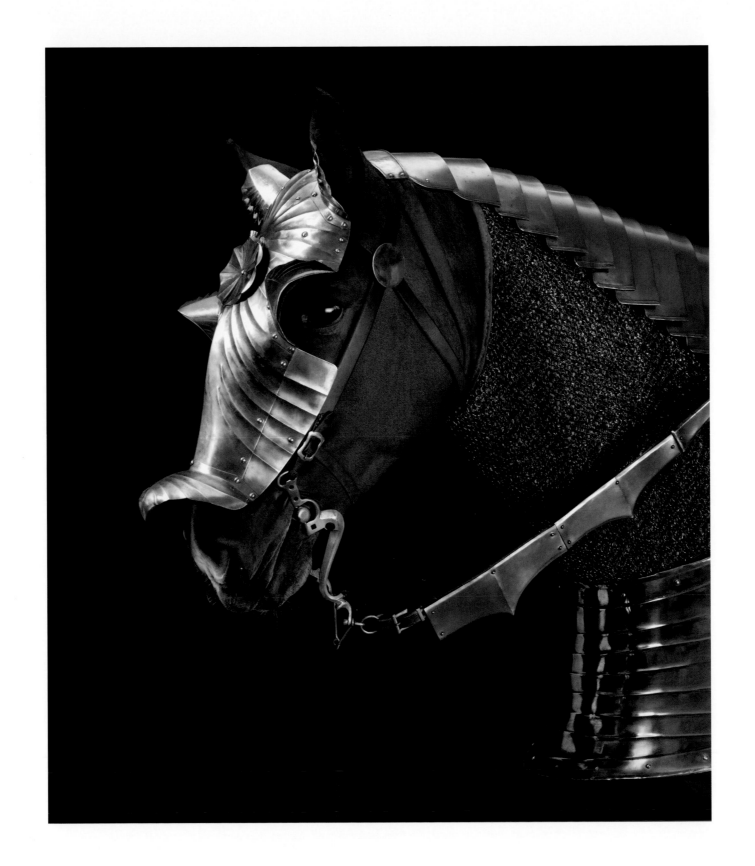

Armor – Irish Sport Horse

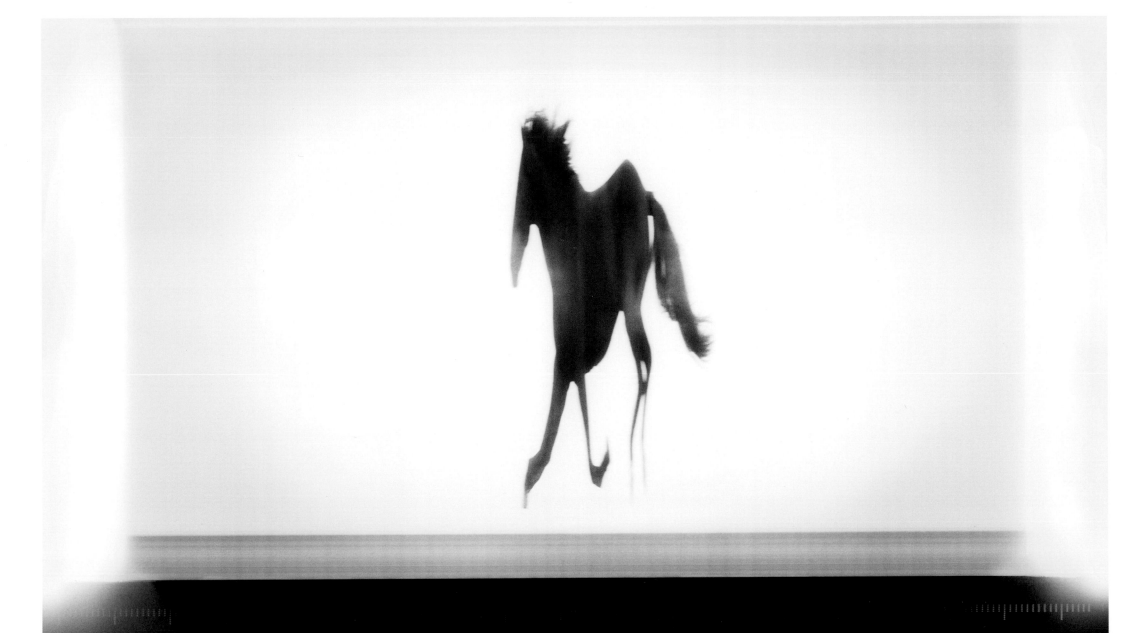

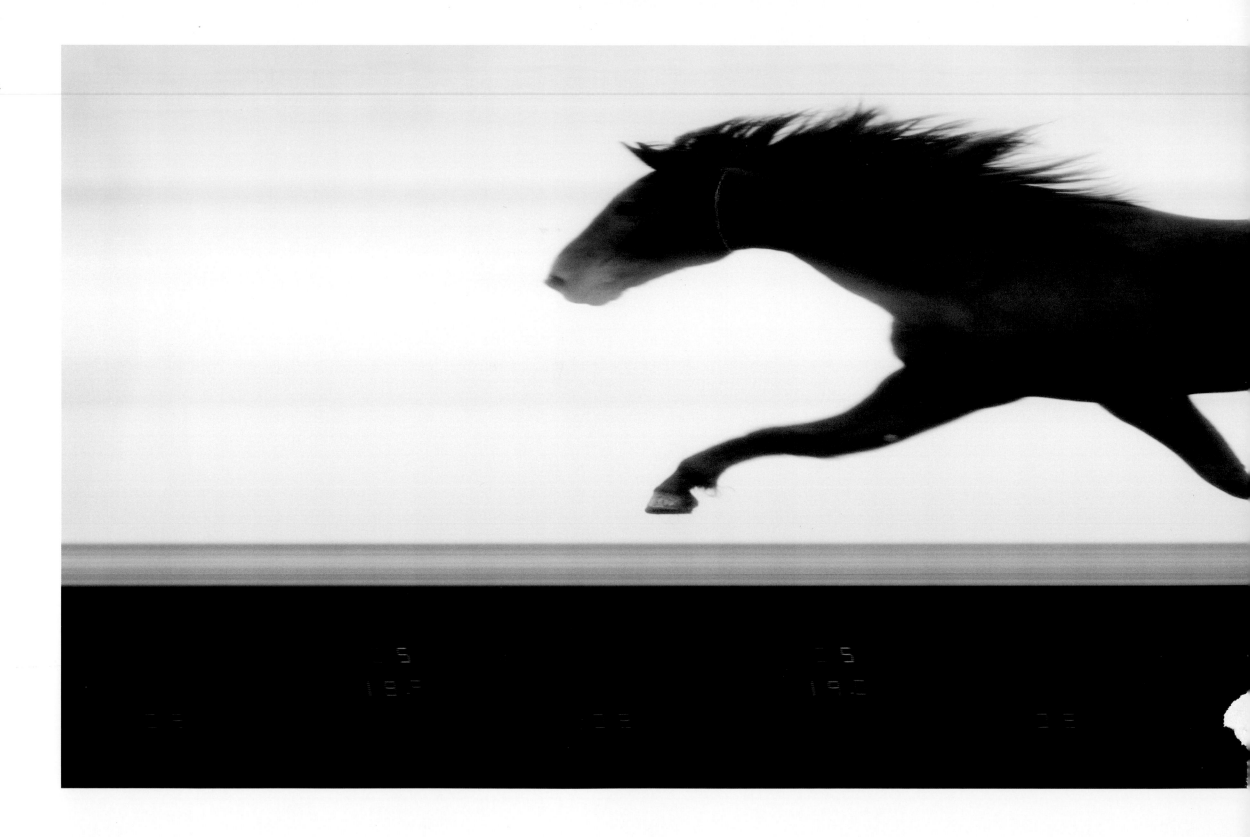

Photofinish camera – Lusitano

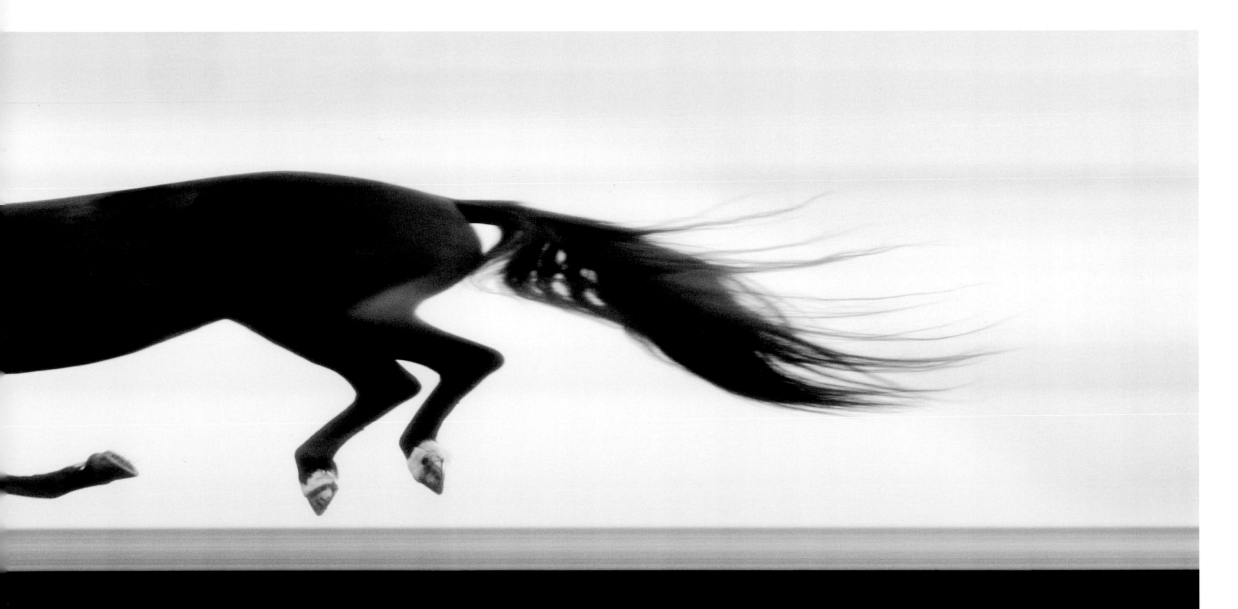

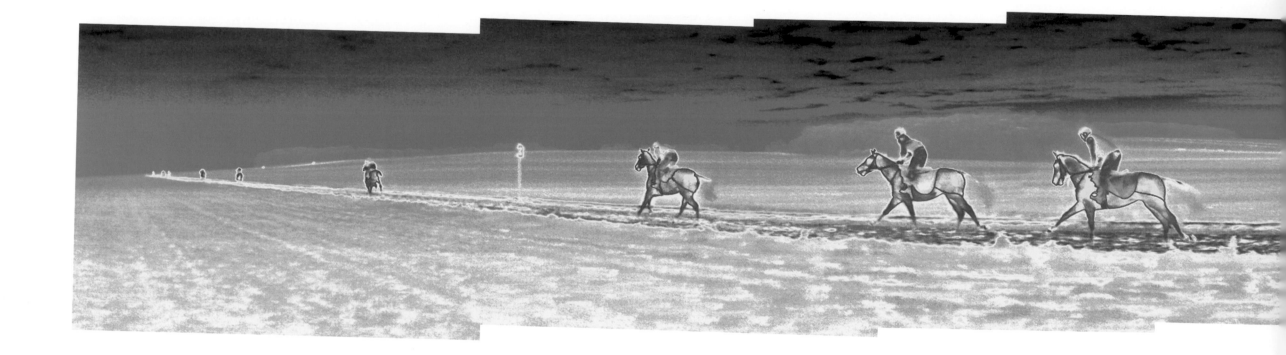

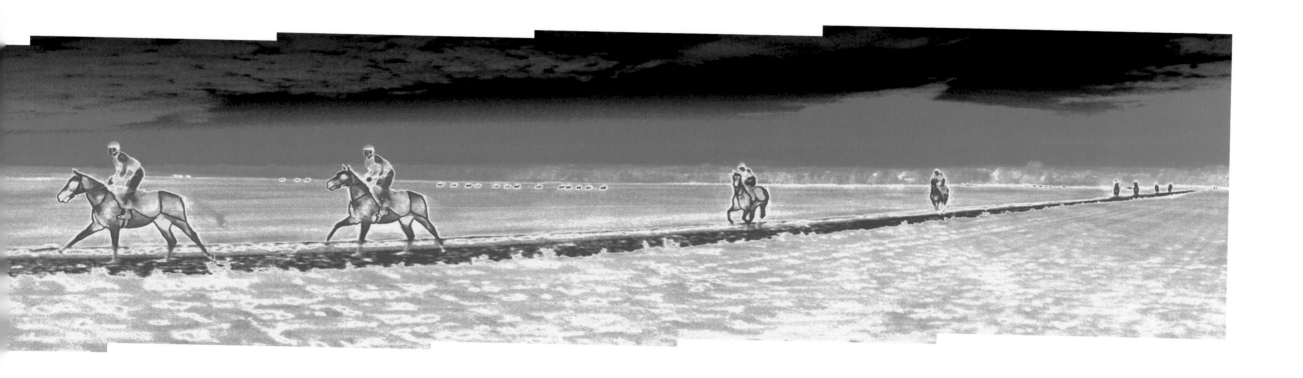

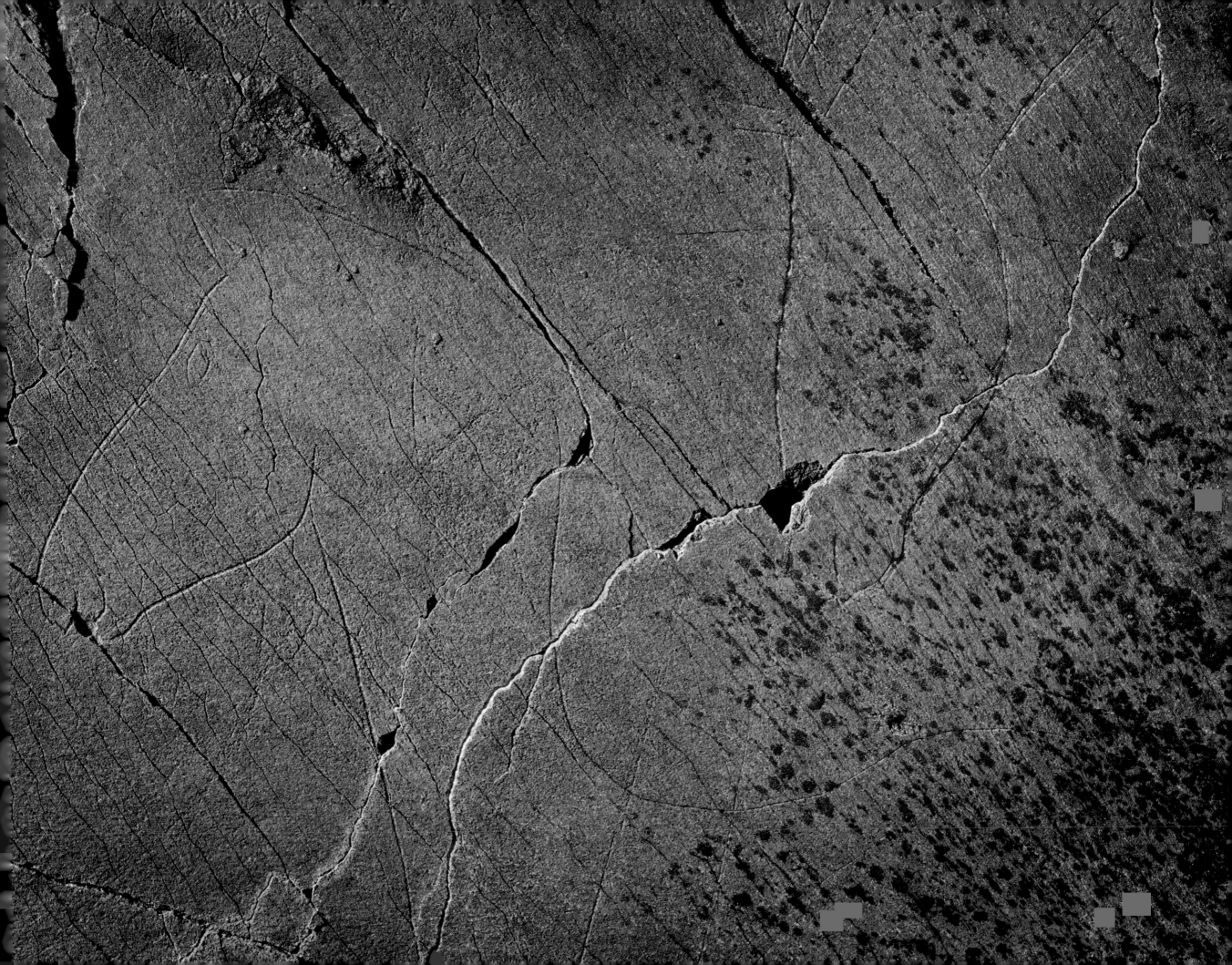

I was advised that you never really finish a book but at some point have to separate from it. The unerring accuracy of hindsight tells me, now, that it was inevitable that this advice would apply to this project: Equus, like anything that has to do with the living and evolving world, offers an infinite range of possibilities to explore, as seemingly limitless as time and space. I have to settle for a sense always that there is more to be seen, created, and recorded, but then who would want it to be otherwise? At some point, though, I needed to frame up my work and invite you to begin your exploration. I hope I've revealed some fresh views and advanced questions regarding the wonder of the horse and its relatives. Feel free to tell me where your investigations take you. One final, challenging idea to ponder might be the comment made by Roland Barthes in *Camera Lucida*: "Ultimately a photograph looks like anyone except the person it represents." Instead of person, I might substitute horse. The remarkable horses in these pages are wonders that we want to see, interpreted and desired by our eyes, genetically modified to our satisfaction. No less wonderful for all of that, but all the more complex for us to ride.

Tim Flach

Cremello Lusitano
Idolo. The cremello color is created by a genetic variation that leads to a cream-colored body and cream or white mane.

Frontispiece

Cremello Lusitano
Idolo.

Frontispiece

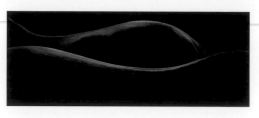

Lusitanos
Dante and Tarantino. The Lusitano, closely related to the Andalusian, has strengths that give it many uses including bullfighting, showjumping, and carriage driving.

Frontispiece

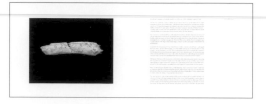

Bone engraving, 13,000 years old
Bone with horse heads engraved on both sides, approximately 13,000 years old. From Courbet Cave, Penne-Tarn, France, now in the British Museum.

p. 8

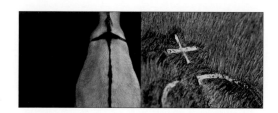

Miniature Donkey
Commander Jack has a dorsal stripe running from the withers to the tail and down the shoulders. It is more common in grey donkeys. Known as the "donkey's cross", legend has it that the mark comes from the donkey standing in the shadow of the cross on which Jesus was crucified.

Lusitano
Xerife II has just been hot-branded. You can see where the hair is scorched from the first attempt. Olive oil was immediately applied to the wound.

pp. 14–15

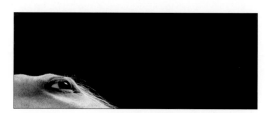

Arabian
Hassan. The Arabian is one of the oldest horse breeds, dating back to before 2,000 BCE.

p. 18

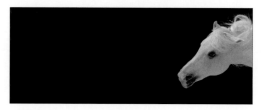

Arabian
Hassan.

p. 21

Andalusian
Pico.

p. 22

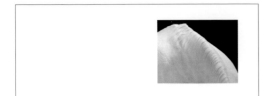

Arabian
Hassan.

p. 25

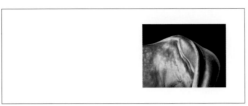

Akhal-Teke
Dalay-Shael. The metallic bloom of this ancient breed's coat is one of its most remarkable attributes. Its appearance comes after 3,000 years of breeding in Turkmenistan, where harsh conditions determined a lean physique and a horse noted for endurance and efficiency. The breed is connected with the now-extinct Turkoman horse, itself seen as one of the origins of the Thoroughbred.

p. 27

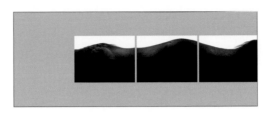

Lusitano
Dante. The triptych, suggestive of a mountain landscape, is a study of the withers and back.

p. 28

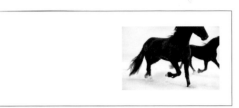

Frisian
Myck S and Olaf M. The Frisian is often used for pulling carriages, as well as for working the land and for riding. Noted for its high-stepping gait, its original homeland was in the north of the Netherlands—the ancient, heavy breed that was native to that area is believed to have mixed with other breeds, including the Andalusian, to create the Frisian.

p. 31

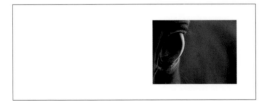

Lusitano
Eye of Imperator.

p. 33

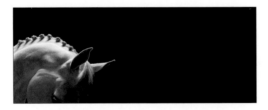

Holstein
Cassia. Often used in dressage and showjumping, this German breed has a highly arched neck with strong muscular definition.

p. 34

Holstein
Cassia.

p. 36

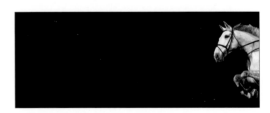

Holstein
Cassia.

p. 39

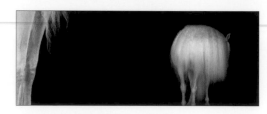

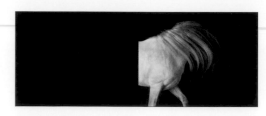

Irish Sport Horse
Cruisings Micky Finn being ridden by Olympic medalist John Whitaker.

p. 40

PRE Andalusian
Mane and head of Farol XXIX, a *Pura Raza Española* (PRE) Andalusian, or the 'pure Spanish race' of the Andalusian. Until 2003 a PRE could only be bay, grey, or black, but a Royal decree now permits all colors within the breed.

p. 42

PRE Andalusian
Rio Viejo.

pp. 44–45

PRE Andalusian
Farol XXIX.

p. 47

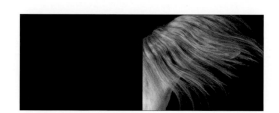

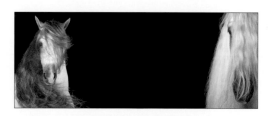

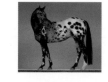
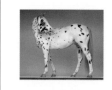

PRE Andalusian
Mane and neck of Farol XXIX.

p. 49

PRE Andalusian
Farol XXIX (left) and Rio Viejo (right).

pp. 50–51

Appaloosa
Detail of Mannog Moonriver showing blanket marking. The Appaloosa can be traced back to selective breeding by the Nez Perce tribe of the American Pacific Northwest. Prior to that, the introduction of horses into the Americas by the Spanish included spotted horses. Some 20,000-year-old cave drawings feature similarly marked horses.

p. 52

Appaloosa
Mannog Moonshadow (left), leopard marking. Mannog Moonriver (right), blanket marking.

pp. 54–55

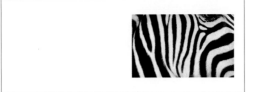

Chapman's Zebra
Nairobi. The Chapman's zebra is a subspecies of the Plains zebra. Zoologists think the stripes may serve as camouflage for the zebra in long grass because its main predator, the lion, is colorblind. It may also make it difficult for a lion to separate an individual zebra from the herd in order to attack.

p. 57

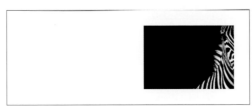

Burchell's Zebra
Jack, a Burchell's zebra, also known as the Plains zebra.

p. 59

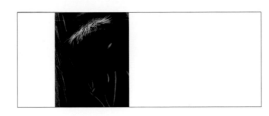

Arabian
Eye of Elwia.

p. 60

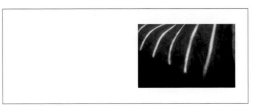

Lusitano
Rouxinol at rest in his stable with light falling through the ventilation.

p. 63

Lusitano
Rouxinol (left) and Heroi (right).

pp. 64–65

Lusitano
Heroi.

p. 67

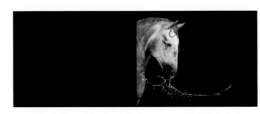

Lusitano
Unico II taking a bath.

p. 69

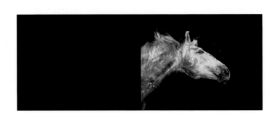

Lusitano
Unico II and soap suds.

p. 71

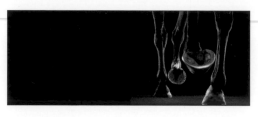

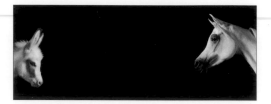

Thoroughbred
Montpellier.

p. 73

Lusitano
Neck of Dante.

p. 75

Thoroughbred
High Ambition working out on a treadmill.

p. 77

Miniature Donkey (Spotted)
Red Baron. This breed is thought to have originated in Sardinia.

Arabian
AJ Hojas has the delicate, pointed ears, flared nostrils, and pronounced dished profile that are sought-after features for the breed—but also increasingly controversial characteristics as they become more extreme.

pp. 78–79

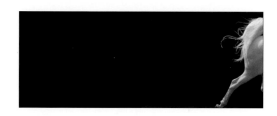

Arabian
Kubaisha.

p. 81

Przewalski's Horse
The only true wild horse, the *equus caballus Przewalskii* is re-establishing its place in the vast, inhospitable spaces of Hustai National Park, Mongolia, after being reintroduced from captive animals. The subspecies appeared to be extinct in the wild by the late 1960s, where it was overhunted and had its territory encroached on. Originally discovered by the Polish Colonel Przewalski in 1879, the horse has never been domesticated and is genetically different from domesticated horses in having 66 instead of 64 chromosomes.

p. 85

Przewalski's Horse
Young stallions fighting. A dominant stallion usually leads a small herd and forces other stallions out when they reach maturity at around three years old. The bachelors may then stay together for two years, practicing fighting skills before seeking to acquire their own harem of mares.

p. 87

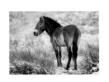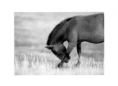

Przewalski's Horse

The Przewalski has primitive features probably unchanged since the last Ice Age. Roughly 47 to 55 inches tall (12hh to 14hh), it has a large head with a strong jaw that enables it to eat coarse grass, shrubs, and parts of trees. The eye position gives it an extremely wide field of view and the animal is highly sensitive to sound and scent. The Przewalski, or *Takh* in Mongolian, has a stiff dark mane, a feature reminiscent of horses depicted in cave art.

pp. 88–89

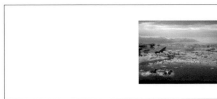

Icelandic Horse

This breed has lived in Iceland since 800 CE in a state of remarkable genetic purity, with laws that have likely prevented any cross-breeding since the 13th century. Broddi and Hersir were happy to get into the glacial waters of the Jökulsárlón Lagoon, but only after running off for an hour and proving to be a handful to recapture. The Icelandic's strong swimming derives from needing to cross turbulent rivers.

p. 91

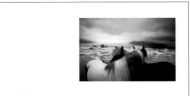

Icelandic Horse

Broddi and Hersir are seen here during a grooming session, also known as "withering", which horses only do when they are truly at ease with each other.

p. 93 and back cover

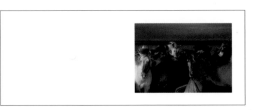

Icelandic Horse

Icelandics at Armot Farm.

p. 95

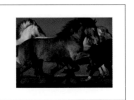

Icelandic Horse

Icelandics at Armot Farm, featuring Diljá. The Icelandic horse is known as a gaited breed because it can perform extra gaits as well as the more familiar ones. The tolt is a four-beat gait, like the walk, with speeds ranging from that of the walk to the canter, but with only one foot on the ground at any time. Some Icelandic horses can also pace, a motion where the legs move in lateral pairs at speeds of up to 30 mph.

p. 97 and front cover

Icelandic Horse

Diljá and Hafdís at Seljalandsfoss, Iceland.

p. 98

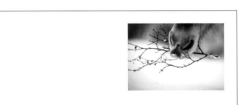

Fjord

Espe Ninni snacks on a wintry branch in the snowy hills above Nordfjordeid, Norway. The Norwegian Fjord horse has adapted to its harsh mountainous environment over hundreds if not thousands of years.

p. 101

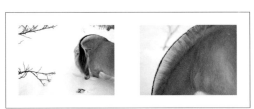

Fjord

Espe Ninni displays the breed's thick, bristly mane, which is similar to that of the Przewalski. The Fjord's mane and tail also have a distinctive band of black hair with silver hair surrounding it on each side.

pp. 102–103

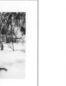

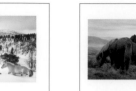

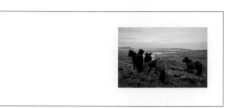

Fjord
Espe Ninni and Edel Mai were comfortable and sure-footed in deep snow and on the rugged terrain. The Fjord horse is versatile, with usage traditionally ranging from farming and sport to riding and transport.

p. 105

Fjord
The Norwegian Fjord horse's coloring is similar to that of wild horses such as the Tarpan, now extinct, and Przewalski's horse. The common colors are variations of dun, ranging from a brown through red to grey, as well as the rarer yellow.

p. 107

Shetland Pony
Spring, Fraser, and Applejack display the thick winter coat and heavy mane typical of the breed. The Shetland pony is well-adapted to the hard climate, poor grazing, and lack of shelter typical of its homeland.

p. 108

Shetland Pony
Floyd, Finlay, PB, and Rody have a compact, insulated form that is perfect for coping with the salty gales, mean pasture, and mostly treeless terrain of rock and peat bogs. Few other horse breeds would survive if put out in the hostile environment of the Shetland Islands.

p. 111

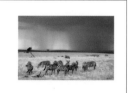

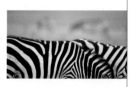

Burchell's Zebra
Also known as the Common zebra or Plains zebra, *equus quagga burchelli* is the most common and widespread zebra. Here it is seen in the Masai Mara, Kenya. A zebra's stripes have a unique pattern, like a fingerprint, and potentially serve a number of functions. One is camouflage from predators, another is that the black and white coloration may cause convection currents that help cool the animal. The black stripes have extra fat beneath them and can be up to 50 degrees Fahrenheit hotter than the white stripes.

p. 113

Burchell's Zebra
Usually found in small herds of one dominant stallion with a few mares and foals, Burchell's zebras come together in larger herds for migration.

p. 115

Burchell's Zebra
Stallions will fight to defend their herds, but on occasion the dominant stallion will allow a friendly stallion, one who they perhaps spent bachelor days with, to take a mare.

p. 117

Grant's Zebra
Equus quagga boehmi is the smallest zebra and has a more northerly distribution through Africa.

p. 118

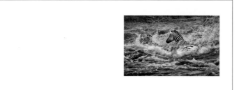

Burchell's Zebra

Crossing rivers during migration is one of the most dangerous times for the zebra, but it takes the risk in order to follow the rains and reach fresh grazing and water.

p. 121

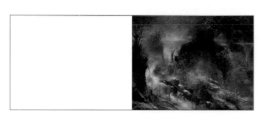

Burchell's Zebra

The Great Migration is one of the world's most exceptional natural phenomena and Africa's greatest wildlife gathering. The animals go on a 300 mile round-trip from the southern Serengeti to the northern edge of the Masai Mara National Reserve. The zebra typically travels alongside the more numerous wildebeest, which provide some protection from predators.

p. 123

Grant's Zebra.

Broad stripes down to the hoof are a distinctive feature of Grant's zebra.

p. 125

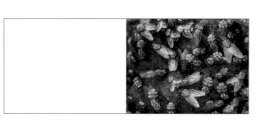

Flies

In most environments where you find horses, you also find flies. These flies from the *Muscidae* family, seen picking over Haflinger horse manure in Tyrol, are called *Phaonia Viarum*. *Muscidae* fossils date back 50 million years, comparable to the earliest ancestors of equus.

p. 127

Marwari

Sand on the skin of Bahadur Shah, in Dundlod, Rajasthan, India.

p. 129

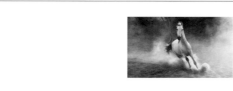

Marwari

Bahadur Shah. Known as the "warrior horse" by the people of Rajasthan, selective breeding of the Marwari for the Rajput rulers began in the 12th century. It is named after the Marwar region around Jodhpur. The warrior tradition prohibited non-military people from riding the horse, so under British rule and even after the country's independence, the breed declined to near-extinction. By the 1990s as few as 500 survived. Its numbers are now being carefully repopulated and the breed is banned from export.

p. 131

Marwari

Bahadur Shah reflected in a puddle.

p. 133

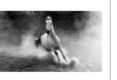

Marwari

The breed is distinguished by the unique form of its ears, often compared to a lyre or scimitar, set high on the poll. The ears can rotate through more than 180 degrees.

pp. 134–135

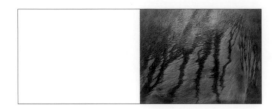

Marwari
Rain on ribs.

p. 137

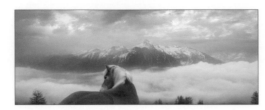

Haflinger
Tassiana overlooks a cloud rising in a valley in Tyrol, Austria. We camped for four days waiting for this distinctive orographic cloud to form; it's like steam rising from a kettle, but on this occasion it took a while for nature to come to the boil.

p. 138

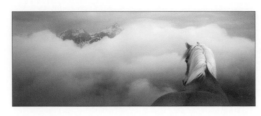

Haflinger
Within a few minutes the valley filled up with clouds, obscuring the facing mountains.

p. 140

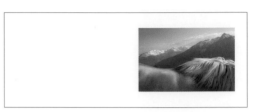

Haflinger
Indigenous mountain horses, cross-breeding with the Arabian horse hundreds of years ago has shaped the distinctive color and form of Austria's Haflinger.

p. 143

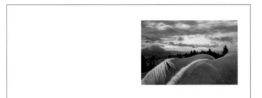

Haflinger
We photographed these horses at the top of the Tyrolean Alps in summer, when they let some of the young males out to graze, socialize, and strengthen their character. We needed at all times to keep the more inquisitive stallions at a distance.

p. 145

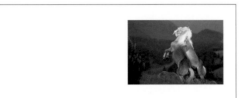

Haflinger
The young Haflinger stallions practice fighting, a primordial drive that can be fatal when mature stallions meet.

p. 147

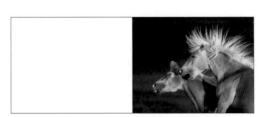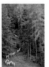

Haflinger

p. 149

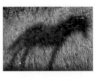

Haflinger

pp. 150–151

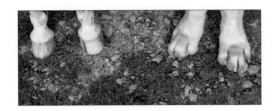

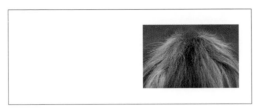

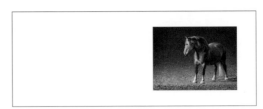

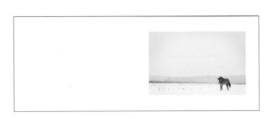

291

British Spotted Pony

Broomells Sunup (left) and Damarkann Mister Meena (right), a Great Dane. The British Spotted Pony is an ancient breed, with markings that would have worked as camouflage when it roamed wild and which are reflected in Stone Age cave art. In addition to spots, this breed also has a striped hoof.

p. 152

Suffolk Punch

The root of Withersfield Ruby's tail is typical of the chestnut coloration of the Suffolk, or Suffolk Punch. This farm horse was prized for its strength and efficiency (it ate less than other horses of equal strength). The breed dates back to just one stallion, Crisp's Horse, born in 1760 in Ufford, Suffolk.

p. 155

Suffolk Punch

The forelegs of the Suffolk are standard width apart but the hind feet are relatively close together, a form that helped the horse avoid damaging crops when working in the field.

p. 157

Latvian

Tonika. A tough day on the outskirts of Moscow in winter provides ideal conditions for demonstrating the hardiness of the Latvian Draught. One of the more recent breeds, it emerged from a mixture of breeding in the 1920s.

p. 159

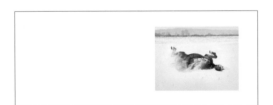

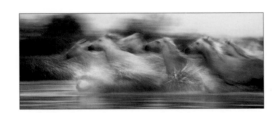

Latvian

p. 161

Camargue

The Camargue horse originates from the Rhône delta in southeastern France, where some are allowed to run wild in the marshlands while others are bred by farmers. It is believed to be descended from prehistoric horses that lived during the Paleolithic period 17,000 years ago. In 1927, Camargue Regional Park was established to protect the horses and cattle of Camargue from human encroachment. *Gardians*, or cowboys, still ride the horse to round up bulls.

p. 163

Camargue

p. 164

Orlov Trotter

Unipol. The Orlov Trotter is named after an 18th century Russian count who imported a grey Arabian stallion from Greece and crossed it with a Danish mare. The resulting foal, Polkan, sired a foal that became the foundation of the breed. It is now one of the leading breeds of trotting horse, although less well-known than the Standardbred and French Trotter. It is used in harness racing and also to improve other breeds. They are ideal *troika* horses because the center one can fast-trot while the other two canter, creating a balanced ride.

p. 167

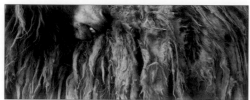

Poitou Donkey

Fillette grooming her coat. The *baudet de Poitou* is a donkey from the Poitou area in France. Remarkable in appearance thanks to its *cadanette*, or dreadlock-style coat of long hair, the breed was never worked but solely kept to sire mules.

p. 168

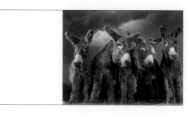

Poitou Donkey

The Poitou jack, or male, was prized for its ability to breed stronger mules of 67 inches (17hh) as long ago as Roman times. As a result, the area prospered and at its height bred as many as 30,000 mules a year. But serious decline set in after World War II and by 1977 there were only forty-four Poitou donkeys left. Since then, careful controls have rescued the breed, but it is still rare.

pp. 170–171

Mustang

Mustangs in Northern California, near Sacramento, in a gathering organized by the Bureau of Land Management to control and preserve these feral animals.

p. 173

Mustang

Horses died out in the Americas more than 10,000 years ago, until the arrival of the Spanish in the early 1500s. The original mustangs were actually horses that escaped either from these Spanish settlers or from Native Americans who took them from the settlers in Central America. (The word mustang is derived from *mesteño*, Spanish for a stray or feral animal.) Over the centuries, many other domesticated horses mixed into the mustang gene pool.

p. 175

Mustang

By 1900, as many as two million mustangs roamed the United States, mostly throughout Texas and other midcontinental states. The current mustang population is estimated to be 29,000 and the horses occupy mainly government-managed lands located in the western states.

p. 177

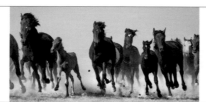

Mustang

A gathering in Utah. The romance of the American West provides both pros and cons for the right of mustangs to roam free. Allies see the animal as a key part of the American heritage, integral to the history of both the settlers and the Native Americans; they even argue for it as a returning, original species. The ranching lobby and some conservationists see it as a non-native species competing for scarce resources.

p. 178

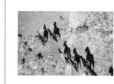

Mustang

This image shows the dominant mare (toward the top left of the frame) leading while the overall dominant stallion brings up the rear, in the best position to guard his herd.

p. 181

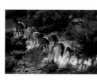

Mustang

Mustangs exist in several separated herds, maintaining some of the differences of their breeding origins. There is a mixture of the original Iberian horse, along with more recent Thoroughbred and several other influences in the horse's characteristics.

pp. 182–183

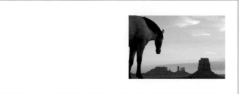

Mustang
Buck overlooking Mitten View, Monument Valley.

p. 185

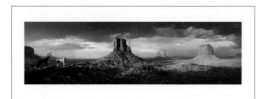

Mustang
Kagen and Prety. Monument Valley is a key part of the myth of the American West. Its distinctive buttes, called the Mittens, have appeared in music packaging, books, and on countless television programs and commercials. From John Ford's *Stagecoach* and numerous other westerns, to Marlboro cigarette ads and Ridley Scott's *Thelma & Louise*, this vista is associated with freedom and the American way of life, as is the mustang.

p. 186

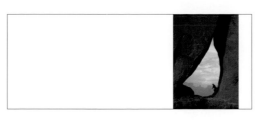

Mustang
Lucky at Teardrop Arch, Monument Valley.

p. 189

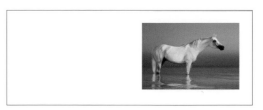

Arabian
A combination of flash and natural light captures Bakarat at the edge of the Arabian Gulf in Abu Dhabi. The style is evocative of contemporary fashion photography, perhaps appropriate for a breed that is the supermodel of the horse world.

p. 191

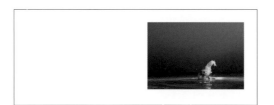

Arabian
Bakarat rising after a roll in the sea.

p. 193

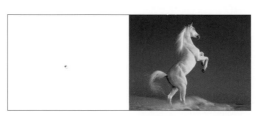

Arabian
Danaf rearing in a manner reminiscent of Ferrari logos and other iconography of horse power.

p. 195

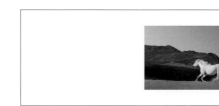

Arabian
Palestra runs past the landmark Fossil Rock in Sharjah.

p. 197

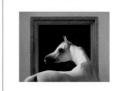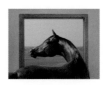

Arabian
Deska HJE (left) at the Ajman Stud with the stable window closed. See the introduction for an explanation of this picture (right) featuring JJ Ballarina, photographed in its stable at the Ajman Stud.

pp. 198–199

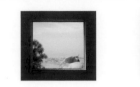 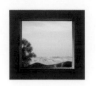

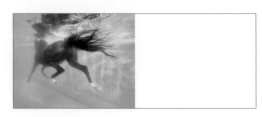

Arabian
Bess Fa'Izah (left) and gazelle at the Ajman Stud. PA Pryme Tymes Legacy (right) outside its stable at the Ajman Stud.

pp. 200–201

Thoroughbred
Barclay Boy near Hungerford, Berkshire, England. The Thoroughbred is the supreme racing horse, emerging in the 17th and 18th centuries when English mares were crossed with three stallions imported from the Middle East (the Darley Arabian, the Godolphin Arabian, and the Byerly Turk). A horse is classed as a Thoroughbred if both its parents are in the General Stud Book, which was first published in 1808.

p. 203

Arabian
Winding Wadi works out in a pool in Dubai. This is done as part of the routine training, and swimming becomes even more vital when injury prevents other training, offering a form of weightless movement that reduces the risk of exacerbating or causing concussion injury.

p. 205

Arabian
Winding Wadi.

p. 206

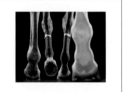

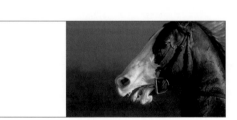

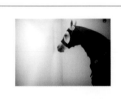

Thoroughbred
Top Target on a treadmill. The machine enables vets to produce standard speed and environmental conditions under which to assess a horse. They are also used by trainers in a variety of disciplines and their use has been shown to reduce concussion injuries that can be sustained during conventional work. They are one of many tools in the modern-day training and veterinary portfolio.

p. 209

Arabian
I wanted to show a horse at full gallop where you could see the veining and nostrils flaring. We tracked Mags Wild Thing (and rider) in two vehicles. I was in the lead vehicle closely followed by an open truck with two assistants aiming flash heads toward the horse while moving at around 30 mph. The result is a kind of hyper-reality.

p. 210

Arabian
The stallion Ansata Malik Shah has thoughts elsewhere than on a man with a camera.

p. 215

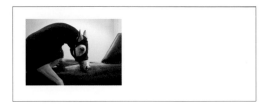

Arabian
Ansata Malik Shah mounts a dummy mare at the Sharjah Equine Hospital. He is wearing a neck and shoulder sweat, which helps develop definition. While artificial insemination is used with Arabians, it is prohibited by breeding and racing authorities for Thoroughbreds.

p. 216

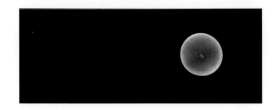

Thoroughbred embryo – Day 10
This embryo is in transit between mares at the Equine Fertility Unit, Newmarket, UK. At this point it is 3.8 mm in diameter. The pre-embryonic inner cell mass (ICM) is clearly visible as a lighter streak in the center. This will eventually give rise to the fetus while the remaining cells will form the placental membranes.

p. 218

Thoroughbred embryo – Day 30
This shows an equine embryo enveloped in the part of the placenta called the amnion. The crown-rump length is 12 mm. The basic body plan is now formed, with the limb buds visible.

p. 220

Thoroughbred fetus – Day 65
The crown-rump length of this specimen is 69 mm. Although devoid of hair, at this stage of gestation the fetus is clearly recognizable as a horse.

p. 222

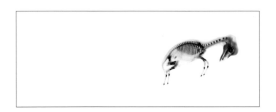

Thoroughbred fetus – Day 75
This equine fetus, stained with alizarin red to show the calcium deposits in the developing skeleton, is almost 75 mm crown-rump at this stage. The skeletal system provides a framework for other body structures and also protects the internal organs. Special cells in the developing bones, called osteoblasts, lay down a fibrous and amorphous matrix in which calcium salts are deposited.

p. 225

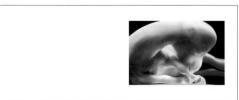

Thoroughbred fetus – Day 85
The mare died from colic, and as a result this foal also died. Colic in horses is defined as abdominal pain, but it is a clinical sign or symptom rather than a diagnosis. It can be fatal, as it was in this case.

p. 227

Thoroughbred fetus – Day 85
Detail of a tail (left). What looks like little more than the molding on a plastic toy can develop into a complex organ—the eye (right).

pp. 228–229

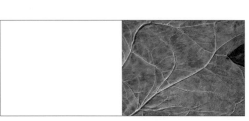

Thoroughbred placenta
This image shows the intricate network of blood vessels on the inner allantoic (fetal) surface of the equine placenta, with a small section of the red, velvety outer chorionic (maternal) surface also visible on the right of the picture. These provide the pathway through which the placental blood supply carries nutrition to the growing fetus.

p. 231

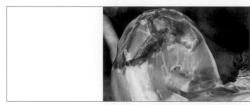

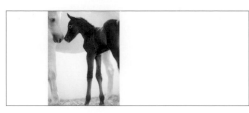

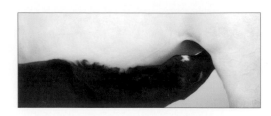

American Paint

Little Rosie. Horse birth usually happens very quickly (I was delighted to catch this while we were at the stable planning the photography of something else). The foal is delivered in the amnion, a shiny, translucent-white membrane interlaced with a network of blood vessels. Horses differ from humans in that the foal is surrounded by two fluid-filled sacs, the amnion and the allantois. The foal's urine is removed down a special tube to the allantoic fluid so that it remains floating in the purer amniotic fluid. The fluid sacs provide protection in the womb.

p. 232

American Paint

Little Rosie's hoof at birth. During late gestation, soft pads—sometimes called the foal slipper, the golden hoof, leaves, or gills—form on a foal's hooves. This eponychium is a soft epidermis cushion covering the tip of each hoof that protects a mare's uterus and genital tract from damage while pregnant and during foaling. Once the foal has been born, these break off and the hooves rapidly harden.

p. 234

Arabian

Arab foal Den Den with mare Nurgis at the Al Qasimi Stables, Sharjah.

p. 236

Arabian

A mare's milk is a major source of nutrition for the early part of a foal's life. Colostrum, a mare's first milk, contains antibodies that provide the newborn with protection against infection before its own immune system matures. For the successful transfer of these antibodies to occur, the foal must suckle within twelve hours of birth.

p. 238

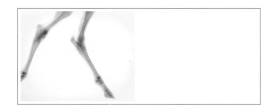

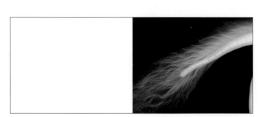

Welsh Section C

A horse's skeletal, tendon, and ligament structures give it the ability to sleep standing up. This is known as the "stay apparatus", which enables it to lock legs. The horse also has a third trochanter (a knobbly part on the bone) on the shaft of the lateral femur, for the attachment of the superficial gluteal muscles that help the canter and gallop. Other species have only two at the end. Equids also have a bicipital groove on the top of the humerus, a double groove for the split tendon of the biceps. Ruminants and carnivores lack this.

p. 241

Welsh Section C

X-ray of a head and neck.

p. 243

Welsh Section C

X-ray of hind legs.

p. 244

Welsh Section C

X-ray of a tail.

p. 247

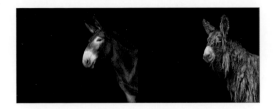

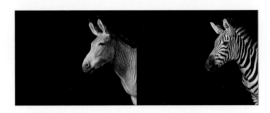

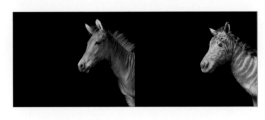

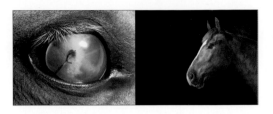

Mule (donkey x horse)

A mule is a cross between a donkey jack and a horse (a stallion crossed with a donkey is a hinny and tends to produce smaller offspring). Reinette is a cross between a Poitou donkey and a Mulassier draught horse, an example of what has been prized since Roman times as the ultimate working animal, the Poitevine mule.

Poitou Donkey

The remarkable coat of the Poitou donkey is called a cadanette. The donkey originates (and is mostly found) in the Poitou-Charente region of France, which is where we photographed Jalousie.

pp. 248–249

Zonkey (donkey x zebra)

Any cross between a donkey and a zebra can be called a zonkey. Other names include zebrass, zebronkey, zedonk, and zenkey. A donkey has 62 chromosomes while a zebra has between 44 and 62, depending on the species. This shows Zane, a cross between a Poitou donkey and a Grevy's zebra.

Grant's Zebra

Zurprize. Grant's zebra is the smallest of the subspecies of Burchell's zebra.

pp. 250–251

Zorse (horse x zebra)

The Zorse is any cross between a horse and a zebra, also known as a zebroid. Zantasia is a Thoroughbred crossed with a Grevy's zebra.

Quagga (extinct)

The quagga is an extinct species of zebra, formerly found in South Africa. It was killed in great numbers as a source of food and hide. The last known specimen died in the Amsterdam Zoo in 1883. In recent years genetic material has been extracted from preserved specimens in an attempt to produce animals resembling the quagga. This specimen was taken to the UK from Amsterdam by Lord Rothschild in 1889 and is now in the Natural History Museum, Tring, UK.

pp. 252–253

Arabian – blind eye

A blind eye does not always cloud over as in this eye of Deserree. The cloudiness could be due to trauma of the corneal oedema, uveitis, or glaucoma.

Welsh Cob

Laddie, a horse looked after by the International League for the Protection of Horses, arrived in their care with an eye removed as a result of disease. The previous owner bought him with an eye infection that proved unresponsive to treatment and the eye was removed under veterinary advice.

pp. 254–255

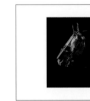

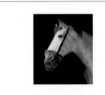

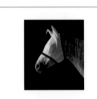

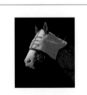

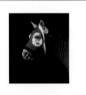

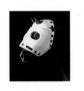

Eyes

Top row, from left: American Paint Horse, Grant's Zebra, Zonkey
Middle row: Perlino, Arabian, Appaloosa
Bottom row: Appaloosa, Zorse, Grulla

The central image shows a foal with the appearance of spectacles, an indication that it will change color to grey. Horses that are destined to be grey as adults can be born any color. Unlike humans, the progressive greying gene leads to greying of the hair at a young age, which is usually first noticeable around the foal's eyes.

p. 256

Riot gear – Dutch Warmblood

Gloucester wears the standard protective equipment issued by the UK Mounted Police Department and used in situations such as riots. First issued in 1985, this model dates from 1988 and it has not changed since.

Chloroform mask – Criollo

Manteca models a chloroform mask as used for anesthetizing horses until the 1950s. Anesthetizing horses was a hazardous business for both horse and handler. The horse could be walked around until it collapsed or was cast (thrown to the ground with ropes) and was then anesthetized.

pp. 258–259

Fly net – Arabian

Wildest Dream wears a fly net, which protects the eyes when flies are a nuisance. Flies are attracted to a horse's eyes in search of moisture.

Blindfold hood – Thoroughbred

This is used to assist the loading of horses into starting stalls before flat races. The hood calms a nervous horse by removing visual distractions.

pp. 260–261

Bodysuit – British Spotted Pony

Broomells Sunup sports a bodysuit, an accessory that has become popular in the preparation for showing horses. It is valued for keeping the coat clean; keeping the mane flat and show plaits in place; and helping bring a shine to the coat as a result of horses producing more grease when rugged up.

Head protector – Arabian

Al Patra, at the Sharjah Equine Hospital, wears an equine head protector, a mask used to prevent trauma after surgery. The protector is often used during recovery after a surgical procedure under general anesthesia to protect an incision or to stop a horse from harming itself through violent movement or imbalance.

pp. 262–263

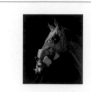 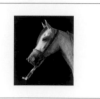 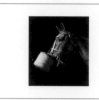 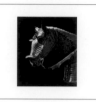

Respiratory measurement – Thoroughbred

This mask features ultrasonic flow meters used to measure respiratory function during exercise. It calculates breath rate per minute (BRPM) and measures both air flow in and out and oxygen levels in and out; from this the computer works out the VO_2 Max, the maximum oxygen uptake. Within the mask there is a beam of ultrasound and it is the interruption to the beam that measures the flows.

Equine inhaler – Arabian

El Badeah uses an inhaler mask featuring a nebulizer. This administers drugs such as salbutenol for recurrent airway obstruction, a complaint similar to asthma in humans.

pp. 264–265

Gas mask – Thoroughbred x Polo Pony

Fettle is modeling a replica of an equine gas mask, based on an original used in WWII. It was a mask used by the British Army on patrol in Syria during the summer of 1941, where they were fighting the Vichy French. This is believed to be the last occasion a mounted British Army cavalry unit saw action.

Armor – Irish Sport Horse

Hotspur wears armor typical of a nobleman's horse in the early 16th century. The Shaffron (face defense) is German, c. 1490; the Peytral (chest defense) is German, early 16th century; the Curb part is based on an English design, early 16th century; and the Mail Curtain and Crinet on the neck is West European, late 15th century.

pp. 266–267

Display at FEI World Cup 2006, Kuala Lumpur

p. 269

Photofinish camera – Lusitano

Rafael gets shrunk and then stretched in time and space as I play with an archival photofinish camera typical of what was used before the introduction of digital technology. This uses the slit-scan technique to produce an image by moving the film past a slit, so exposing along the film as the horse passes by (helping to ensure that you don't miss the crucial moment). Similar technology was also used for special effects in movies, notably in a sequence of Stanley Kubrick's *2001: A Space Odyssey* and to achieve the warp speed effect of the *USS Enterprise* in *Star Trek*. For photo technology buffs: I used an Omega Electronics Photosprint OPS2 and shot on a Kodak film that is no longer produced. This type of camera was first used to decide the placings in a 1947 race at Epsom, UK.

p. 271

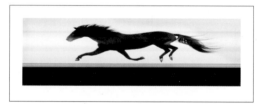 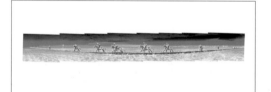

Photofinish camera – Lusitano

This image stretches the subject more by passing the film through faster than in the previous shot.

p. 272

Thermographic – Thoroughbred

Vets use thermal imaging in conjunction with physical examination to detect problems such as lameness. This image of training taking place at Newmarket records infrared radiation and assigns colors to the different wavelengths. Radiation is generated by the different emissivity of subjects in the image, being the proportion of energy in an object that is emitted as opposed to reflected. Here, the highest temperatures have been assigned white and the temperature scale goes down from there to red, orange, yellow, green, blue, purple, and black.

p. 274

Rock art, Côa Valley, Douro, Portugal

Ribeira de Piscos, Rock 11. The valley contains the largest collection of outdoor Paleolithic art in the world and is remarkable for having art of many prehistoric periods in one area. Przewalski-like horses feature among the figures. The petroglyphs were only examined by archeologists after 1994, halting plans to dam and flood the valley, and date back to between 20,000 and 10,000 BCE. Techniques used include fine line scratches (filiform), pecking, and abrasion. The engravings may originally have also been colored with paint, but no traces remain.

p.277
Front endpapers: Ribeira de Piscos, Rock 1
Back endpapers: Penascosa, Rock 6

Behind and before these images were numerous shoots, trips, meetings, conversations, emails, phone calls, and other preparation. I benefited from a fantastic range of help from many people, not to mention horses, in order to create what you have here in your hands. The animals, wonderful as they are, never just wander into a shot to wait for me to do my thing (and it wouldn't be much of a project if it was that easy). It took a lot of expert help and advice from individuals and organizations that are totally dedicated to their animals and their causes. To thank all the individuals who made everything possible would take more than your patience and my records. But if I miss any credits below, please be sure that I appreciated and thank all involved, from those who were holding a halter just out of shot, to a quiet genius somewhere inside a research institute whose learning I have gratefully taken on board. Any mistakes, of course, are mine.

I must single out for special mention Luisa Vasques, who assisted me throughout the planning and shooting and without whose calm and enduring efforts I would never have been able to produce these pictures. I must also note Samantha Beckett, whose work as production coordinator we could not have done without. For seeding in my thoughts many years ago curiosity around matters equine, my gratitude goes to my mother, Mary. Finally, everyday I need to pay back my wife, Yuyu, and son, James, who put up with so much without ever complaining. First I filled my diary with trips to strange corners of the globe in the quest for equus in every light and season, and then I filled my days and nights with long stretches in the studio selecting and refining the images. Immense tolerance is clearly needed if you want to live with a photographer and his passions.

Heartfelt thanks also to: Animal Health Trust; Lewis Blackwell; Andrew Bodley; Igor Botchkarev; Thomas B. Capstick; Cheltenham Racecourse; Tara Clark; Tobias Coles; Tim Corballis; Matt Cumani; Bryony Daniels; Julie Day; Nicola Dove; Raghuvendra Singh Dundlod; Dale Durfee; Wendy Edgar; Paul Foster; Hansjörg Köll; Charlie Henson; Tim Hobbs; Deirdre Hyde; Anne Ismer; Jennifer Jenning; Rene Kiel; Sarah King; Alexandra Cerveira Pinto Sousa Lima; Debbie Loucks; Dawn Martin; Sally McGurn; Lucy Monro; Moscow Stud Farm #1; Claudia Pendrid; Rosa Pinard; Dr. João Pedro Ribeiro; Monty Roberts; Alison Schwabe; Belinda Seward; Mila Simões de Abreu; Nathalie Tafelmacher; Meinhard Trojer; Marina Veneziale; Eileen Verdieck; Tina Walker; Jaci D. Wickham; and Sandra Wilsher.

Produced and originated by:
PQ Blackwell Limited
116 Symonds Street
Auckland, New Zealand
www.pqblackwell.com

For Abrams:
Editor: Esther de Hollander
Jacket Design: Michelle Ishay-Cohen
Production Manager: Alison Gervais

Library of Congress Cataloging-in-Publication Data:

Flach, Tim.
 Equus / By Tim Flach.
 p. cm.
 ISBN 978-0-8109-7142-4 (harry n. abrams, inc.)
 1. Horses. 2. Horses—Pictorial works. I. Title.

SF303.F58 2008
779'.3296655—dc22

 2008011885

Printed and bound in China
10 9 8 7 6 5 4 3

Abrams books are available at special discounts when purchased in quantity for premiums and promotions as
well as fundraising or educational use. Special editions can also be created to specification. For details, contact
specialmarkets@abramsbooks.com or the address below.

115 West 18th Street
New York, NY 10011
www.abramsbooks.com

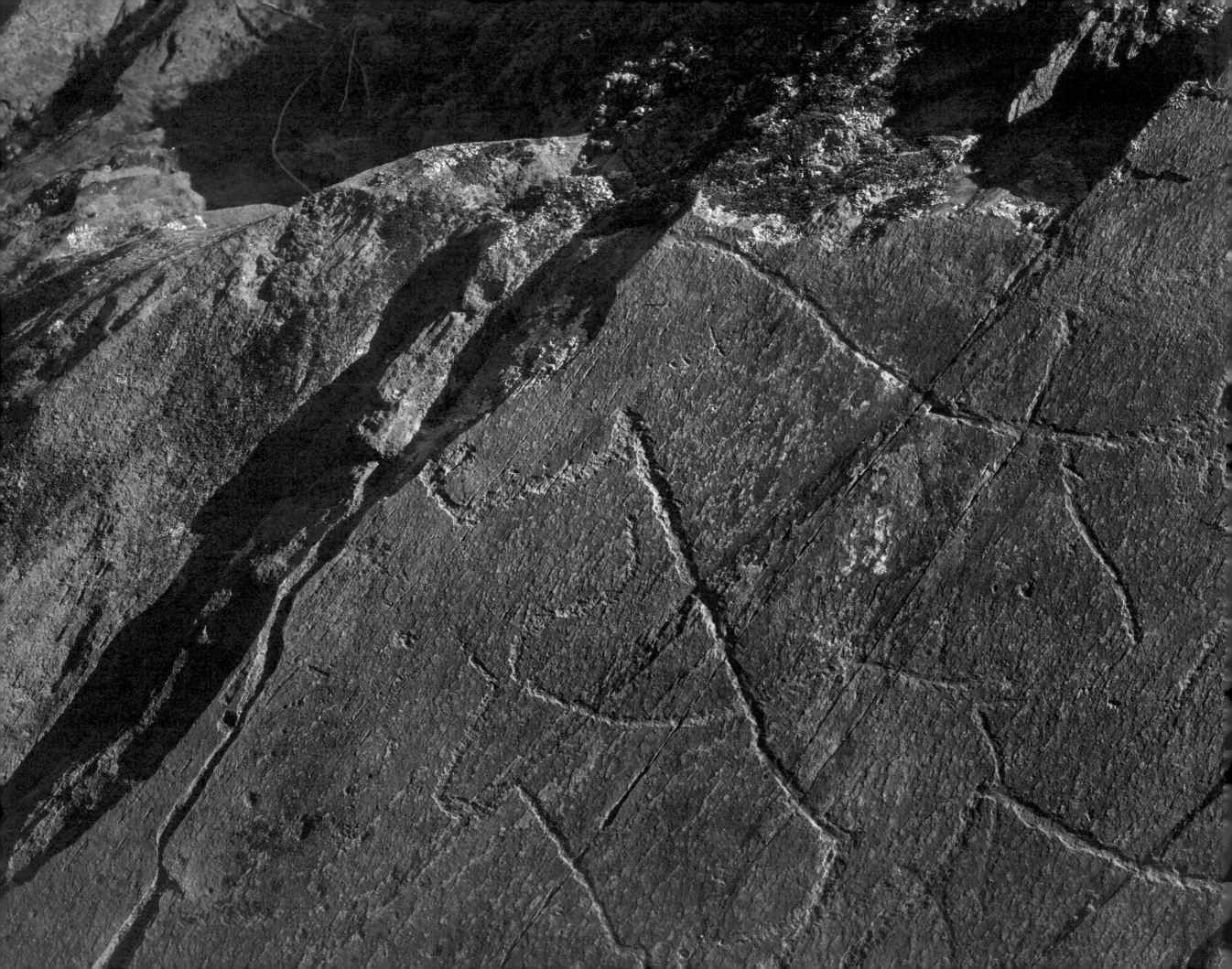